❖ WILLIAM MERRITT CHASE ❖

Modern American Landscapes, 1886–1890

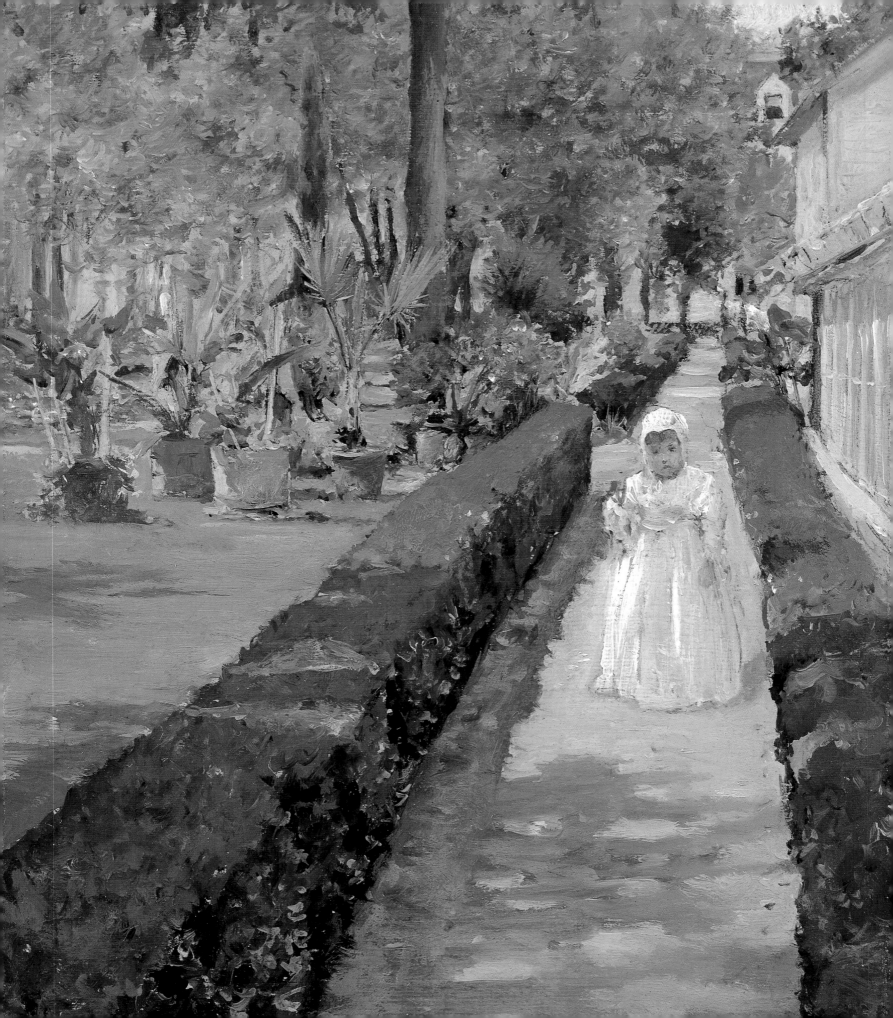

WILLIAM MERRITT CHASE

Modern American

Landscapes, 1886–1890

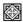

Barbara Dayer Gallati

BROOKLYN MUSEUM OF ART

IN ASSOCIATION WITH

HARRY N. ABRAMS, INC., PUBLISHERS

Published on the occasion of the exhibition *William Merritt Chase: Modern American Landscapes, 1886–1890* at the Brooklyn Museum of Art, New York

This exhibition is made possible by The Henry Luce Foundation, Inc. Generous support has been provided by The Ronald H. Cordover Family Foundation and The David Schwartz Foundation. The BMA is also grateful to Mr. and Mrs. Richard A. Debs, Mr. and Mrs. John S. Tamagni, Mrs. Avery Fisher, Constance and Henry Christensen III, Mr. and Mrs. Paul Bernbach, Mr. and Mrs. Edgar M. Cullman, Jr., Mr. and Mrs. Joseph T. McLaughlin, Sol Schreiber, and Mr. and Mrs. William D. Watt.

Support for the catalogue was provided through the generosity of Furthermore, the Publication Program of the J. M. Kaplan Fund, as well as a BMA publications endowment created by The Iris and B. Gerald Cantor Foundation and The Andrew W. Mellon Foundation.

EXHIBITION ITINERARY

Brooklyn Museum of Art
May 26–August 13, 2000

The Art Institute of Chicago
September 7–November 26, 2000

The Museum of Fine Arts, Houston
December 13, 2000–March 11, 2001

Library of Congress Cataloging-in-Publication Data
Gallati, Barbara Dayer.
 William Merritt Chase modern American landscapes, 1886–1890 /
Barbara Dayer Gallati.
 p. cm.
 Includes bibliographical references (p.) and index.
 ISBN 0–8109–4558–4 (Abrams : cloth)—ISBN 0–87273–140–5
 (Museum pbk.)
 1. Chase, William Merritt, 1849–1916—Criticism and interpretation.
 2. Impressionism (Art)—United States. 3. Landscape painting, American.
 I. Title.

 ND237.C48 G365 2000
 759.13—dc21 99–53543

This publication was organized at the Brooklyn Museum of Art
James Leggio, Head of Publications and Editorial Services
Project Manager: Joanna Ekman
Editor: Fronia W. Simpson

For Harry N. Abrams, Inc.
Project Manager: Margaret L. Kaplan
Editor: Elaine M. Stainton
Designer: Dana Sloan

Printed and bound in Japan

PHOTOGRAPH CREDITS

Contents

Foreword 7

Preface and Acknowledgments 9

Lenders to the Exhibition 11

INTRODUCTION

Modern American Landscapes, 1886–1890

13

CHAPTER ONE

"Whither Does It All Lead?"

21

CHAPTER TWO

1886: A Year of Transition

37

CHAPTER THREE

America Rediscovered

51

CHAPTER FOUR

Discovering Meaning in Chase's Realism

137

CHAPTER FIVE

A Reputation Reclaimed

163

Selected Bibliography 181

Exhibition History 184

Index 187

FOREWORD

The Brooklyn Museum of Art is pleased to have organized *William Merritt Chase: Modern American Landscapes, 1886–1890*, the most recent in a distinguished series of Museum exhibitions that have articulated the history of American art in both scholarly and innovative ways. It is appropriate for Brooklyn to present this exhibition, not only because the Museum holds one of the largest public collections of Chase's art, but also because this project brings to light the painter's strong connections with Brooklyn in the 1880s, when he set out to revise his career with paintings of Prospect Park and other familiar sites in this borough and in Manhattan. The exceptional works in this exhibition amply explain Chase's success in reclaiming critical approbation in his own time and demonstrate why his art has retained its importance today. Colorful, vital, and immediate, Chase's park and harbor paintings record how he ingeniously transformed familiar public spaces into the subjects of high art and, through them, underscored the modernity of his vision.

The exhibition was conceived and organized by Barbara Dayer Gallati, Curator of American Painting and Sculpture, who also wrote this groundbreaking publication. I wish to express my thanks to her and to the members of the Museum staff whose talents contributed to the realization of the exhibition and publication.

I extend my deep appreciation to the many lenders, both public and private, who have so generously lent important paintings and pastels for the purpose of uniting this small but select group of works for the first time. The Museum is delighted to share this exhibition with two highly esteemed institutions, and I wish to express my gratitude to my colleagues James N. Wood, C.E.O. and President of The Art Institute of Chicago, and Peter Marzio, Director of The Museum of Fine Arts, Houston, for their enthusiastic support of this project.

On behalf of the Board of Trustees, I want to thank The Henry Luce Foundation, Inc., for its generous support of this project, and also The Ronald H. Cordover Family Foundation and The David Schwartz Foundation for their deeply appreciated contributions. All of us at the BMA are also grateful for the support of Mr. and Mrs. Richard A. Debs, Mr. and Mrs. John S. Tamagni, Mrs. Avery Fisher, Constance and Henry Christensen III, Mr. and Mrs. Paul Bernbach, Mr. and Mrs. Edgar M. Cullman, Jr., Mr. and Mrs. Joseph T. McLaughlin, Sol Schreiber, and Mr. and Mrs. William D. Watt. Funds for the catalogue have been provided through the generosity of Furthermore, the Publication Program of the J. M. Kaplan Fund, as well as a publications endowment created by The Iris and B. Gerald Cantor Foundation and The Andrew W. Mellon Foundation. We remain grateful to our friends at both foundations for their foresight in establishing this critical endowment.

For the ongoing support of the Museum's Trustees, we extend special gratitude to Robert S. Rubin, Chairman, and every member of our Board. Without the confidence and active engagement of our Trustees, it would not be possible to initiate and maintain such a high level of exhibition and publication programming as is exemplified by *William Merritt Chase: Modern American Landscapes, 1886–1890*.

Arnold L. Lehman
Director

PREFACE AND ACKNOWLEDGMENTS

The exhibition *William Merritt Chase: Modern American Landscapes, 1886–1890* is, above all, about an artist's choices. Because the creative process is often deliberately mystified and romanticized by artists and by writers about art, the fact is sometimes overlooked that art usually has a good measure of pragmatic decision-making at its source. This book and the exhibition it accompanies provide a detailed account of a brief, albeit critical period of this famous painter's life to better understand why and how he transformed his art and reputation at a particular point in his career. In addition to presenting Chase in a new light, this study investigates in detail for the first time his brightly colored, sun-filled urban scenes, recognized today as the first significant works in which a variant Impressionist style was used to portray American landscape subjects. Although Chase's paintings of Brooklyn and New York parks and harbors count among the most familiar and best-loved works of late-nineteenth-century American art, it is hoped that this reconsideration of the motives that inspired the images will stimulate even greater admiration for them.

Many individuals generously contributed their support and expertise in bringing the exhibition and publication to fruition. My sincere appreciation extends to everyone mentioned here as well as to those whose help will come after the deadline for this writing. This project would not have happened without the enthusiasm and leadership of Arnold L. Lehman, Director of the Brooklyn Museum of Art. Encouragement from Linda S. Ferber, Andrew W. Mellon Curator of American Art, and Roy R. Eddey, former Deputy Director, provided the impetus to propose the idea as an exhibition. A major undertaking such as this project depends on the expertise of virtually every department in the Museum, but the acknowledgments here focus primarily on those who were instrumental in the groundwork for the exhibition and the book. I am greatly indebted to Sarah Elizabeth Kelly, Andrew W. Mellon Research Associate of American Art, for her fine research skills, insight, energy, diligence, and passion for the entire research process. The American Painting and Sculpture department's Research Assistant, Sarah Snook, and volunteers Joan Blume and Leslie Beller were also extremely helpful in lending their time and talents, as was our Departmental Assistant, Stephanie Leverock. The staff of the Museum's Art Reference Library, headed by Deirdre Lawrence, Principal Librarian/Coordinator of Research Services, was exceptionally responsive to our research needs, as was Deborah Wythe, Archivist/Manager of Special Library Collections.

Among my curatorial colleagues at the Museum, Linda S. Ferber again deserves particular recognition for reading the manuscript in its early stages, and listening and reacting to my ideas with good counsel. I would also like to thank Teresa A. Carbone, Associate Curator, American Painting and Sculpture; Marilyn S. Kushner, Curator of Prints, Drawings, and Photographs; Kevin Stayton, Curator of Decorative Arts; and Barry Harwood, Associate Curator of Decorative Arts. I am especially grateful to Ken Moser, Vice Director, Collections, and his staff in Exhibition Management, including Hannah Mason and Heidi Vickery-Uechi, for their help in organizational matters. Similarly, special thanks go to the tireless efforts of the Museum's Chief Registrar, Elizabeth Reynolds, and her staff. Others deserving of special mention are Dean Brown, the Museum's Chief Photographer; Judith Frankfurt, Deputy Director for Administration; and Peter Trippi, Vice Director for Development, and members of his staff, particularly Barbara Burch, Michele Snyder, Taiga Ermansons, and

John Carini. My thanks go as well to Deborah Schwartz, Vice Director for Education and Public Programs; Charles Froom, Chief Designer; Sally Williams, Public Information Officer; and Cathryn Anders, Collections Manager. The editorial and management skills of James Leggio, the Museum's Head of Publications and Editorial Services, and Joanna Ekman, Editor, kept the publication process on track through all phases. And, as she has done so brilliantly with previous Museum publications, freelance editor Fronia W. Simpson has added her fine and judicious guidance in editing the text. This project has given me the pleasure of working once again with the staff of Harry N. Abrams, especially Margaret L. Kaplan, Elaine Stainton, Margaret Chace, Dana Sloan, and others of Abrams's excellent editorial and design team.

I am particularly grateful to Judith A. Barter, Field-McCormick Curator of American Arts, and Andrew Walker, Assistant Curator of American Painting and Sculpture, at The Art Institute of Chicago, and to Emily Ballew Neff, Curator of American Art and Sculpture, at The Museum of Fine Arts, Houston, for their early enthusiasm, which not only resulted in generous loans from their respective institutions, but also culminated in a superb partnership for the exhibition's tour.

My deep appreciation goes to all of the private and institutional lenders to the exhibition who are acknowledged separately. It is because of them that we have the privilege of seeing this group of Chase's paintings together for the first time. Credit and gratitude also go to each of the following individuals, all of whom helped enormously in locating paintings, arranging for loans, or providing materials and information integral to this book: Warren Adelson, Elizabeth Oustinoff, and Susan Mason, Adelson Galleries, Inc.; Robert Bardin; Frederick D. Hill, James Berry-Hill, and Bruce Weber, Berry-Hill Galleries, Inc.; Michell Hackwelder, The Brooklyn Historical Society; Judith Walsh, Librarian, and the staff of the Brooklyn Collection, Brooklyn Public Library; Richard Drucker, Brooklyn Navy Yard Development Corporation; Eric P. Widing and Polly J. Sartori, Christie's, Inc.; Jonathan Kuhn and Donald G. Glassman, City of New York Parks and Recreation; Henry Adams, The Cleveland Museum of Art; Hugh Gourley III, Colby College Museum of Art; Thomas Colville, Thomas Colville Fine Arts; Jonathan Boos, Epic Fine Arts, Inc.; Louis D. Fontana; Karen K. Gabrielsen; Gerald Peters, Reagan Upshaw, and Lily Downing Burke, Gerald Peters Gallery, Inc.; Dr. Charles Gilbert; Stuart Feld, M. P. Naud, and Susan Filosa, Hirschl & Adler Galleries, Inc.; Randall Suffolk, The Hyde Collection; Vanessa Burkhardt, Indianapolis Museum of Art; Vance Jordan and B. J. Topol, Vance Jordan Fine Art, Inc.; James M. Keny, Keny Galleries, Inc.; Melissa de Medeiros, M. Knoedler and Company; Alan Kollar; Joan Barnes, The Manoogian Collection; Jo Meszaros; H. Barbara Weinberg and Peter Kenny, The Metropolitan Museum of Art; Joan Michelman; Lori A. Mott, University of Michigan Museum of Art; Margaret Lynne Ausfeld, Montgomery Museum of Fine Arts; Eileen K. Morales and Marguerite Lavin, Museum of the City of New York; Theodore E. Stebbins, Jr., and Erica Hirshler, Museum of Fine Arts, Boston; Gregory Planges, National Archives, New York; Elizabeth Broun and Virginia Mecklenburg, National Museum of American Art, Smithsonian Institution, Washington, D.C.; Nicole Wells, The New-York Historical Society; David Nisinson; Alicia Longwell, The Parrish Art Museum; John Pierrepont; Ronald G. Pisano; Ganine St. Germaine, formerly of the Prospect Park Archives, and her successor, Julie Moffat (formerly of the Brooklyn Public Library); Lee Roberts; William B. Ruger; Rachel Mauldin and Karen Zelanka, San Antonio Museum of Art; Mr. and Mrs. Richard J. Schwartz; Edward Shein; Nancy Harrison, Peter Rathbone, and Lara Shirvinski, Sotheby's, Inc.; Ira Spanierman and Betty Krulik, Spanierman Galleries, Inc.; Norman Taylor; Lawrence W. Nichols and Patricia Whitesides, The Toledo Museum of Art; Lucia Cassol, Thyssen-Bornemisza Collection; Lois Wagner, Lois Wagner Fine Arts Inc.; Robin Jaffee Frank, Yale University Art Gallery; Richard York, Richard York Gallery, Inc.; and Barbara Zipperer.

Finally, I wish to acknowledge the work of Norman Bryson, whose writing is a rich mine of stimulation and challenge. Although I may not always agree with him, certain of his themes ring true for me, especially: "The viewer is an interpreter, and the point is that since interpretation changes as the world changes, art history cannot lay claim to final or absolute knowledge of its object" (Bryson, *Vision and Painting: The Logic of the Gaze*, 1983). It is in that spirit that this book was written, with the added hope that the new interpretations presented here will reveal valuable layers of meaning in Chase's art.

Barbara Dayer Gallati
Curator, American Painting and Sculpture
Brooklyn Museum of Art

LENDERS TO THE EXHIBITION

The following individuals and institutions were joined by a number of private individuals and collections that wished to maintain anonymity. The Museum gratefully acknowledges the generosity of all of the lenders, whose gracious cooperation made this exhibition and book possible.

The Art Institute of Chicago

Brooklyn Museum of Art

Carmen Thyssen-Bornemisza Collection

Colby College Museum of Art, Waterville, Maine

Gerald Peters Gallery, Inc., New York

Marie and Hugh Halff

Hirschl & Adler, Inc., New York

Manoogian Collection

The Metropolitan Museum of Art, New York

Montgomery Museum of Fine Arts, Montgomery, Alabama

Museum of Fine Arts, Boston

The Museum of Fine Arts, Houston

Richard and Susanna Nash

National Museum of American Art, Smithsonian Institution

The Parrish Art Museum, Southampton, New York

John Pierrepont

The Saint Louis Art Museum

San Antonio Museum of Art

Shein Collection

Mr. and Mrs. Peter G. Terian

The Toledo Museum of Art

University of Michigan Museum of Art, Ann Arbor

Vance Jordan Fine Art, Inc., New York

Steven C. Walske

Erving and Joyce Wolf Collection

Yale University Art Gallery, New Haven, Connecticut

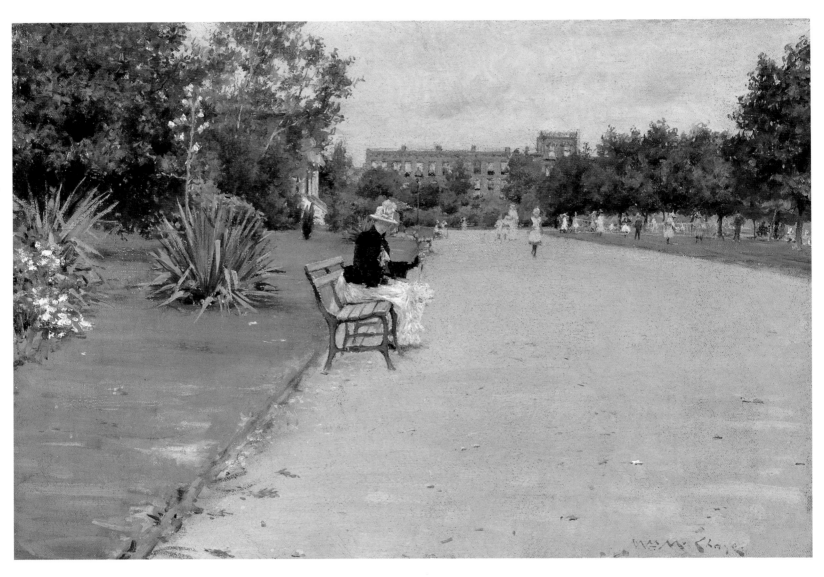

Pl. 1. A City Park, 1887. Oil on canvas, 13⅝ × 19⅝ inches. The Art Institute of Chicago, Bequest of Dr. John J. Ireland, 1968.88. © 1999 The Art Institute of Chicago. All Rights Reserved.

Introduction

MODERN AMERICAN LANDSCAPES
1886–1890

This project grew from what seemed at first to be a fairly straightforward question: Why do some of William Merritt Chase's paintings of Brooklyn's Prospect Park not look like Prospect Park?[1] The search for the answer initiated an examination of all of Chase's park subjects, a body of work belonging to a larger subset within his oeuvre—Brooklyn and Manhattan scenes executed between 1886 and 1890. This discrete group of works is consistently described in the Chase literature as not only beautiful but also remarkably innovative, in that they are the first paintings in which an Impressionist style was used to depict American subjects.[2] Yet, as the research continued, it became apparent that, despite Chase's historical position as a "first" in terms of his application of Impressionism to native scenery, very little was known about the works themselves, what they actually portrayed, why Chase chose to paint them, how they were received by the contemporaneous audience, and what, if any, effect that reception had on the trajectory of Chase's career. As the title of this exhibition and book indicates, the focus of this study is Chase's incorporation of the American landscape into his subject matter. More than that, however, it investigates both the modern character of the geographic spaces he chose to paint and the avant-garde manner in which he painted them. In addition to outlining the aims of the project, this introduction sets forth some of the problems attendant on Chase studies in general and on this area of his career in particular.

The paintings that Chase displayed at the 1889 Paris Exposition Universelle were chosen as a narrow but reliable constellation of works by which the artist's opinion of what shall be called his "civilized urban landscapes" might be gauged. The exposition—one of the great nineteenth-century world fairs—was a momentous event for American painters. Paris was then the capital of the Western world's art production, and there could be no better venue for a generation of mainly European-trained American artists to demonstrate (and test) their artistic powers. Of all the national blocs contributing, the Americans were second in number only to their French hosts. Among the 189 American painters participating, it was William Merritt Chase (1849–1916) who, with eight paintings on view, exhibited the largest number of works. Although Chase's strong presence at the exposition should not be considered extraordinary (in addition to being an artist of proven ability, he was president of the Society of American Artists and adept at organizational politics), the nature of the work he displayed was unusual within the context of the United States art section.[3]

Three of the paintings Chase exhibited at the exposition are on view in the present exhibition and are central to its aims: *A City Park* (Pl. 1), *Peace, Fort Hamilton* (Pl. 2), and *Gowanus Bay* (also known as *Misty Day, Gowanus Bay*) (Pl. 3), all of which depict Brooklyn, New York, locales. Two additional landscapes, *A Bit of Long Island* and *Stoneyard*, were also displayed, but remain unlocated.[4] These comparatively small, freely brushed outdoor subjects stood in graphic contrast to the other paintings shown by Chase, the most famous of which is the full-length *Lady in Black* (fig. 1).[5] This portrait of Chase's student, Maria Benedict Cotton (1868–1947), emphatically aligned his art with figure painting, a subject area that had overtaken landscape as the dominant iconography in the United States mainly as a result of the teaching practices in the

Paris ateliers, where so many Americans had trained in the 1870s.[6] Chase's paintings, possessed of radically divergent subjects and styles, reinforced the already common perception of eclecticism that attached to his artistic identity. Beyond that, however, when they are considered against the larger scheme of the exposition's American section, Chase's landscapes were unique for several reasons. Although they were certainly not the only landscapes on view, they were the only views of an American city and its suburbs, a fact that set them apart from such works as Childe Hassam's (1859–1935) *Rue Lafayette: Winter Evening* (fig. 2) and Frank Myers Boggs's (1855–1926) *Place de la Bastille, Paris* (Musée Vivinel, Compiègne). Typical of the American landscape paintings at the exposition were relatively anonymous rural scenes exemplified by Alexander Helwig Wyant's (1836–1892) *Landscape* (fig. 3) and Julian Alden Weir's (1852–1919) *Lengthening Shadows* (Collection of Dr. and Mrs. Demosthenes Dasco in 1989).[7] The differences between Chase's landscapes and those

of his colleagues, however, were likely to be overlooked, not only because the exposition galleries were so crowded with paintings and viewers but also because Chase's intimately scaled works were handicapped at the outset, since they competed in a value system in which the size of a painting was usually part of the equation in determining its consequence. Size notwithstanding, these paintings (by virtue of the places they depicted) revealed an underlying eccentricity on Chase's part that marked them as anomalies within the broader field of American landscape production.

Chase's *City Park*, *Peace, Fort Hamilton*, and *Gowanus Bay* were virtually ignored in the critical commentary devoted to the exposition, although, since he received a second-class (silver) medal, his name was mentioned frequently and positively.[8] For the most part, both French and American reviewers focused on how imitative of the Europeans the American artists were.[9] An occasional oblique reference in favor of Chase's subject matter was inserted in broader discussions, such as: "The Americans

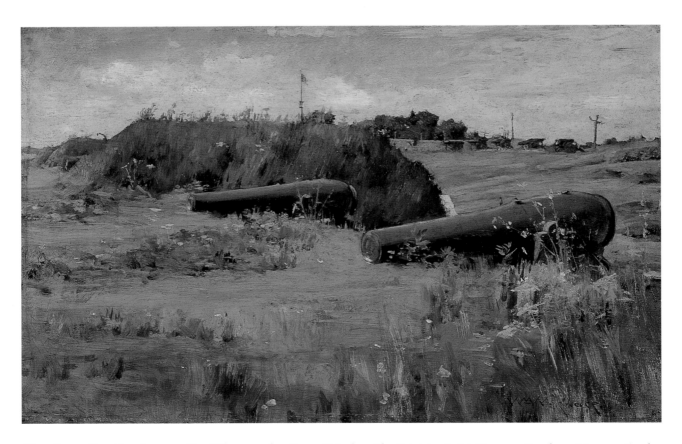

Pl. 2. Peace, Fort Hamilton, c. 1887. Oil on panel, 10⁵⁄₁₆ × 15⅞ inches. The Saint Louis Art Museum, Purchase: Museum Funds.

14

who study everywhere and paint at home are not inferior to these [American artists living abroad] in any intrinsic virtue. So far as the present collection of American works is a fair test no better work is seen here than Chase's."[10] Invariably, when they were mentioned, the landscapes were considered as a group, as witnessed by the *New York Herald*'s brief summary listing the artist's exhibits: "William M. Chase, a 'Portrait' of a lady, a portrait of his pupil, Miss Rosalie Gill, a portrait of his wife and babe, in Japanese costumes, and five little views about New York and Brooklyn."[11] Of the reviews surveyed in the course of this study, only William A. Coffin's comments offered a serious appraisal of Chase's landscapes: "The small pictures of city scenes about Brooklyn parks and docks, than which nobody has painted anything better in their way, do not show here at their full worth. The little canvases are lost on the big walls, and the light is so high that the pictures are in the shadow cast by the frames. For all that, enough may be seen to leave no doubt of their merit; and their cleverness and artistic quality are incontestable."[12]

Given the vast amount of research recently devoted to the careers of American artists trained in Europe and the reception of their work at home and abroad, it is surprising that Chase's artistic profile in the 1889 exposition has not been analyzed.[13] More surprising is that this segment of his work comprising New York and Brooklyn park and coastal scenes has not been closely studied.[14] If only on the basis of his own emphasis of this group of works at the exposition, we must assume that Chase deemed his urban-suburban Brooklyn landscapes to be significant examples of his art. It will be shown that they were vital components in his complex project of ongoing self-definition (or reinvention).[15] Just as they represent a critical transitional phase in Chase's career, these paintings may also be looked to as the primary harbingers of the stylistic and thematic shifts that finally took firm hold in the American visual arts in the 1890s.

The period of Chase's interest in painting Brooklyn and Manhattan scenes is clearly demarcated, limited to five summer painting campaigns beginning in 1886 and lasting through 1890 (the year before he began spending the summer seasons teaching at the Shinnecock Summer School of Art at the eastern end of Long Island). Prior to 1886 Chase had traveled to Europe each year, a luxury that he put aside temporarily because of family responsibilities. Most scholars attribute his adoption of American urban subjects to the hiatus in his regular pattern of summer pilgrimages to Europe, indicating that enforced proximity to these varied locations throughout the

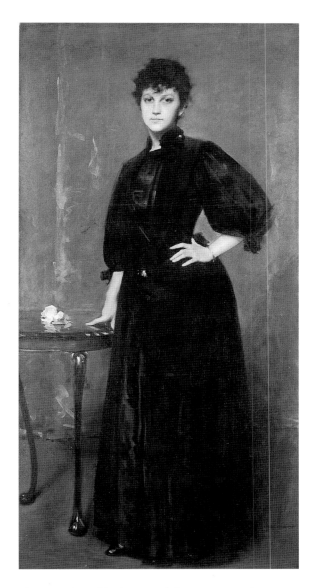

Fig. 1. Lady in Black, *1888. Oil on canvas, 74¼ × 36⁵⁄₁₆ inches. The Metropolitan Museum of Art, Gift of William Merritt Chase, 1891.*

metropolitan area prompted his artistic investigations of them. Similarly, the disappearance of the urban scene from his art is generally explained by his seasonal residence in Shinnecock from 1891 to 1902. The reasoning behind these assumptions is valid for the most part, and, in the absence of written confirmation from the artist, it offers a feasible narrative that accounts for the brief tenure of a stylistically and thematically cohesive category within his oeuvre. Yet the narrative is incomplete. Not only does it fail to explain why Chase

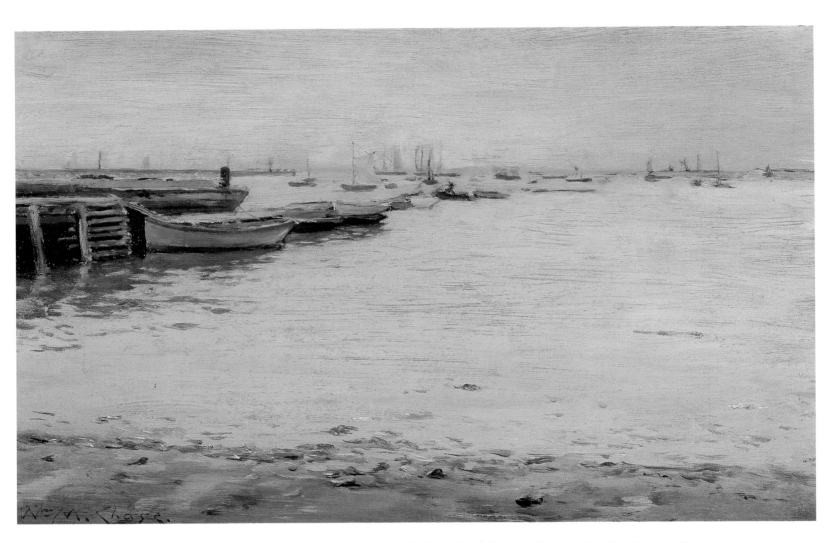

Pl. 3. Gowanus Bay (*also known as* Misty Day, Gowanus Bay), *c. 1888. Oil on panel, 10 × 15½ inches. Private collection.*

began depicting urban subjects rather than simply continuing the figure, still-life, studio, and portrait genres with which he was already associated, but it also overlooks the specific content of each painting. As familiar as many of these paintings are to scholars and collectors of American art, the present research revealed that many of the sites they portray have been misidentified, and, as a result, a layer of meaning readily apparent to Chase's contemporaneous audience has been lost.

This exhibition and book intend to contribute to the already extensive Chase scholarship by providing the first working chronology of this portion of the artist's oeuvre. The goal is not without its pitfalls, for the process is hampered by unhelpful generic titles and undated works. More frustrating, however, is the realization that a number of significant paintings from this period in Chase's career were apparently never reproduced and remain unlocated. On the other hand, several fine and heretofore unpublished paintings are shown and discussed here for the first time. Among the most exciting yields of this project is new documentation that enlarges the scope of Chase's park subjects, whose identification was previously limited to Prospect Park in Brooklyn and Central Park in Manhattan. Now, with Brooklyn's Tompkins Park, Washington Park, and the Brooklyn Navy Yard officially admitted to Chase's roster of sites, the cultural, political, and economic significance of these paintings expands, forming a much more complex network of ideas, which would have registered immediately for the late-nineteenth-century New York audience.

As we consider this body of work, it becomes clear that Chase, unlike his American contemporaries, deliberately focused on American urban and suburban spaces with the aim of underscoring the civility of modern American culture. This content is overtly presented in his depictions of public parks and the grounds of the Brooklyn Navy Yard, territories that were established, institutionalized public spaces set aside for the general improvement of the populace. In contrast to Chase's images of the regulated geography of parks are his paintings of the outer, suburban resorts of Brooklyn, the most famous of which is Coney Island. These, too, are framed in a conservative iconography that intentionally omits references to the increasingly relaxed interchange between social classes and the sexes (a social fluidity that, though not literally represented, is nonetheless embedded in the meaning of Chase's paintings because of the prevailing and contrasting imagery of those spaces in popular culture). A comparable ploy surfaces in his treatment of the Brooklyn

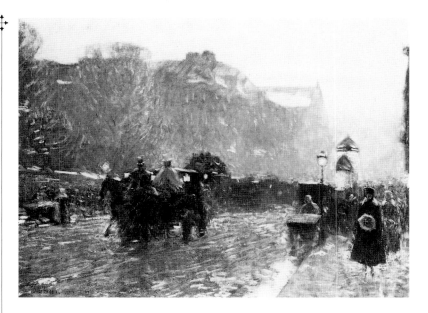

Fig. 2. Photograph of Childe Hassam's Rue Lafayette: Winter Evening *(c. 1888, oil on canvas, 20 × 26 inches, unlocated). Peter A. Juley & Son Collection. National Museum of American Art, Smithsonian Institution.*

Fig. 3. Alexander Helwig Wyant, Landscape *(also known as* Keene Valley*), 1884–86. Oil on canvas, 18⅛ × 30 inches. Brooklyn Museum of Art, 13.43, Gift of Mrs. Carll H. de Silver in memory of her husband.*

docks in that, by transforming them into aestheticized, high art subjects, Chase challenged viewers to explore the cultural connotations attached to those ordinarily rough and chaotic commercial spheres. Most of these public spaces are still put to the same purposes today, and thus the present-day audience is invited to consider its own experience of these sites. Taking a broader view, the invitation extends to anyone wishing to examine the relationship of public and private space in American social history. The paintings under examination here may also elicit consideration of our own daily movements through a rapidly changing environment. In many ways, all of us seem to be living in a historicized present. That is, familiar spaces are often undergoing transformation: the building that was there last week has been demolished to make way for a new one; neighborhoods are transformed within the space of a few years (take, for instance, Times Square); and residential populations shift rhythmically with surges and declines in real estate values. Any one of us who has lived in an area for a decade or more may tend to see it in light of what it once was, now is, and may become. It is suggested here that the content of Chase's urban landscapes likewise depends on the notion of the historicized present, for his depictions of specific sites seem to accumulate meaning from the reflexive relationship of memory and contemporary experience, thereby accentuating the linked sensibilities of modernity and change.

Such an approach intersects with the issue of realism in Chase's art and introduces a series of questions. For example, was Chase (who was noted as a realist) truthful in the ways he depicted these public geographies, or, for example, was he creating artistic fictions that conflicted with contemporaneous viewers' knowledge of the politics behind the creation of parks and the realities of their experience? If his imagery was fictive, did it promote the highly publicized aims of the parks' creators or did it engage an overriding aesthetic that would serve to advance his career within the larger arena of national and international art production? In this connection the idea of modernity emerges as a critical consideration. In addressing the changing landscapes of Brooklyn and Manhattan as the two cities became increasingly urbanized, Chase signaled his position as a modern artist. The radical compositions he employed were already established signs of the social transformation of urban and suburban geography put in place by such advanced European artists as Edgar Degas (1834–1917) and Gustave Caillebotte (1848–1894). In the visual forum of the 1889 exposition, where the question of stylistic influence was constantly debated, Chase's landscape submissions suggest that he intentionally separated himself from the American expatriate contingent and simultaneously aligned his art with that of the French Impressionists, who had had no hand in training Americans and whose work was not shown at the exposition. Such a distinction is vital to the understanding of the motives behind Chase's relatively sudden changes in technique and subject matter, which surfaced in 1886. What will be shown is that he embraced a variant Impressionist mode to relieve the barrage of negative critical commentary provoked by his identity as a painter working in a Munich-inspired style. In turn, this introduces the matter of European influence, a concern that was at the core of contemporaneous critical discussions. Art commentary in journals and newspapers of the 1880s was dominated by pleas calling for American artists to create an authentic, national art. Chase heeded the nationalist call by quickly adapting a subject matter redolent of the avant-garde ideal of "modern life"—in this case modern *American* life. Ironically, the style in which he expressed his "domestic" subjects was as clearly derived from foreign sources as was his Munich technique, but it did not smack of learning at the feet of European masters. Instead, Impressionism became a tool for the artist to declare himself an equal with his groundbreaking French contemporaries. In this way Chase adroitly established a level playing field for himself in artistic contests, thereby fulfilling the original aims of Americans who had sought European training and placating the critics who demanded a distinctly American art.

In addition to discussing the factors introduced above, this study endeavors to elaborate on the existing texts on Chase's work in the 1880s, which, although they are extremely valuable in their reiterations of Chase's career, are not completely satisfying with respect to their interpretive content. The methodology guiding this research has of necessity entailed going over ground previously covered by art historians whose work I admire and respect, in particular Ronald G. Pisano, the principal Chase scholar, whose investigations of the artist's life and work form the basis for modern Chase studies; William H. Gerdts, whose pioneering surveys of American Impressionism offer an abundance of fact and insight; and the recent exhibition and catalogue by H. Barbara Weinberg, Doreen Bolger, and David Park Curry, *American Impressionism and Realism: The Painting of Modern Life, 1885–1915*. Their work has stimulated the new questions leading to this highly focused look at Chase's Brooklyn and Manhattan paintings.

1. I was attracted to this topic in the course of writing *William Merritt Chase* (New York: Harry N. Abrams, Inc., in Association with the National Museum of American Art, Smithsonian Institution, 1995). In the research for that monograph it became clear that many of Chase's Brooklyn landscapes were misidentified and deserved deeper investigation.

2. See, for example, William H. Gerdts, *Impressionist New York* (New York, London, Paris: Abbeville Press Publishers, 1994), 181.

3. For a comprehensive treatment of the American art section at the 1889 Paris Exposition Universelle, see Annette Blaugrund et al., *Paris 1889: American Artists at the Universal Exposition*, exh. cat. (Philadelphia: Pennsylvania Academy of the Fine Arts. in Association with Harry N. Abrams, Inc., 1989).

4. *The Stoneyard* was possibly the small (7 × 10 inch) painting of the same title owned by Thomas B. Clarke by 1891. See H. Barbara Weinberg, "Thomas B. Clarke: Foremost Patron of American Art from 1872 to 1899," *American Art Journal* (May 1976), 72. The collector probably purchased it from an auction of Chase's work held at Ortgies & Co. in March 1891, the catalogue for which lists as no. 29, *Stone Yard*. That painting was mentioned in a pre-auction review: "See, too, how full of pictorial interest and how lovely in color is the little picture of a 'Stone Yard,' No. 29, where a long yellow building forms a background for great heaps of pale gray stone." "Some Questions of Art," *Sun*, March 1, 1891, 14. The generic title of *A Bit of Long Island* currently renders it impossible to determine which painting it might be.

5. The two other works were *The First Portrait* (The Museum of Fine Arts, Houston) and *Portrait of Miss Gill* (unlocated).

6. For a detailed study American artists' academic training in France, see H. Barbara Weinberg, *The Lure of Paris: Nineteenth-Century American Painters and Their French Teachers* (New York, London, Paris: Abbeville Press Publishers, 1991). During the 1870s Munich was the second most popular destination for artistic training among American students, and, while the prescribed techniques differed, competence in representing the human figure was also the principal aim of the curriculum. For a summary of American artistic activity in Munich, see Michael Quick and Eberhard Ruhmer, *Munich and American Realism in the Nineteenth Century*, exh. cat. (Sacramento, Calif.: E. B. Crocker Art Gallery, 1978).

7. For an illustrated list of the oil paintings shown in the United States section of the 1889 exposition with annotations providing locations of works as of 1989, see Blaugrund et al., *Paris 1889*, 267–97. From this it may be noted that the majority of landscapes by Americans depicted foreign lands.

8. For a listing of the awards for the American painters, see "Our Art Honors at Paris," *New York Herald*, July 27, 1889, 2. Within the Class I (oil paintings) category, John Singer Sargent (1856–1925) and Gari Melchers (1860–1932) won medals of honor; Alexander Harrison (1853–1930), George Hitchcock (1850–1913), Eugene Vail (1857–1934), and Edwin Lord Weeks (1849–1903) won first-class medals; and Chase was one of fourteen who received a second-class medal. Third-class medals (bronze) went to thirty-eight, and there were twenty-four honorable mentions cited.

9. See, for example, Maurice Hamel, "Les Ecoles étrangères," *Gazette des Beaux-Arts,* 3rd pér., 2 (1889), 382–84, and W. C. Brownell, "The Paris Exposition, Notes and Impressions," *Scribner's Magazine* 7 (January 1890), 18–35.

10. "Exposition Art," *New York Herald*, May 19, 1889, 13.

11. "Our Artistic Show at Paris," *New York Herald*, March 8, 1889, 6.

12. William A. Coffin, "The Fine Arts at the Paris Exposition," *Nation*, no. 1268 (October 17, 1889), 311.

13. In her fine essay, "Cosmopolitan Attitudes: The Coming of Age of American Art," H. Barbara Weinberg (in Blaugrund et al., *Paris 1889*, 49) cites *The First Portrait* as an example of Chase's Munich experience and *Lady in Black* as evidence of his absorption of the styles of Carolus-Duran (Charles-Emile-Auguste Durand; 1838–1917) and John Singer Sargent. Only a passing mention is given to the more numerous landscapes shown by Chase at the exposition, with the summary statement, "During the 1880s Chase lightened his palette in a series of New York park scenes that are indebted to the works of Giuseppe de Nittis (1846–1884); they anticipate Chase's fuller commitment to Impressionism in the 1890s." Chase's exposition landscapes were similarly overlooked in D. Dodge Thompson's "'Loitering Through the Paris Exhibition': Highlights of the American Paintings at the Universal Exposition of 1889" (in Blaugrund et al., *Paris 1889*, 62), where the artist's *Gowanus Bay* is one of a list of paintings categorized as "traditional maritime painting, in which seagoing vessels are the central focus."

14. Although many of the Brooklyn and New York landscapes are reproduced in Ronald G. Pisano, *Summer Afternoons: Landscape Paintings of William Merritt Chase* (Boston, Toronto, London: Bulfinch Press, 1993), they were accompanied by an introductory text, the length of which afforded only a summary treatment of the works.

15. For a discussion of Chase in the context of his public image, see Sarah Burns, *Inventing the Modern Artist: Art and Culture in Gilded Age America* (New Haven and London: Yale University Press, 1996), in which the artist is mentioned throughout the volume and especially 20–24.

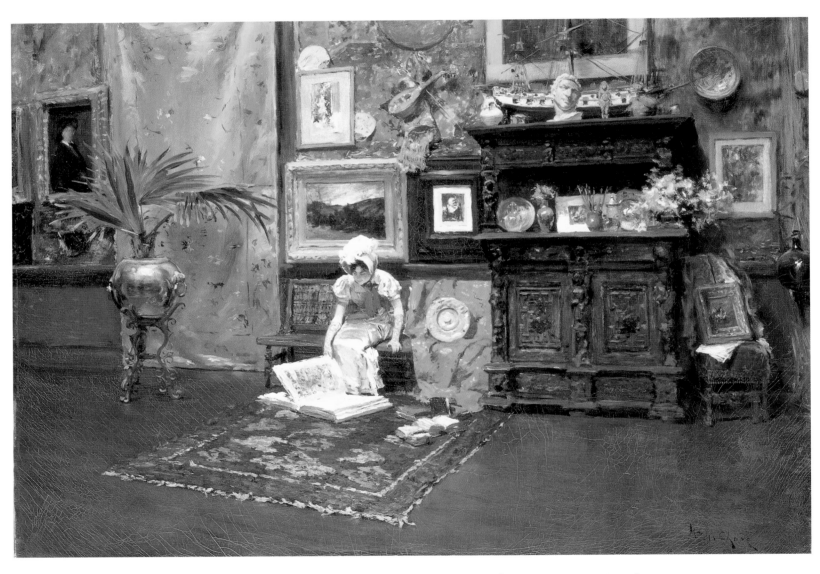

Pl. 4. In the Studio (*originally titled* Studio Interior), *c. 1882. Oil on canvas, 27¼ × 39¾ inches. Brooklyn Museum of Art, 13.50, Gift of Mrs. Carll H. de Silver in memory of her husband.*

Chapter One

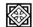

"WHITHER DOES IT ALL LEAD?"

The years preceding the 1886 debut of the civilized urban landscape in Chase's art were marked by a series of aesthetic and professional negotiations for Chase and the whole American art world. As a member of the generation of painters and sculptors who had trained abroad and returned home to establish their careers, Chase was faced with the problem of tailoring the stylistic products of his foreign study to suit an audience that not only demanded an identifiably "American" art but also applauded the efforts of younger artists to release American culture from the stultifying pall of provincialism. This fundamental conflict—how to be American and still function within an international culture—and the manner in which Chase chose to resolve it form the basis of the artistic attitudes that ultimately guided the development of his art. At the foundation of the issue was the question of originality. Chase's solution was what he later called the "composite" image—a painting that borrowed freely from a variety of sources but still bore the stamp of the artist's personal vision.[1] It is proposed here that Chase devised this mechanism of synthesis, or the "composite" concept, in response to the negative criticism that converged on him as the most visible American proponent of the Munich style. Within this solution we see Chase engaging a normalizing mode in which the radical features of current European artistic trends would be suppressed to such an extent that nativist critics would be mollified. At the same time formal allusion to advanced compositional devices deployed by progressive European painters and the application of such devices to American

subjects would permit Chase to maintain his status as an innovator who participated in the international arena. The most persuasive evidence of the synthetic process is Chase's concentrated production of urban park and coastal imagery from 1886 to 1890. By examining the events of Chase's career between 1878 and 1886, it is possible to determine why he needed to arrive at a pleasing and beneficial solution that established an equilibrium between national and foreign ideals in his art. In addition to investigating his exhibition activity and critical responses to his art in the period leading up to 1886, this chapter will also take into account Chase's ongoing process of self-education by looking at contemporary European art.

With the exception of a brief period of study in New York in 1869–70, Chase had spent his first two decades in the Midwest.[2] Born in the rural town of Williamsburg, Indiana, in 1849, he grew up with a thirst for travel and a passion for art. By the time he reached adulthood, his family had moved to Saint Louis, and through the good offices of several local patrons, Chase was finally able to make his long-desired journey to Europe in 1872 for further art training. In 1878 he returned to the United States after having lived in Europe for nearly seven years. Prior to his departure he had made nominal progress toward a professional career as a painter, but his time at the Munich Royal Academy and his exposure to historic and contemporary European art were the most powerful instruments in preparing him for professional success.[3] In truth, he left the United States a painter and returned an artist. This transformative experience was not limited to his art alone,

for when he set ashore in New York Chase also arrived equipped with the desire and potential to transfigure himself, using as his model the worldly, cosmopolitan stance adopted by the European artists he admired. That he had a plan along those lines is evident, proved in part by a letter he sent to the influential American art dealer Samuel P. Avery from Venice in April 1878, in which he announced his plans to quit Europe and seeking Avery's opinion on his prospects.[4] A rare surviving example of Chase's personal correspondence, the letter bears quoting at length because of the insight it provides regarding his motives at the time:

My dear sir

I desire to ask you a few questions, will you please excuse the liberty I take, being an entire stranger to you as I am.

Before begining [sic] my questions however, I desire to thank you for the interest you have manifested in my behalf in New York. You may have already heard that I was very much pleased when I heard that you had bought my picture "Ready for the Ride." In buying my picture and exposing it as you did, you did me a favor Mr. Avery which I hope some day to be able to return.

Now the success my things have had in New York (which bye [sic] the way is far greater than I ever expected) has caused me to feel that perhaps I could do something in New York. It has been my desire for some time, to return home and paint some of our wonderfully handsome women, children & fine looking men. You may not know that last summer I painted Director [of the Munich Royal Academy] Piloty's children five in number, and as far as pleasing him with them goes, they were a success. They will be photographed and published by "Photographisch [sic] Gesellschaft" in Berlin for an Album known as the "Piloty Schule Album" you will therefor [sic] have an opportunity of seeing what they are like. Piloty has told me that he would willing give any letters that might be of any service to me in America. I have since I first came abroad/six years ago/collected antiquities and studio [illegible] of all sorts. Have also exchanged for a great many sketches some by the best artists in Munich, and besides a great many studies and copies made by myself, I have 4 quite valuable modern pictures. Also some 25 or 30 old pictures. So that if I should come to America I can furnish a very elegant studio. Mr. Shirlaw and Dielman can tell you something of the things I have.

The following are the questions I desire to ask.—Do you think/now that the times are so very hard/that I could get Portraits in New York to do? Can I get a large studio in a desirable locality

in the city? It is my intention/as soon as I can afford it/to keep a furnished studio in London or Paris and one in New York or Boston and spend my time in either place as best suited to the work I may have underway. I am young, yet being only 28 and there is no reason why I should not carry out my design if I live long enough. My last but not least question is, if I should come to N.Y. would you be willing to take charge of all my work and allow me to refer people to you on all business transactions concerning my pictures? If I [illegible] I would like to leave this side about 1st of July. I am very busily engaged on a large picture 5 × 9 feet in size for a wealthy Munich gentleman. Will finish it in about six weeks and then return to Munich. I have an order to fill there which will take me about two weeks. Hoping Mr. Avery, I am not presuming to [sic] much on the mere fact of you having bought one of my pictures, and that it will not inconvenience you to write me a line in answer to this, I am my dear sir, Yours most sincerely W. M. Chase.[5]

Although it is humble in tone, Chase's letter reveals the health of his ambition in its design to impress the dealer with reminders of his American successes, his European commissions, his readiness to furnish a grand studio, and his aspirations for an international career. The letter also discloses Chase's apprehension about reentering cultural territory which was, after six years' absence, unfamiliar, and, what is more, economically depressed. In connection with the state of the country's financial affairs, Chase was apparently (at least for the purposes of his communication with Avery) cheerfully reconciled to the necessity of relying on portraiture for an income, an avenue that deviated considerably from the more inventive subjects that he already deployed in Europe, as exemplified by his *Moorish Warrior* of about 1878 (fig. 4). If Avery replied to Chase, the letter is unrecorded. The strength of Chase's optimism, however, is confirmed by his return to New York, where he soon took the most prestigious space in the Tenth Street Studio Building, began teaching at the Art Students League, and devoted himself to reinforcing his reputation as one of the leading younger artists by exhibiting his work as frequently and widely as possible.

As his letter to Avery indicates, Chase had already gained a respectable measure of critical and public attention by sending his paintings from Europe to American exhibitions. The 1875 display of *The Dowager* at the National Academy of Design (hereafter NAD) was his first notable success. Owned by Chase's Saint Louis patron W. R. Hodges, the painting

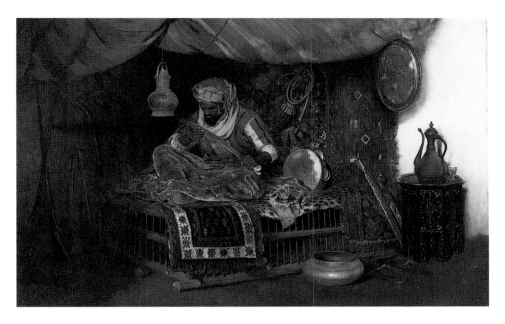

Fig. 4. The Moorish Warrior, *c. 1878. Oil on canvas, 58⅛ × 92⅝ inches. Brooklyn Museum of Art, 69.43, Fractional Promised Gift of John R. H. Blum and Healy Purchase Fund B.*

(subsequently purchased by the artist Eastman Johnson [1824–1906]) was likely a work that shared in eliciting Henry James's comments about the Munich paintings of Chase and Frank Duveneck (1848–1919) published in the *Galaxy* that year. James focused on the force of the Munich style, saying: "Their great quality, we repeat is their extreme naturalness, their unmixed, unredeemed reality. They are brutal, hard, indelicate . . . but they contain the material of an excellent foundation."[6] Not long after, Chase's colorful *"Keying Up"— The Court Jester* (Pennsylvania Academy of the Fine Arts, Philadelphia) won a medal of honor at the 1876 Centennial Exposition in Philadelphia, and, when it was shown again in 1878 at the NAD, it buttressed the already firmly held critical opinions of Chase's "genius."[7] The same was true of *Ready for the Ride* (Union League Club, New York), one of four paintings that represented the artist at the inaugural exhibition of the Society of American Artists (hereafter SAA) in 1878 and the one whose ownership by the sophisticated Samuel P. Avery was advertised in the catalogue. Cited as "certainly the finest he has yet sent home," this work and *Boy Smoking— The Apprentice* (fig. 5) made indelible impressions on the minds of the critics and ultimately assumed the canonical role of materially representing the impact of Munich training

on American artists. Thus, even before he resettled in New York in 1878, Chase's art had become synonymous with the idea of the Munich style, as typified by a dark, richly colored palette, *alla prima* facture, and subject matter that focused on character study. This view of Chase's art was encouraged by such writers as Mariana Van Rensselaer, who in 1881 wrote the first major article devoted to Chase, in which *The Apprentice*'s "intense, if unbeautiful reality" was pitted against the "sickly conventionality of the portrait studies to which our public had been most accustomed."[8]

From the last years of the 1870s through the first half of the 1880s, Chase strove diligently to maintain his status as one of New York's most promising artists. His efforts involved the creation of a network of professional affiliations including memberships in the SAA (1879), the exclusive Tile Club, the Society of Painters in Pastel (founded in 1882), and the American Watercolor Society. This institutionalized professional activity and the wide press and periodical coverage it received were important factors in the transformation of the American arts. Chase was one of the first American artists to acknowledge and successfully exploit the business aspects of the field while at the same time managing to wrap himself in the bohemian but gentlemanly aura of art.[9] It is significant,

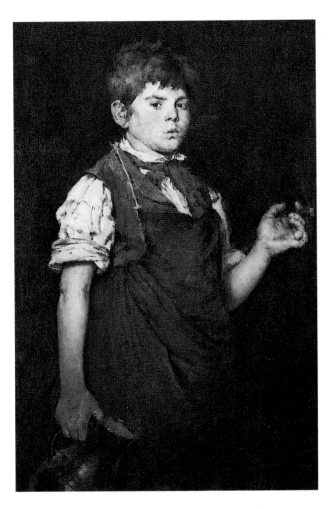

Fig. 5. Boy Smoking—The Apprentice, 1875. Oil on canvas, Wadsworth Atheneum, Hartford, Purchased through the gift of James Junius Goodwin.

of the SAA. The first pointed critical assaults on Chase occurred in 1880, when he was represented by twelve works (really nine oils and three prints by Frederick Juengling [1846–1889] after his works) at the society's third annual exhibition. John La Farge (1835–1910), the society's vice president, was the one-man jury responsible for choosing that year's exhibition. Although credit or blame for featuring Chase (whose works represented more than 7 percent of the total number displayed that year) could be given to La Farge, general opinion held Chase (who was, after all, the society's president) culpable for what seemed a scandalous display of self-promotion. In one of the most vitriolic reviews concerning the matter, one writer complained:

William Merritt Chase, the President of the Society, covers more wall with his canvas than any other exhibitor. . . . His portraits are exceedingly sensational in treatment and one in particular, with a fiery red background and a coat of arms unmeaningly stuck in one corner, is very characteristic of the young man who painted it . . . while he is represented outside of portraiture by a street scene entirely devoid of interest, containing nothing but the dark, dirty walls of an old brick building, and a rough painty looking foreground. There is not a figure or vestige of life in the work, and the study expended upon the composition of a thousand such works would not overtax the intellect of a school boy. A large number of the members of the Society of American Artists have put themselves very prominently before the New York public as representatives of the Munich school, but at every exhibition one looks in vain for work from their studios that would warrant their assuming the position they claim to be entitled to.[11]

however, that he was absent from the academy's walls from 1880 through 1887 since even his ambitions did not permit him to break ranks with the SAA's more militant anti-academy factions who advocated a separatist policy in the relations between the two organizations. Thus, Chase's principal exhibiting venue at this time was the SAA, which, though still in its infancy, was the acknowledged outlet for progressive art in America. Chase's 1880 election to the presidency of that organization further consolidated the existing public perception of him as a painter of advanced work.[10]

After a short honeymoon with the critics, however, rumblings of dissatisfaction began to sound in the tone writers took in their discussions of Chase's influence on the workings

To be sure, other reviewers found much to be admired in Chase's 1880 showing. The powerful portrait of General James Watson Webb (Shelburne Museum, Shelburne, Vt.) was found especially worthy of praise by S. G. W. Benjamin, who declared that Chase had "done nothing better since he left his studio in the old convent in Munich." Benjamin couched his praise in a monitory tone, for while he approved of the "vividness of conception, luminousness of color, [and] broad and massive handling," he emphasized that these elements had been carried to their limit and warned against "overstepping the bounds of the permissible."[12] This last phrase implied the dangers of the Munich style, and, while Benjamin was delicate in his reference to it, other writers were not. One of the most salient features of the 1880 criti-

cism is that Chase's detractors made specific connections between his position as the society's president and the more radical aesthetic directions some of the society's members appeared to be taking. In the long run many writers despairingly credited the Munich school's influence as not only the source of Chase's artistic faults but also the cause of the society's general decline. As Jennifer Bienenstock has pointed out, the aftereffects of what was interpreted as blatantly high-handed management of the society's internal workings included the alienation of its more conservative members as well as the disaffection of those resident abroad.[13] Yet the dissension within the society was largely political in nature; the internal disputes were not fought on stylistic grounds. It was the press that bound Chase's reputation even more closely to the negative effects of the Munich influence.

Chase's artistic profile suffered under the pall of Munich associations over the next few years, even after the paintings he exhibited manifested substantially fewer stylistic features directly connected with an authentic Munich facture. By that time, however, the evidence required to assert the ruinous Munich influence had been reduced to the mere presence of clever brushwork and weak (that is, non-narrative) subject matter. In the wake of the scathing reviews he had received

in 1880, Chase appears to have attempted to distance himself from Munich ideals with his 1881 SAA displays, which included the first of his studio pictures, *Interior of a Studio* (The Saint Louis Art Museum) and several European scenes. Although Chase's palette and brushwork in *Interior of a Studio* maintained the qualities of Munich technique, the personalized subject matter (that is, the artist in his studio) automatically conferred an Americanness on the painting that would have exempted it from charges of being thematically weak or, still worse, foreign. Among the other works he showed that year was *In Venice* (fig. 6). The small, light-filled view of buildings along one of the city's canals looks forward to Chase's later renditions of Brooklyn docks in terms of its bright palette, horizontal orientation, small scale, and "anonymous," unpretentious view that captures the character of the place without setting it out in detail.

None of the paintings by Chase shown at the 1881 society exhibition drew much comment, perhaps indicating a retaliatory stance on the part of the critics for his dominance the previous year. Bienenstock also notes a trend emerging within the society's membership that may signify a general reaction to the criticism generated by the 1880 display. Although it is difficult to confirm the validity of her claim, Bienenstock per-

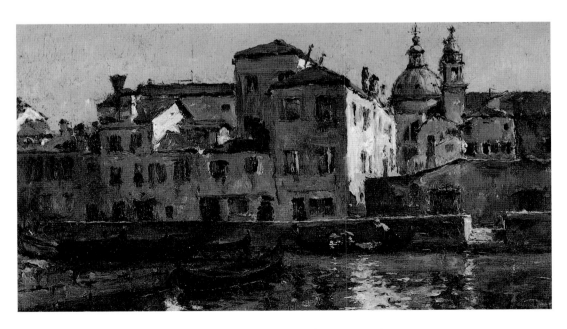

Fig. 6. In Venice, c. 1877. Oil on panel, 8½ × 13 inches. Museum of Art, Rhode Island School of Design; Bequest of Isaac C. Bates.

ceives evidence of concerted efforts to minimize the Munich aesthetic on the part of Chase as well as other artists and cites several published comments including Samuel Benjamin's approbation of William S. Macy's (1853–1945) *New England Hillside* for its "progress from his earlier sooty tones."[14] Assuming the accuracy of this interpretation, such critical approval would have further encouraged artists to abandon the old-master tonalities that betokened Munich's stylistic authority.

Chase's *Riverside Landscape* (unlocated), shown in the society's Supplementary Exhibition of 1882, may be symptomatic of his efforts to relinquish his dependence on the style that had originally brought him acclaim.[15] Yet, if he intended the painting to be a factor in an attempt to reconfigure his reputation, the exercise backfired. Even the usually sympathetic Mariana Van Rensselaer failed to disguise her disappointment, as indicated by her terse remark: "Mr. Chase sent a river landscape, not especially good, it seemed to me, except in the rendering of the soft gray cloudy sky."[16] The *Art Amateur*'s critic had similarly damning things to say: "A painter is bound to make his picture so far interesting as to leave us in no doubt why he painted it . . . but Mr. Chase does not satisfy us at all. Had Mr. Chase painted his picture in the little there might have been subject enough to go around; as it is we leave his table quite hungry. Clever brushwork and nothing else is a Barmecide feast indeed."[17] The same critic's animosity was directed at another Munich acolyte, Frank Currier (1843–1909), whose art was characterized as "all paint and fury, signifying nothing."[18] As these comments attest, the absence of narrative content seemed the most disturbing to the critics, and, indeed, descriptions of Chase's *Riverside Landscape* indicate that it complied with the more decorative art-for-art's-sake aesthetic that was coming into vogue at that time. The aesthetic, transmitted chiefly in the art of James McNeill Whistler (1834–1903), deemphasized narrative elements in favor of the subjective interpretation of content, giving priority to formal expression through design and carefully orchestrated color. Whistler's famed *Arrangement in Grey and Black: Portrait of the Artist's Mother* (1871, Musée d'Orsay, Paris) was prominently featured in the SAA exhibition that year (it was one of the few works to be displayed in both the regular and supplemental showings). Yet the majority of critics were disinclined to mention it, giving over most of their discussion to Thomas Eakins's (1844–1916) *Crucifixion* (Philadelphia Museum of Art).[19]

A survey of reviews for the 1882 show reveals that nega-

tive reactions to Whistler's rarefied aesthetics shaped the critical assessments of Chase's paintings that year. The *New-York Daily Tribune* stated that Chase's landscape "seemed hardly worth while at all" and questioned its value even on the most basic terms: "As a composition, if composition it may be called, it is entirely wanting in interest: a straight band of water across the foreground; then a straight bank of meadow with two or three willows very uncompromising in their stiffness; and above all a straight band of sky, an unrelieved mass of dull gray clouds. . . . Mr. Chase rarely fails to keep his work in tone, and this is in tone, but the tone is not attractive—to us at least—and only attractive tone can make up for the want of beautiful color and beautiful lines." Abbott Handerson Thayer's (1849–1921) *Nantucket* (unlocated) suffered similar criticism, and, whereas the writer found Thayer's and Chase's tonal compositions too weak, Currier's three landscapes were so vigorously painted that "all we see is the material with which he has worked very hard to say nothing."[20]

The connection between Whistler and the direction taken by the progressive faction within the SAA was alluded to in a subheading of a review that referred to the SAA as the "American Grosvenor Gallery." By no coincidence, the same review contained a vehement denunciation of Chase's art.[21] The unidentified writer began his review by taking the Supplementary Exhibition to task by characterizing the majority of the works on display as "either experimental, sensational or both." After a vituperative introduction focusing on Currier (whose landscapes were found "chiefly conspicuous in showing how much paint can be plastered on to a given surface of canvas"), the writer proceeded to devote the bulk of his column to Chase's *Riverside Landscape* in a lengthy diatribe that revealed the completeness of his bias against the artist:

William Merritt Chase, although paying a trifle more attention to form than Currier, is also very impressionist and unfinished in a large work hung on the line in one corner of the gallery. Chase paints a fairly drawn head, although his flesh color is often apt to be very false, and he is also quite clever at turning out a piece of still life, but his landscapes are such as the Creator Himself must puzzle over. Like the universe before the creation of the world, they are without form and void, very void. In his work at the American Society he gives first a quantity of yellowish white streaks of paint, then weak masses of dirty green, and ends up with a spotty surface of dingy brown, which is supposed to be a sky. The thought expended upon such a work must

have been brain racking; but to speak seriously, for a man with the reputation of Mr. Chase to put forth such a thing as he exhibits at the American gallery is insulting to the common sense of the public, and it is a pleasure to note that the public is already beginning to call upon Mr. Chase for something to justify the pretensions he makes to high art. He painted his "Ready for the Ride" and "Court Jester" before he left Munich, but since coming home he has done nothing to justify the good impression these two works, painted under the eye of his foreign master, created. He has, to be sure, painted a few substantial portraits, full of tricky effects of color, and once in a while he sets something in the way of still life up before him and paints it in the same slap dash, devil take the hindmost style, but the public has looked in vain for original ideas in the composition of his works. He is neither tragic, sentimental, poetical nor humorous in his works. If Mr. Chase simply set himself up as a portrait painter his art life would not be so open to adverse criticism, but he goes in as a great champion and teacher of the Munich school, when his work has thus far shown him to have but a vague idea of the breadth and elements of the school he professes to admire so highly. Piloty, Josef Brandt and other great masters of the Munich school have shown through their pictures that the great and controlling object kept in view by the followers of the Munich as well as the other art schools of Germany, is variety of thought in composition. Becoming a good colorist and draughtsman is greatly a mechanical process, but an artist, like a poet, is judged by the power of his mind to evolve ideas, or his imagination to create beautiful or sublime thoughts. But where have we left the poor blank mass of paint which represents Mr. Chase at the Society of American Artists? As we return to it we feel convinced it is not the sort of work the great masters of Munich would like to see by one of their crack pupils, much less by one who professed to be a prophet of their school in a new land.[22]

The intensity with which the *Daily Eagle*'s critic delivered his commentary and his reference to the Grosvenor Gallery suggest an underlying critical agenda: to agitate for an artistic cause célèbre that would parallel the scandal of the 1878 *Whistler v. Ruskin* trial in London.[23] Occasioned by John Ruskin's scathing remarks about Whistler's 1877 Grosvenor Gallery displays (particularly *Nocturne in Black and Gold: The Falling Rocket* [The Detroit Institute of Arts]), Whistler's libel suit against England's most powerful critic took aesthetic controversy from the cloistered realm of the studio to the headlines of the daily papers. Although no such scandal arose out of the 1882 reviews directed at Chase, the potential (however denatured) was there to manufacture an American version of the Ruskin trial, this time with Chase as the pivotal artistic protagonist. That the mere thought of such a sensation in New York was possible may be attributed to the increasing showmanship of artists like Chase who consciously designed themselves for the purposes of the marketplace. The public profile that Chase was in the process of constructing for himself was intentionally provocative. The highly publicized grandeur of his studio alone signaled the extent of his ambitions and drew as much attention to the nature of his personality and the environment he manufactured for himself as it did to the character of his art.[24] Chase's place in the public eye yielded positive and negative results: his reputation became permanently linked with advanced art practices and he became an easy target for the invectives of American critics in the early 1880s.

Chase showed only two works in the SAA's 1883 annual. Although his reduced visibility might be interpreted as either a humbled withdrawal from the critical fray or a conciliatory move to restore a perception of democracy in the SAA's workings, it was no doubt also due to a decrease in his painting activity that year owing to his work in selecting foreign paintings for the 1883 Pedestal Fund Loan Exhibition. Interestingly, Chase seems to have stubbornly chosen to display two paintings, *The Hackensack River* (fig. 7) and *In the Studio* (Pl. 4), that were likely to exacerbate the previous year's dissension surrounding his art. If this was his aim, he succeeded to a degree. The writer for the *Nation* declared *In the Studio* "a piece of showy, rather than good, painting" with a subject having "no unity, being the scattered paraphernalia of a modern studio—mere *roba* [Ital., goods, wares]; and Mr. Chase has failed to bring out the interest which might be found in even so bad a subject were its chiaroscuro faithfully studied." The same writer complained that *The Hackensack River* "has some conspicuously bad drawing" and concluded that "Mr. Chase seems to cultivate a bad method of handling—a method that does not vary expressively in the rendering of objects of different kinds. His trees, grass, sky, and water are all done in the same way." In the end, the writer called for a return to the artistic values of the Renaissance Venetians, Bellini and Titian,

rather than [those] of the present schools of Munich and Paris, and give us beautifully colored and quietly finished work. But we can pardon the want of finish and accept mere sketches in

Fig. 7. The Hackensack River (*also known as* Landscape), *c. 1883. Oil on canvas, 33 × 51½ inches. Museo de Arte de Ponce, Puerto Rico, 62.0319.*

place of finished pictures, if only the sketches be executed on thoroughly true principles, and be right and beautiful as they go. It is the want of right cultivation in fundamental principles— whether for rapid sketching or finished painting—that we have so constantly to complain of; not the mere fact that our artists just now prefer to work sketchily.[25]

While ignoring *In the Studio*, another writer put *The Hackensack River* at the head of a list of paintings "all clad in demure gray" and described Chase's work saying:

This is well enough painted, although we might ask for a little more truth to nature, and is another illustration of the artist's ceaseless versatility. Yet we cannot help suspecting that Mr. Chase did not go out to sit upon the banks of the Hackensack and paint this picture. It was rather in his comfortable studio that he resolved upon a fresh manifestation of his skill in colors, and said to himself, "I'll go in for tone." Would there not be more freshness, vigor, and true vitality in the works of Mr. Chase and his neighbors if they devoted themselves to painting from nature instead of working up sketches according to studio schemes of color?[26]

In general the critics writing about the 1883 SAA exhibition were more measured in their comments, revealing less anger and offering constructive, if not positive, opinions. Furthermore, several reviewers, though not entirely enamored of Chase's two paintings, at least extended favorable, albeit brief, mention of his landscape.[27] Significantly, one reviewer noticed that *The Hackensack River* hinted that Chase had been "pondering the ways of Mauve and Maris," an observation that marks a subtle change that was occurring in Chase's art as a result of his intensive survey of contemporary European art in conjunction with his duties in organizing the Pedestal Fund Loan Exhibition held later that year.[28] The more liberal writer for the *Art Amateur* made a perceptive pairing of *In the Studio* and Charles Ulrich's (1858–1908) *Carpenter*, finding "delight" in both pictures despite their contrasting techniques and, by implication, establishing a parallel between the function of the modern artist's studio and the common carpenter's workshop.[29]

The comparatively moderate responses to Chase's 1883 SAA paintings suggest that the critics were gradually adjusting to the aesthetic transition occurring in American art at the time. In part this was true. The collective critical eye was

becoming accustomed to a greater variety of styles and was attempting to meet the challenge of synthesizing and assessing what must have seemed an overwhelming confusion of often conflicting aesthetic agendas.[30] Chase's part in the selection of works for the art section in the Pedestal Fund Loan Exhibition did much to promote knowledge and appreciation of contemporary foreign art among the general public and the art community. Mounted to raise funds for the installation of Frédéric Auguste Bartholdi's (1834–1904) *Liberty Enlightening the World* (the Statue of Liberty), the exhibition opened December 3, 1883, at the National Academy of Design (and later in abridged form in Brooklyn) to rally New York's financial support of France's gift to the nation.[31] Because he had traveled regularly to Europe throughout the early 1880s to keep abreast of the latest art, maintain contact with foreign and expatriate colleagues, and to exhibit his work in Paris, Munich, and Brussels, Chase was ideally suited to shoulder the task of curating the exhibition, a job he shared primarily with J. Carroll Beckwith (1852–1917). The two friends were credited with having selected the 194 works by 70 artists. It was generally claimed "that no such beautiful and instructive collection has ever before been brought together in this country—no other composed so exclusively of first-rate works."[32]

Because of the exigencies of time and money the paintings were drawn from private American collections (mainly based in New York) and from cooperative dealers, the most visible of whom was Daniel Cottier.[33] Dependent on geographic proximity and the goodwill of lenders, the show mirrored current local collecting activity and therefore contained an abundance of French art in the Barbizon style, thus accounting for the solid representation of the Barbizon artists Jean-Baptiste-Camille Corot (1796–1875), Narcisse-Virgile Diaz de la Peña (1807–1876), and Jean-François Millet (1814–1875).[34] A number of Hague School paintings were shown, and the realist contingent was in force as well, with works by Gustave Courbet (1819–1877) and Théodule Augustin Ribot (1823–1891). Critics apprehended the bias of Beckwith and Chase's collective eye, noting that they favored a "certain ultra-artistic class of work."[35] By this it was meant that they preferred painterly, non-narrative works that eschewed moralizing or sentimental imagery—the type of art, critics observed, that appealed more to connoisseurs than it did to the general gallery visitor. The most sensational canvases were Edouard Manet's (1832–1883) *Boy with a Sword* and *Woman with a Parrot* (both, The Metropolitan Museum of Art, New

York), both of which were secured from the collection of Erwin Davis, whose recent purchase of the two paintings had been transacted partly on the advice of Chase.[36] These paintings, in addition to Degas's *Ballet Dancers* (Hill-Stead Museum, Farmington, Conn.), were objects of great curiosity, and, although they were not universally applauded, they led one critic to conclude:

There is little doubt that all the good painting of the men who will come into notice during the next ten years will be tinged with impressionism; not, perhaps, as it has been put into words by the critics, but as it has been put into paint by Manet and a few others. Looked at in this way the action of the committee in giving Manet the place of honor may be excused, although there are many much better pictures exhibited than his. The more popular French contemporaneous artists receive very little consideration at the hands of Messrs. Beckwith and Chase.[37]

By virtue of his strong hand in the selection process it was (and may be) assumed that Chase included works that reflected his own artistic predilections. Ronald G. Pisano has pointed out the strong parallels between the configuration of the Pedestal Fund Exhibition's checklist and Chase's private collection of works, noting, for instance, that both included works by Adolphe-Joseph-Thomas Monticelli (1824–1886), Louis Mettling (1847–1904), Antoine Vollon (1833–1900), Ferdinand Roybet (1840–1920), Anton Mauve (1838–1888), Ribot, Alfred Stevens (1823–1906), and Georges Michel (1763–1843).[38] One of the intangible benefits of his work on the project was that it brought Chase into contact with powerful collectors. The social component of the exhibition and its organization was considerable in that it attracted the interest of the cream of New York society. It may also be suggested that Chase's curatorial choices were consciously guided (at least in part) by a mindfulness of his own current difficulties with the press. Certainly he must have spent some mental energy in trying to predict how the Pedestal Fund display would be received. If it were a success, it might aid him in cultivating patronage and help neutralize the critical animosity that had been directed at his art.

Other possible benefits accrued to Chase. The curatorial role he assumed allowed him to maintain a place of considerable stature in the public spotlight without the risk of earlier accusations of self-advancement. In this way he could actively promote his taste, yet maintain a relatively removed position,

since his own art was not at issue. Interestingly, as one reviewer noted, there was only one popular German artist represented in the exhibition, Ludwig Knaus (1829–1910), whose 1874 appointment as the head of the Berlin Academy and whose prior association with the Düsseldorf Academy obviated any occasion for critical references to Munich.[39] This lacuna reflects the dearth of Munich paintings in New York at the time and also reveals that Chase was conveniently relieved of the burden of considering works that would have encouraged a continuation of press discussions pertaining specifically to his relationship with that school.

The circumstances surrounding the exhibition shaped the tone of the reviews, thus making the interpretation of these writings problematic. Given that the paintings were selected from the collections of powerful men, it would have been unseemly to criticize the loans they had generously offered for so noble a national cause. Thus, the negative commentary that appeared in print was negligible and focused not so much on the paintings displayed but on the absence of works

by such popular French academic artists as Alexandre Cabanel (1823–1889), Jean-Léon Gérôme (1824–1904), and Adolphe-William Bouguereau (1825–1905). It is in this context that Chase and Beckwith were faulted for catering to the tastes of connoisseurs rather than the public.[40] The object here, however, is not to summarize the Pedestal Fund Exhibition and its reception, but to discover within the range of works it included paintings that may have appealed particularly to Chase and that weighed in the transformation of his art in the mid-1880s. In this respect several works by other artists are singled out as key images that may have contributed to Chase's aesthetic reconstruction: James-Jacques-Joseph Tissot's (1836–1902) *Richmond Bridge* (see fig. 63), Giuseppe de Nittis's *Place de la Concorde* (fig. 8), Mihály Munkácsy's (1844–1900) *Luncheon in the Garden* (see fig. 16), and Jacob Hendricus Maris's (1837–1899) *Schreierstoren, Amsterdam* (see fig. 33).[41] Despite the varied subjects and stylistic "schools" of these paintings, they are united by their common roots in contemporary urban life, non-historicizing

Fig. 8. Photogravure of Giuseppe de Nittis, Place de la Concorde, *1875, from Armand Silvestre et al.,* The Gallery of Contemporary Art *(Philadelphia: Gebbie & Co., 1884). Art and Architecture Collection. Miriam and Ira D. Wallach Division of Art, Prints and Photographs. The New York Public Library. Astor, Lenox and Tilden Foundations.*

attitudes, and, when narrative is implied (as in the Tissot and the Munkácsy), the recital of narrative elements set in open or parklike spaces. In terms of type, these paintings represent the juste milieu of European taste, a mode of imaging contemporary life that was palatable and fashionable without being stridently revolutionary in subject or facture. At the same time, they corresponded to the realist bent that Chase had acquired in Munich in that they were emotionally distant, provoking little moral judgment from the viewer. The possible impact of the works cited here (or their counterparts) on Chase's development will be discussed in subsequent chapters. For the present purposes it should be noted that, although these paintings were listed among the "noteworthies" in the press, none received lengthy commentary, confirming the aesthetic middle ground they occupied in 1883.

Just three months after the close of the Pedestal Fund Exhibition, the Society of Painters in Pastel (the Pastel Society) held its debut exhibition at the New York gallery of W. P. Moore. Although the society had been founded in 1882 by Robert Blum (1857–1903) with Chase's strong input, the organization had not generated sufficient artistic energy to mount an exhibition until 1884. As it was, the group exhibited only four times, in 1884, 1888, 1889, and 1890.[42] Its brief, episodic life notwithstanding, the Pastel Society not only stimulated interest in the medium itself but also served to broaden taste for up-to-date applications of it. Reviewers traced its revival to Whistler, singling him out as the chief instrument in nurturing American interest in pastel as a means for "Impressionist" experiment.[43] Also credited with galvanizing the narrow American movement were the pastels of the Italian artist Giuseppe de Nittis. Mariana Van Rensselaer offered a thoughtful analysis of de Nittis's influence, asserting that his art demonstrated that pastel "was suitable for the most ambitious efforts. . . . De Nittis paints the most elaborate compositions in which the strongest color, the most difficult effects, and the most powerful handling are attempted. . . . He does, indeed, touch the outer limit of the art on the side of impetuosity and strength, and his example has visibly molded current practice."[44]

From the Pastel Society's inception, Chase's predominance was acknowledged. Represented in the first exhibition by sixteen works (out of a total of 64), he was easily perceived to be as assertive a presence in this new organization as he was at the SAA. Yet, Van Rensselaer, whose *Century* article was the lengthiest and most considered in its approach, men-

tioned Chase only in passing, as if to rebuke him for his conspicuous presence: "At the end of the scale, in the direction of audacity, Mr. Chase's portrait of himself, as vigorous and vehement a piece of work, both in color and handling, as any painter need desire to show in any medium whatsoever." According to Van Rensselaer, Blum deserved the bulk of the critical laurels, "not so much because his pictures were very diverse and very clever, as because he showed in some of them a deeper intention, a more original impulse, than any of his fellows."[45] Notwithstanding the novelty of the medium, which offered audiences yet another opportunity to examine the performance of younger artists' "manual dexterity," the 1884 pastel exhibition led critics to the same conclusions they had drawn elsewhere—namely, that American artists were too much like their European counterparts. Complaining that the exhibition contained "not a drawing which could not have been made anywhere else as well as in America," the writer for the *Art Amateur* bemoaned that there was "not a trace of contemporary home-life." As usual, Chase's work provided the fulcrum for leveraging arguments for and against the exhibition as a whole: "Mr. Chase has shown us a corner of his studio again for the twentieth time, and it might as well be a studio in Paris as in New York. . . . Mr. Chase's contributions included a clever portrait of himself and several subjects from Holland, all of them characteristic, the best, one from Scheveningen, showing a beach and drive the very counterpart of East Hampton, where, as far as we know, no one ever found a subject for landscape. . . . But probably there are twenty Americans ready to buy a bit of Scheveningen for one that will look twice at a corner of East Hampton." In anticipation of a second Pastel Society exhibition, the same writer expressed the wish that the displays would equal the technical skills witnessed in 1884 and would also communicate "more originality of subject, which may be, if not distinctively national, at least American in suggestion."[46]

As the process of establishing a hierarchy within the new aesthetic order matured, critical commentary began to divide roughly between writers who concentrated on technique and those who focused on subject matter. The growing sophistication of the critics notwithstanding, it was a gradual operation, and, if the more measured reactions in the 1883 reviews of his art led Chase to believe that the critical tides had turned, he was sadly mistaken, as witnessed by the press appraisals of the six paintings he showed in the 1884 SAA annual. By today's standards the most noteworthy of Chase's works in the

Fig. 9. Courtyard of a Dutch Orphan Asylum (*originally titled* Garden of the Orphanage), *c. 1883. Oil on canvas on board, 66⅛ × 78⅛ inches. Washington University Gallery of Art, St. Louis. University purchase, Subscription Fund, 1885.*

galleries was *Portrait of Dora Wheeler* (1883, The Cleveland Museum of Art). Also on view were the large *Courtyard of a Dutch Orphan Asylum* (originally titled *Garden of the Orphanage*) (fig. 9), *The Young Orphan, Spanish Bric-a-Brac Shop, Study of a Child,* and a still life. The differences manifested between contemporary taste and that of New York's critical community in the 1880s register strikingly here; where the now greatly admired *Dora Wheeler* was roundly criticized because of its superficial, decorative qualities that ignored the "soul" of the sitter, the now generally overlooked *Courtyard of a Dutch Orphan Asylum* was treated sympathetically on the grounds that it revealed that Chase had "escaped from his studio and got out of doors."[47] The poor New York reception of *Dora Wheeler* must have been a shock to Chase since his hopes for it would have been shaped by the painting's prior success at the Paris Salon, where it had won an honorable mention in 1883. Also worth noting here is that the favorable comments about *Courtyard of a Dutch Orphan Asylum* stemmed from the writer's appreciation for the semblance of the out-of-doors, a quality that *The Hackensack River* (shown the prior year) had failed to convey. A pattern may be detected through a sequential examination of reviewers' opinions that reveals not only their resistance to Munich-derived painting but also a dislike for decorative features discovered in such works as *Dora Wheeler*. On the other hand, their comments encouraged a type of naturalism that, according to their recommendations, would be found in approaching the outdoor subject firsthand.

With that said, however, it must be pointed out that the disastrous reviews Chase gathered in 1884 had very little to do with his paintings and much to do with his visibility, which the critics perceived was at the expense of other artists.[48] The *Art Amateur*'s writer opened his review by accusing the SAA of foisting the "greatest exhibition of charlatanry" on the public thus far and blamed Chase for it:

The deference to Mr. Chase shown by the Society in placing his works on the line in such superabundance, while better pictures were excluded altogether from the exhibition, justifies the retirement from the committee of [Augustus] St. Gaudens and other serious men, to avoid taking part in such a travesty of selection. . . . It will be well for American art if this convulsion be the

last, and the Society of American Artists drop out of a field where, if distinguished competence is not always to be expected, at least conspicuous buffoonery is not pardonable. Among Mr. Chase's contributions a codfish alone in his "Still-Life" is above mediocrity. If he were clever in his execution of these inanities, there would be some excuse for admiration of them, for even good legerdemain in painting has a certain interest; but his hand is heavy and inaccurate at the same time.[49]

The remainder of the lengthy review discussed the works of other artists against the foil of Chase's disgrace. Beckwith (who showed one painting, *Children by the Brook*) was accused of following Chase's poor moral example, which included reckless disregard for nature and refinement, lack of propriety, and disdain for the public in the assumption that "the learned are so few that it is of no use to bother one's self to work hard for them." Abbott Thayer's *Sisters* (fig. 10) was disdained because it evidenced symptoms of the "vicious characters of the [Munich] school, which [seemed] to have taken control of the Society." Ruger Donoho's (1857–1916) *Mauvaise Herbe* (unlocated) was found guilty of the same "vacuities" exhibited by Chase's work.[50] The general critical consensus held that "[e]verything points to the conclusion that the society has fallen into the wrong hands, or that indifference and self-seeking have taken the place of the old zeal and disinterested love of art which made it the foremost art society in America."[51]

As witnessed by the criticism cited throughout this chapter, Chase returned from Europe hailed as a genius, but within a span of a few years he saw his currency plummet as rapidly as it had risen. The timing of his own plan for self-promotion and transformation worked against him inasmuch as it coincided with an already volatile moment of transition in American aesthetics. Following the devastating reception of the annual exhibition in 1884, the SAA administration immediately set out to reorganize its constitution and selection process. In the meantime, it failed to organize an exhibition for 1885. Just as the society recognized its need to "regroup" if it were to survive, Chase may have determined that his career was at a similar juncture. As the chief proponent of the radical membership of an already identifiably liberal organization, Chase was attacked on both personal and aesthetic grounds. Not only was his work considered empty of serious (and more important, "American") content, but its technical characteristics denoted a flimsy sleight of hand owing to the mixture of

Fig. 10. *Abbott Handerson Thayer,* The Sisters, *1884. Oil on canvas, 54¼ × 36⅛ inches. Brooklyn Museum of Art, 35.1068, Bequest of Bessie G. Stillman.*

the ill effects of Munich training or, alternatively, the adoption of monotonous compositions and tones arising out of a denatured Whistlerian style. It must be assumed that Chase, who was so attuned to public image, was acutely aware of the disastrous 1884 reviews and studiously considered their content. He may have especially taken to heart one critic's admonishments: "It is worth his while to stop and inquire of himself seriously—whither does it all lead?"[52] That he had already modified his art in response to press criticism is suggested by his 1883 displays, and, while that presumably palliative move was not entirely successful, it was noticed sufficiently to encourage a more concerted effort to renovate his art in a way satisfying to himself and to the critics. Thus, just as 1885 was a critical year for the SAA in reestablishing itself as a viable institution, the same year may be viewed as a watershed in Chase's career, a period during which he examined the direction his art should take in the quest to regain artistic priority.

ᴓ NOTES ᴓ

1. In an address to students given at the Metropolitan Museum of Art in 1916, Chase stated, "Keep yourself in as receptive a state of mind as possible, and be like a sponge, ready to absorb all you can. . . . And let me say here, 'I have been a thief; I have stolen all my life'—I have never been so foolhardy as to refrain from stealing for fear I should be considered as not 'original.' Originality is found in the greatest composite which you can bring together." William Merritt Chase, unpublished manuscript of a speech, The Metropolitan Museum of Art, New York, January 15, 1916, reproduced in Abraham David Milgrome, "The Art of William Merritt Chase," Ph.D. dissertation, University of Pittsburgh, 1969, 115.

2. The standard biographical sources on Chase are Katherine Metcalf Roof, *The Life and Art of William Merritt Chase* (1917; repr., New York: Hacker Art Books, 1975); Ronald G. Pisano, *William Merritt Chase, 1849–1916: A Leading Spirit in American Art*, exh. cat. (Seattle: Henry Art Gallery, University of Washington, 1983); Keith L. Bryant, Jr., *William Merritt Chase: A Genteel Bohemian* (Columbia and London: University of Missouri Press, 1991); and Barbara Dayer Gallati, *William Merritt Chase* (New York: Harry N. Abrams, Inc., in Association with the National Museum of American Art, Smithsonian Institution, 1995).

3. For Chase's years in Munich, in addition to the basic biographical sources cited in note 2 above, see Michael Quick and Eberhard Ruhmer, *Munich and American Realism in the Nineteenth Century*, exh. cat. (Sacramento, Calif.: E. B. Crocker Art Gallery, 1978), and Barbara Dayer Gallati, "William Merritt Chase and the Munich Legacy: The Americanization of an 'Intense, Unbeautiful Reality,'" in *ViceVersa: Deutsche Maler in Amerika, Amerikanische Maler in Deutschland, 1813–1913*, exh. cat., Deutsches Historisches Museum, Berlin (Munich: Hirmer Verlag, 1996).

4. The art dealer and collector Samuel Putnam Avery (1822–1904) was a powerful figure in developing the art market in the United States. A promoter of American and European artists, Avery not only sought to create a climate of appreciation for their work but also worked vigorously to establish major cultural institutions, including the Metropolitan Museum, the New York Public Library, and the Avery Architectural Library of Columbia University, which bears his name. For insight about his collecting activity at the time he purchased Chase's *Ready for the Ride*, see Madeleine Fidell Beaufort, Herbert L. Kleinfield, and Jeanne K. Welcher, eds., *The Diaries 1871–1882 of Samuel P. Avery, Art Dealer* (New York: Arno Press, 1979).

5. Letter from Chase to Samuel P. Avery, April 2, 1878. Samuel P. Avery Papers, The Metropolitan Museum of Art. The large picture to which Chase referred is most likely *The Moorish Warrior* (see fig. 4), now in the collection of the Brooklyn Museum of Art (acc. no. 69.43). Chase's years at the Munich Royal Academy overlapped with those of Walter Shirlaw (1838–1909) and Frederick Dielman (1847–1935), both of whom preceded him in establishing studios in New York (in 1875 and 1876, respectively).

6. Henry James, "On Some Pictures Lately Exhibited," originally published July 1875 in the *Galaxy*, reprinted in John L. Sweeney, ed., *The Painter's Eye: Notes and Essays on the Pictorial Arts by Henry James* (Cambridge, Mass.: Harvard University Press, 1956), 98–99.

7. See, for example, "Fine Arts. The National Academy Exhibition," *Brooklyn Daily Eagle*, April 7, 1878, 2.

8. Mariana G. Van Rensselaer, "William Merritt Chase. First Article," *American Art Review* 2 (January 1881), 93.

9. Chase's transformation from bohemian to gentleman is recounted throughout the literature devoted to him. For his changing public profile in the context of late-nineteenth-century American art, see Sarah Burns, *Inventing the Modern Artist: Art and Culture in Gilded Age America* (New Haven and London: Yale University Press, 1996).

10. See Jennifer Martin Bienenstock, "The Formation and Early Years of the Society of American Artists, 1877–1884," Ph.D. dissertation, City University of New York, 1983.

11. "The Third Annual Exhibition of the Society of American Artists," *Brooklyn Daily Eagle*, April 13, 1880, 2.

12. S. G. W. Benjamin, "The Exhibitions. IV. Society of American Artists. Third Exhibition," *American Art Review* 1 (1880), 261.

13. Bienenstock, "The Formation and Early Years of the Society of American Artists," 94–95.

14. See ibid., 125, where she quotes Benjamin, "Society of American Artists. Fourth Annual Exhibition," *American Art Review* 2 (1881), 72.

15. Because of limited gallery space and the number of submissions for the 1882 SAA annual, two consecutive exhibitions were organized, the latter of which was called the Supplemental Exhibition.

16. M. G. Van Renselaer [*sic*], "Society of American Artists, New York—II," *American Architect and Building News* 11, no. 334 (May 20, 1882), 231.

17. The critic's reference to a Barmecide feast has its source in an *Arabian Nights* story that features a banquet. The guests receive empty plates but pretend to eat. The term generally means illusory.

18. "The American Artists' Supplementary Exhibition," *Art Amateur* 7, no. 1 (1882), 2.

19. For reviews of Eakins's *Crucifixion*, see, for example, "The Society of American Artists," *New York World*, May 15, 1882, 5; "Society of American Artists," *New-York Daily Tribune*, May 17, 1882, 5; "The American Artists' Supplementary Exhibition," *Art Amateur* 7, no. 1 (1882), 2; and M. G. van Renselaer [*sic*], "Society of American Artists, New York.—II," *American Architect and Building News* 11, no. 334 (May 20, 1882), 231.

20. "Society of American Artists," *New-York Daily Tribune*, May 4, 1882, 5.

21. "Pictures. The Society of American Artists. Its Supplementary Exhibition—Some of the More Noticeable Works of the Collection—Examples of the Impressionist School of Art. Looking at Nature Through High Art Spectacles—What May Be Seen at the American Grosvenor Gallery—Works by Thayer, Chase, Millet, Currier and Others of the Advanced School," *Brooklyn Daily Eagle*, May 14, 1882, 1.

22. Ibid. Interestingly, the writer failed to differentiate between the two Munich "schools": that of the Royal Academy and that of the Leibl-Kreis, or the circle of Munich realists influenced greatly by Courbet via Wilhelm Leibl (1844–1900). It was the latter group with which Chase principally aligned himself stylistically. His self-advertisement as a student of Karl Theodor von Piloty (1826–1886; whose standards, but not his work, he admired) was likely calculated to aggrandize his professional standing in America.

23. For a brief summary of the *Whistler v. Ruskin* trial, see Richard Dorment, "Whistler v. Ruskin," in Richard Dorment, Margaret F. MacDonald, et al., *James McNeill Whistler*, exh. cat. (London: Tate Gallery Publications, 1994), 136–37.

24. For an excellent treatment of this issue see especially Burns, "The Artist in the Age of Surfaces: The Culture of Display and the Taint of Trade," part 1, section 2, in *Inventing the Modern Artist*.

25. "Fine Arts. The Sixth Annual Exhibition of the Society of American Artists," *Nation*, no. 298 (April 12, 1883), 328.

26. "The Society of American Painters. Second Notice," *New-York Daily Tribune*, April 15, 1883, 5.

27. See, for instance, "Art Exhibitions. The Society of American Artists," *New York Sun*, March 25, 1883, 5, in which Chase's landscape was listed with others by George Inness (1825–1894), R. S. Gifford (1840–1905), and William Lamb Picknell (1853–1897), all of which were deemed "remarkably good."

28. "The Society of American Artists. Sixth Annual Exhibition," *New-York Daily Tribune*, March 25, 1883, 5. The critic referred to Anton Mauve (1838–1888) and Jacob Hendricus Maris (1837–1899), who were principal figures in the Netherlandish art movement known as the Hague School, which flourished at the end of the nineteenth century. See Ronald de Leeuw, John Sillevis, and Charles Dumas, eds., *Dutch Masters of the Nineteenth Century*, exh. cat., Grand Palais, Paris (London: Weidenfeld and Nicolson, 1983).

29. "The Society of American Artists Exhibition," *Art Amateur* 8, no. 6 (1883), 125.

30. For studies of those aesthetic transitions, see especially H. Wayne Morgan, *New Muses: Art in American Culture, 1865–1920* (Norman: University of Oklahoma Press, 1978); Kathleen Pyne, *Art and the Higher Life: Painting and Evolutionary Thought in Late Nineteenth-Century America* (Austin: University of Texas Press, 1996); and Burns, *Inventing the Modern Artist.*

31. For a thorough account of the paintings shown in the exhibition, see Maureen C. O'Brien, *In Support of Liberty: European Paintings at the 1883 Pedestal Fund Art Loan Exhibition,* exh. cat. (Southampton, N.Y.: The Parrish Art Museum, 1986).

32. M. G. Van Rensselaer, "The Recent New York Loan Exhibition," *American Architect and Building News* 15, no. 421 (January 19, 1884), 29.

33. The Scottish dealer Daniel Cottier (1838–1891) opened a branch of his business in New York City in 1873. He was influential in promoting American interest in interior design (as stimulated by the theories of John Ruskin and William Morris). In addition to being an early champion of the SAA and the new aesthetic order it represented, he was also instrumental in establishing a market for Hague School and Barbizon artists in New York. See Elizabeth Broun, *Albert Pinkham Ryder,* exh. cat., National Museum of American Art (Washington and London: Smithsonian Institution Press, 1990), 42–65.

34. The checklist for the exhibition is reproduced in O'Brien, *In Support of Liberty,* 23–25.

35. "The Pedestal Fund Art Loan Exhibition," *Art Amateur* 10, no. 2 (January 1884), 43.

36. In 1881 the American painter Julian Alden Weir went to Paris to purchase contemporary French paintings for the collector Erwin Davis, who had promised Weir that his purchases would ultimately reside in the collection of the Metropolitan Museum of Art. Among other things Weir purchased were Manet's *Boy with a Sword* and *Woman with a Parrot,* which Davis gave to the Metropolitan Museum of Art in 1889. Although Weir transacted the purchase from Durand-Ruel on his own, Chase is usually credited for directing him to Manet's art. As Roof recorded, "One day as he was strolling along the Boulevard he [Chase] chanced to meet Alden Weir. . . . As soon as Chase heard his friend's errand he exclaimed: 'Come with me right away to Durand-Ruel's. They have two wonderful Manets there. You must have them.'" Roof, *William Merritt Chase,* 94.

37. "The Pedestal Fund Art Loan Exhibition," *Art Amateur* 10, no. 2 (January 1884), 42.

38. Ronald G. Pisano, "William Merritt Chase: Innovator and Reformer," in O'Brien, *In Support of Liberty,* 67.

39. "The Pedestal Fund Art Loan Exhibition," *Art Amateur* 10, no. 2 (January 1884), 43.

40. "The Pedestal Art Loan," *New York Times,* December 16, 1883, 5. "Now the collection as it stands appeals to far too few picture-lovers and picture-buyers here. There is no painter represented whom one could wish away, but there are many who ought to be represented and are not. Bouguereau, for instance, Cabanel, Merle, and such painters as they are tremendously popular, and nowhere more so than in New York; in fact, they may be said to live on American orders." This comment brings up an issue plaguing many American artists at the time—the matter of their secondary rank in an art market dominated by European painters. Chase and Beckwith may have been trying to manipulate taste by weaning patrons, critics, and the public from these popular academic artists and encouraging them to look at Europeans whose work had greater relevance to advanced aesthetic attitudes in contemporary American art production.

41. Of the four works listed here, the Tissot and the Munkácsy were definitely included in the 1883 exhibition. It is highly probable that de Nittis's *Place de la Concorde* was also included in the exhibition on loan from the New York hotel owner Samuel Hawk. The Maris *Schreierstoren, Amsterdam* is illustrated here because it is representative of the works by him promoted in New York by Cottier in the early 1880s. See discussions of these works in the context of the Pedestal Fund Art Loan Exhibition in O'Brien, *In Support of Liberty.*

42. For the Pastel Society, see Dianne H. Pilgrim, "The Revival of Pastels in Nineteenth-Century America: The Society of Painters in Pastel," *American Art Journal* 10 (November 1978), 43–62, and Bruce Weber, "Robert Frederick Blum (1857–1903) and His Milieu," Ph.D. dissertation, City University of New York, 1985, especially 207–27.

43. American artists and writers used the terms *Impressionism* and *Impressionist* somewhat loosely in the late nineteenth century. In addition to referring specifically to the French Impressionist movement, the terms were applied to the art of such diverse painters as Whistler, Inness, and Thomas Wilmer Dewing (1851–1938), generally for the purpose of separating these suggestive painterly styles from a more literal approach rooted in naturalism. For a discussion of the varied meanings of "Impressionism," see chapter 4, "Impressionism in America: Its Reception and Terminology," in William H. Gerdts, *American Impressionism,* exh. cat. (Seattle: Henry Art Gallery, University of Washington, 1980), 27–31.

44. M. G. Van Rensselaer, "American Painters in Pastel," *Century Magazine* 29 (December 1884), 207.

45. Ibid., 208.

46. "The Pastel Exhibition," *Art Amateur* 10 (May 1884), 123–24.

47. "Mr. William M. Chase's Art," *Art Interchange* 12, no. 13 (June 19, 1884), 148; and "Society of American Artists (Last Notice)," *New-York Daily Tribune,* June 2, 1884, 2.

48. Writing about the 1884 exhibition, Bienenstock states: "Large scale rejections [of paintings for SAA display] had been necessitated in the past by the limitations of small gallery spaces; but in 1884 they appear to have been prompted less by the exigencies of limited space than by Chase's desire to facilitate the domination of that exhibition by himself and his pupils, whose works usurped approximately one-fourth of the available exhibition space. . . . The partiality shown to Chase's students at the exhibition of 1884 may have been due to the apparent wholesale rejection of his students' works by the National Academy of Design, whose annual exhibition, for the first time, opened prior to that of the Society. According to a purposefully vague contemporary article, an unnamed 'man' in the Society [presumably Chase] stated that 'he' did not choose to exhibit his works at the Academy's exhibitions, but his pupils did. According to this article, the Academy's hanging committee of 1884 overheard this statement by a 'man' in the Society, and ensured that in 1884 his pupils did not exhibit" (164–65).

49. J. M. T., "The American Artists' Exhibition," *Art Amateur* 11, no. 2 (July 1884), 30.

50. Ibid.

51. "Society Artists," *New York Times,* May 25, 1884, 9.

52. "Mr. William M. Chase's Art," *Art Interchange* 12, no. 13 (June 19, 1884), 148.

Pl. 5. Prospect Park, *1886. Oil on panel, 6½ × 9½ inches. Collection of Richard and Susanna Nash. Photograph courtesy Vance Jordan Fine Art, Inc.*

Chapter Two

1886: A YEAR OF TRANSITION

The summer of 1885 was the last that Chase would spend in Europe until 1896, when he guided the first of his summer classes abroad. His 1885 trip was eventful, highlighted by a brief, but exhilarating friendship with James McNeill Whistler, whose memorable portrait Chase painted in London.[1] With his attention taken up by Whistler's initially irresistible demands, Chase had barely enough time to squeeze in a trip to Belgium to see the International Exhibition in Antwerp at the end of the summer before returning to New York to resume teaching at the Art Students League. Regardless of the pleasures yielded by his months abroad, 1885 was likely an unnerving period for the artist professionally and financially, for he had no major exhibitions to his credit that year owing to the hiatus in the SAA annuals, his continuing absence from the NAD, and no pastel exhibition for which to prepare. But for a few portrait commissions, Chase's income derived primarily from his teaching, and, without the exposure of his work in exhibitions, there was little opportunity for him to maintain public visibility apart from the parochial news surrounding his reelection as president of the foundering SAA.

The circumstances of Chase's private life in 1886 must also have added significantly to the anxiety he felt with respect to the impasse his career had reached. Although his decision not to travel to Europe in the summer of 1886 has been almost universally attributed to his marriage, it has come to light recently that the matter was far more complicated. The artist's future wife, Alice Gerson, was pregnant well before the couple married, and, contrary to all of the Chase literature to date, the marriage did not take place until February 8, 1887.[2] Their first child, Alice (Cosy), was born February 9, 1887, the day following the wedding.[3] Chase had nominally courted the considerably younger Alice Gerson for a number of years. The daughter of Julius Gerson, the manager of the art department for the lithographic firm of Louis Prang and Company, she had been raised in a household filled with art and music and enlivened by the comings and goings of her father's artist and literary friends.[4] Already linked to the Gersons by a network of mutual acquaintances, Chase was brought into the inner circle of the family by the painter Frederick S. Church (1842–1923) about 1879 or 1880, when Alice was in her early teens. Chase soon incorporated the Gerson sisters, Alice and the older Virginia and Minnie, into his own sphere of activity by frequently using them as his models. The relationship between Chase and the young Alice has been described as a warm and playful one and there is no reason to suggest that a serious romance developed between the two before Alice was of an appropriate age. What is of primary interest here are the effects these private events wrought on an already crucial moment in Chase's career. Certainly the fact that the marriage was delayed until the birth of the baby was imminent indicates that there was reluctance either on Chase's or Alice's part to marry. And, given the situation and the social mores of the time, it was most likely the inveterate bachelor and professionally ambitious Chase who hesitated to "do the right thing" until the very last minute.

In the context of this new information (and regardless

of his feelings in the matter, which doubtless will never be known), Chase's appetite for success and his need to recapture critical approbation take on added dimensions. He had obviously cherished his bachelorhood, for it had allowed him the freedom to travel at will and to live in a relatively bohemian style in his studio. A wife and child would enforce an unsought pattern of conventionality and domestication on his life that conflicted with the public image of cosmopolitan sophistication that he was so industriously constructing for himself. On the other hand, if he failed to marry Alice and/or acknowledge the child as his and the matter were to become public, his reputation and therefore his prospects for professional success would suffer as well. At the least he would have to reconfigure his strategy of self-promotion, which relied on personal celebrity. Lurking at the foundation of each of these concerns was Chase's poor financial situation, which made the timing of taking on the responsibility of a family particularly inauspicious. His highest hopes for financial relief must have rested on his first one-man exhibition, scheduled to open at the Boston Art Club late in the year.[5] The Boston show represented an unusual opportunity for any artist at the time to showcase a wide range of work and was bound to draw the critics by virtue of its rarity alone. Thus, whereas the dynamics of his personal life may still be credited for keeping him in the United States over the summer of 1886, the cumulative effects of personal and professional anxieties formed a potent impetus for the assertion of new and radical aesthetic strategies that would reform his artistic identity.

In the meantime the SAA exhibition had opened in May to cautiously favorable reviews. Although the exhibition itself was small (with 121 works), the selection committee had been increased to thirty and the display revealed a fairly equable balance between artists resident at home and abroad. These facts in themselves were almost a guarantee that the outrage previously lodged against Chase and his cronies for their alleged crimes of favoritism would cease. Deeming the show "respectable," the *Art Amateur*'s critic introduced his article by acknowledging that the "high and even average of merit attained reflects almost as much credit on the committees on selection and hanging as on the individual artists whose works are exhibited."[6] Vindicated on the administrative side, Chase also fared well with respect to his art, coming second only to Sargent in the area of portraiture despite the striking contrasts between the art of the two men. Even against the sharp blacks and whites of Sargent's brilliant portrait of Mrs.

Wilton Phipps (private collection, exhibited as *Portrait of a Lady*, no. 95), Chase's tonal pastel portrait of his future wife Alice Gerson (*Meditation*; private collection) was judged "not merely clever, which Mr. Chase's pictures always are; it is an earnest, sustained and perfectly natural bit of work."[7] At least in the opinion of the *Art Amateur*, Chase was on the road to artistic redemption, yet these restrained words of encouragement for the artist's four contributions to the SAA were feeble in comparison with the reactions drawn by Chase's Boston show and its subsequent reduced display for a sale of his art at Moore's Art Galleries in New York in early March 1887.

In Boston, Chase's selection of 133 works in oils, pastels, watercolor, and "black-and-white" (a term usually referring to prints or drawings in black and white) not only dazzled the art community in their demonstration of his versatility and an "industry short of marvelous" but also reinforced his reputation (for good or bad) as an artist whose strengths lay in technique and not "large or serious motive."[8] As the Boston correspondent for the *Art Amateur* put it:

[The town] went in full force, and repeated its visits with enthusiasm, and it is unanimously voted that nothing has been seen here at all like it since [William Morris] Hunt's day. Such fertility, variety, dash, gayety, excitement! Such frank singleness of delight in cleverness, in painting as painting; such naïve confession that the fun of the doing of it is the main thing; such happy unconsciousness that art has any ulterior objects, any moral mission or historical function! . . . This "enfant terrible" from New York, whither we go for "intellectual rest," dashing in among our prim proprieties and pale poetesses of art, has given us a sort of holiday racket, and we shall miss him immensely when he has gone back again and left our most respectable painters and painting-schools turning out their well-known regulation products. But, all the same, we cannot but cling to a doubt whether Mr. Chase's is the last word in art, whether there be not higher motive, deeper sentiment, yes, even more serious ability and sounder technique than his.[9]

Surely it must have been difficult to assess works that ran the gamut of subject matter, media, and degree of finish. Yet with hindsight, Chase's program attains clarity when it is noted that none of his early and famous Munich paintings were included in an exhibition that functioned as a retrospective. Furthermore, while the Boston critics overlooked them, at least twenty-three (or nearly 17 percent) of the works fea-

tured scenes painted in and around Brooklyn.[10] The products of the recent summer's activity, these works heralded for astute observers the new direction Chase had chosen for his art. Another critic for the *Art Amateur*, writing about the slightly reconfigured exhibition at Moore's in 1887, apparently caught the meaning of Chase's intent. After stating that the display "may be said to have been the most interesting exhibition ever held here of the works of an American artist," he proceeded:

Those who think of Mr. Chase principally as the pupil of Piloty, and as an honored member of the Munich school, will be, according to the breadth or narrowness of their views, agreeably or disagreeably surprised at the variety of subjects, methods and aims of this versatile and extremely clever painter. He evidently appreciates the most different sorts of painters, Munkacsy as well as Whistler, Vollon as well as Velasquez; but he cannot be said to belong to any school, unless it be the modern school; and, whether impressed by a certain phase of art, or a certain aspect of nature, the work of his brush always expresses a thought or feeling of his own.[11]

Their significant presence notwithstanding, Chase's newest landscape efforts received scant, although positive attention from the same writer, who noted "a number of exquisite little studies of land and water about New York, Coney Island, Long Island, and the Lower Bay."[12] The small scale and sketchy finish of the paintings in question doubtless accounted for the critics' cursory treatment of them, something that becomes a factor in the task of trying to match known, undated works lacking original titles with listings in exhibition records of the nineteenth century. Be that as it may, two small Prospect Park paintings (Pls. 5 and 6) exemplify the group of local landscapes Chase debuted in Boston. The first of these may, in fact, be that listed in the Boston catalogue as belonging to the influential collector of American art, Thomas B. Clarke.[13] In addition to the twenty or so Brooklyn landscapes on display in the Boston and/or New York exhibitions were several other Brooklyn subjects less obvious in their identification with place—namely *Pet Canary* (see Pl. 10), a portrait of the artist's youngest sister, Hattie (born c. 1872), silhouetted against a window overlooking a green lawn, and *Wash Day—A Back Yard Reminiscence of Brooklyn* (see Pl. 9). Both works subtly announced Chase's personal and professional allegiance to a distinct, albeit private, American geography by virtue of their connection with Chase's father's Brooklyn home. With the two last named paintings

Chase aestheticized his life, establishing a personal iconography of place, as it were, that objectified the idea of home in much the same way that he had repeatedly personalized and objectified his Tenth Street Studio in his art. Such paintings not only marked a new thematic direction for Chase but also announced a radical departure in style, which disclosed the artist's growing attentiveness to French innovations and introduced a nascent Impressionism to his facture.

Chase's pronounced emphasis on American scenes in his newest work may simply be a result of the fact that he painted what he saw during his first stateside summer in years. Yet the sudden emergence of his interest in local subjects may have been a deliberate experimental device engineered not only to appease critics who lobbied for American themes, but also to carve out a subject matter that would be perceived as uniquely his. Otherwise, he could have easily ignored landscape altogether and continued to concentrate on portrait, figure, and still-life painting, which had already brought him a modicum of success.

A conjunction of circumstances and events may be credited with shaping Chase's efforts to repatriate his artistic identity, not the least of which were his inherent aesthetic restlessness and openness to experimentation. In that connection the groundbreaking exhibition of French Impressionist works mounted in New York by the Parisian dealer Paul Durand-Ruel presented immeasurable stimuli for Chase in his quest for an alternative style that would dispel the cloud of Munich from his painting.[14] The exhibition of 289 oils, pastels, and watercolors had opened at the American Art Galleries on April 9, 1886, and treated the New York audience to its first intensive view of what the much publicized but still little known French avant-garde had to offer. The display must have been confusing to the uninitiated, for although it was billed as a survey of Impressionism, it included the work of numerous artists outside the Impressionist fold, including Henry Lerolle's (1824–1929) *Organ Loft*, Jules-Joseph-Augustin Laurens's (1825–1901) *Austrian Staff before the Body of General Marceau*, and Frédéric Montenard's (1849–1926) *Grande Route de Toulon à La Seyne*. These paintings and others of their ilk were installed in the lower introductory gallery through which viewers had to pass to reach the "true" Impressionists on the upper level. That level gained, however, the casual viewer's confusion must have persisted given the technical variety that existed even among the core figures of the Impressionist circle and their close associates. Strolling

Pl. 6. Prospect Park, 1886. Oil on panel, 6¼ × 9½ inches. Private collection. Courtesy Megan Moynihan Fine Arts, New York. Photograph courtesy of Sotheby's, Inc.

through the galleries one would have encountered such diverse and now famous works as Edouard Manet's *In the Conservatory* (Nationalgalerie, Berlin), one of Claude Monet's (1840–1926) versions of the Gare Saint-Lazare, Paris, Gustave Caillebotte's *Floor Scrapers* (1875, Musée d'Orsay, Paris; listed as no. 30, *The Planers*), Georges Seurat's (1859–1891) *Island Grand Jatte* (likely a study since the finished work was shown at the 1886 Paris Impressionist exhibition, which ran from May 15 through June 15), and Pierre-Auguste Renoir's (1841–1919) *Dance at Bougival* (Museum of Fine Arts, Boston), none of which shared a unified stylistic vision, yet all of which qualified as exemplars of modernity. The writer for the *Art Interchange* provided a caustic estimate of the entire affair, which he claimed was "interesting, if not profitable."[15] His preferences clearly lay with the more conservative artists, and his lack of sympathy for Manet's work was fueled by his inability to reconcile Théodore Duret's introductory statements in the catalogue concerning plein-air technique in the face of Manet's and Degas's art especially.[16] While these discrepancies were a source of discussion and curiosity in the press, Chase, who was undoubtedly familiar with the types of the works on view (if not the specific paintings), must have attended the exhibition with a different purpose in mind: not to acquaint himself with this art, but to reassess it, taking advantage of seeing hundreds of works from the modern French school at one time from the vantage point of his current aesthetic position, which was at a crossroads. What is more, Chase's curiosity probably extended to seeing what the public and critical reactions would be to gauge better which way the aesthetic winds were blowing in New York and thereby guide his own artistic choices.

The following points, extracted from reviews of the 1886 Impressionist exhibition, are selected on the basis of the relative importance Chase may have placed on them. It is not surprising that the recently deceased Manet (he died in 1883) received the greatest attention in the press. His work was relatively familiar to New Yorkers (through the paintings owned by Erwin Shaw previously shown at the 1883 Pedestal Fund Loan Exhibition), and his reputation as the forerunner of the Impressionist movement was firmly entrenched. Billed as the "King of the 'Impressionists'" by the leading American art writer, Theodore Child, Manet was almost universally respected in the United States, but his figure paintings made critics uneasy because of the "monstrous truth" they communicated.[17] Positioned as a transitional figure who linked the brutal realism of Courbet with the gentler realities of the Impressionists, Manet was described as a master of technique, whose "reactionary desire in favor of truth and simplicity . . . carried his theories into regions where the esprit bourgeois could not follow him."[18] Although it may seem odd at first, Chase's status in America occupied roughly parallel ground in terms of his reliance on dark tonal values, sketchy, unfinished paint surfaces, and a truthful, rather than prettified treatment of his subjects. From an art-historical perspective this connection reflects Courbet's influence manifesting independently in the two artists—received by Manet directly, and absorbed by Chase primarily by way of Wilhelm Leibl (1844–1900) in Munich. What is more, the paintings by the great Spanish baroque master, Diego Velázquez (1599–1660), stood at the foundation of art for both men, a connection that brought them together in the mind of at least one critic: "Manet, who was represented by a number of striking examples, large and small, is absurdly over-rated when compared, as he has been, with Velasquez. He is more like our own Wm. M. Chase, minus his barbaric splendor of color and plus a touch of Goya's savage imagination."[19] Although Chase might have been pleased with this statement, it is highly unlikely that he would have wanted to capitalize on such connections, especially since the critics took delight in other aspects of the Impressionist exhibition.

By and large, Monet and Renoir earned top honors from the American critics, and, so far as subject matter was concerned, the landscapes garnered often unqualified praise:

Some of the most delicious landscapes ever painted are to be seen in this exhibition. Claude Monet (not Manet) leads the school, and after him come Sisley, Boudin, Pissarro, and others of more or less extreme tendencies. Many French critics rate Boudin higher than Monet. Whatever is exquisite, tender, subtle, in landscape art, is found in Monet's works here exhibited. One might say that the feminine principle of impressionistic art is embodied in its landscapes and the masculine in its figures.[20]

If anything, Chase may have formed a conceptual kinship with Monet, whose productions were declared stunning in their variety of subject and execution and therefore suggested an eclecticism paralleling Chase's:

And Claude Monet! What observation, what variety of execution, surprising us at every turn, what independence of all methods

prescribed, and of his own, when he pleases! . . . We know of no other modern painter who has the qualities displayed in these pictures, and displayed in such abundance. . . . The Station at St. Lazare, *no. 203, is another master-piece. It recalls Turner's "Rain, Steam, and Speed," . . . but as it is more real, so it is more full of varied life and contrasted effect. . . . If Mr. Durand-Ruel had done nothing more than to bring us the pictures of this artist, he would have rendered us a great service.*[21]

Even Louis-Eugène Boudin (1824–1898) prospered at the hands of the conservative *Art Interchange* critic, who allowed that "the clever little coast and marine views by Boudin belong to the more serious work of the exhibition."[22] Among the figure painters Renoir was judged the most pleasing:

Renoir is another surprise, but he is so aggressive, and leaps so like a matador into the arena, and faces with such gayety of heart the little black bull of convention, that he sometimes takes away our breath—with admiration! . . . Renoir, like the English Pre-Raphaelites, has thrown his bitumen-pots and tobacco-juice out of the window, and has determined to paint colors as he sees them. . . . He paints his daughter sitting in the green-house at her work, No. 149, herself the most brilliant flower, all scarlet, blue and gold, or another lady with a little child, The Sisters; On the Terrace, *No. 181, where the same brilliant colors show against a network of delightfully suggested landscape.*[23]

Degas, on the other hand, provoked anxiety, for his works spoke of the unhealthy debauchery of Parisian life. He was characterized by one critic as "abrupt—bizarre—fierce, and almost terribly fascinating." Another wrote of him:

His eccentricity almost reaches the sublime. There is a moral and artistic depravity in him which is almost Mephistophelean. His ballet compositions, with their vicious, ugly-faced women, pathetic to the last degree, are like nothing so much as modern Parisian sabbats at which Satan presides. The Ballet of Robert Le Diable, showing a row of male heads in the orchestra chairs, and the darkened stage with its phantom shapes, is strikingly original in composition and in its sharp contrasts. . . . They are terribly significant.[24]

Taking the above-quoted passages into account, Chase may have interpolated from them and his firsthand assessments of the paintings a blueprint on which to base his goals for the coming summer's painting. Manet, who was by then too much associated with the past in stylistic terms (especially because of the dark, flat inflections of his paint surfaces), at least confirmed the realist vision that infused the works of the Impressionists overall. Monet registered strongly, both for his landscape subjects and for the subtle delicacy with which they were wrought. Renoir (fig. 11) stood apart for his integration of figure and landscape, and especially represented a potential ideal for Chase because of the gentility of his imagery. So far as Degas's work was concerned, Chase likely concluded it best to avoid its "coarse" subject matter, but nonetheless found Degas's manipulation of compositional space irresistible. Indeed, elements of radical treatments of illusionistic space had previously emerged in Chase's art (as, for instance, in his 1882 *Outskirts of Madrid*, Yale University Art Gallery), thus confirming his awareness of and preference for a compositional format that indicated a modern artistic outlook.

The work of Berthe Morisot (1841–1895) also deserves consideration at this juncture, for although her work in the 1886 Durand-Ruel exhibition received only passing notice, it is known that Chase admired her art. Of Morisot's paintings shown in New York in 1886, *La Toilette* gained the most attention, and it may be that this was the very same Morisot that Chase owned and later sold in his 1896 studio sale.[25] Indeed, Morisot's concentration on women and children in urban and seaside settings (for example, *On the Balcony* [c. 1871–72, private collection] and *View of Paris from the Trocadéro* [1872, Santa Barbara Museum of Art]) may have particularly influenced Chase in the formation of an iconography in which landscape helped to define the activities of women and, conversely, in which the female figure aided in determining the city as a civilized cultural terrain.

On the whole, Impressionism offered an alternative to Munich facture that still allowed for and, indeed, insisted on the *alla prima* painting techniques in which Chase had been trained. What is more, Chase had already flirted with plein-air painting, conducting his first experiments in the practice on his Tile Club excursions and during his trips to Spain and Holland. The effects of outdoor light that Chase explored, however, coincide with the qualities of what has been called the "glare aesthetic," in which the dual properties of light—to reflect and to define through illumination—interact to form a brilliant, almost blinding sense of sunlight.[26] Although Chase's palette had soon lightened and his brushwork become more abbreviated (thus suggesting the characteristics associated

with French Impressionism), his treatment of light never succumbed to the Impressionist imperative in which solid forms dissolved in the ephemeral, unifying atmosphere of the classic Impressionist technique. Instead, Chase ultimately occupied a middle ground, eschewing the extreme white light of the "glare aesthetic" in favor of a more evenly disposed type of illumination that sustained the integrity of forms.

Although there is no word from Chase as to what he gained from the 1886 exhibition, his *Prospect Park* (see Pl. 5) may be looked to as indirect proof of his reading of the paintings and the commentary they evoked. The painting depicts the terrace near the Concert Grove at the southeastern end of Brooklyn's Prospect Park, an elegant, formal space dominated by the sweeping curve of the walks bordered by carefully designed plantings and punctuated by elaborately carved balustrades. In it Chase synthesized avant-garde compositional approaches, particularly by leaving a substantial void in the foreground that bears the fluid markings of a wide brush to indicate the shade of the trees just outside the pictorial space. From the shaded foreground the eye is drawn to the sunlit walk that seems to decrease in width as the eye travels its length along the curve, until it disappears from view. The pull to the more distant spaces of the scene, however, is counteracted by the emphatic horizontal provided by the line created by the highlighted wall at the left that is augmented by the darkened lower edges of the balustrades and carried through the line of red flowers on the right. The complexity of this seemingly arbitrarily chosen composition is at first concealed by the painting's small scale. But the notion of casualness is erased once the artist's choices are examined closely, for he deliberately applied a modern spatial trajectory to a location that also spoke of modern life—a public park, where the solitary woman dressed in white may be read as a sign for the gentility of these public spaces. Walking among the flowerbeds, she establishes a presence roughly echoing Monet's uses of the figure in a landscape that is defined by light and color created by broken brushwork, which, though fluid, is the product of a controlled freedom distinct from the slashing bravura strokes associated with Munich facture. Chase's palette reaches a high key in this work, thus declaring an affinity for the prismatic colors of Impressionism, if not a wholehearted commitment to what he considered the overly systematic application of the "science" of color that he detected in Monet's art.[27]

It would be a mistake to attribute Chase's experiments of

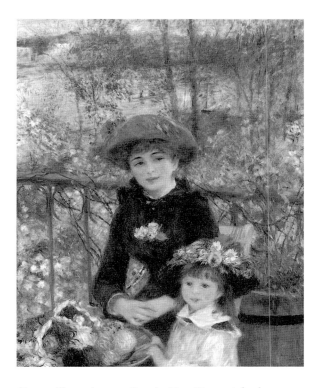

Fig. 11. Pierre Auguste Renoir, Two Sisters (*also known as* On the Terrace), *1881. Oil on canvas, 39⁹⁄₁₆ × 37⁷⁄₈ inches. The Art Institute of Chicago, Mr. and Mrs. Lewis Larned Coburn Memorial Collection, 1933.455*

the summer of 1886 solely to the Impressionist exhibition, for there are other potent factors to be considered. One such factor is the influence of Alfred Stevens, who, although Belgian born, was essentially French in his ways and art. Chase's meeting with Stevens in Paris in 1881 is consistently mentioned in the Chase literature.[28] In addition to reportedly advising Chase to lighten his palette, Stevens's considerable influence on the American is also revealed by Chase's frequent borrowing of motifs from the Belgian's repertoire of studio, beach, and marine paintings.[29] If they had faded, Chase's memories of his visit with Stevens were probably refreshed in 1886 when Stevens's book of art advice appeared to some note in America.[30] Equated with William Morris Hunt's (1824–1879) *Talks on Art* and Thomas Couture's (1815–1879) *Conversations on Art*, Stevens's book was liberally quoted in one newspaper art column that Chase was likely to have read.[31] Among the selection of aphoristic statements the

columnist reproduced was "One should be of his own time, should be subject to the influence of the sun and of the country in which he lives and of his early education. Even a mediocre painter who has painted his own time will be more interesting in the future than the one who, with more talent, has painted an epoch that he has not seen."[32] Although the idea of being of one's own time was ingrained in Chase, Stevens's words quoted here introduced the aspect of being of one's own country as well and thus may have reinforced Chase's growing inclinations to paint the local scene.

But what was the local scene? Chase's studio was in New York City. He taught in New York City. In all respects, his social and professional life took place in Manhattan. His private life, however, extended to the then separate City of Brooklyn, where his parents lived on Marcy Avenue in what is now the Bedford-Stuyvesant section of today's borough.[33] The artist's biographies testify to his strong family affections, and even without the verification of the written word, his paintings bear witness to his personal regard for home life, inasmuch as he literally transformed his wife, children, and other members of his extended family circle into art. With his parents established in Brooklyn, Chase likely had the occasion to make many a trip across the East River by means of the newly opened Brooklyn Bridge or by one of the numerous ferries that connected the two cities. These trips familiarized Chase with the topography of an exciting urban landscape that was still something of a novelty to Manhattanites, given that the directional flow of people across the river was shaped mainly by Brooklynites going to work in Manhattan and returning home in the evening. For most nonresidents, Brooklyn represented an excursion to the ocean's edge, or trips to the playgrounds of Coney Island or Brighton Beach, which entailed a specially planned day or weekend outing, rather than the casual visual experience attached to the workaday river crossing of the commuter. Even the famed Prospect Park, which rivals its Manhattan equivalent, Central Park, in terms of design, complexity, and purpose, was probably known to relatively few visitors from outside its home city except for foreign travelers, who were attracted by its reputation. Chase's increasing acquaintance with Brooklyn, therefore, was synchronous with his search for new motifs, and, although areas of that city had been depicted by other artists, it was he who converted it into the currency of the avant-garde.

In addition to the stimulus of his own visual experience, Chase was also probably inspired to consider urban subjects in response to tentative moves on the part of his immediate colleagues exhibiting at the SAA to embrace the cityscape in their subject matter.[34] As early as 1879 Julian Alden Weir had displayed his large *In the Park* (see fig. 12) to predominantly unfavorable reviews.[35] Although prominently displayed along with a sketch for the painting, *In the Park*—a crowded scene in New York's Union Square Park of character types including a little girl selling violets, a blind beggar, street rowdies, a "bohemian" type reading a newspaper, and a young woman making her way through the crowd—was judged "commonplace in sentiment, raw in color, and out of drawing."[36] The critics had little to say about its setting, although one noted:

In the Park . . . is a large figure piece, supposed to represent a scene common enough in any city park—some people sitting on a bench, and others passing by. As this work was sent to the exhibition unfinished, portions of it being flat masses of color, touched up in places to give certain effects, it would be unfair to judge it as a complete production. The composition is faulty in that the figures are crowded upon the canvas, and the grouping is not true to nature. Men do not stand at the back of park benches to ogle women seated in front of them; at least not in New York.[37]

Weir's only other essay into urban imagery seems to have been the 1881 *Snowstorm on Mercer Street* (private collection), which shares a gritty bleakness with the earlier *Duane Street* (Brooklyn Museum of Art), by Louis Comfort Tiffany (1848–1933). Tiffany's potent image of downtown tenements occupied the critics well after its first display at the 1878 Paris Exposition Universelle, for it testified to the strength of New York subjects if they were well painted.[38]

Fernand Lungren's *Impression of a Rainy Night, New York* (tentatively identified as fig. 13) also gained substantial comment when it was shown at the 1881 SAA exhibit. Lungren (1857/59–1932), who may have been the first American artist to attempt a "Europeanized" view of urban New Yorkers negotiating the reflective, rain-slicked sidewalks of a fashionable commercial district, is little known today. Yet his *Impression of a Rainy Night, New York* was highly admired by the powerful critic Edward Strahan, who wrote of it as

a vital and rude impression straight from nature. In this vigorous bit of an "impression" we have the real confusion and blotted splendor of lamplight on wet streets, a mad ballet of umbrellas and can-caning cabs hurled together in bursts of illumination,

*the yellow dots of street-lamps looking bleared under the broad
desert-like glare of the electric globes, whose sheeted garishness
is given in its effect, though the individual lights are judiciously
elevated "in supposition," above the picture-frame. Vollon, with
his still-life or his port views; De Nittis, with his city fogs;
Degas, with his ballet girls in lime-light, are all suggested by this
most difficult, most sincere, most able picture, which equals in
its felicitous success all that they have to teach. Such a picture
forms a criterion, and in some sense, a date. It would not have
been comprehended ten years ago.*[39]

Although Lungren was not a member of the SAA, Chase,
who was on the society's Exhibition Committee, would cer-
tainly have been attentive to Lungren's submissions to the
society.[40] The two had ample chance to get to know each
other the following year, when Lungren joined Chase,
Beckwith, Blum, and other artists on the SS *Pennland*, which
sailed for Antwerp in June 1882.[41] From 1884 to 1886 Childe
Hassam similarly investigated the contemporary urban scene
in his paintings of the streets near his Columbus Avenue
apartment in Boston. His impressive *Rainy Day, Boston* (1885,
The Toledo Museum of Art) was shown at the 1886 SAA exhi-
bition, where it was described by one reviewer as "properly
gloomy and dispiriting."[42] Hassam's priority in exploring urban
subject matter, however, cannot be ignored. And, whereas he
more extensively exploited the theme from 1886 to 1889 while
he was in Paris, the products of his French period that were
displayed in American exhibitions over that three-year span
eliminated him from contention in the drive for a definitive
American art.

Perhaps more significant for Chase were John H.
Twachtman's (1853–1902) canvases showing the dynamic
shapes of boats and harbor equipment along the New York
docks, which roughly recalled the Venetian views the two
had painted while together in Italy in 1877. Twachtman
showed *In New York Harbor* at the 1879 SAA exhibition at the
Pennsylvania Academy of the Fine Arts and *Tenth Street Dock*
at the 1881 annual in New York. The latter was found to be

*a very bright and clever piece of work of which the only real
defect is the undue sharpness with which the masts of the fishing-
craft are reflected. The scene is full of life. The water is real and
liquid. The scene altogether is admirable. Though one of the
most modest pictures of them all, it is an interesting example of
the suggestions in color and form offered by the water-front of*

Fig. 12. Engraving after Julian Alden Weir, In the Park, *c. 1879,
from the* Daily Graphic, *reproduced in John I. H. Baur, "J. Alden
Weir's Partition of 'In the Park,'"* Brooklyn Museum Quarterly
25, no. 4 (October 1938), 124. Brooklyn Museum of Art Library
Collection.

Fig. 13. Fernand Lungren, possibly Impression of a Rainy
Night, New York, *c. 1880. Oil on canvas, 13¼ × 14½ inches.
Photograph courtesy Hirschl & Adler Galleries, New York.*

New York. Mr. Twachtman has not merely yielded to the inspiration of the genius loci, but he has transcribed what he saw with capital boldness and precision. In fact, his technique is as much to be commended as his choice of a subject and the fidelity to nature with which he has heeded it.[43]

Twachtman's paintings may be seen as a source of immediate encouragement for Chase to try his hand at his own variations of the subject of urban docks, as seen, for instance in *Woman on a Dock*, most likely originally titled *Rotten Row, Brooklyn* (Pl. 7).

The works singled out here and a smattering of others reveal the slow shift that was taking place in American art toward focusing on subjects denoting the country's modern life.[44] Chase's administrative duties at the SAA put him in the position to see such trends and to glean from the hundreds of paintings that passed before his eyes those features he might put to use in his own work. In that respect Chase was rare in that he admitted the benefits of borrowing from the works of other artists. Portions of an interview conducted by Benjamin Northrop, a reporter for the *Mail and Express,* later reprinted in the *Art Amateur* attest to Chase's attitude: "Absolute originality in art can only be found in a man who has been locked in a dark room from babyhood. . . . Since we are dependent on others, let us frankly and openly take all that we can. We are entitled to it. The man who does that with judgment will produce an original picture that will have value."[45] It is through this lens of informed selection that Chase's park and harbor paintings may be interpreted; they are the product of a process designed to release Chase from the stalemated aesthetic position in which he was mired in 1885 and form the bridge to the Shinnecock landscapes that mark his mature style.

Ironically, Chase's bid to associate himself with indigenous landscape did not register immediately, as demonstrated by the comments of one writer who poised Thomas Worthington

Whittredge's (1820–1910) "strictly American" works in opposition to Chase's "foreign" productions, and even tacitly questioned the aptness of classifying Chase as American:

Mr. Chase is one of the ablest and readiest painters that we have and although he is hardly to be regarded as a native product, being in his art but a reflex of Munich methods, he and his fellow students from Munich are to be thanked for showing some of the American artists what may be done with bristles and paint. By his vigorous brush strokes he has swept away half a century's growth of false creeds and false workmanship; he has gone to the heart of things instead of niggling ornamentally around the exterior of them; yet how little of his work has soul in it. . . . If Mr. Chase and others who learned their trade away from home have taught us how to paint, these representative men [Whittredge, John Casilear, Frederick Kensett, S. R. Gifford, Daniel Huntington, and Frederic E. Church] have shown us what to paint. They have revealed the glories of our plains and mountains, the beauty of our lakes, our fields and pastures.[46]

Given that such nationalist issues still formed the core of many critical discussions in which Chase's art represented foreign influence, it is difficult to imagine that Chase would have been immune to the critics' exhortations for an American art. Although the small landscapes he showed in Boston may have seemed to his audience to be merely pretty, trifling studies, they were the first step in his artistic transition. The March 1887 sale at Moore's, termed a "clearing out sale" in the newspapers, brought him ten thousand dollars—a respectable sum in what the critics acknowledged was a "dull season."[47] This junction of circumstances—money in hand, the figurative clean slate of a studio cleared of paintings, and a fresh start with the critics—represented an opportune moment for Chase to pursue and enlarge on the possibilities he had begun to explore over the summer of 1886.

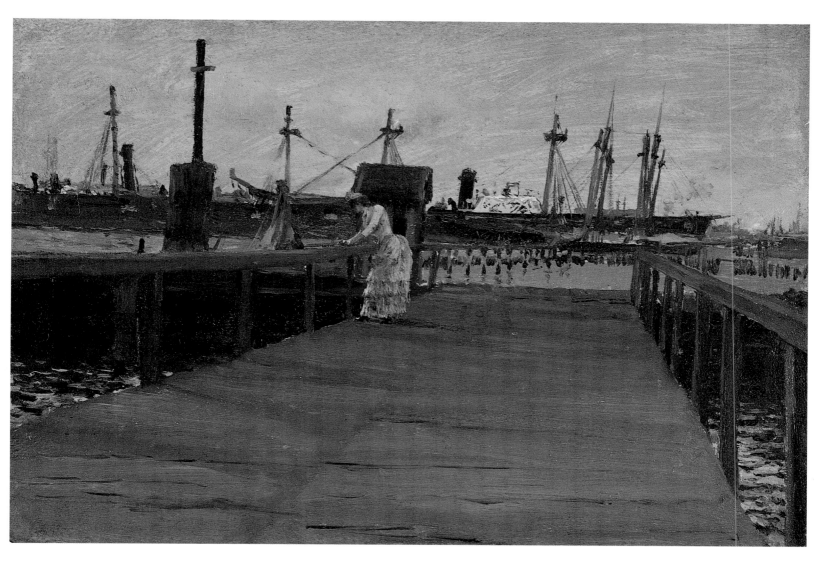

Pl. 7. Woman on a Dock (*possibly* Rotten Row, Brooklyn), *1886. Oil on board, 6½ × 9½ inches. Private collection. Courtesy Berry-Hill Galleries.*

1. For Chase's account of his friendship with Whistler, see William Merritt Chase, "The Two Whistlers: Recollections of a Summer with the Great Etcher," *Century Magazine* 80 (June 1910), 219–26.

2. The marriage certificate is on file at the New York City Department of Records and Information Services, Municipal Archives (no. 71356) and documents the February 8, 1887, marriage of William Merritt Chase, age 38 years on his next birthday, living at 51 West 10th Street (his studio), to Alice Gerson, age 21 years on her next birthday, living at 110 East 47th Street, the daughter of Julius and Mary Virginia Marks Gerson. The civil ceremony was witnessed by Minnie Gerson and Pauline Marks, the latter of whom was possibly an aunt or a cousin on Alice's mother's side of the family.

3. The date of Alice Dieudonnée (Cosy) Chase's birth is provided in Ronald G. Pisano and Alicia Longwell, *Photographs from the William Merritt Chase Archives at The Parrish Art Museum*, exh. cat. (Southampton, N.Y.: The Parrish Art Museum, 1992), 15.

4. For a description of the Gerson household and family friends, see Juanita J. Miller, *My Father C. H. Joaquin Miller—Poet* (Oakland, Calif.: Tooley-Town, 1941). Joaquin Miller's father-in-law, the hotelier Horace Leland, was the Gersons' landlord when they lived at 11 East 29th Street, New York. The Gerson "salons" were characterized by casual domestic concerts, dramatics, and tableaux vivants, which were attended by a mix of people including, among others, the photographer Napoleon Sarony, Miller, and the painters Robert Blum, John Twachtman, and Frederick S. Church. The group, defined by its connections to Gerson, deserves closer investigation as it promises to provide additional information about social interaction among artists, writers, and musicians in New York in the 1880s.

5. The exhibition was organized under the auspices of the American Art Association. Chase did not seem to have any particular connections in Boston apart from his professional relationship with the publisher of the *American Art Review*, Sylvester Koehler, from 1879 to 1881.

6. "The American Artists' Exhibition," *Art Amateur* 15 (June 1886), 25.

7. Ibid. For Sargent's portrait *Mrs. Wilton Phipps* (private collection), see Richard Ormond and Elaine Kilmurray, *John Singer Sargent: Complete Paintings. Volume I, The Early Portraits* (New Haven and London: Published for the Paul Mellon Centre for Studies in British Art by Yale University Press, 1998), 139–40, 252.

8. T., "A Boston Estimate of a New York Painter," *Art Interchange* 17, no. 12 (December 4, 1886), 4.

9. Greta, "Art in Boston," *Art Amateur* 16 (January 1887), 28.

10. This figure is based on the works listed in the catalogue of the Boston exhibition, *Exhibition of Pictures, Studies and Sketches by Mr. William M. Chase, of New York City under the Auspices of the American Art Association at the Gallery of the Boston Art Club*, November 13–December 4, 1886. The works, identified on the basis of title and descriptions in contemporary reviews, are nos. 17, *Afternoon in the Garden*; 35, *On the Lake, Prospect Park*; 36, *Brooklyn Docks*; 40, *The Hills—Back of Brooklyn*; 42, *Sandunes—Coney Island*; 43, *At West Brighton, Coney Island*; 45, *In the Park*; 46, *In Prospect Park*; 47, *A Summer Afternoon in My Garden*; 60, *A Bit off [sic] Fort Hamilton*; 63, *By the Side of the Lake*; 64, *Pulling for Shore*; 65, *Washing Day—A Backyard Reminiscence of Brooklyn*; 75, *Gray Day on the Bay*; 79, *Prospect Park* (owned by T. B. Clarke); 95, *The Pet Canary*; 97, *Near Brighton, Coney Island*; 98, *A Bit on Long Island*; 99, *The Old Pier, Brooklyn*; 101, *Old Boats—Long Island*; 102D, *Afternoon Tea in the Garden*; 114, *In the Garden*; 120, *Hasty Sketch of a Young Girl*.

11. "The William Merritt Chase Exhibition," *Art Amateur* 16 (April 1887), 100.

12. Ibid.

13. See H. Barbara Weinberg, "Thomas B. Clarke: Foremost Patron of American Art from 1872 to 1899," *American Art Journal* (May 1976), 72, in which the measurements of Clarke's Prospect Park painting are provided.

14. Paul Durand-Ruel (1831–1922), after originally handling the works of French Barbizon painters, became the principal dealer and promoter of French Impressionist art.

15. "The Impressionists' Exhibition at the American Art Galleries," *Art Interchange* 16, no. 9 (April 24, 1886), 130.

16. Théodore Duret (1838–1927) was a journalist and art critic, whose writings championed the art of Edouard Manet in particular.

17. Theodore Child, "The King of the 'Impressionists,'" *Art Amateur* 14 (April 1886), 101–2. Manet was earlier recognized as the "chief inventor and apostle" of the school of Impressionists or independents in the first of an unsigned, three-part series on contemporary Parisian art that appeared in 1880. "Glimpses of Parisian Art," *Scribner's Monthly* 21, no. 2 (December 1880), 170.

18. "The Impressionists," *Art-Age* 3, no. 33 (April 1886), 165.

19. R. R. [Roger Riordan], "The Impressionist Exhibition," *Art Amateur* 15 (June 1886), 4.

20. "The Fine Arts. The French Impressionists," *Critic* 5, no. 120 (April 17, 1886), 196.

21. [Clarence Cook], "The Impressionist Pictures," *Studio*, n.s., 1, no. 21 (April 17, 1886), 253.

22. "The Impressionists' Exhibition at the American Art Galleries," *Art Interchange* 16, no. 9 (April 24, 1886), 131.

23. [Cook], "The Impressionist Pictures," 253.

24. "The Fine Arts. The French Impressionists," *Critic* 195; "The Impressionists," *Art-Age*, 166.

25. Morisot's *Before the Mirror* was listed as lot 1093 in the 1896 catalogue for the auction of a portion of Chase's art collection and the contents of his studio. *The Collection of William Merritt Chase, N.A.*, American Art Galleries, January 7–11, 1896. William A. Coffin's introduction to the catalogue refers to the painting as *The Toilette*, thus introducing the possibility that Chase's Morisot (now in the collection of The Art Institute of Chicago) was the same *La Toilette* exhibited as no. 141 in the 1886 Durand-Ruel Impressionist exhibition at the American Art Galleries. *Works in Oil and Pastel by the Impressionists of Paris*, exh. cat. (New York: American Art Association, 1886). This provenance is confirmed in Hans Huth, "Impressionism Comes to America," *Gazette des Beaux-Arts*, 6th ser., 29 (April 1946), 239, n. 22.

26. The term *glare aesthetic* was coined by William H. Gerdts. In explaining the concept, Gerdts notes a similar manner in depicting light shared by the artists of the European juste milieu and states: "These artists were interested in the effects of intense daylight, portrayed in strong tonal contrasts, often achieving the powerful effect of glare from reflecting surfaces. Thus flat, or near-flat, areas and surfaces are often significant spatial forms in their paintings. These may appear as broad areas of background or horizontal 'support' areas on which figures, merchandise and buildings stand, but they function more significantly than only in such a passive manner. They are mirrors from which dazzling sunlight is reflected back toward the spectator and upon which strong silhouettes of still clearly rendered forms may be cast, allowing for the intensification of color and light without dissolution of form." William H. Gerdts, *American Impressionism*, exh. cat. (Seattle: Henry Art Gallery, University of Washington, 1980), 18.

27. In preparatory notes for a lecture, Chase clearly stated his opinion about Impressionism: "The School of the Impressionists has been an enormous influence upon almost every painter of this time. The successful men like Monet succeed in rendering a brilliant and at times almost dazzling impression of light and air. Most of this work I consider as more scientific than artistic." Archives of American Art, Smithsonian Institution, Washington, D.C., reel N/69-137, frame 474.

28. J. Carroll Beckwith records the visit in his diary (entries for September 4 and 5, 1881), J. Carroll Beckwith Diary, National Academy of Design, New York. Katherine Metcalf Roof, *The Life and Art of William Merritt Chase* (1917; repr., New York: Hacker Art Books, 1975), 95, also records it. From then on the meeting of Stevens and Chase is treated as standard information in recounting Chase's stylistic development.

29. Certainly one of the most obvious comparisons is that found in the pairing

of Chase's *Friendly Call* (National Gallery of Art, Washington, D.C.) and Stevens's *Salon of the Painter* (1880, private collection), which, as Nicolai Cikovsky, Jr., has written, was purchased from Stevens by William K. Vanderbilt for his New York mansion. Cikovsky, "Interiors and Interiority," in D. Scott Atkinson and Nicolai Cikovsky, Jr., *William Merritt Chase: Summers at Shinnecock, 1891–1902*, exh. cat. (Washington, D.C.: National Gallery of Art, 1987), 56.

30. Alfred Stevens, *Impressions on Painting*, trans. Charlotte Adams (New York: G. J. Coombes, 1886).

31. William Morris Hunt, *Talks on Art*, comp. H. M. Knowlton (Boston and New York: Houghton Mifflin Co., 1875); Thomas Couture, *Méthode et entretiens d'atelier* (Paris: L. Guérin, 1868).

32. C. M. S., "Gallery and Studio," *Brooklyn Daily Eagle*, August 1, 1886, 11.

33. Brooklyn City Directory for 1886–87 lists the residence of David H. Chase at old no. 483 Marcy Avenue.

34. James McNeill Whistler's *Nocturne in Black and Gold: The Falling Rocket* (1875, The Detroit Institute of Arts) and John Singer Sargent's *In the Luxembourg Gardens* (1879, Philadelphia Museum of Art) are often cited as precedents leading to Chase's incorporation of urban subject matter into his art. See, for instance, H. Barbara Weinberg, Doreen Bolger, and David Park Curry, *American Impressionism and Realism: The Painting of Modern Life, 1885–1915*, exh. cat. (New York: The Metropolitan Museum of Art, 1994), 136, 143, and Ronald G. Pisano, *Summer Afternoons: Landscape Paintings of William Merritt Chase* (Boston, Toronto, London: Bulfinch Press, 1993), 9, where he cites Sargent's *Luxembourg Gardens, Twilight*, c. 1879, The Minneapolis Institute of Arts. Although Chase's awareness of these famous works is undisputed, it is just as likely that the works cited in the text here had an equally palpable influence in bringing his attention to the viability of such themes.

35. The painting was divided (presumably by Weir) in the early twentieth century. Two portions of it, *Union Square* and *The Flower Seller*, are in the collection of the Brooklyn Museum of Art. The third surviving portion (a portrait of the artist Wyatt Eaton as the man reading the newspaper) is in the collection of the National Museum of American Art, Washington, D.C. See John I. H. Baur, "J. Alden Weir's Partition of *In the Park*," *Brooklyn Museum Quarterly* 25 (October 1938), 124–29.

36. M. G. Van Rensselaer, "The Spring Exhibitions in New York," *American Architect and Building News* 5, no. 176 (May 10, 1879), 149.

37. J. B. F. W., "Society of American Artists," *Aldine* 9 (1879), 281.

38. "The Society of American Artists," *Sun*, March 23, 1879, 2. The same writer focused his lengthy column on the merits of American urban and harbor subject matter: "There should be more joy over one decent study of a dirty New York tenement house with its familiar accessories, than over ninety and nine regulation proprieties from Normandy or Bagdad [*sic*]. Deep shall be the debt of gratitude to the men who lead the way in independent exploration at home, in preference to seeking a vicarious knowledge of nature in the unnatural atmosphere of foreign studios. . . . There are brick walls about New York as good as any in all Brittany, and they have just as valuable discolorations, and their details of decay are just as interesting. . . . No intelligent person who has studied the etchings that Mr. Whistler has made of old warehouses and wharves on the Thames, bits about Wapping and the lower river, can doubt that he would have found just as good material on the water front of this city. There are few things that are more interesting or valuable in their way than the etchings in question, and any day about New York will reveal a thousand equivalents to them in the matter of subject."

39. Edward Strahan, "Exhibition of the Society of American Artists," *Art Amateur* 4 (May 1881), 117.

40. For the membership of the SAA's Exhibition Committee for 1881, see Jennifer Martin Bienenstock, "The Formation and Early Years of the Society of American Artists, 1877–1884," Ph.D. dissertation, City University of New York, 1983, 142–43 n. 3.

41. Ronald G. Pisano, *William Merritt Chase, 1849–1916: A Leading Spirit in American Art*, exh. cat. (Seattle: Henry Art Gallery, University of Washington, 1983), 59.

42. "The American Artists' Exhibition," *Art Amateur* 15 (June 1886), 25. For Hassam's Boston paintings of 1884–86, see Jennifer A. Martin Bienenstock, "Childe Hassam's Early Boston Cityscapes," *Arts* 55 (November 1980), 168–71, and Ulrich W. Hiesinger, *Childe Hassam, American Impressionist* (New York: Jordan-Volpe Gallery; Munich: Prestel-Verlag, 1994), 21–27.

43. Archibald Gordon, "The Impressionists," *Studio and Musical Review* 1 (16 July 1881), 79, quoted in Lisa Peters, "John Twachtman (1853–1902) and the American Scene in the Late Nineteenth Century: The Frontier within the Terrain of the Familiar," Ph.D. dissertation, City University of New York, 1995, 82–83.

44. Other examples are Homer Dodge Martin's (1836–1897) *View—Tenth Street and Sixth Avenue* (SAA, 1880, no. 3); Arthur Quartley's (1839–1886) *New York from the Jersey Shore* (SAA, 1882, no. 79); O. Heinigke's (1851–1915) *Long Pond, Bay Ridge* (SAA, 1883, no. 67) (all unlocated).

45. "Notes and Hints," *Art Amateur* 30 (February 1894), 77.

46. C. M. S., "Gallery and Studio. The Pictures of Chase and Whittredge Contrasted," *Brooklyn Daily Eagle*, March 6, 1887, 2.

47. Ibid.

Pl. 8. Terrace, Prospect Park, *c. 1886. Pastel on paper, 9⁵⁄₁₆ × 13¹³⁄₁₆ inches. National Museum of American Art, Smithsonian Institution, gift of John Gellatly.*

Chapter Three

AMERICA REDISCOVERED

By 1891 much of Chase's reputation rested on the fruits of his plein-air experiments of 1886. What had been initially viewed as pleasant, albeit insignificant, sketches gradually came to be perceived as "marvelous little masterpieces" and "little jewels."[1] This radical turnabout in their reception is indicative of the increased sophistication of American audiences, critics, and artists in their capacity to appreciate a variety of styles, a capacity that was nurtured by the fact that art had become a virtual industry in the urban centers of the American Northeast. Chase had labored hard to promote this cultural transformation over the decade of the 1880s, not only by helping (through the modification of his own public image) to convert the concept of the artist from bohemian outsider to the status of gentlemanly sophisticate, but also by championing the display of contemporary foreign art. What is more, his leadership in the SAA and continued support of American artists whose work escaped the provincialism of their academic counterparts aided in achieving an unofficial détente between the SAA and the NAD. The art of the SAA's "new men" had matured and their work was absorbed into the realm of the familiar. Many of them were now also exhibiting at the NAD, as was Chase, who, though still president of the SAA, resumed his affiliation with the academy in 1888 when he participated in that year's exhibition and was elected to associate membership.

The normalized organizational relationships evidenced in the late 1880s mirrored an aesthetic normalization achieved by Chase in his art that was actuated mainly in his urban and suburban subjects. The process was summarized in 1891 by one writer:

Sometime after his return to New York, Mr. Chase began to drift from his acquired German style, and to develop a distinct style of his own. For a time he was somewhat influenced by Whistler and other impressionists, but latterly he has been boldly and consistently original, seeking his subjects in the neighborhood of New York City and painting them without regard to the conventions of any school. Of this last style, some of the most attractive examples were little studies along the Brooklyn docks, in the Navy Yard, and the Wallabout Basin. Some landscapes from the strange region, as picturesque in its way as anything in Holland or Normandy, between Prospect Park and the city of Brooklyn, might indeed suggest to our wandering landscape artists that they should not keep their eyes hermetically sealed while in their own country.[2]

As the *Art Amateur's* columnist put it, Brooklyn was a "strange region," the picturesqueness of which validated its function as subject matter. By focusing on Brooklyn subjects, Chase discovered his own niche in American art and in doing so established himself as a truly "American" artist.

BROOKLYN IN THE 1880s

The Brooklyn that Chase knew was the third largest city in the United States with roots in several of the oldest colonial settlements on the eastern seaboard.[3] The city itself was born in 1835 with the City Charter that consolidated the original towns that grew from the first land grants established on Long Island by the Dutch West India Company, carved out of tracts purchased from the Indians living there at the time of the company's expansion.[4] Five of the six towns—Breuckelen (Brooklyn, formed 1646), New Amersfoort (Flatlands, formed 1647), Midwont (Flatbush, formed 1652), New Utrecht (formed 1657), Boswick (Bushwick, formed 1661)—were settled by Dutch farmers, while the sixth, Gravesend, was granted to the English Anabaptist Lady Deborah Moody in 1645 and retained an English identity. When the Dutch were forced to cede the territory encompassing these villages to England (the duke of York) in 1664, the governing powers infused an English veneer over the settlements, which were formally united, mainly for administrative purposes, in 1683 as Kings County. For all intents, however, the cultural identity remained Dutch, and, as the historian John Kouwenhoven noted, "In his childhood my own father, born in 1870 on a Flatlands farm nine generations of the family had tilled, heard Dutch nursery rhymes from his mother and grandmother."[5]

Brooklyn's place in the nation's history was pivotal. After the early and bloody 1776 Battle of Long Island (also called the Battle of Brooklyn), part of which was fought on ground now within Prospect Park, the area was occupied by British troops until 1783. Although no further battles or skirmishes of consequence took place on Brooklyn soil, the British prison ships anchored in Wallabout Bay (the site of the future U.S. [Brooklyn] Navy Yard) were the scourge of the revolution in that the major cause of death among the revolutionaries in the area stemmed not from battle, but from shipboard captivity.[6] After the Revolution Kings County returned to its quiet, rural ways, but as forecast by the 1835 City Charter, its time as a network of sleepy farming villages was on the wane. Throughout the remainder of the century additional towns were annexed by the City of Brooklyn until its outline conformed to the borders of the borough as it exists today.

The development of Brooklyn real estate was closely tied to the economic development of New York, for lower prices for property within easy commuting distance of Manhattan's business districts spurred a series of real estate booms that

transformed, for example, two large farms in what is now Park Slope to a grid system of subdivided lots in the 1850s based on the original 1839 plan for organizing the layout of Brooklyn's streets. Public transportation had improved rapidly from its early beginnings in 1814 when the Fulton Ferry (named for Robert Fulton's steam-powered boats) made crossing between Brooklyn and Manhattan a common convenience. By 1860, five different ferry companies were carrying 32 million passengers across the East River annually, and, by 1868, the number had swelled to approximately 50 million. And, as Kouwenhoven points out, it was not the Brooklyn Bridge that killed the ferry business but, instead, the building of the first subway tunnel connecting the two boroughs in 1908 that brought a close to that great era of metropolitan transportation.[7]

Between 1880 and 1890—the decade of greatest concern with respect to the works considered here—the population in Brooklyn increased from approximately 570,000 to 800,000.[8] And, although its image suffered then as it does now because of its perceived second-class rating compared with the "other city" across the river, Brooklyn developed a cultural identity of its own that still separates it from Manhattan.[9] Over its history Brooklyn has at times seized the world's attention, and one of those moments was the 1883 opening of the Great East River Bridge, John Augustus Roebling's engineering masterpiece that has gained iconic status as a symbol of the modern age.[10] The following year saw the publication of Henry R. Stiles's monumental two-volume *Political, Professional and Ecclesiastical History and Commercial and Industrial Record of the County of Kings and the City of Brooklyn, N.Y. from 1683 to 1884*, an invaluable history that remains unequaled in its scope and detail.[11] Although Brooklyn's commuter reputation as the "bedroom of New York" emerged in the 1850s, it was also a major commercial center. By the 1880s the Brooklyn docks were controlling more goods than their overburdened and decaying Manhattan counterparts.[12] Post–Civil War industrial expansion had made Brooklyn the center for the five "black arts": glassmaking, porcelain manufacture, printing, petroleum and gas refining, and iron making. And, by 1890 it was the site of the largest sugar-refining operations in the world.[13] None of this seems to have had a direct impact on Chase in terms of the look of his art, yet it is significant that he enjoyed the patronage of Thomas A. Howell, the owner of the sugar refining firm of B. H. Howell, Son & Co., who lived at 269 Henry Street in Brooklyn Heights from at least 1878 to 1888.[14] At the time of the 1889 sale of Howell's art collection (when he

apparently moved to Manhattan), Howell owned three works by Chase: *My Studio* (known as *In the Studio*; see Pl. 4), a pastel titled *Terrace, Prospect Park* (possibly the work of the same title now in the collection of the National Museum of American Art, Pl. 8), and a second pastel titled *An Old Garden*.[15]

If the prospect of appealing to the untapped resource of potential Brooklyn patrons hovered in Chase's consciousness, he did not wage an aggressive campaign in that direction. This in itself seems curious, since it would have been logical for Chase to have tried actively to build support in the city that had inspired his newest iconography. While he exhibited occasionally at the Brooklyn Art Association (hereafter the BAA), none of his Brooklyn scenes appear in the exhibition listings.[16] What is more, considering the richness of Brooklyn's cultural life, it seems stranger still that Chase would have oriented the professional aspects of his career almost exclusively to Manhattan.[17] Yet Chase may have been conflicted by the very fact that Brooklyn's reputation as "a strange region," which was so useful in aesthetic terms, would have also served to marginalize his professional identity. Despite its own thriving industrial, cultural, economic, and social systems, Brooklyn was no match for Manhattan, which stood at the center of the nation's arts, then as now. The divisions between the two urban cultures were especially obvious in the area of the arts. Even a cursory

survey of late-nineteenth-century critical writing reveals that Brooklyn-based artists were consistently referred to as "Brooklyn artists" regardless of the venue at which they showed their work. Although many painters, Chase included, frequently contributed paintings to the BAA, for example, their participation over the years was less consistent. Conversely, the vast majority of artists affiliated with the BAA (many of whom were women) rarely had significant records as exhibitors outside their home city.

Chase's relationship with Brooklyn was ambiguous in that he was neither a permanent resident nor a tourist. Rather, as stated above, his acquaintanceship with the area was likely formalized because of his parents' residence there.

CHASE'S "DOMESTIC" BROOKLYN PAINTINGS

Wash Day—A Back Yard Reminiscence of Brooklyn (Pl. 9) is a boldly conceived painting filled with the visual dramas of rushing perspectives, briskly painted surfaces, and vibrant patterns of light and shadow. The eye fights to find the center of this asymmetric composition, meeting powerful resistance in the diagonals formed by the clotheslines that converge near the tree on the right. The radically cropped figure of the laundress recalls the same compositional device perfected by Degas and looks forward to Chase's 1888 *Hide and Seek* (fig. 14),

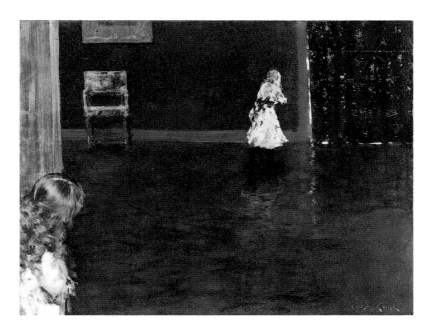

Fig. 14. Hide and Seek, 1888. Oil on canvas, 27⅝ × 35⅞ inches. The Phillips Collection, Washington, D.C., acquired 1923.

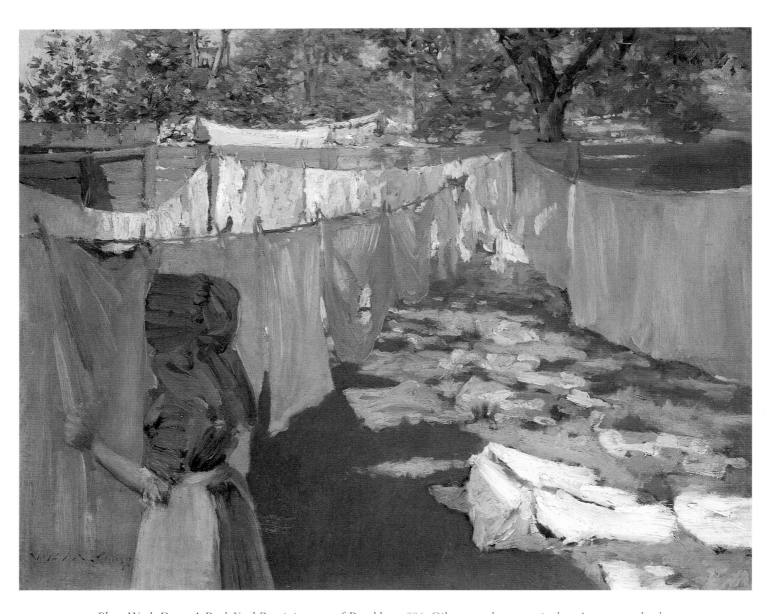

Pl. 9. Wash Day—A Back Yard Reminiscence of Brooklyn, *1886. Oil on panel, 22 × 25 inches. Anonymous lender.*

not only in terms of the abruptly cropped figure in the lower left, but also with respect to the dynamic diagonal path that cuts each composition. (The conceptual line of the diagonal is formed in *Hide and Seek* by the direction of the girl's gaze toward her playmate at the upper right and is reinforced by the pattern of reflected light on the studio floor. In *Wash Day* a similar strategy is used, in this instance with the clothesline connecting the columnar form of the woman with the vertical trunk of the tree on the upper right.) As he did in the small *Prospect Park* discussed in the previous chapter (Pl. 5), Chase invested in this modestly scaled painting of equally modest content a host of formal information that would alert sophisticated viewers to its modernity. At the same time, the image of a commonplace Brooklyn backyard was comforting enough to put almost any viewer, casual or informed, at ease. The unpretentious middle-class image provoked a playful response in the New York critic who saw it in Chase's 1887 sale exhibition at Moore's and pronounced that "*Washing Day* is one good thing that has come out of Brooklyn. The women [*sic*], the duds, the suds, all are good in it."[18] In addition to its pivotal position in defining the new directions Chase's art was taking, *Wash Day* is intriguing on another count—just whose backyard do we see?

This leads to the thorny problem of determining the artist's domestic arrangements during the early years of his marriage. Previous discussions surrounding this aspect of his life are vague and at times contradictory.[19] And, while it might ordinarily be sufficient to say simply that Chase was living and working in Brooklyn for a time, glossing over the question puts at risk the possibility of understanding the essence of Chase's Brooklyn paintings. In an effort to clarify this matter, it is necessary to return to the seminal source of Chase studies: Katherine Metcalf Roof's 1917 *Life and Art of William Merritt Chase*. A former Chase pupil, Roof wrote this biography with the cooperation of Chase's widow, Alice Gerson Chase, his mother, Sarah Swaim Chase, and others closely affiliated with him, all of whom understandably desired to present Chase in the best possible light. Roof states unequivocally that "The first winter of their married life the Chases lived for a short time in the Tenth Street Studio apartment, afterward taking rooms on East Ninth Street. The next year they moved to Brooklyn, where they lived for a few months with the painter's parents."[20]

Chase's father, David Hester Chase, his wife, Sarah, and their youngest child, Hattie, lived in a rented house at 483

Fig. 15. Block Map showing Marcy Avenue, Brooklyn. Records of the Finance Department, City of New York, Property Division, Brooklyn Office of Assessors and Assessments. The location of 671 (old 483) Marcy Avenue is indicated at the upper left.

Marcy Avenue, a short block between Kosciusko Street and De Kalb Avenue. The house, a wooden structure built by 1874, occupied a long, narrow lot measuring 16 feet in width by 98 feet 7½ inches in depth. The 2½-story house extended only 40 feet into the lot, leaving considerable yard space in the rear that melded with the backyards of other houses whose fronts faced Kosciusko and De Kalb (fig. 15).[21] David Chase's business acumen had never been his strong point. Accounts of his failed business ventures feature strongly in Chase biographies and more than once the youthful Chase had sacrificed his own professional desires and returned to his native Midwest to help his parents in periods of financial stress. Given David Chase's age (he was probably in his late 70s in 1886) and the fact that William was the eldest son, it is likely that the family chose to move nearer to him mindful of the need for proximity with the onset of old age and the physical and economic dependence it sometimes entails.[22]

David Chase appears for the first time in 1886–87 city directories and disappears in 1891–92. Listed most often as a cabinetmaker living at 671 (old no. 483) Marcy Avenue, David Chase also sold musical instruments from that address for two of those years. With his parents' relocation to the East in 1886 came another very practical reason for Chase to forgo his customary trip to Europe along with the most potent

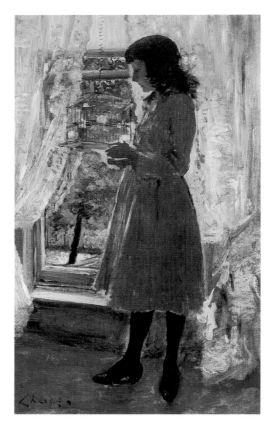

Pl. 10. The Pet Canary, 1886. Oil on canvas, 19½ × 12 inches. Photograph courtesy Sotheby's, Inc.

explanation for his turn to Brooklyn subjects that year. To return to the painting *Wash Day—A Back Yard Reminiscence of Brooklyn*, this information goes far in arguing for the conclusion that the backyard in question can be none other than Chase's father's. Several other unlocated paintings and pastels that Chase displayed in Boston were doubtless scenes of the same domestic space: *Afternoon in the Garden* (no. 17); *Afternoon Tea in the Garden* (no. 102D); *In the Garden* (a pastel, no. 114); *A Summer Afternoon in My Garden* (no. 47); and even the pastel *Study of a Glass Ball* (no. 113), the last of which was described as including the reflection of a garden in a decorative globe.[23]

Such information supplies a new narrative context for some of Chase's work. Just as *Wash Day* accrues meaning in this vein, so too does *Pet Canary* (Pl. 10). Not only is it an experimental exercise in capturing interior and exterior light in an Impressionist mode, it now reads as an intimate portrait of the painter's young sister Hattie on the second floor of the Marcy Avenue house. From her unmistakable profile silhouet-

ted against the white curtain, we are drawn to the canary that holds her attention and from that bright spot of yellow downward to the tree on the street below. By means of the standard Victorian iconography in which the caged bird is equated with the circumscribed life of women, Chase created a highly personal moment in which his little sister, recently transplanted from the familiar social terrain of her midwestern home, may contemplate the greater restrictions of her freedom in a new, as yet uncharted territory. Later works, for instance, *I Am Going to See Grandma* from about 1889 (Pl. 11), assume a broader meaning as well. The pastel is ostensibly a simple genre subject of a mother preparing a child for an outing. It need not be anything more. However, it does not register as such with viewers familiar with Chase's art inasmuch as the protagonists are unquestionably his wife and child, both of whom were becoming well known to his audience. While the setting here is probably the parlor in the artist's East 40th Street home in Manhattan, the title creates in the mind's eye the child's destination, evoking the trip downtown through Manhattan, over the river, and into the quieter, more neighborly, and greener realms of Brooklyn. This biographical layering of content, as it were, is symptomatic of Chase's mode of constructing his paintings, and, pronouncements of his adherence to a realistic vision notwithstanding, such imagery relies on a network of content that was rich for him and for those who were privy to the spaces he referenced.

One of the most masterful works of Chase's career is *The Open Air Breakfast* (Pl. 12), a painting that is particularly relevant to this study. The scene portrays the same backyard as that shown in *Wash Day*, seen from a slightly different angle, but identifiable conclusively by the white wooden stairway that occupies approximately the same position in the upper portion of both works. The figures are usually recognized as (from left to right) Chase's sister-in-law, Virginia Gerson, his first child, Alice ("Cosy"), Alice Gerson Chase, and his sister Hattie. However, the woman in the hammock bears little resemblance to the dark-haired Virginia, whose features are well known through other paintings of her. Although the identification of this figure has slight impact on the overall meaning of the painting, the subject's features and coloring are closer to those of Alice's other sister, Minnie. In comparison with other paintings by Chase, *The Open Air Breakfast* possesses a peculiarly emblematic character, an artificiality analogous to that of Velázquez's *Meninas* (Prado, Madrid), a painting that he knew well—or perhaps even to

Pl. 11. I Am Going to See Grandma, *c. 1889. Pastel on paper, 29 × 41 inches.*
San Antonio Museum of Art, Texas, Gift of Dr. and Mrs. Frederic G. Oppenheimer.

Pl. 12. The Open Air Breakfast, 1887. Oil on canvas, 37⁷⁄₁₆ × 56¼ inches. The Toledo Museum of Art, Purchased with funds from the Florence Scott Libbey Bequest in Memory of her Father, Maurice A. Scott, 1953.136.

Courbet's *Painter's Studio: A Real Allegory Summing up Seven Years of My Artistic Life* (Musée d'Orsay, Paris). And, while the painting's conception may have exploited the more art-historically rooted ideals of Velázquez or Courbet, Chase may also have considered the more recent painting *Luncheon in the Garden* (fig. 16) by the Hungarian artist Mihály Munkácsy as inspiration. Owned by the widow of the collector Robert L. Stuart, Chase and Beckwith had included the painting in the Pedestal Fund Exhibition, where it was shown under the title *In the Garden*. Munkácsy's image of four women and a child gathered around a graciously but informally set table in the out-of-doors conjures a similar type of bourgeois gentility as that established by Chase in *The Open Air Breakfast*. Munkácsy had trained in Munich and then transferred his artistic allegiance to a dark realism stemming from his admiration for Courbet, applying it to a subject matter dominated by peasant imagery. In France by the late 1870s, Munkácsy responded to the lighter palette and modern subjects of the Impressionists, factors that were decisive in the radical shift his art underwent at that time and that are manifested particularly in this work.[24] In considering this painting for the 1883 exhibition Chase may have recognized the parallels between the current parameters of his own aesthetic renovation and the pattern that Munkácsy had followed in achieving the stylistic and thematic transformation of his art.

On the surface, Chase's *Open Air Breakfast* may be enjoyed as a pleasant depiction of a leisurely alfresco breakfast on a bright summer's morning. Yet, taking into account the biographical layers Chase manipulated to create content and the possible influences cited above, the painting reads as a statement summarizing his own artistic progress, his family relationships, and the increasingly blurred divisions between the two areas of this life. The obliquely angled fencing creates a modern *hortus conclusus* (enclosed garden) that separates this small plot of private yet open space from the larger world. And, in this distinctly stagelike setting Chase recalls the similarly constructed spaces of his studio pictures, in which he deftly revealed the program of his art philosophy.[25] Here, however, he converted an even more personal territory into an extension of his studio, in which people, objects, and the resting dog function as signs of his art by recapturing and reordering motifs from his earlier paintings.[26] Hattie's stiffly posed figure claims our attention because of its rigidity, which is anomalous within the scheme that suggests relaxation and ease. Although Alice and her sister seem to engage in casual

conversation, Hattie stands apart, her gaze directed outward in acknowledgment of the artist-viewer's presence. It is the blankness of that gaze that undermines the painting's status as pure genre, for its emotional flatness acts as a magnet for the eye, disrupting the narrative flow. Through the device of Hattie's gaze, Chase implicates himself as a participant in the scene, thereby manufacturing a conceptual self-portrait and completing the connection between this painting and those of Velázquez and Courbet mentioned above, both of which—also visual declarations of the artists' aesthetics, accomplishments, models, and influences—contain self-portraits.

The Open Air Breakfast has never been securely dated, and oddly, for a painting of this scale and obvious import, it seems not to have been exhibited until 1915, when it was shown at the twenty-eighth Annual Exhibition of American Oil Paintings and Sculpture at the Art Institute of Chicago.[27] It is occasionally dated about 1886 on the assumption that it is *Afternoon Tea in the Garden* shown in Chase's Boston exhibition and purchased out of the 1887 Moore sale by Stanford White.[28] However, this cannot be so since *The Open Air Breakfast* remained with the artist until his death, passing to his wife, who sold it in the 1917 sale of his work at the American Art Galleries, New York.[29] Recent publications have assigned it a

Fig. 16. Mihály Munkácsy, Luncheon in the Garden (*also known as* In the Garden), *late 1870s. Oil on canvas, 32 × 42 inches. The New-York Historical Society. Reproduced from F. Walter Ilges*, M. von Munkácsy (1897). *Brooklyn Museum of Art Library Collection.*

date of about 1888.[30] The painting now requires a date of 1887, taking into account the fictions constructed around the 1886 marriage and relying on Roof's statement that the newlyweds moved in with Chase's parents for a few months "the next year." This would have been an eminently practical arrangement since Cosy's birth in February was a matter that demanded discretion. Although no formal announcement of the wedding was issued, the story must have been leaked to the press, for at least two articles featuring the startling news of Chase's marriage to his model appeared shortly after the ceremony. One, headed "Mrs. William Merritt Chase" and illustrated by a line drawing of his admired pastel portrait of her titled *Meditation* (private collection), was cast in an odd tone, as if to encourage the reader to arrive at the truth of the circumstances:

Mr. Chase, the painter, one of the founders of the Society of American Artists, has announced to his friends that he is married to Miss "Tony" Gerson, the young woman who for two or three years had posed as his model. He was known to be a man of peculiarly luxurious tastes and social ambition. As to Miss Gerson kind words and generous praise were lavished on every hand. Mr. Chase had been fortunate enough to secure her services when she first began to pose, and he has monopolized her time ever since. She is now about twenty years of age.[31]

The writer's care in pointing out that Chase had been the sole beneficiary of his young bride's modeling favors introduces the questionable relationship normally perceived to exist between artists and their models at the time. Furthermore, by emphasizing their working relationship instead of presenting this information in the traditionally structured announcement format, the writer insinuated that the event was somehow "outside" customary social practice. Absent were the facts normally included in such news items, such as the bride's parentage, the date and location of the ceremony, and the names of those in attendance. Only Alice's sister Virginia was mentioned and then merely because of her notoriety as a writer. Indeed, the article closed with editorializing comments on the subject of artists and models:

Artists marrying their models is a subject which seems to capture the fancy of the novel writer, but has, so far as New York experience goes, been illustrated very infrequently in real life. Mr. Freer married his model last summer, a very handsome and worthy young lady named Keenan. The engagement [unlike the Chases']

was duly announced, and during the year preceding the marriage Miss Keenan, of course, posed for no artist save her future husband.[32]

An even more suggestive article was published, which reveals Chase to have lied about the situation, claiming that the two had been married secretly for a year. This one, headed, "Mr. W. M. Chase Marries His Model. The Artist a Benedict for One Year and a Father for One Week," opened the way for even more speculation, especially in the following paragraph:

A mysterious and interesting feature of the case, and one which lent vitality to the gossip and gave stronger wings than it otherwise would have had, was that Mr. Chase was able, at the same time that he announced the fact of being a husband, to mention also that he was a father. He had been married a year and there was a baby in the case. Here was a rare bit of news for the colony of artists' wives. No such sensation had varied the monotony of Academy exhibitions and Chickering Hall picture sales for many a long day. Beyond the mere fact of announcing his new responsibilities, however, Mr. Chase vouchsafed no information to his closest friends.[33]

In the light of this type of publicity, the Brooklyn home of Chase's parents was doubtless a welcome haven for the couple, for it enabled Chase to remove his wife and child from the public scrutiny his professional life encouraged while it also permitted him convenient access to his Manhattan studio. Furthermore, without the comfort and counsel of her own mother (who reportedly died when Alice Gerson Chase was young), it was likely that she appreciated the opportunity to reside with her in-laws during an emotionally trying period of adjustment to marriage, motherhood, and social embarrassment. Certainly the fresh air of Brooklyn promised a more healthful environment for Cosy than that of the couple's rooms in Manhattan. Based on this thinking, *The Open Air Breakfast* must have been painted in the late spring or summer months of 1887 if the baby in the high chair is accurately identified as Cosy.

Chase's reluctance to part with the painting—or even display it until 1915—demands explanation. A plausible reason is that its meaning registered on such a deeply emotional level that selling it was out of the question. Not only did it record an idyllic moment among the younger generations of women in his extended family, but it also placed them within the embrace of the previous generation inasmuch as they were enclosed within the protected garden of the artist's par-

ents. Another point that bears consideration in attempting to determine why the painting was not displayed until 1915 centers on the issue of propriety. To today's viewers the image probably resonates with the ideas of quiet middle-class gentility of days gone by. Yet, in the mid-1880s, it would have been considered an inappropriate public display of private life. It was one thing for Chase to use his wife, sisters-in-law, or sister as models for paintings that retained a veneer of anonymity achieved by placing them within standardized iconographic formats that invoked broader, less personal content. Thus, for instance, Hattie as model in *The Pet Canary* was depersonalized because the majority of the audience would have connected the painting with the familiar meaning that equated the female subject with the caged bird. Similarly, images of Virginia Gerson in Chase's studio deny the notion of portraiture, for they are assimilated into the genre of the studio picture. The studio setting itself established neutral ground since it was in actuality a quasi-public space. But to render the informality of the private sphere public and to populate it with portraits of family intimates violated the social rules of the time in which the professional and domestic arenas were decidedly separate.[34] Although it could be argued that Chase was merely creating a modern conversation piece (which this is), that particular mode of portraiture was out of fashion at that time and, furthermore, would ordinarily have entailed a greater level of formality in setting, mode of dress, and figural arrangement. Even in the area of commissioned formal portraiture at this time, the titles of works put on exhibition often read as *Portrait of a Lady*, *Miss X*, or *Portrait of a Lady in Street Costume* to shield the identities of the sitters.[35] In the cases of artists who usually (and later) employed family members to sit for them—for example, Abbott Handerson Thayer and George De Forest Brush (1855–1941)—they took their subjects "out of time" by enmeshing them within an iconography rooted in classical or Renaissance imagery, thus blending the contemporary identities with traditional, hierarchical meanings. Chase's public persona advanced his identification with the enterprising, gentlemanly aspects of his profession. His strategy of self-promotion via the advertisement of his art through the imagery of his studio (his place of business) was acceptable because of the general public interest in decorative interiors and the seductive concept of "art life." Apart from the specifics of the chronology of marriage and birth in this instance, Chase's personal conservatism, however, would have prevented him from overstepping the bounds of polite

society by making a public spectacle of his family within the normally protected confines of their home.[36]

The Open Air Breakfast also marked a watershed in Chase's aesthetics; it commemorates the transitional moment in his career when he became committed to a subject matter that incorporated figure painting and the American landscape. While the composition itself exhibits strong parallels with his slightly earlier, large-scale outdoor genre scenes (*Courtyard of a Dutch Orphan Asylum*, c. 1883, fig. 9, and *Sunlight and Shadow*, 1884, Joslyn Art Museum, Omaha, Nebr.), it is the first major work in which Chase could be said to have effectively repatriated his imagery. Regardless of whether or not he showed the painting publicly, it pointed the way to his more fully elaborated park and coastal scenes that followed shortly thereafter. For the purposes of examining those works, the Marcy Avenue property shown in *The Open Air Breakfast* may be considered Chase's geographic center in Brooklyn, from which he could easily make his explorations of Brooklyn's "strange regions."

Prospect Park

Brooklyn's Prospect Park (fig. 17) opened to the public in an unfinished state in 1867, and, although it was preceded by the opening of the much larger Central Park in Manhattan, which admitted visitors officially in 1859, it was the first of the public parks that Chase chose to paint. It was probably no coincidence that the bill for the allocation of land for public parks in Brooklyn was passed by the New York State Legislature in 1859, the year that Central Park opened; the civic-minded Brooklyn city fathers were intent on ensuring that their municipality would offer its residents the same advantages enjoyed by New York's populace. Like the committees for park construction in New York, Brooklyn's commissioners projected that the park would act as a balm for harried urbanites, citing that "the intense activity and the destructive excitement of business life as here conducted, imperatively demands these public places for exercise and recreation."[37] Later reports reveal other agendas for the building of a major Brooklyn park that were lodged in a social and economic ideological framework designed to further Brooklyn's competitiveness with New York. As the president of the Park Commission, James Samuel Thomas Stranahan, stated: "The Prospect Park of the City of Brooklyn must always be conceded as the great natural park of the country; presenting the most majestic views of land and ocean, with

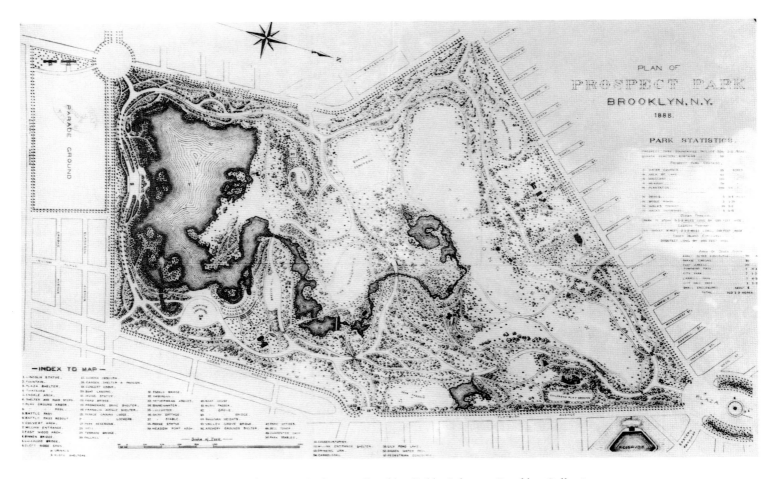

Fig. 17. Map of Prospect Park, 1888. Brooklyn Public Library—Brooklyn Collection.

panoramic changes more varied and beautiful than can be found within the boundaries of any city on this continent. . . . The park will hold out strong inducements to the affluent to remain in our city, who are now too often induced to change their residences by the seductive influences of the New York park."[38] The land that was eventually acquired is an irregularly shaped parcel of 526 acres bordered on the east by Flatbush Avenue (even in the 1850s a major route connecting the City of Brooklyn and the Town of Flatbush); on the south by Parkside Avenue; on the west by Prospect Park West (Ninth Avenue) beginning at 15th Street; and on the north by Grand Army Plaza, where Union Street, Flatbush, Vanderbilt Avenue, and Eastern Parkway converge. The configuration of the park lands changed over the course of its development, mainly by the selling off of the "East Side Lands" originally included, which are across Flatbush and now occupied by Mount Prospect Park, the Brooklyn Botanic Gardens (opened in 1911), and the Brooklyn Museum

of Art. A second major revision to the original allocation of properties was the acquisition of expensive lots along Ninth Avenue (now Prospect Park West), which were undeveloped except for Grace Hill, the mansion of the Litchfield family, which was designed by Alexander Jackson Davis (1803–1892) and completed in 1857.[39] Litchfield Villa, as it is called, remained privately owned until 1883, when it became the office for the Park Commission, a function that it still fulfills.

The commissioners were quick to hire the civil engineer Egbert L. Viele (1825–1902), the original chief engineer of Central Park, to submit a plan for the design. Viele's 1861 proposal was tabled by the more urgent matters of the Civil War, and while the commissioners continued to acquire property made cheap by the wartime economy, they had time to consider Viele's plan, which was eventually deemed untenable.[40] When the war ended and Viele was out of the picture, the commissioners hired Calvert Vaux (1824–1895) who resurveyed the

land and enlarged the park plan, eliminating at the same time the cumbersome division posed by Flatbush Avenue traffic that cut through Viele's original design. Vaux, who was one-half of the famous team of Olmsted and Vaux, who had created the Greensward Plan for Central Park, convinced his reluctant former partner Frederick Law Olmsted (1822–1903) to return from California to reunite their talents for this new project.[41] Olmsted and Vaux presented their plan to the Brooklyn commission in January 1866, and by May, it was approved along with their official appointment as the park's architects.

Even before Prospect Park opened formally, completed portions of it were available to the public as early as 1867. By 1868 it was claimed that approximately 100,000 people per month had visited during the summer, and in 1871 that number had risen to 250,000.[42] Neither Prospect nor Central Park has been a static landscape since inception, as witnessed by the constant modifications and renovations each undergoes today. The sites of the two parks were vastly disparate in geologic configuration and thus posed significantly different design problems. Prospect Park, whose contours are chaotic compared with the stable rectangle of Central Park, was imposed on a glacial moraine forming a dominant hilly ridge running the long way through the center of the park. The land itself was fairly heavily wooded with old trees (unlike Central Park, where the indigenous trees had been burnt away by British forces during the Revolution), and it also had low, boggy areas that required filling.[43] Regardless of the modifications the land required, Olmsted and Vaux were essentially guided by the natural topography and took advantage of the ridge so that it would act as a natural perimeter for the interior edge of Long Meadow, an uninterrupted stretch of green lawn running the length of the western side of the park. This enormous expanse of meadow encompasses 74 acres, which outstripped the largest open area then in Central Park—the North Meadow, which consisted of 28 acres. Long Meadow set the tone for the rustic, pastoral nature of the Prospect Park design, the three main features of which were the Meadow, the wooded hills, and the 60-acre man-made lake that was quickly fashioned. The original benches, bridges, and shelters furnishing the park were quaintly rustic as well, with rough-hewn tree branches serving as the primary material for benches, and wooden, sometimes thatched-roof structures serving as refreshment and comfort facilities. In all, a visit to Brooklyn's park was akin to a visit to the country. As George Harvey's watercolor of about 1871 (fig. 18) shows, Prospect Park

Fig. 18. George Harvey, Prospect Park, *c. 1871. Watercolor on paper, 12¼ × 17⅜ inches. Courtesy Vance Jordan Fine Art, Inc., New York.*

was not the natural wilderness, of course, but a quiet, arcadian interlude contrived for respite from the growing city, which was (and is) barely perceptible from within the park's precincts.

Chase was certainly not the only nor the first artist to consider the park's potential as subject matter, but since most of the works to record the park were done in watercolor or print media, he does qualify as the first major artist to feature the park in oils. Yet, a few years before he began painting Prospect Park scenes, a small coterie of Brooklyn artists, Strafford B. Newmarche (fl. 1866–80s), Clinton Loveridge (1838–1915), and the better-known Samuel S. Carr (1837–1908), had exhibited Prospect Park subjects. In 1882 the art correspondent for the *Brooklyn Daily Eagle* reported: "Strafford Newmarche, at his studio on Gates Avenue, is busily employed preparing for the exhibitions. He has painted some very picturesque bits of scenery in Prospect Park during the past summer and demonstrated the fact that our artists can find any quantity of landscape material without leaving the city limits."[44] Two years later he was also noted in the same newspaper for his paintings at the Brooklyn Art Club exhibition, among which were *Lake, Prospect Park* and another Brooklyn view, *Fort Wadsworth from Fort Hamilton.*[45] Ironically, Newmarche was a recently transplanted Englishman, who was enthusiastically welcomed by the Brooklyn press, apparently because of his attention to local subjects. Carr was also

Fig. 19. Samuel S. Carr, Pic-Nic Prospect Park, Brooklyn, *1883. Oil on canvas, 22⅛ × 36⅛ inches. Terra Foundation for the Arts, Daniel J. Terra Collection, 1992.22. Photograph courtesy of Terra Museum of American Art, Chicago.*

English by birth and was active in Brooklyn from 1870 until his death. At one time the president of the Brooklyn Art Club, he specialized in Brooklyn subjects, painting not only the park but also numerous Coney Island beach scenes. His *Pic-nic Prospect Park, Brooklyn* (fig. 19) is one of the more successful works within an oeuvre marked by a naïve charm but somewhat limited painterly talent. Carr's painting of children most likely enjoying one of the hundreds of official Sunday school picnics recorded in the park's annual reports corresponds to contemporaneous photographs (fig. 20) and periodical illustrations documenting this healthful and communal activity that the park encouraged. Carr lived at 46 12th Street in Brooklyn, where he shared studio space with Loveridge. Both artists were known particularly for their bucolic views of the sheep grazing in the nearby park, and, as noted in 1893, Carr's "studies of sheep have recently attracted attention, and he spends much time in sketching their many attitudes and movements in Prospect Park, near which . . . his studio is situated."[46] Carr was obviously inspired by the reality of his experience of the park (see fig. 21), for his paintings of the grazing sheep that could be found at the 15th Street end of the park reportedly match contemporaneous descriptions of the area:

Beyond the tennis courts, a wide piece of unkempt pasturage recalls the distant country. This part of Prospect Park is genuinely rural in its character. At certain hours of the day the casual pedestrian who wanders, mayhap, by chance into this section, finds himself confronted by a natural picture, perfectly composed and full of positive but harmonious color. Disposed upon this expanse of fresh herbage is a flock of sleek and well-fed sheep, their wooly sides well matching the tiny floating islands of cloudland which drift listlessly through the blue ether of the upper air. Nibbling the turf or shambling about with that amusing helplessness so characteristic of their race, the restless flock lends a live interest to the scene and forces the thought to turn in reminiscent reverie to the masterful canvases of Mauve and Millet, whereon choice bits of nature just like this of Prospect Park have been lastingly reflected for the eyes' delightment and gentle excitation of the emotions.[47]

Although these artists developed local (that is, Brooklyn) reputations, few of their park paintings were shown outside that city's borders. Isolated examples of Prospect Park imagery can be cited in the NAD exhibition records, for instance, the obscure Arthur Brown's unlocated *June Morning in Prospect Park,* which was admired in 1887 by the *New York Times*'s writer, who declared the "study of sunlight and shadows of a

Pl. 13. Mrs. Chase in Prospect Park (*possibly* On the Lake, Prospect Park)*, 1886. Oil on panel, 13¾ × 19⅝ inches.*
The Metropolitan Museum of Art, Bequest of Chester Dale, 1962, The Chester Dale Collection (63.138.2).

Fig. 20. *Sunday School Picnic, Prospect Park, 1887. Photograph. The Brooklyn Historical Society.*

Fig. 21. *Sheep in Prospect Park, c. 1900. Photograph. The Brooklyn Historical Society.*

June morning in Prospect Park, Brooklyn, very pleasant to see."[48] However, until Chase's paintings of the park were exhibited, the region's artistic profile in the 1880s was practically nonexistent with the exception of reproductions in popular periodicals. What is more, apart from Carr's, the works of the artists cited here remain generally unknown today.

Perhaps the earliest of Chase's Prospect Park paintings is a work now known as *Mrs. Chase in Prospect Park* (Pl. 13), an oil on panel inscribed to Chase's friend and close associate on the Pedestal Fund project, J. Carroll Beckwith. This painting, which may be the same as *On the Lake, Prospect Park* shown at Boston in 1886, depicts Alice Gerson contemplatively posed in a rowboat floating near the grassy banks of what is

assumed to be the lake in the Brooklyn park. The word *assumed* is used deliberately, for although the lake site is doubtless correct (based on the painting's title, *Chase's Wife on the Lake in Prospect Park*, when it was sold by Beckwith's widow in 1926), the close-cropped horizonless composition precludes identification of the location based on the image alone.[49] Such a compositional approach announces Chase's exploration of a modern outlook and recalls the similarly horizonless works of the French painter Jules Bastien-Lepage (1848–1884), who may be credited with the American vogue for such compositional ploys.[50] A more specific relationship, however, emerges in the painting's kinship with Beckwith's experimental outdoor subjects, which, if they were not well known in and of themselves, were identifiable by virtue of their appearance in the background of Beckwith's extraordinarily successful portrait of William Walton that had been shown in the painter's studio in the spring of 1886, and later to great acclaim at the 1887 Paris Salon.[51] Beckwith's paintings, although they can be roughly termed impressionist in the broader, late-nineteenth-century use of the term, are closely aligned with the works that came out of the Grez-sur-Loing colony in France in the mid-1880s in that they display the muted tonalities, relatively blocked-in brushwork, compositional devices, and subject matter typical of the short-lived but highly recognizable style that appealed to English and American followers of Bastien-Lepage.[52] That Chase knew Beckwith's lake and riverside paintings is without question, and he was probably eager to experiment with the plein-air Grez aesthetic that was popular but not particularly associated with the Parisian Impressionism of such artists as Manet, Degas, and Monet. His reliance on Beckwith's work may be reflected by the fact that he gave this painting to Beckwith, perhaps as a token acknowledging his emulation. In this connection *Mrs. Chase in Prospect Park* may be looked to as a stylistic experiment, which, once tried, was discarded in favor of the brighter palette and wider vistas that characterize his other park subjects. Yet Chase occasionally returned to the compositional strategy associated with Bastien-Lepage, exploiting it to the extreme in his large pastel portrait of his sister Hattie in *Good Friends* (Pl. 14). Although the pastel undeniably focuses on the figures of the girl and one of Chase's favorite hounds, the idea of the park setting is nonetheless strong, introduced by the uninterrupted expanse of green lawn culminating in a line of trees in the distance. To be sure, no other ground in Brooklyn provided such a view, and, as constrained

Pl. 14. Good Friends, *c. 1886. Pastel on paper mounted on linen, 48 × 48 inches. Private collection. Photograph courtesy Hirschl & Adler Galleries, Inc.*

Fig. 22. Boat House, Prospect Park. Postcard, c. 1906. The Brooklyn Historical Society.

Fig. 23. View of Steps of Main Terrace, Concert Grove, Prospect Park. Photograph. The Brooklyn Historical Society.

Fig. 24. Engraving after T. de Thulstrup, Lawn Tennis in Prospect Park, *from* Harper's Weekly *(July 11, 1885), 445. Brooklyn Museum of Art Library Collection.*

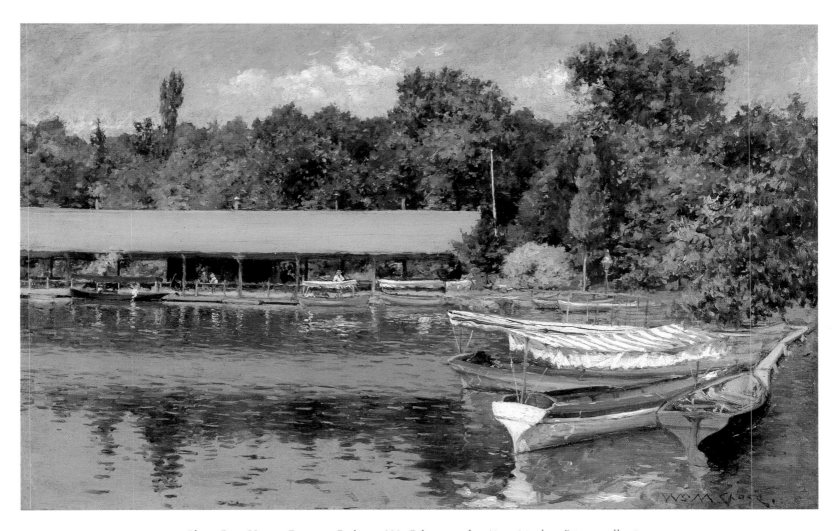

Pl. 15. Boat House, Prospect Park, *c. 1888. Oil on panel, 10¼ × 16 inches. Private collection.*

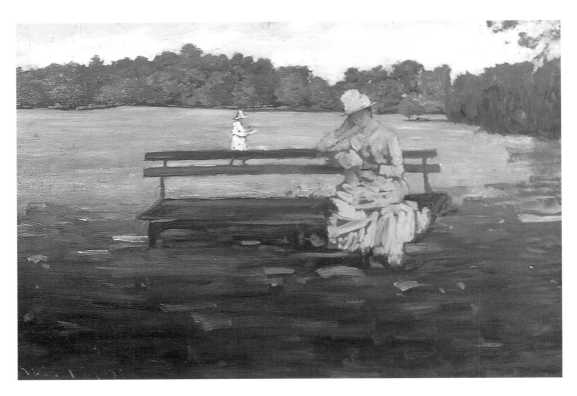

Pl. 16. Prospect Park, Brooklyn, *c. 1886. Oil on panel, 17 × 25½ inches. Private collection, New York. Photograph courtesy Spanierman Galleries, Inc.*

Pl. 17. Prospect Park (*possibly* Croquet Lawn, Prospect Park)*, 1886. Oil on canvas, 10 × 16 inches. Collection of John Pierrepont.*

as that view is within the limits of the picture plane, it broad-casts a distinct sense of place through ironically minimal means.

The general lack of stylistic cohesiveness among Chase's Prospect Park paintings may betray their early position in the chronology of his outdoor urban scenes, for they range from the tonal Grez-like work discussed above to an essentially French Impressionist look, exemplified by the exquisite, high-key *Boat House, Prospect Park* (Pl. 15). Exemplifying the vari-ety of techniques encompassed by these works are two intriguing paintings, both of which are currently known only as *Prospect Park* (Pls. 16 and 17). The first shows a young woman seated on a park bench situated on a slight rise over-looking the park's Long Meadow.[53] The bench dominates the image; positioned close and parallel to the picture plane, it reads as a set of dark rectangular strips, the lowest of which approximately marks the vertical halfway point of the compo-sition. The flat, almost matte paint is applied in broad, largely unmodulated passages of color that eliminate the sensation of atmospheric depth, thus forcing the illusion of space to depend on the eye's upward transition from one horizontally oriented band of color to the next. This emphatically reduc-tive mode is accentuated by the intentionally awkward place-ment of the figure of the young girl in white, whose logical position in space is farther back than she appears to be. The ultimate effect of the image is ironic in that the solitary read-er ignores the vista behind her—the park's grandest open space—perhaps as a sign of Chase's acknowledgment of his experiment in denying the traditional pictorial means of creat-ing the illusion of spatial recession. Bold in its effect, this technique quells the gestural, painterly stroke for which Chase was known and bears similarity to the summary paint application and unmodulated lights and darks of Manet's art. The compositional tensions also seem to grow out of Chase's absorption of Whistler's affinity for abstract geometries that simultaneously define pictorial space and assert the physical priority of the two-dimensional surface.

The second painting introduced above reveals an even greater bid on Chase's part to adopt an avant-garde position within the American vernacular of public space. Again he concentrated on the park's Long Meadow, allowing its green expanse to fill nearly the entire space of the composition, leaving the definition of the vista to the variations of darker greens of the trees, the cursory marks of white indicating fig-ures in the distance, and the strip of sky above. Although it, too, is reminiscent of Whistlerian compositions, Chase

eschewed the delicate tonal washes of color that were the hallmarks of Whistler's art and instead expressed this abstract vision with an unalloyed bluntness of color and stroke.

Although both of these paintings were probably included in Chase's 1886 Boston exhibition, they, like the other Brooklyn landscapes, were not singled out for discussion. It was apparently enough for the critics to appreciate the new direction in his subject matter without delving into the niceties of stylistic complexities, which may have proved too challeng-ing a task. Formal issues aside, however, both paintings are extraordinarily attuned to the sense of place, and, for anyone familiar with the park terrain, the spots they portray are immediately recognizable (see, for example, fig. 20). Yet, with the exception of the *Boat House, Prospect Park* and several works focusing on the terrace near the Concert Grove, Chase's paintings rarely deal with sites that coincided with park imagery in the popular press or as it was purveyed in souvenir form (figs. 22–24). While this issue will be discussed at greater length below, it needs introduction here with respect to several aesthetic ploys engaged by Chase. One was his tactic to convert common, unpretentious subject matter into art—a tenet he prescribed in his teaching.[54] His applica-tion of it emerges in these specific (real) yet anonymous park views, which allude to contemporary French realist (Impressionist) subjects, yet do not succumb to the vulgarity that Americans associated with French art.[55] In this way Chase's paintings represent a reconciliation of American and French taste in which a normalization takes place whereby the plain—or common—American scene permitted Chase to exercise extreme choices elsewhere, that is, in the formal and technical aspects of his art. In his explorations of other areas of Brooklyn Chase's practice of obscuring or masking the identity of a public place became accentuated to the point where it would be recognized only by those truly intimate with it or by those familiar with other examples of his art, which helped to "place" the locale. For Chase, this iconogra-phy of obfuscation became a habit of seeing and, in part, accounts for the confusion today over the sites of his paintings.

TOMPKINS PARK

A fair number of Chase's park pictures have been commonly interpreted as Prospect Park subjects, identified as such sim-ply through the process of elimination governed by the assumption that if they do not show Central Park, they must

be Prospect Park. Naturally, if Chase painted only two parks, this approach would be acceptable. However, this is not the case, for contemporaneous exhibition checklists and reviews provide titles of paintings by Chase referring to Tompkins Park. For example, Chase exhibited a work titled *In Tompkins Square, Brooklyn* at the 1888 SAA annual. Earlier that year a review in the *Art Amateur* for the exhibition of paintings at the gallery of the Eden Musée, New York, stated:

The new pictures are chiefly by Americans, the most notable being the four contributed by William M. Chase, who seems to be "going in" exclusively for landscapes just now, a departure one cannot regret, so long as he gives such charming, sparkling bits of out-door life as he has been painting in and about Brooklyn. The scene on a summer day in Tompkins Park, with the figures of a lady and child admirably introduced, is brilliantly executed and is full of atmosphere; and certainly no less can be said of the view of the Church of the Puritans by early morning light—a difficult effect very well managed.[56]

Such references are provocative inasmuch as the Chase literature has not accounted for these works, nor has it, until recently, recognized the possibility that a considerable number of Chase's Tompkins Park paintings have been misidentified as Prospect Park subjects.[57]

Fig. 25. Olmsted and Vaux, Preliminary Design (with north at the bottom) for Tompkins Park, Brooklyn, from Olmsted & Vaux & Co., "Report on Tompkins Park Improvement," in Eleventh Annual Report of the Commissioners of Prospect Park (Brooklyn, 1871). Brooklyn Museum of Art Library Collection.

Tompkins Park (not to be confused with Tompkins Square in Manhattan) is a small neighborhood park in Bedford-Stuyvesant, situated a short walk from the Marcy Avenue address at which the house rented by David Hester Chase was once located. Bordered on the north by Lafayette Avenue, on the east by Tompkins Avenue, on the south by Greene Avenue, and on the west by Marcy Avenue, the park on its shorter ends is only two blocks long (fig. 25). The land was designated a public square in the original 1839 Brooklyn street plan, but civic records indicate that no improvements were made until jurisdiction over the land was ceded to the Brooklyn park commissioners in 1869, when they were charged with the responsibility of having the park functional within a year.[58] Already under hire by the commissioners, Olmsted and Vaux undertook the comparatively minor duties of designing Tompkins Park and supervising the work. The park, because it was such a small area surrounded by houses, demanded a scheme unlike the rustic landscape of Prospect Park. In their proposal for the park design, Olmsted and Vaux recognized the particular problems attendant to creating a pleasant environment for recreation within a fairly densely populated area: the need for security; the need to direct activity away from the edges of the park, where noise would disturb the occupants of nearby houses; and the need for minimal and inexpensive maintenance. The solution the team arrived at was presented in part as follows:

Our plan herewith presented provides for a spacious central quadrangle, planted only with large trees, which are arranged symmetrically, but not in avenues or straight rows. It will be observed that a portion of the ground is shown in turf, and a portion in gravel. . . . On each side of the central umbrageous quadrangle, and between it and the streets, there is a garden, which being unshaded by trees, may be made very bright and elegant with flowering shrubs and plants, and perfect turf, and these will be equally well presented to the view of passers-by and the residents of the opposite houses.[59]

Based on the Olmsted and Vaux plan and the present conformation of Tompkins Park (since renamed Von King's Park), five of Chase's paintings can be securely identified as views from within the interior of the landscaped residential square designed in 1870 and completed in 1871. These include *A City Park* (Pl. 1), *The Park* (originally *In Tompkins*

Pl. 18. The Park (*originally* In Tompkins Park), *1887. Oil on board, 10¼ × 16 inches. Collection of Marie and Hugh Halff.*

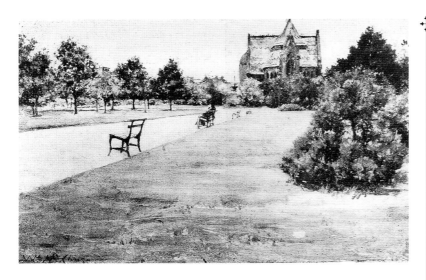

Fig. 26. Summer—Scene in the Park (originally The Church of the Puritans), 1887. Unlocated. From "William Merritt Chase," Fine Arts Journal 34 (November 1916). Art and Architecture Collection. Miriam and Ira D. Wallach Division of Art, Prints and Photographs. The New York Public Library. Astor, Lenox and Tilden Foundations.

Fig. 27. Church of the Puritans, Lafayette and Marcy Avenues, Brooklyn, before 1915. Brooklyn Public Library—Brooklyn Collection—Brooklyn Eagle Photograph Collection.

Park; Pl. 18), two works up until now titled *Prospect Park in Brooklyn* (Pls. 19 and 20), and an unlocated painting known only through reproduction, *Summer—Scene in the Park* (originally *The Church of the Puritans*; fig. 26).[60] It is the last of these works that is most obviously a Tompkins Park scene, for the hulking mass of the Church of the Puritans looms on the far right, marking the corner of Lafayette and Marcy Avenues (fig. 27).[61] With this work establishing the guidelines, so to speak, for Chase's Tompkins Park paintings, it may be observed that the other works cited here share the same features: the long, angled views along the straight gravel walks, the perimeter gardens, the central lawn planted with irregularly but symmetrically arranged trees, and the low, residential structures visible at the edges of the park. These features, so emphatically portrayed in each of these compositions, are entirely in keeping with Olmsted's design for a residential urban square (specifically Tompkins Park) and manifestly conflict with his rustic, pastoral plan for the larger Prospect Park. Indeed, the vistas characterizing the Tompkins Park user's experience incorporated the immediate urban surroundings. Such views were physically impossible from within Prospect Park, for, as Clay Lancaster has noted, "A brilliant innovation in the Brooklyn [Prospect] park is the ridge of heavily planted earth just inside the walls, that makes an effective screen blocking out the urban scene and permitting an instant illusion of being in the country."[62]

Together, the five Tompkins Park paintings illustrated here prevent the continuation of assumptions about Chase's artistic license with respect to geographic realities, for they literally plot the look of the park from end to end. (For the purposes of clarity here, the paintings, some of which lack their original titles, will be referred to by their owners.) If we were to follow the line of sight provided in *Summer-Scene in the Park* to the corner of Marcy and Lafayette and take an imaginary left turn, we would then occupy the approximate space where Chase set up his easel to paint the Colby picture (Pl. 19). The Colby painting affords the view looking down the short, Marcy Avenue side of the park looking south toward Greene Avenue (marked by the spire of St. George's Episcopal Church).[63] Near the corner of Marcy and Greene is a three-story building, which, according to the Sanborn Map of 1888 (fig. 28), is 570 Greene Avenue. The Parrish painting (Pl. 20) depicts a portion of the view in the Colby painting, pinpointed by the water fountain but seen from a shifted perspective that surveys the perimeter strip of plantings near the

street. If we return to the place where this tour began (on the Lafayette side) and look in the opposite direction, we then see the view portrayed in the Halff painting (Pl. 18), which shows Tompkins Avenue between Lafayette (to the left) and Van Buren (a street that dead-ends on the park). The corner of Tompkins and Van Buren is stamped by the four-story building at the upper right of the composition (the only four-story building on that block, which contained mainly one-story commercial establishments—the only such establishments to front the park). Chicago's painting (Pl. 1) offers yet another vista, this time from a vantage point along the Greene Avenue side looking toward Marcy, which is conclusively identified by the four-story house at 722 Marcy Avenue between Clifton and Greene—the only building of that height among the otherwise uniformly three-story houses on that block. The columned building shown within the park grounds on the left of the Chicago painting is probably the shelter house mentioned in the 1886 *Annual Report of the Brooklyn Park Commissioners* for which two hundred dollars was allocated for the repair of floors and sills, and painting.[64]

The strong geometric character of the walkways that cut through Tompkins Park encouraged Chase to explore the innovative perspectival compositions that he had seen in the work of such avant-garde artists as Degas, Caillebotte, and de Nittis. And, in comparison with his earlier Prospect Park subjects and his later paintings of Central Park, Chase's Tompkins Park images come closest to a current French vision, in terms of style and the capacity to invoke the modern mood. Chase, however, did not confess to French sources with respect to these radical perspectives and, instead, cited his own casual discovery, which led to his propensity for such a compositional structure: "About the very best lecture in perspective that I ever had was once when I stood at the back end of a railroad-train and saw a track running to a point away from me—and I never have forgotten it, and I have seemed to see things diminish in the distance so ever since."[65] Yet the optical rush through the urban streets of Paris or from the back of a speeding train was tamed in Chase's hands by virtue of the quiet intimacy of the spaces he portrayed especially in Tompkins Park. Populated mainly by mothers and/or nurse-

Fig. 28. *Map of blocks surrounding Tompkins Park, Brooklyn. Sanborn Map, 1888. Brooklyn Public Library—Brooklyn Collection. Arrows indicate St. George's Episcopal Church and Church of the Puritans.*

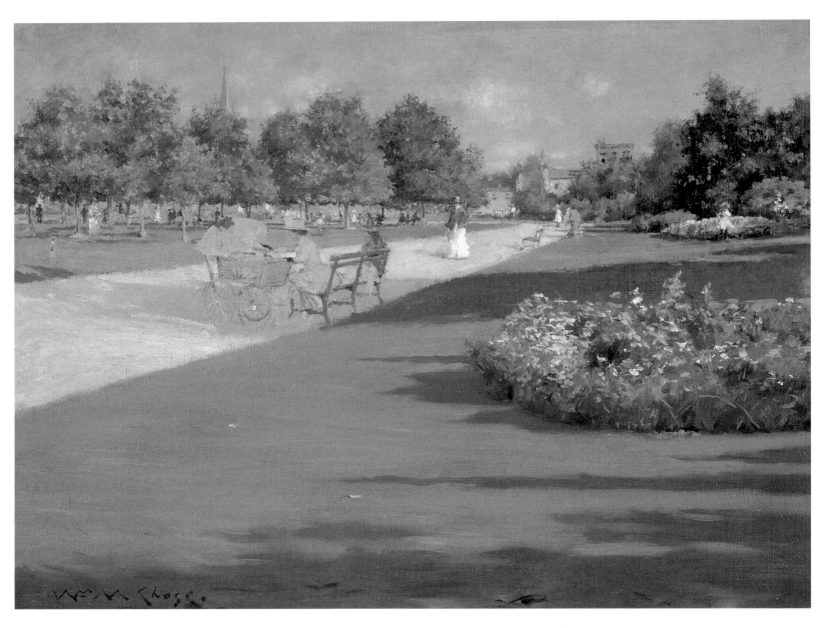

Pl. 19. Tompkins Park, Brooklyn, *1887. Oil on canvas, 17⅜ × 22⅜ inches.*
Colby College Museum of Art, Gift of Miss Adeline and Miss Caroline Wing.

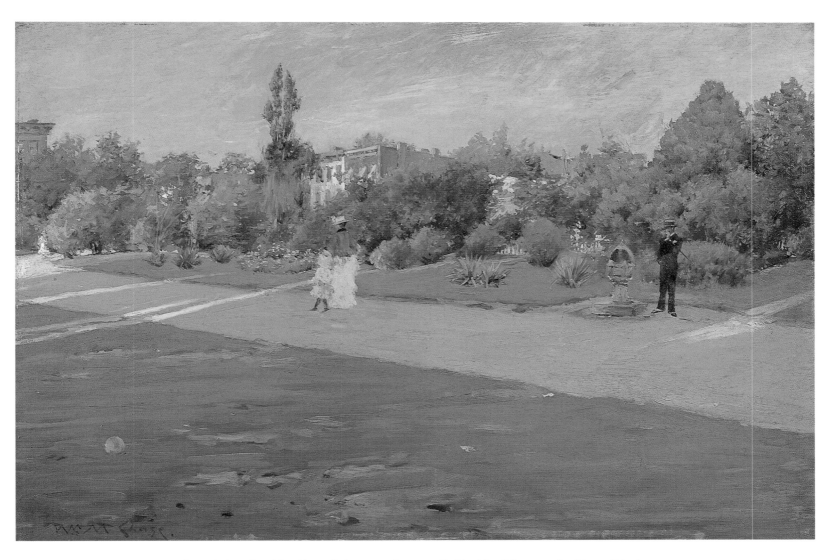

Pl. 20. Park in Brooklyn (*formerly known as* Prospect Park), *1887. Oil on panel, 16⅛ × 24⅛ inches.*
The Parrish Art Museum, Southampton, New York, Littlejohn Collection, 1961.5.11.

maids and children strolling the pathways or sitting on the garden benches, Tompkins Park was utterly domestic in aspect. Never the destination of tourists who might visit on special occasions, the little park belonged to the community surrounding it, and its geography was part of their daily routine. It is in this connection that Chase himself knew the park, for his imagery reflects how he and his family would have used it for outings with Cosy during her first summer, when the artist and his wife were living with his parents. Not only was this little park a conveniently short walk from the Marcy Avenue house, but it also offered the anonymity and seclusion that would guarantee their privacy. Thus, Chase's Tompkins Park subjects, which begin to be mentioned in exhibition reviews in late 1887 and throughout 1888, should be assigned the date of 1887. It is almost certain that the artist's painting activity in this park was restricted to the summer of that year, for in 1888, with an allocation of ten thousand dollars, extensive modifications were made. According to the 1888 annual report, "the width of the paths and of the grass boundary border was reduced twelve feet each and the turf from the border transferred to the main plot, thereby increasing the grass area nearly two acres. The main plots were plowed . . . the junctions were fenced in with iron posts, and galvanized iron wire."[66] With this work in progress over the summer of 1888, the park could hardly have been an inviting spot for outdoor painting.

It seems odd that these distinctive views of a public space should have been subsumed within the identity of Prospect Park. Yet in retrospect, the "loss" of place becomes understandable once the changing demographics of that space are considered, along with what may be suspected as Chase's collusion in concealing the park's identity. Originally only two or three of these paintings seem to have borne a title that specified the Tompkins Park site, while the rest were shown under generic titles such as *A Park*, *A City Park*, or *A Little City Park, Brooklyn*.[67] Why this was so can only be a matter of speculation, but ultimately, the effect deflects the reading of the strong biographical content from the image, thus promoting a more universal reception of the paintings, which allows them to shed a provincial or regional flavor and join the larger body of international art production of the era. Chase's idiosyncratic approaches to his subjects reflect his experimentation not only with style but also with how his reputation would be perceived in relation to what he painted. He seems to have relished the contradictory nature of things, again, taking the most common or unexpected view of the familiar and converting it to high art.

THE NAVY YARD

Chase's most esoteric excursions into the "common" landscape of Brooklyn led to the Navy Yard, where he not only explored the docks and harbor line but also investigated portions of the naval base's inner precincts. The painter's unusual exploitation of the latter as artistic subject matter was surprising but pleasing to one critic, who noted in his review of the 1889 pastel exhibition:

Of Mr. Chase's landscapes we like best the simplest, appropriately named "A Bit of Sunlight." It is a view in the Brooklyn navy-yard of a straight, flagged path, between two trim grass plots, with the trunks of a few trees and a low, gray wall for a back ground—very unpromising material, one would think. But as a close study of tones it is most interesting to the connoisseur, and the resulting effect of sunshine is so natural as to take the unprepared spectator by surprise.[68]

The pastel that drew this comment is likely the one illustrated here (Pl. 21), which provides a forthright but unassuming view of the wall mentioned by the *Art Amateur*'s writer. The same wall appears again in Chase's paintings: in a work that has traditionally been identified as Prospect Park (retitled *Brooklyn Navy Yard*, Pl. 22), as well as in *Afternoon in the Park* (see Pl. 48) and *In Brooklyn Navy Yard* (probably *In Navy Yard Park*, Pl. 23).

The Brooklyn Navy Yard (a large tract of land, the administration of which is now divided among several public and private agencies) was established by the United States Navy in 1800. Officially called the New York Naval Shipyard, it was described in Stiles's *History . . . of the County of Kings*:

Beyond Gold Street, the Navy yard occupies an extensive tract fronting on the Wallabout Bay, but the Wallabout basin and canal redeems a considerable district for commerce and manufactures. The Navy Yard indirectly makes a considerable addition to our commerce, in the extent of supplies of all sorts required, and brought thither from various quarters, in the arrival and departure of vessels belonging to the fleet, and of the schoolships, and in the coming of ships from the navies of other nations, either on friendly visits or for repairs.[69]

As this passage demonstrates, the Navy Yard, by 1883, was seen by some writers mainly as an adjunct to the shipping industry of New York. However, its history was rich and well recog-

Pl. 21. A Bit of Sunlight, *c. 1888. Pastel on paper, 7½ × 12½ inches. Private collection.*

Pl. 22. Brooklyn Navy Yard, *c. 1887. Oil on panel, 10⅛ × 16 inches. Erving and Joyce Wolf Collection.*

nized by nineteenth-century New Yorkers and Brooklynites. Originally a major center for fitting ships destined to challenge pirates in the Caribbean, the Navy Yard soon played a crucial role as a base for ship repairs during the War of 1812 against the British, a war that was fought largely at sea. It was from the Brooklyn Navy docks that the *Fulton,* the first ocean-going steamship in U.S. Navy history, was launched. During the Civil War, approximately six thousand workers were employed there for the purpose of converting private merchant ships for wartime duty and for maintaining the yard as the primary base of operations for the U.S. fleet's repairs.[70] The famed ironclad *Merrimac* was fitted at the Brooklyn Navy Yard, which in itself was a cause for swelling local pride.

James D. McCabe Jr.'s popular 1872 *Lights and Shadows of New York Life; or, the Sights and Sensations of the Great City,* which recommended an excursion up the East River as one of the best ways to see the size of New York and Brooklyn, stated: "Not the least of the attractions is the United States Navy Yard, an admirable view of which may be obtained from the deck of the steamer in passing it."[71] Yet, as witnessed by an 1882 article in *Harper's Weekly*, tourists were encouraged to make a closer inspection of the naval base. The writer especially recommended visiting sections having romantic appeal, one of which was Rotten Row: "No portion of the Brooklyn Navy-yard is of more general and historic interest than 'Rotten Row,' that part of Wallabout Creek just off the 'Cob' Dock, where are laid up in ordinary those war vessels which for one reason or another have been condemned and retired from active service." Admitting the outmoded condition of the "poor old hulks" of ships that had outlived practical use, the writer continued, explaining that on a moonlit night the viewer "could easily in imagination reconstruct their former glory." Four ships were then mothballed, anchored at the docks of Rotten Row—the *Vermont,* the *Susquehanna,* the *Ticonderoga,* and the *Constitution.* Citing the last as the most important attraction, the writer claimed the *Constitution* "alone worth a visit to Rotten Row. What national monument is better known or more venerated by the American people than the battered hull of 'Old Ironsides?'"[72] Indeed, not only had the *Constitution* acquired the status of a national treasure, stemming from its 1812 victories, but more recently she had dispatched herself nobly when she was refitted for exhibition at the 1876 Centennial Exposition and later carried the American exhibits to the 1878 Paris Exposition Universelle. The *Harper's* writer further

noted that when the *Constitution* was anchored in the Brooklyn Navy Yard for several weeks in 1880, she "was visited by throngs of people."[73] Such descriptions cast the Navy Yard in a radically different frame of reference compared with contemporary public perception of it. Gated and secure, it is now the province of warehouses, importers, exporters, moviemakers, and others, whose daily business takes place without public notice. The dramatic, ghostly industrial contours of the Navy Yard are seen most often from the elevated Brooklyn-Queens Expressway and do little to suggest its present or past life. For Chase, excursions into the Navy Yard may have evoked the memory of his youthful escapade of 1867 when he and a friend joined the U.S. Navy's apprentice program. The two boys soon had a change of heart about navy life, a decision that necessitated David Chase's journey from Indianapolis to Annapolis to obtain their release. Twenty years later and firmly enmeshed in his painting career, Chase, on strolls through the historic naval base, may have thought what his life might have been like had his father not rescued him.

In the context of the descriptions provided here, Chase's *Woman on a Dock* (see Pl. 7) certainly complies with late-nineteenth-century perceptions of the Navy Yard, and it may well be the painting Chase exhibited in 1888, the year of his return to the NAD, titled *Rotten Row, Brooklyn Navy Yard* (no. 112). The high masts of the ships set the stage for the solitary young woman, whose contemplative demeanor and stylish dress denote her membership among the tourists who paid homage to the nation's history by visiting one of the great symbols of a heroic military past. Other facets of national cultural identity were asserted in the Navy Yard as well. These, however, were obliterated by the changed uses of the base and its transfigured landscape, their charm revived in Chase's almost pastoral images of the green, shaded lawns that bounded the Navy Yard's inner avenues, on which fronted administration buildings, stately officers' quarters, and the Naval Lyceum, all of which offered a genteel image of the peacetime navy and attested to the area's function as a cultural center.

Most important in re-creating a picture of the Navy Yard and the image it projected in the late nineteenth century is the Naval Lyceum, an organization founded in 1833 by Navy and Marine Corps officers to "promote the diffusion of useful knowledge, foster a spirit of harmony and a unity of interests in the service, and cement the links which unite us as professional brethren."[74] The group, which included in its membership James Fenimore Cooper, sponsored a museum, library,

reading room, and bimonthly magazine and grew in status and use to the point that it attracted over ten thousand visitors in 1879. The museum, library, and reading room were located on the third floor of the Lyceum Building (fig. 29). Among the most notable works in the rapidly growing collection (which was a mixed assortment of natural history objects, coins, autographs, and fine art) were the portraits of distinguished Americans donated by the New Yorker Luman Reed in 1835.[75] These included Asher B. Durand's (1796–1886) copies after Gilbert Stuart's (1755–1828) portraits of Washington, the elder Adams, Madison, and Monroe, and Durand's own portraits of John Quincy Adams and Andrew Jackson. Another fine work added to the collection within a short time was Horatio Greenough's (1805–1852) marble bust of George Washington, presented in May 1836 by the New Yorker John C. Halsey.[76] Although the lyceum's primary constituency consisted of military personnel, it was also intended to serve the community. As stated in the 1836 *Naval Magazine*: "The most valuable and most important newspapers and periodical publications of the day, are always to be found on the reading table; and every effort is made to render the rooms of the Lyceum at once a favorite and improving resort of the gentlemen of the Navy, and an object of attraction worthy the notice, both of our neighboring fellow-citizens, and of the passing stranger."[77] The reference to the "passing stranger" conjures an openness rarely associated with military bases today, but the picture it summons is harmonious with the imagery of Chase's paintings. Although the artist avoided obvious pictorial references to the decorative pyramids of cannon balls that lined Main Street in the yard and entirely omitted depicting the popular Lyceum Building, he alluded to them by portraying the adjacent grounds. The Lyceum Building (referred to later by the Navy as Building No. 1) faced south on Main Street. Nearby were the commandant's quarters believed designed by Charles Bulfinch (1763–1844) and constructed in 1806. According to one description, "the terraced ground leading to the Commandant's quarters was supported by a stone wall. . . . Between this wall and Main Street, there was a beautifully kept lawn on which was a band stand. Musical concerts were given at certain regular intervals. The entire scene presented a fascinating spectacle to visitors and all others within the Navy Yard."[78] The wall still stands, but the use and appearance of the land it occupies are dramatically different.[79]

It was this "beautifully kept lawn" and the double-tiered retaining wall bordering it (fig. 30) that Chase featured in his

Fig. 29. *Lyceum Building, Brooklyn Navy Yard, from James H. West,* A Short History of the New York Navy Yard. *February 23, 1941 [New York: Navy Yard, 1941]. Brooklyn Public Library—Brooklyn Collection.*

depictions of the inner reaches of the Navy Yard. Yet the same irony of presentation occasionally deployed by Chase in other instances—that of rendering a public space anonymous by eliminating well-known conventional landmarks—is put to more calculated use in his Navy Yard "interiors." This trope is taken to the extreme in a painting formerly published as *Prospect Park* (see Pl. 22), a work now more aptly called *Brooklyn Navy Yard* for want of its original title. Although there seems to be no contemporaneous commentary on the painting, it would seem fair to assume that the nearly "subjectless" work would have attracted scant note by the general viewers, who were just being weaned from explicit narrative themes. A few critics would likely have appreciated the composition for its daring simplicity (such as the one quoted above who had implied that the related pastel, *A Bit of Sunlight*, was geared for the taste of connoisseurs). Chase, however, turns provocateur by flaunting the plainness of his subject. Denuded of obvious content, the painting investigates its subject in formal terms. Yet the artist was prepared for the challenge of defending his art by slyly including a landmark (the retaining wall) that would imbue the composition with cultural reference and ultimately validate the importance of the space portrayed. Chase's radical fashioning of "common" reality is thereby elevated to avant-garde practice. At the same time, by choosing this unconventional view of the Navy Yard, Chase surreptitiously loaded this traditionally masculine purview with an aura of gentility. Accomplished

mainly by the female presence, these paintings reconstruct the common expectations attached to the public identity of the geography, emphasizing the site as an appropriate territory not only for women but for children as well (Pl. 24). On a personal level these paintings impart a feeling of isolation, which may reflect the secrecy that the Chases maintained about the timing of the arrival of their child.

In addition to painting the more refined confines of the Navy Yard, Chase focused on its marine aspects in a set of small works whose formal characteristics blended with his other images of the extensive system of docks and waterways that gradually defined the northern edges of Brooklyn. These areas included the Wallabout Bay, Basin, and Canal, and the Gowanus Bay and Canal. The approximately seventy-acre Wallabout shoreline had recently been converted from its natural salt marsh state and, by 1883, was "covered with large warehouses, factories, and dwellings, among which [were] the immense lumber yards of Cross, Austin & Co., said to be the largest retail lumber yards in the United States."[80] With the development of the docks on the Brooklyn side of the East River, land prices rose precipitously (increasing by 10–20 times the original values), and arteries of public transportation

were soon built to accommodate growth. The Gowanus Canal, on the other hand, was a man-made waterway that stretched from Gowanus Bay nearly a mile inland, where it split into five branches. The Gowanus system developed in the 1840s and, as was the case at Wallabout, spurred a boom in land values and residential development. Unlike the Navy Yard, whose role in the actual distribution of goods was tangential, the Wallabout and Gowanus systems were relatively newly built to support the growing industries of Brooklyn and, what is more important, to relieve the overburdened and decrepit dock facilities lining Manhattan Island. As Stiles pointed out:

Unlike any other great seaport of our country, or the world, Brooklyn and the county of Kings has no separate existence as a port of entry; but, while possessing an unrivaled water front, with the most magnificent docks and piers in the world, and an unlimited capacity for expansion, till it may be able to receive and store the entire products of a continent, it suffers the humiliation of knowing that all this vast commerce is credited to New York City; and that there does not exist either in the New York Custom House, the reports of the Produce Exchange, or the New York Chamber of Commerce, or indeed, in the records of

Fig. 30. Brooklyn Navy Yard, looking southwest toward Commandant's House, 1913, NA–25. Naval Districts and Shore Establishments, Record Group 181; National Archives and Record Administrations—Northeast Region (New York City).

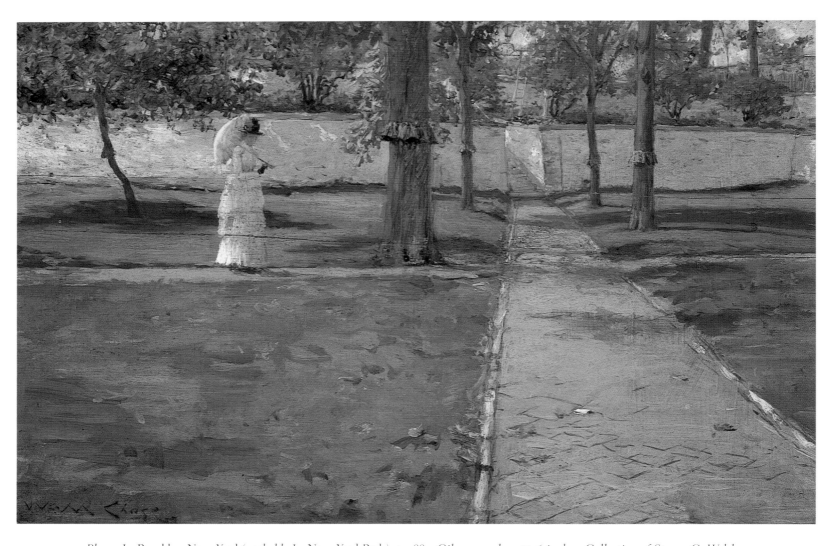

Pl. 23. In Brooklyn Navy Yard (*probably* In Navy Yard Park), *c. 1887. Oil on panel, 10 × 16 inches. Collection of Steven C. Walske.*

Pl. 24. Child on a Garden Walk, *c. 1888. Oil on panel, 10⅞ × 7¼ inches. Private collection.*

any government or mercantile office, the data for giving to Brooklyn its quota of credit for her share in this immense traffic, which has no rival on this side of the globe.[81]

Chase's paintings of these dock sites provide a curiously quiet and picturesque version of what were assuredly some of the noisiest, most chaotic spots to be seen in either New York or Brooklyn. His distanced visions of the shoreline bear little resemblance to the countless precedents set by earlier artists whose attentions had been drawn to the waterways surrounding New York since colonial times. Artists who were mainly marine specialists and/or painters of ship portraits, such as Thomas Birch (1779–1852), Thomas Thompson (1770s–1852), and Thomas Chambers (active in the U.S. 1832–66), had usually sought to create definitive, characteristic views that displayed relationships between water and landmasses or the energy of harbor life.[82] No matter the style of such paintings, they are unified by a sense of movement, whether it be conveyed by choppy waters, cloudy skies, billowing sails, smoke and steam, or narrative interest. For the most part, imagery of New York's harbors originated from both documentary and artistic aims, as found for instance in an early, rare depiction

of the base, *The Brooklyn Navy Yard* of 1839 by A. M. Walker (act. 1839–79; fig. 31). Framed within the romantic aesthetic wherein nature plays a dramatic role in the overall effect of the work, the painting suggests Walker's desire to emulate the style of the more noted marine artist Thomas Birch as well as her intention to record the variety and types of structures and ships lining the water's edge.

Chase was not alone among his contemporaries in his pursuit of harbor subjects, yet his interpretations of the city docks yielded impressions far removed from John H. Twachtman's forcefully conceived compositions featuring the gritty spectacle of dockside activity. As mentioned above, Twachtman's paintings of the North River (Hudson) docks achieved critical acclaim at the 1881 SAA exhibition. Writing of *Tenth Street Dock*, the critic for the *New-York Tribune* had observed that despite the fact that "it might be a dock in any part of the city, or in any city for that matter . . . there is no doubt that it represents a real dock, with ships and boats and water as they are to be seen, with all the huddle and confusion that seems to the landman to exist, but which the seaman and the wharfmaster and longshoreman know to be compatible with order and system."[83] Twachtman's paintings of

Fig. 31. A. M. Walker, The Brooklyn Navy Yard, *1839. Oil on canvas, 20 × 30⅛ inches. The Brooklyn Historical Society. Photograph: Brooklyn Museum of Art Archives.*

New York harbor views were sometimes reproduced as illustrations for the proliferating body of articles devoted to the subject. As Lisa Peters has determined, Twachtman's *Hudson River at Twelfth Street* (originally reproduced as *Oyster Boats, North River*) corresponds with contemporaneous descriptions of the daily movements of the oyster fishermen at the dockside markets that consisted of storefront town houses facing landward, whose back entrances opened to the waters from which the fishing boats would deliver the catch.[84] Twachtman's views are visual complements to the written accounts of the rat-infested wharves, rotting piers, and colorful denizens of the alternately gloomy or lively dockside markets and taverns, all of which were described at length by McCabe and others. Linked by a Dickensian attitude in their will to portray realistically extremes of a particular range of society and its activity, Twachtman's paintings and the articles in the popular press functioned jointly to sensationalize, indeed, exoticize this dank region on whose labor the city depended for its economic priority.

It would be fair to say that Chase probably appreciated Twachtman's paintings and was prompted by their example to try his hand at portraying comparable regions in Brooklyn. Fairer still is the assumption that both Twachtman and Chase took inspiration from Whistler's paintings and etchings of Wapping and Thames subjects, which were generally admired and were favorably mentioned in the same *New York Sun* review that advised American painters to avoid the "empty inspirations of foreign claptrap—the unattainable and worthless" and to look to the artistic potential of the "countless subjects on Manhattan Island" for their art.[85] Making a pointed comparison between the beauties of Venice and the Adriatic and those of the sun rising over New York's North River, the writer concluded that even the possibilities presented by the "prosaic footing of a Jersey City ferryboat are worth considering."[86] With such urgings from the critics, it seems no coincidence that both Twachtman and Chase (who had lived and painted together in Venice) were the same two American artists who soon attempted to translate New York river and dock subjects into a modern vernacular art.

A comparison of Chase's painting currently known as *The East River* (Pl. 25) and Twachtman's *Dredging in New York Harbor* as reproduced in *Harper's Weekly* (fig. 32) helps to clarify the differences separating the work of the two men. Twachtman's work, although it illustrated an 1882 article about the dredging business, is believed to have been painted in 1879, independent of any type of commission, and later

sold to the magazine.[87] The composition is dominated by the grotesque form of the dredging scow, whose monstrous jaws not only scoop the accumulated sludge from the floor of the river to deepen the channel but also salvage the detritus of lost cargo and discarded materials that the dredger would flog for a price. Despite the value of the dredger's activity on the river, it was a job associated with scavenging and squalor and referred, not to the glories of economic activity (represented by the steamer and sailing ships in the distance), but rather to the darker side of the shipping industry. In contrast to Twachtman's view, Chase's *East River* eschews such narrative references to labor of any kind. Granted, the contours of the buildings, ships, and smokestacks lining the river are integral to the composition and indirectly refer to the buzz of activity associated with the labor of the docks, yet Chase seems bent on creating a casual impression produced by an eye scanning the entire scene that aims not to investigate the particular, but to discover the general.

Whereas Twachtman concentrated on the North River and later turned to suburban coastal views in New Jersey, Chase consistently looked eastward, away from Manhattan to the Brooklyn shoreline. Several factors may be cited as the impetus behind Chase's preference for the Brooklyn view. Foremost among them is his constant desire to be seen as an innovator; even if he owed his interest in the subject to his close colleague Twachtman, it would not do for him to be seen as an imitator, and that alone would be sufficient to account for his concentration on different shores. A second consideration is based in the contrasts presented by the Manhattan and Brooklyn docks. As mentioned above, Manhattan's shoreline was so severely deteriorated that, as one writer put it: "The piers . . . are disgraceful. A few piles are driven in the mud, timbers are laid over them, and planks are spiked over these. When they have rotted sufficiently, these piers are offered by the city to the commerce of the world at exorbitant rents. They are too narrow even for the circulation of a junk-cart. The wonder is that a respectable ship will submit to be delivered in such a berth."[88] By contrast, Brooklyn's docks—at Wallabout and Gowanus—were new and thriving, and the Navy Yard possessed a venerable status accorded by its place in the nation's history and efforts in the cause of patriotism. In this context, contemporary perceptions of these sites must have engaged more positive associations involving newness, modernity, and the respectability found lacking in their Manhattan equivalents, which were

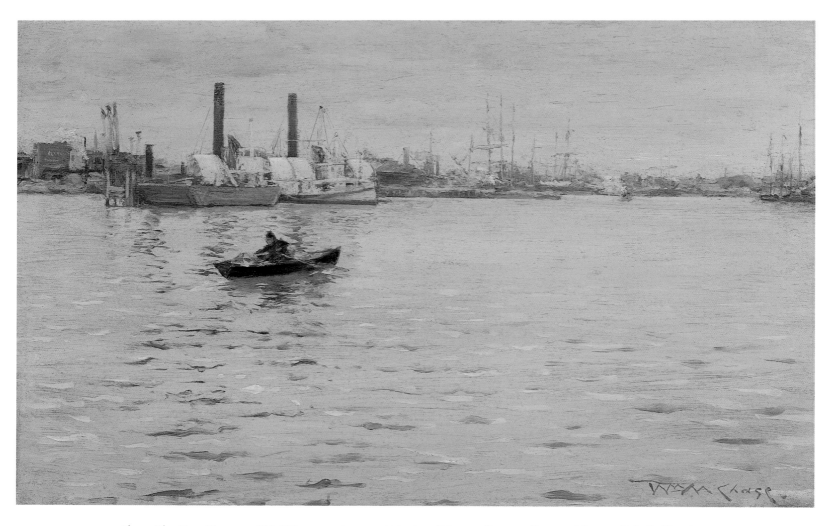

Pl. 25. The East River, *c. 1886. Oil on panel, 10 × 15¾ inches. Private collection. Courtesy Thomas Colville Fine Arts.*

Fig. 32. Engraving after John H. Twachtman, Dredging in New York Harbor, *from* Harper's Weekly 26 *(June 10, 1882). Brooklyn Museum of Art Library Collection.*

rapidly losing business to the new docks across the river.

Chase's paintings of these docks, although patently real in what they portrayed, were not reportorial in their affect. In the small, jewel-like panel *Harbor Scene, Brooklyn Docks* (Pl. 26), Chase relegates the docks and buildings of the Navy Yard to the middle distance, thus allowing them to be read as a mass of shapes and colors constructed from "impressionist" brushwork. Distinctions of function or labor are thereby ignored, with the whole massing of form consolidating to signify the idea and, to be sure, the general look of the docks. By eliminating mundane detail from his conception, Chase develops a schematic ideal that cushions the viewer from the literal and harsh realities of the place that did not conform to the painter's view of appropriate content. Yet, unlike Twachtman's generic treatments of similar subjects, which, as the critic noted, could not be tied to a specific place, Chase's views would have been immediately recognizable to the contemporary audience—or at least to those who rode the East River ferries or even to those who never left Manhattan but who occasionally looked to the east toward Brooklyn. Embedded within Chase's mosaic of abstract painted shapes were the forms of such local landmarks as, for example, the bright strip of green on the left of *Harbor Scene, Brooklyn*

Docks, which marks the location of Cob Dock, a remarkable man-made feature of the Navy Yard comprising nineteen acres of landfill that extended into the lower portion of the river. Dismantled by the Navy in 1913, Cob Dock once accommodated a garden and Old Sailors' Hall with a library and stage for amateur plays.[89] Chase adopted a similar strategy for identifying what looks to be another portion of Cob Dock, *View of Brooklyn Navy Yard* (Pl. 27), which provides a view of the garden and buildings with the tall masts of ships anchored on the river side of the landfill in the background. Also in the distance is the dome of the Williamsburgh Savings Bank, barely visible just to the right of the center of the composition, which also signals the reality of place— namely an area, that in the mid- to late nineteenth century was a popular resort for the rich.[90] The bank building at 179 Broadway (in Brooklyn) was completed in 1875 and boasted a grand design that signified the wealth and status of the inhabitants and frequenters of the area, the land values of which had skyrocketed with the building of the new Wallabout docks.[91]

Chase's inclusion of these local landmarks (for instance, Cob Dock and the Williamsburgh Bank dome) functions as a type of cultural mapping. The two architectural elements are not featured but are simply shown as part of the physical fabric of the landscape, testimony to Brooklyn's economic and cultural development. In picturing the city in this way, Chase deliberately avoided the sensational imagery at his disposal that would have announced the ineluctable forces of modernity that were rapidly transforming the look of the two cities and the lives of the residents. While it may be curious that Chase ignored in these paintings of the East River regions the newest and greatest landmark of the age—the Brooklyn Bridge—the absence of such overt monuments to progress corresponds with the normative impulses found elsewhere in his art. All of this converges with Chase's personal quest for gentlemanly status for the artist in society, a public image that he may have deemed to require a nuanced, gentrified iconography of economic expansion rather than one that denoted the rampant, monstrous energies of progress. Thus, rather than following the leads of his avant-garde American contemporaries, Whistler and Twachtman, Chase looked to other sources on which to model his cityscapes, which would allow for the creation of a refined, cultured (aestheticized) imagery in which the fruits of financial and industrial development were implicated and not explicitly portrayed. Such inspiration was to be found in the paintings of the contemporary Hague

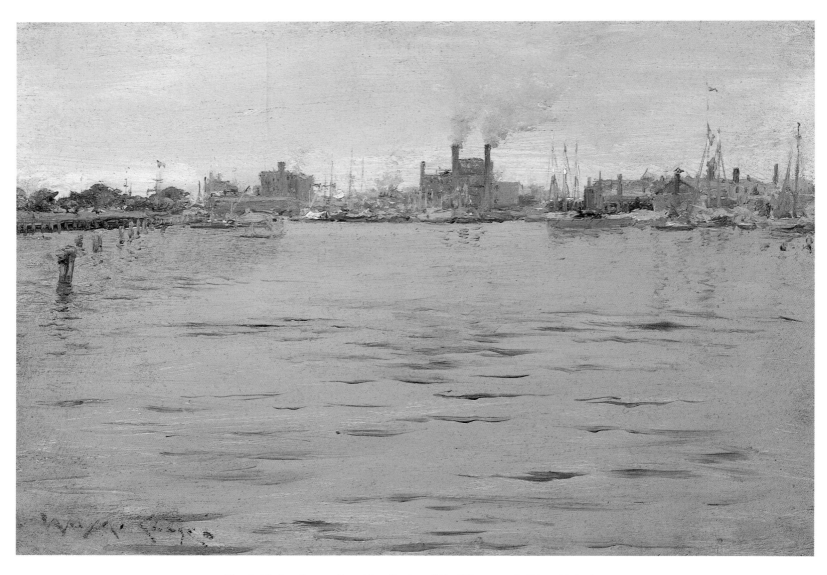

Pl. 26. Harbor Scene, Brooklyn Docks, *1886. Oil on wood, 6⅛ × 9⁵⁄₁₆ inches.*
Yale University Art Gallery, Edwin Austin Abbey Memorial Collection.

School artists, examples of which Chase and Beckwith had included in the Pedestal Fund Loan Exhibition and which Chase, himself, collected for his private enjoyment.[92] In considering, for example, Jacob Hendricus Maris's 1882 *Schreierstoren, Amsterdam* (fig. 33), it is possible to discern a like approach in picturing a flourishing city and its docks. The horizontally oriented scheme in which water, land, and sky are represented faithfully in clearly defined registers offers a template on which Chase could base his compositions. In fact, taken in isolation, the right-hand portion of the Maris painting illustrated here is the approximate equivalent of Chase's harbor scenes in which distance and atmosphere function to veil the sharpness of architectural forms. In these paintings the harsh realities of harbor and city life are virtually absorbed by the sketchy painterly effects. The scene, the accuracy of which cannot be questioned, evinces a sense of middle-class prosperity without chaos—qualities long associated with Amsterdam's traditional identity as a center for international trade. Chase's avoidance of overt signs of industrial and economic advances may also be compared with a similar tendency remarked in the works of the French

Impressionists, in which the images of middle- and working-class recreation are inhabited by subtle signs of progress, buttressed thematically by the notions of the changing patterns of labor within the population that enabled leisure pursuits.[93]

Chase applied this formula to other coastal regions of Brooklyn. The painting tentatively identified as *Repair Docks, Gowanus Bay* (Pl. 28) and *Misty Day, Gowanus Bay* (see Pl. 3) are characterized by greater formal spareness. Yet despite their reductive, distant views across wide stretches of water, they, too, would have evoked the contemporaneous viewer's associations with the expanded Gowanus Pier and the canal system attached to it. The minimal, avant-garde perspective taken by Chase must have been a potent reminder of the rapid transformation the area had recently undergone. In John Mackie Falconer's 1877 painting, *At the Foot of Hicks Street* (fig. 34), the shores of Brooklyn were still lined by dilapidated piers, shanties, and shacks; yet by 1884 this quaintly picturesque aspect of Brooklyn had been erased by the completion of the Brooklyn Basin with its "wide piers, with large warehouses and extensive sheds for the storage of goods, and for dry dock and ship building purposes."[94]

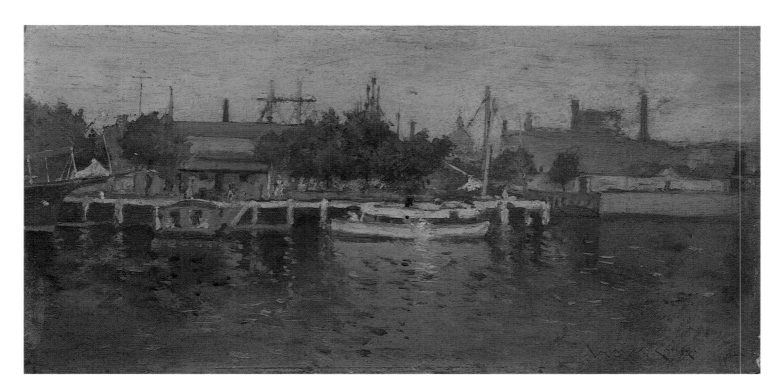

Pl. 27. View of Brooklyn Navy Yard, c. 1886. Oil on panel, 5 × 10⅛ inches. University of Michigan Museum of Art, Gift of Mr. and Mrs. Norman Hirschl, 1961.1.170.

Fig. 33. Jacob Hendricus Maris, The Schreierstoren, Amsterdam, 1882. Oil on canvas, 32 × 58½ inches. Philadelphia Museum of Art: The William L. Elkins Collection.

Fig. 34. John Mackie Falconer, At the Foot of Hicks Street, 1877. Oil on canvas, 16⅛ × 24½ inches. The Brooklyn Historical Society. Photograph: Brooklyn Museum of Art Archives.

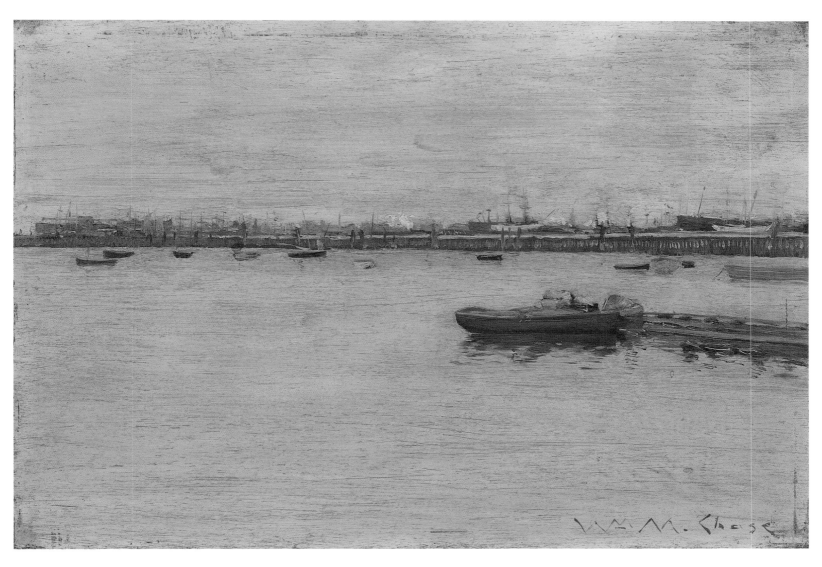

Pl. 28. Repair Docks, Gowanus Pier (probably), c. 1888. Oil on wood, 9¼ × 13⅛ inches.
The Cleveland Museum of Art, Gift of Mrs. John B. Dempsey, 1957.423.

BROOKLYN'S RESORTS

Chase's explorations of Brooklyn's coast took him southward to parts of Long Island that had recently become highly desirable tourist destinations. As his biographer Katherine Metcalf Roof noted, Chase and his wife spent at least one summer in a rented cottage at Bath Beach, a small resort located between Gravesend and Fort Hamilton.[95] Named for the English spa town of Bath, Bath Beach was in the 1880s a quiet, rural spot, ideal for family holidays away from the sweltering heat of the city. Chase's paintings of the area reflect the bourgeois respectability of the resort, where young mothers and their children could enjoy the seaside air without the noise or jostle of crowds.

Afternoon by the Sea (Pl. 29) delivers such an impression of a domestic holiday, which, although comparatively casual, would nonetheless require the transfer of the household—pets and all—to the shore. The tranquility and intimacy of this large outdoor image are unusual for the artists of Chase's circle at the time, for they usually devoted themselves to either landscape or single-figure subjects, rarely integrating the two into a true genre modality. A lone swimmer standing on a raft captures the attention of the young girl (likely Chase's sister Hattie)—the only evidence of the hidden beach's use. The yachts dotting the nearer waters signify the recreational activities of the area, while the freighters in the distance act as reminders of the vast trade interests supplying the funds for such luxuries. Given the work's departure from American art production at the time, it is necessary to look to European art for comparable works and/or sources. Such a search reveals Chase's direct assimilation of this motif from a series of paintings by his erstwhile mentor Alfred Stevens. Although no conclusive evidence exists documenting Chase's knowledge of Stevens's 1883 *Mother with Her Children on a Terrace* (fig. 35) or the Belgian painter's earlier works of similar composition (*In Deep Thought*, 1881, The Saint Louis Art Museum; and *La Veuve et ses enfants*, 1883, Musées Royaux des Beaux-Arts de Belgique, Brussels), the similarities shared

Fig. 35. Alfred Stevens, Mother with Her Children on a Terrace, *1883. Oil on canvas, 26½ × 38½ inches. Private Connecticut collection. Photograph courtesy Christie's, Inc.*

Pl. 29. Afternoon by the Sea, c. 1888. Pastel on linen, 20 × 30 inches. Courtesy Gerald Peters Gallery, Inc., and Hirschl & Adler, Inc. Photograph courtesy Hirschl & Adler, Inc.

by these works and Chase's *Afternoon by the Sea* make inescapable the assumption that the American borrowed heavily from Stevens's work to yield what is probably one of the most conspicuous examples of Chase's concept of the composite work of art.[96] The likelihood of Chase's knowledge of all three paintings is strong owing to his frequent trips to Europe throughout the early 1880s. What is more, he was sure to have kept abreast of Stevens's art inasmuch as he was a serious collector of that artist's work (at one point he owned twelve paintings by Stevens). That Chase borrowed from Stevens is not surprising, for other examples of his adaptations of Stevens's motifs are well known. What is remarkable, however, is the extent of the borrowing in this instance. It is theorized here that Chase's purpose in aligning himself so obviously with a recent painting by Stevens came not only out of his admiration for Stevens but also from his need for assurance that his borrowing would be recognized immediately by the powerful American collectors of Stevens's art (August Belmont, William T. Walters, H. O. Havemeyer, Alexander Turney Stewart, and William K. Vanderbilt) whose patronage he sought. Derived from motives rooted equally in self-advertisement and homage to a great European contemporary, *Afternoon by the Sea* functions as one of Chase's finest attempts at translating a strong European image into the American vernacular and ultimately transcends reliance on its sources.

Afternoon by the Sea signals another shift in Chase's attention. Unlike his harbor subjects, which focused on the visual interest supplied by the docks, ships, and buildings lining the shore, Chase turns seaward here, a reorientation paralleled by the little girl whose gaze is drawn (and draws us) to the watery vista beyond the boundary of the railing. A number of paintings from this period relate to this seaward view, implicating the vantage point of land by the inclusion of minimal dockside appurtenances. *Seashore* (originally *A Gray Day*, Pl. 30), a work tentatively identified as *Sailboat at Anchor* (Pl. 31), *A Stormy Day, Bath Beach* (Pl. 32), and the tiny *Seascape* (Pl. 33) could easily be considered mere experiments in reductive composition, but they take on extended meaning by virtue of their connections with the imagined visual experience of the girl in blue. The influence of Whistler in these minimalist tonal essays is undeniable and consistently cited, yet Stevens must be mentioned here as well, for Chase's suggestive abstractions of the bay relate to similar compositional strategies carried out in the Belgian's marine paintings of the 1880s. Unlike those of Whistler and Stevens, however,

Chase's works assert a subtle insistence on the specific character of the place from which he paints; the almost ubiquitous wooden pole jutting from the water assumes a colophonic role, here becoming a sign of the locale's identity in addition to being a schematic signature.

This pattern of borrowing on Chase's part calls to question the validity of categorizing his art as truly realistic.[97] That these paintings may have been constructed deliberately to appeal to sophisticated American collectors of European art helps to explain Chase's shunning of subjects that would recall the boisterous, unruly crowds so closely identified with Brooklyn beaches and amusements. McCabe had observed as early as 1872 in his summary of recommended excursions in and around New York, "The famous resorts of Rockaway and Coney island are reached in from one to two hours by steamer. At either of these places a day may be spent on the sea shore. The surf-bathing is excellent at both, and each may also be reached by a railway. Of late years, Coney Island has become a favorite resort of the roughs of New York and Brooklyn, and, as a consequence, is not as attractive to respectable visitors as formerly."[98] Owing to rapid commercial development, however, Coney Island's reputation was vastly improved by 1882, as witnessed by a lengthy *Harper's Weekly* article in which the writer declared that, "Coney Island has achieved a national reputation goes without saying. It is as well known as Niagara Falls, Long Branch, or Saratoga, and one of its greatest wonders lies in the fact that this well-established fame rests upon a basis of so short a period of time."[99] To the credit of the New York banker Austin Corbin, whose lavish Manhattan Beach Hotel opened in 1877, the area experienced a renaissance.[100] By the time Chase was painting in the vicinity, tourists had their choice of numerous elegant hotels. Class distinctions between visitors were well defined and ultimately broke along the lines that subdivided the original area named Coney Island into four neighborhoods: Norton's Point (Seagate), West Brighton, Brighton Beach, and Manhattan Beach. The older section near the Pavilion, despite its fine view of the surrounding waters, was "still largely patronized . . . by a class who are glad to buy round-trip tickets for twenty-five cents, and obtain their bathing suits for ten or fifteen cents more." Steamboats to the island left the battery every half hour, and within an hour, passengers could alight at one of two huge Coney Island iron piers, owned and managed by the Iron Pier and Iron Steamboat System. The first of the two piers (the Iron Pier)

Pl. 30. Seashore (*originally* A Gray Day)*, c. 1888. Oil on panel, 22 × 27 inches.*
The Museum of Fine Arts, Houston, Gift of Mr. and Mrs. Ralph E. Mullen.

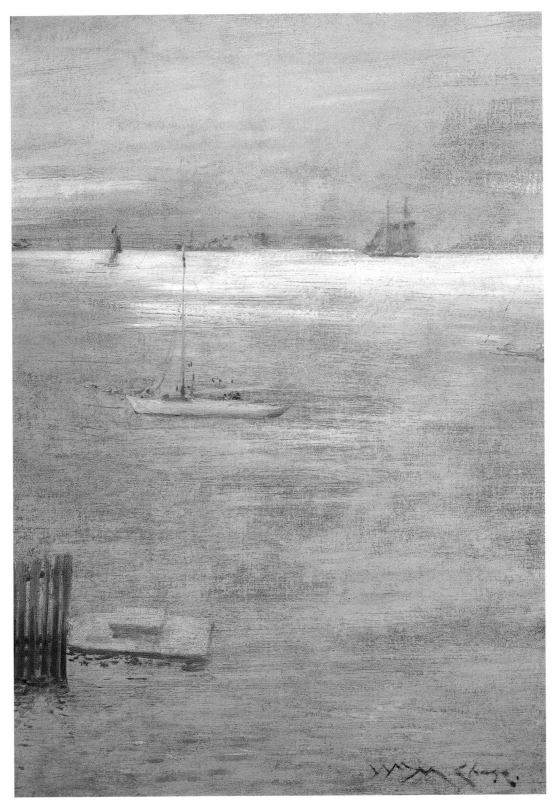

Pl. 31. Sailboat at Anchor *(probably), c. 1888. Oil on canvas, 26 × 17 inches. Courtesy Adelson Galleries, Inc., New York.*

Pl. 32. A Stormy Day, Bath Beach, c. 1888. Oil on panel, 14¼ × 10 inches. Private collection. Photograph courtesy Richard York Gallery, New York.

Pl. 33. Seascape, c. 1888. Oil on panel, 6⅜ × 9⅜ inches. Private collection. Courtesy Gerald Peters Gallery.

was described as "running out a great distance into the sea . . . built so firmly in the shifting sands as to defy the severest storms. It was furnished with saloons, restaurants, bathrooms, and a vast breezy promenade, lighted at night by electricity, and provided with an excellent band of music."

While the burgeoning Coney Island establishments offered plenty of harmless diversions for thousands of people, the crowds, as pictured in an illustration for the *Harper's* piece (fig. 36), left much to be desired for those who preferred less noise, less confusion, and less danger of unwanted contact with strangers. For those with enough money, the alternatives to the heaving masses were Corbin's exclusive Manhattan Beach Hotel and the even more elitist Oriental Hotel at Manhattan Beach, a fenced-in section on the island accessible only by a train that pulled into a station where Pinkerton men were posted to assure that only the "right" people entered the area. Indeed, the atmosphere there was markedly different, and, as the *Harper's* writer reported, the trip was well worth it.

[I]t is so quiet and so cool, the people are so well dressed, and the music of Gilmore's Band is so superior to that of any other on the island. . . . The lawns are more extensive here than elsewhere, the flowers brighter and more numerous. A fine board walk, built over the bulkhead, against which the great waves dash with a deep roar, frequently flinging their spray high above it, connects the Manhattan with the Oriental; but there we will not go unless we are millionaires prepared to stay a week or more; for the notices in the corridors and on the piazzas to the effect that transient visitors are not wanted would make us feel uncomfortable . . . and detract largely from the self-complacency with which we enjoy the comforts of the Manhattan, where "transients" are welcomed.[101]

The entire panoply of leisure and its forms of recreation, entertainment, and holiday accommodation contributed to the popular phenomenon of Coney Island (fig. 37). But it all must have been a bit too common for Chase's taste—or what his expectations were for the taste of his patrons. However, he capitalized on the Coney Island and Brighton Beach names by including them in the titles of several paintings—a move no doubt to tease the spectator into seeking out those paintings on exhibition walls—just as one is teased today by the artist's little *Landscape, near Coney Island* (Pl. 34), in

Fig. 36. Engraving after H. A. Ogden, On the Iron Pier, Coney Island—The Rush for the Last Boat, *from* Harper's Weekly 26 *(July 29, 1882). Brooklyn Museum of Art Library Collection.*

Pl. 34. Landscape, near Coney Island, c. 1886. Oil on panel, 8⅛ × 12⅝ inches. The Hyde Collection Art Museum, Glens Falls, New York.

Pl. 35. Coastal View. Oil on panel, 10½ × 16 inches. Courtesy Sotheby's, Inc.

Fig. 37. Engraving after F. Barnard, Art and Nature at the West End of Coney Island, *from* Harper's Weekly 31 *(July 16, 1887), cover. Brooklyn Museum of Art Library Collection.*

which young women wander in the sea grasses growing among the sandy dunes. It is only when the composition's low horizon is examined that a hint of the Coney Island of mass amusements emerges, here in the form of Colossus, the 122-by-150-foot elephant constructed of wood and tin, which was a novelty hotel containing thirty-four guestrooms.[102] Also marking the horizon not far from the elephant is the 300-foot Iron Tower, which had been a popular feature at the 1876 Centennial Exposition and subsequently transported to West Brighton.[103] Similarly, Chase's small coastal scene featuring a deserted sandy shore with a pier in the distance (Pl. 35) focuses on the natural scenery of the area within reach of encroaching commercial enterprises.

These paintings demonstrate Chase's persistence in seeking the unconventional or least-known characteristics of popular and/or historic sites. In that connection, an examination of the territory surrounding the spot shown in *Afternoon by the Sea* helps to situate it further by relating it to another work, *Bath Beach: A Sketch* (Pl. 36), which depicts the seaside walkway along Bensonhurst Drive and Park near the Fort Hamilton end of the suburban resort. The description for the painting in the catalogue of the artist's 1917 estate sale noted: "On the left is the blue-gray bay, looking up toward Fort Hamilton and across Forts Lafayette and Wadsworth to the Staten Island Hills in the distance, and steamers appear dimly at the entrance to the Narrows."[104] By the 1880s this coastal road was lined by elegant hotels (figs. 38 and 39) and yacht clubs. Farther inland were summer villas occupied mainly by upper- and middle-class wives and children who were joined on weekends by their husbands and fathers. Although the exact location of the house depicted in Chase's *Kathleen Cottage, Bath Beach* (fig. 40) remains undiscovered, the drawing documents one of the gracious summer residences for which the area was known and, indeed, records the appearance of the vacation "cottage" occupied by the Chases over the summer of 1889. The drawing reproduced here was one of a series commissioned by the *New York Herald* to illustrate articles previewing works by noted artists that were "recently completed or nearly finished [and which had] not yet appeared in a public exhibition." The article announced that the related painting of the same title (fig. 41) was in the collection of Frank Hecker of Detroit and would have its public debut at the next SAA exhibition.[105] Although in this work Chase maintained his relatively newly established allegiance to an Impressionist manner (evidenced in the

Fig. 38. Willowmere Hotel, Bath Beach, New York. Postcard. Collection of Louis D. Fontana.

Fig. 39. Bensonhurst Drive, Brooklyn, New York. Postcard. Collection of Louis D. Fontana.

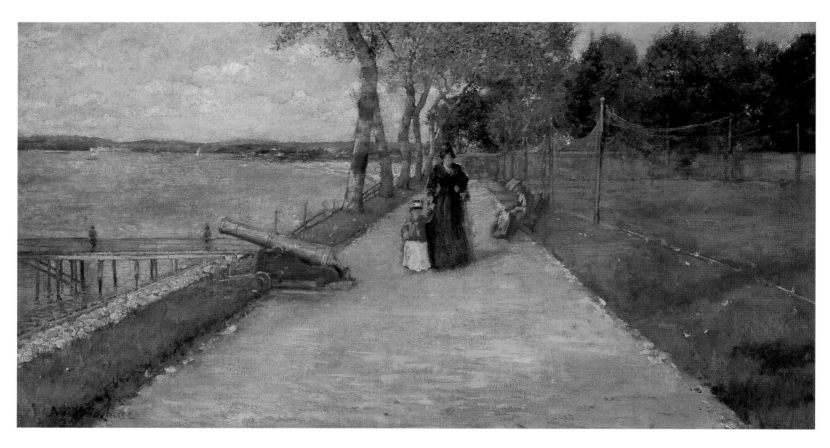

Pl. 36. Bath Beach: A Sketch, c. 1888. Oil on canvas, 27 × 49¾ inches. The Parrish Art Museum, Southampton, New York, Littlejohn Collection, 1961.5.24.

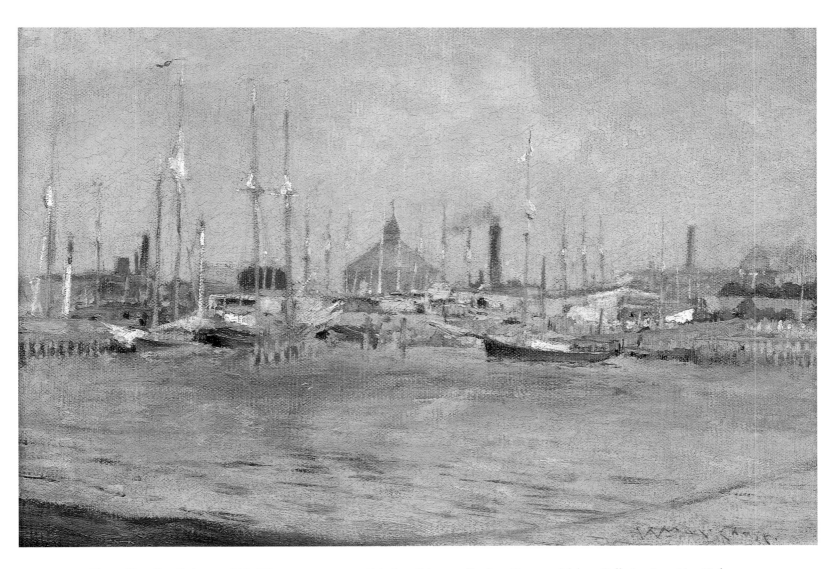

Pl. 37. Near Bay Ridge, c. 1888. Oil on canvas, 10 × 14⅝ inches. Private collection. Courtesy Adelson Galleries, Inc., New York.

writer's description of the "greensward flecked with sunlight"), he rejected the radical compositions that so firmly substantiated the spaces of his park paintings as venues of modern life. This marked (and rare) instance of a conventional compositional point of view may indicate a distinction between the ways the painter perceived public and private spaces.

Although it was reduced to a decorative function, the cannon on the walkway in *Bath Beach: A Sketch* was a potent reminder of the area's historic military role. The U.S. Army post, Fort Hamilton, was a major feature in Bay Ridge, which merges with the northernmost point of Bath Beach. Built on a site originally occupied by a Dutch blockhouse and subsequently by Fort Lewis, from which the British were repelled in 1812, Fort Hamilton was built between 1825 and 1831 and named for Alexander Hamilton in honor of his action in the Battle of Brooklyn. The fort was a training center during the Civil War, while the nearby Fort Lafayette (the water battery) was a prison for Confederate officers.[106] Chase acknowledged the historic presence of the military and its visible traces on the landscape not only by including the telltale cannon at the margin of his *Bath Beach* but also by featuring the guns in an unusual painting, *Peace, Fort Hamilton* (see Pl. 2). The close-up view of the cannons, surrounded by long grasses indicative of their retirement from use, was one of the five works Chase submitted for the exhibition when he returned to the NAD in 1888. A revolutionary work in terms of its subject and Impressionist style, the painting nonetheless virtually waved the American flag in the faces of critics calling for a national subject matter. Raising a mechanism of war to a peacetime icon, Chase simultaneously incorporated the content of the locale's past and present within a single image. A similar message was conveyed in a more narrative fashion by Frederick J. Sykes (1851–1926) in his *Fort Lafayette Looking East towards Shore Road, Bay Ridge, Brooklyn* of about 1885 (fig. 42), in which the stark, forbidding stone walls of the old prison preside over a scene reclaimed by peaceful activity represented by the solitary fisherman and the large white houses on the shore across the water. Chase's *Near Bay Ridge* (Pl. 37), although relying on the same formal strategies applied to his depictions of the Navy Yard, reiterates the leisure associations of the area by focusing on pleasure craft moored at the docks. Both painters, however disparate their approaches, focused on a landscape rarely treated by others. In their own ways, Chase and Sykes conveyed the idea of the transitional status of the land as it acquired a suburban identity.

Fig. 40. Kathleen Cottage, Bath Beach, 1889. *Pen and ink on paper, 7⅞ × 8½ inches. Collection of Mr. and Mrs. Stuart P. Feld.*

Fig. 41. Kathleen Cottage, Bath Beach, 1889. *Unlocated. Brooklyn Museum of Art Library Collection, Schweitzer Gallery Files.*

Fig. 42. Frederick J. Sykes, Fort Lafayette Looking East towards Shore Road, Bay Ridge, Brooklyn, *c. 1885. Oil on canvas, 10 × 16 inches. Courtesy Hirschl & Adler Galleries, Inc.*

A small group of Chase's landscapes from this period remains in relative obscurity, owing mainly to his attentiveness to the nondescript suburban character of the landscapes they portrayed and the scant mention they received in the 1880s press. Yet these views of the marginal no-man's-land between city and country deserve investigation inasmuch as they also qualify as factors in Chase's 1886 bid to reorient critical opinion of his art. A small oil on panel currently titled *Brooklyn Landscape* (Pl. 38) exemplifies the problematic nature of recognizing what may be considered some of Chase's most creative attempts to capture the modern American landscape of his experience—that is, the initial signs of what would ultimately become the late twentieth century's urban sprawl that covers the eastern corridor of the nation. Chase showed a work called *Hills— Back of Brooklyn* in his 1886 Boston exhibition, and it can be assumed that it failed to sell, since a painting of the same title appears in the 1887 listings

for the auction at Moore's, the 1890 auction exhibition at the American Art Association, and again in the listings for the 1891 auction of his works at Ortgies. This and other pieces from this subgroup (*A Bit of Green, Back of Brooklyn, Over the Hills and Far Away* [not to be confused with the Shinnecock landscape of the same title in the Henry Art Gallery collection], and *A Bit on Long Island*) also share the fact that they were displayed only in the 1886 Boston exhibition or in connection with Chase's sales at auction. A review of the Ortgies pre-auction show describes *Hills—Back of Brooklyn* as a scene "cut through and terraced by man, and again channelled [*sic*] and carved and clothed with grass by nature."[107] Appreciated primarily as painterly studies, Chase's "common little" landscapes were found "all quite natural."[108] Beyond that, however, this group of innovative works should be recognized as among the boldest of Chase's early experiments in the avant-garde treatment of outdoor space.

Pl. 38. Brooklyn Landscape, c. 1886. Oil on panel, 10 × 14 inches. Courtesy Vance Jordan Fine Art, Inc., New York.

CENTRAL PARK

At the same time that Chase was investigating Brooklyn's "strange" regions, he began to explore the artistic potential of one of the most famous pieces of American real estate—Central Park. Spurred by the republican idealism of early-nineteenth-century writers who called for a grand public garden wherein all citizens could partake of the natural beauties to which they were entitled, and which all could enjoy on an equal social footing, Central Park was the product of the acute realization that the rapid urbanization of Manhattan would quickly erase the opportunity for setting aside lands for the common benefit of the community. As early as 1836, the nature poet and newspaper editor William Cullen Bryant had privately expressed his opinion on New York's need for a park.[109] It was not until 1844, however, that Bryant published his proposal in an *Evening Post* editorial calling for the city to acquire an attractive forested tract of 160 acres on the Upper East Side along the East River. This area, known as Jones Wood, did not appeal to the city fathers for a variety of reasons, one of which was that the coastline of Manhattan possessed economic potential far too great to be "sacrificed" for public health and enjoyment.[110]

Bryant's arguments for a park, however, had a potent effect, for he played on strong American cultural insecurities by pointing out that even New York—the greatest city in the United States—failed to compete with European metropolises with respect to providing the amenities afforded by such spaces as Kensington Gardens, St. James's Park, Regent's Park, or Hyde Park, all of which were in one city alone, the great cultural capital, London.[111] Bryant's pleas for a park also originated in his belief that only sizeable open tracts of planted grounds could counteract the ills of urban blight by assuring the populace of free and ready access to fresh air and light. While Bryant was appealing to the city at large in his editorials, a smaller but no less passionate audience was found among the readership of the *Horticulturalist*, a periodical in which the writings of the talented landscape architect Andrew Jackson Downing (1851–1852) frequently appeared.[112] Downing expanded on the arguments of Bryant. Writing from London in 1850, he introduced a summary tour of the gardens at Kew, saying:

I will merely say, en passant, that every American who visits London, whether for the first or the fiftieth time, feels mortified that no city in the United States has a public park—here so justly considered both the highest luxury and necessity in a great city. What are called parks in New-York are not even apologies for the thing; they are only squares, or paddocks. In the parks of London, you may imagine yourself in the depths of the country, with, apparently, its boundless space on all sides; its green turf, fresh air, and, at certain times of the day, almost its solitude and repose. And at other times, they are the healthful breathing zones of hundreds of thousands of citizens![113]

Articles and editorials containing comments such as these solidified opinion favoring a park and also fueled extensive debates about its ultimate nature and location. In the long run,

Fig. 43. Map of The Central Park 1871–2 (*from the* Second Annual Report of the Board of Commissioners of the Department of Public Works for the Year Ending May 1, 1872). *New York City Parks Photo Archive.*

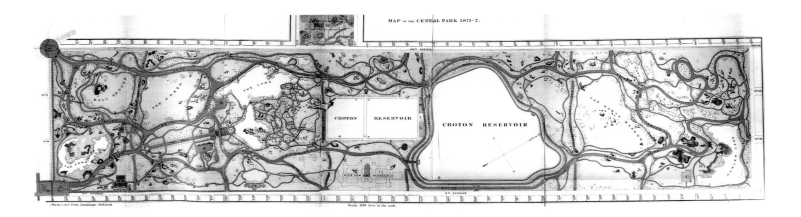

the creation of a "central" park was ratified, justified by its capacity to inspire a civilizing order among the working classes, its potential to improve health conditions, its promise of generating new wealth through the development of lands bordering it, and, finally, because it guaranteed New York's elevation to the status of other great cities of the world by demonstrating the attainment of a cultivated, refined urban environment.[114]

The nuances of each phase of the politically charged maneuverings surrounding the allocation of parklands were avidly followed by the press. Finally, in 1853, the New York State Legislature authorized the city to buy 524 acres bounded on the north and south by 106th and 59th Streets and on the east and the west by Fifth and Eighth Avenues. (The current boundaries were set in 1859 with the addition of acreage from 106th to 110th Streets; fig. 43). After an agonizingly slow, bureaucratic start, a Board of Commissioners was appointed in 1857 along with an advisory board whose members included Bryant, the reporter Horace Greeley, the botanist Asa Gray, and the novelist Washington Irving, who served as its president.

The partnership that yielded Central Park—Olmsted and Vaux—may be traced to Downing, as the two men were introduced at Downing's home in 1850. The professionally trained architect Calvert Vaux had met Downing in England that summer and was persuaded to return to the United States to work in Downing's Newburgh, New York, office, where he contributed to the landscape designs for the U.S. Capitol and the Smithsonian Institution. Downing's tragic drowning in 1852, Vaux's marriage to Mary McEntee (the sister of the Hudson River School painter Jervis McEntee [1828–1891]), and the 1857 publication of Vaux's *Villas and Cottages: A Series of Designs Prepared for Execution in the United States* led Vaux to move to New York City in 1857.

Olmsted had recently been hired by the Central Park commissioners as park superintendent, charged initially with the task of clearing the land in preparation for grading. He came to the job (obtained largely through friendly connections with members of the advisory board) as a talented and passionate amateur who, to that time, had been what could be called a gentleman farmer whose personal interests had drawn him to the field of landscape design. His amateur status aside, he was well versed in the history of landscape theory, having studied the works of such English authors as William Gilpin and Sir Uvedale Price, from which he absorbed the romantic landscape ideals expressed in the concepts of the picturesque, sublime, pastoral, and beautiful.[115] Olmsted's

interests had taken him to England, where he saw these theories put into practice for himself through his exploration of public parks, most notably Sir Joseph Paxton's newly opened People's Park at Birkenhead, near Liverpool. His reports of his travels through the English landscape appeared in several articles in Downing's *Horticulturalist* and thus established his relationship with the prominent landscape designer.

The Park Commission announced the competition for the Central Park design in October 1857, and it was through Vaux's invitation to Olmsted to collaborate with him on a competition entry that the two became professionally associated. Their Greensward Plan, submitted on April 1, 1858, was declared the winner of the competition later that month, and shortly thereafter construction began on the first great public park to capture national attention. While the physical and political history of the park is fascinating and well recounted elsewhere, the critical point that needs stating here is that making of the park itself was soon translated into a body of popular imagery that saturated the newspaper and periodical press. What is more, artists were soon drawn to the drama of the transformation of the landscape that took place before their eyes. Unlike the comparatively meager visual history attached to Prospect Park, Central Park generated greater interest from artists—partly through the novelty of the subject it offered, which was essentially a new genre for American consumption: the urban landscape, which in turn yielded a new set of outdoor social activities that increased American painters' range of subject matter available on home shores.

The impact of Central Park on the leisure aspects of New Yorkers' lives was revealed in various art forms almost immediately. Winslow Homer's (1836–1910) illustrations *Skating on the Ladies' Skating-Pond in the Central Park, New York* and *The Drive in the Central Park, New York* (figs. 44 and 45) appeared in the January 28, 1860, and September 15, 1860, issues of *Harper's Weekly*. Both leisure activities were extraordinarily popular and became part of the common visual experience of park life early in the construction of the site. As Roy Rosenzweig and Elizabeth Blackmar have noted in their history of Central Park, one of the first areas of the park to become operational was Central Park Lake at West 73rd Street, which was reportedly first used by approximately 300 skaters on a December Sunday in 1858. This fairly modest number ballooned to 10,000 by the following Sunday, and estimates have it that perhaps twice as many skaters crowded the lake on Christmas Day.[116] Whereas skating was within the economic reach of just

Fig. 44. Engraving after Winslow Homer, Skating on the Ladies' Skating-Pond in the Central Park, New York, *from* Harper's Weekly *(January 28, 1860), 56–57. Brooklyn Museum of Art, 1998.105.34, Gift of Harvey Isbitts.*

Fig. 45. Engraving after Winslow Homer, The Drive in the Central Park, New York, September, 1860, *from* Harper's Weekly *(September 15, 1860), 584–85. Brooklyn Museum of Art Library Collection.*

Fig. 46. *Jervis McEntee,* View in Central Park, *1858. Oil on canvas,* 13½ × 23¾ *inches. © Collection of The New-York Historical Society.*

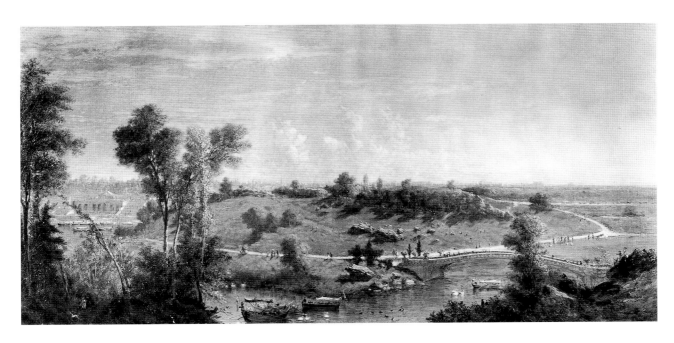

Fig. 47. *George Loring Brown,* Central Park, *1862. Oil on canvas,* 21 × 43 *inches. Museum of the City of New York, Gift of Miss Lillian Draper, 72.42.*

about everyone, driving was an expensive enjoyment available to the very few New Yorkers who could afford the expensive carriages and horses it required. The weekly and, for some, daily circuit of the park drives by carriage was conducted not only for the purpose of taking fresh air but also for participating in a deeply entrenched social ritual that offered the opportunity to see and be seen "in society." Driving, therefore, was essentially a competitive sport, the definition of which encompassed the gentlemanly activity of racing (an offense according to strict park codes) and also the more refined but equally competitive mission of social one-upmanship for men and women.

In the "higher" art of oil painting it is not surprising to find that Vaux's brother-in-law, Jervis McEntee, was among the first of the city's established artists to put the park on canvas. His *View in Central Park* of 1858 (fig. 46) is believed to have been made to accompany one of the competition plans submitted for the park's design and once bore a label inscribed in part: "View from Terrace site looking towards Vista Rock and showing proposed site for ornamental water."[117] Although it is technically an oil sketch, the painting's fluid brushwork and focus on a barren landscape that is neither urban nor rural in character ironically foretell the aesthetics later operative in Chase's depictions of the undeveloped suburban tracts of Brooklyn or the grassy Shinnecock dunes. McEntee's painting is fascinating especially because, in comparison with slightly later paintings of the same or neighboring terrain, it adds perspective to the radical changes that were wrought on the geography of Manhattan over a brief span of time. Just four years later George Loring Brown (1814–1889) painted his panoramic view of Central Park (fig. 47), in which he applied the standard compositional Claudean formula then in fashion with the artists of the mid-century Hudson River landscape school. Cast in the language of the historicized landscape, Brown's painting blended the established tradition of the topographical city view with the format of other mainstream works such as Asher B. Durand's *Progress* (1853, The Warner Collection of Gulf States Paper Corporation, Tuscaloosa, Ala.), George Inness's *Lackawanna Valley* (1855, National Gallery of Art), and Jasper Francis Cropsey's (1823–1900) later *Starrucca Viaduct, Pennsylvania* (1865, The Toledo Museum of Art). Brown's *Central Park* folded the park's birth into the vernacular of the allegorical landscape and thus conflated the imagery of ancient ruins of past civilizations with the rapid changes taking place at the heart

Fig. 48. Johann Mongles Culverhouse, Skating Scene, Central Park, *1865. Oil on canvas, 20 × 35 inches. Museum of the City of New York, The J. Clarence Davies Collection, 29.100.1301.*

Fig. 49. John O'Brien Inman, Moonlight Skating, Central Park, The Lake and Terrace, *c. 1878. Oil on canvas, 30 × 48 inches. Museum of the City of New York, Gift of an Anonymous Donor, 49.415.2.*

of one of the world's newest civilizations. Whereas this image of high-minded content, superimposed on a strict topographical framework, was probably meant to appeal to an audience of sophisticated collectors, such paintings as Johann Mongles Culverhouse's (c. 1849–1891) *Skating Scene, Central Park* and John O'Brien Inman's (1828–1896) *Moonlight Skating, Central Park, The Lake and Terrace* (figs. 48 and 49) catered to a taste more attuned to the here and now of contemporary living and

Fig. 50. George Harvey, Central Park, c. 1860. Watercolor on paper, 10⅞ × 17¼ inches. Courtesy Vance Jordan Fine Art, Inc., New York.

functioned as intermediary images between the illustrations of Homer (or the popular Currier and Ives prints of similar outdoor sporting scenes) and the loftier content intended in Brown's work.

Other artists responded to the park in more specific ways. For instance, George Harvey's (1801–1878) precisely painted watercolor *Central Park* (fig. 50) may at first appear to be a simple, picturesque record of the pleasures of nature afforded by a stroll along the park's winding pathways. Yet the artist has focused on one of the most innovative engineering designs associated with Olmsted and Vaux's Greensward Plan—the arched bridges (in this case Willowdell Arch near East 67th Street) that permitted a variety of vehicular and pedestrian traffic to flow separately without marring the aesthetics of the landscape. Such depictions correspond to the multitude of fine art illustrations devoted to the park that proliferated throughout the 1860s and 1870s that provided genre vignettes of particular architectural features nestled within the landscape, placed there not only to create a picturesque view from another vantage point but also to accommodate the park's users as they paused to contemplate the vistas afforded from the spot. Some of these vignettes were commissioned

for early guides to the park, among which were Clarence Cook's *Description of the Central Park*, published in 1869, which contained one hundred engravings after drawings by the then noted Albert Fitch Bellows (1829–1883), and artist T. Addison Richards's (1820–1900) *Guide to the Central Park* of 1876.[118] While publications such as these are indicative of the park's growing identity as a tourist attraction, other imagery emerged that signified its daily use by local populations.

The German-born painter William Hahn (1829–1887), although best known for his elaborate genre paintings documenting the racial and social mix of California life, applied a similar approach in his *Pony Path in Central Park* (fig. 51), which he executed during a two-year sojourn in New York prompted by the depression that hit San Francisco in 1877. Here the park is the province of mothers, nursemaids, and children, with the rambunctious antics of a little girl riding her white pony providing the narrative raison d'être. While the overt subject of the narrative is the confusion caused by the little girl's recklessness, Hahn also contrasts the pastoral nature of the park and its intended role as a place for quiet contemplation with the realities of its use. As the sheep scatter to avoid the running pony, they draw attention to the left

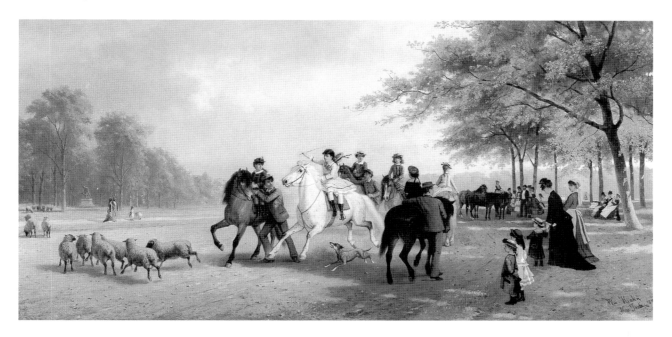

Fig. 51. William Hahn, Pony Path in Central Park, *1878. Oil on canvas, 22 ×
44 inches. Thomas Gilcrease Institute of American History and Art, Tulsa.*

portion of the composition, where, in the distance, stands
John Quincy Adams Ward's (1830–1910) *Indian Hunter,* an
enlarged version of his 1860 sculpture that was commissioned
for installation in the park in 1869. Embedded within this
ostensibly innocuous narrative of childish mischief are issues
surrounding the purpose of the park that were central to dis-
sension that arose between Olmsted and the park administra-
tors at the time. Among these was Olmsted's antipathy to the
decoration of the parklands with what he considered extrane-
ous sculpture, the presence of which interfered with his con-
ception of the park's design as a work of art in itself. In addi-
tion, Olmsted and Vaux's original vision for the park as a
precinct for the refined enjoyment of nature was being com-
promised by the growing incursion of recreational pursuits
smacking of "entertainment" that conflicted with Olmsted's
rigid standards of appropriate public behavior. Growing out of
the 1870 transfer of the park's administration from the hands
of the commissioners to the purview of the city government
under Boss Tweed's Tammany rule, the disputes ultimately
devolved on politically directed deployment of funds, which
encompassed payment of park workers' salaries and the basic
upkeep of the park. Shaped by the larger impact of the finan-

cial depression that swept New York in the late 1870s, this
complicated chapter in the park's (and, indeed, the city's) his-
tory saw Olmsted fired from his position as superintendent of
Central Park in 1877 in a climate when New York's citizenry
was questioning its ability and desire to maintain the park at
such great public expense. The elitist attitudes that had
stirred the park's inception (under cover of republican princi-
ples) were rejected, and, as Rosenzweig and Blackmar have
observed, the events of the 1870s opened the way for the
democratization of park use as a result of the evolving defini-
tion of civic institutions and their functions.[119] The democratic
outlook that reshaped the common public perception of the
park in the 1870s is a local microcosm of the battle between
elitism and populism that has been consistently waged in
American culture since the colonial era. That the political
skirmishes in New York often centered on the park is no sur-
prise, given the tremendous value of the real estate along the
avenues bordering it, which, despite the severity of the eco-
nomic crash, continued to increase in value, as witnessed by
the inexorable northward development of residential areas
that were mainly the abodes of the wealthy. As visible
reminders of the aristocratic (though benevolent) attitudes of

Fig. 52. Burr H. Nicholls, Near Central Park, *reproduced in George W. Sheldon,* Recent Ideals of American Art *(New York and London: D. Appleton & Company [1888–90]). Brooklyn Museum of Art Library Collection.*

Fig. 53. Cottages on Eighth Avenue near 78th Street, seen from the Cave in the Ramble, Central Park during construction. Photograph, 1860. Museum of the City of New York.

the park's founders, the burgeoning number of mansions flanking its boundaries afforded Democrats of the 1870s the opportunity to underscore the motivations of personal gain that attached to the origins of the park.

Hints of such sentiments emerge in commentary directed to the few park subjects displayed at the NAD in the years surrounding Chase's first artistic excursions into Central Park. A reviewer for the *New York Times* criticized Jan Chelminsky's (1851–1925) 1885 park paintings, saying, "Mr. Jan Chelminsky has a scene from Central Park cleverly painted, but not imbued with local color, the ladies and gentlemen may do for some German drive, or, by a stretch of the imagination, for the Bois de Boulogne, but they are not New-Yorkers. The same is true of his *Bridle Path*, a scene of riders in Central Park."[120] By implication, the writer faulted Chelminsky for depicting a certain class of people, whose social status (hinted at in their designation as "ladies and gentlemen") suggested upper-class privilege and whose actions and appearance separated them from the majority of park visitors. At the other social extreme was Burr H. Nicholls's (1848–1915) *Near Central Park* (fig. 52), reproduced in George W. Sheldon's *Recent Ideals of American Art.* An unusual subject because it featured the shanties of the poor who were being displaced then as they had been in 1858, when the ground for the park was first appropriated for clearing (fig. 53), the painting afforded Sheldon the opportunity to make a rare but pointed social observation: "Mr. Burr Nicholls's study of the shanty *Near Central Park* represents a rapidly-vanishing phase of our metropolitan civilization. Masons and carpenters are now taking possession of the lots in the neighborhood of the park, and large stone and brick dwellings, with all modern improvements, will soon occupy the sites so long and so modestly held by the squatters."[121]

CHASE IN CENTRAL PARK

Introductions to this aspect of Chase's subject matter often begin with the highly publicized dispute between the artist and the officious Brooklyn parks superintendent, Aneurin Jones, which occurred in the summer of 1890. Jones had refused Chase his usual permit to paint in Prospect Park in June, citing an unwritten and apparently fictional rule of his own making, which barred professional artists from sketching in the park.[122] What ensued was the proverbial tempest in a teapot elevated to a cause célèbre, with park officials and

Chase exchanging barbs in the press. Chase's side of the story appeared in the June 19 *Brooklyn Daily Eagle*:

I have had permits to paint in Prospect Park for the past two years. They were made out for the entire year, were on the printed blank forms and were given me at the park office. This year I wanted to paint the rhododendrons above the terrace wall, for which I have been too late the previous seasons, and so I went over early. I did not find Mr. Jones at the park office, but found his clerk, who refused the permit. . . . The clerk said permits were not granted to professionals.[123]

The article goes on to say that on finally speaking with Jones, Chase was told to submit his application by mail. Having done so without reply after ten days, Chase returned to the park office, where the park policeman indicated that he would receive no reply since he had failed to enclose return postage. Conflicting newspaper accounts magnified the absurdity of the situation, which brought embarassment to George V. Brower, the park president, who in one interview professed ignorance of Chase's fame as an artist. Claiming his own informed cultural privilege through his membership in the local Rembrandt Club, Brower implied that had Chase been legitimately famous, he would have been known to him.[124] To this Chase indignantly responded that he had been invited to lecture at that very Rembrandt Club the year before.

Judging from the bits and pieces concerning the contretemps that peppered art gossip columns through August, part of the problem may have had to do with Jones's own amateur efforts at landscape painting, which fed his animosity for the more successful artist. A short article titled "The New Autocrat at the Park" observed that "subsequent experience has demonstrated that he is something of an artist, a good deal of a crank, and wholly a Welshman."[125] The humorous potential of the situation was quickly seized on, and as late as August an *Art Amateur* columnist was still gleefully poking fun at Jones:

The following lines are addressed by the Sun to the Superintendent of Prospect Park, Brooklyn, who recently refused Mr. Chase permission to paint there: "You are at least consistent Mr. Jones,/To let no artist in your fair park work,/We judge that none has even been there yet,/From what we've seen of your queer landscape work." The epigram is neat, but in point of fact, if there is not some excellent landscape gardening at Prospect Park, Mr. Chase, judging from his many delightful little pictures

taken there, must, while painting from nature, have drawn upon his imagination.[126]

Had Jones been cooperative, Chase, who obviously reveled in the publicity, would not have received the press's sympathetic attention, nor would he have had the opportunity to invite so much general attention to his park subjects. Most of the newspaper articles provided complimentary descriptions of Chase's work, which, for example, identified him as "the well known artist in whose canvases the choicest bits of Prospect Park scenery have been reproduced for several years past."[127] However it is not true, as is generally assumed, that the Jones episode precipitated the redirection of Chase's focus to Central Park, for the reproduction in Clarence Cook's 1888 *Art and Artists of Our Time* of *Lilliputian Boat Lake, Central Park* (fig. 54) attests to the fact that the artist had already painted at least one major canvas featuring the New York park perhaps as early as 1887.[128]

The painting, as it was reproduced in Cook, displays the tranquil Ornamental Water, a small pond just inside the park's border near Inventors' Gate at 72nd Street and Fifth Avenue. The rolling slope of green lawn at the end of the pond marks its northern point, where José de Creeft's (1884–1982) popular 1959 sculpture *Alice in Wonderland* stands today. The composition itself incorporates what are now recognized as Chase's signature devices: space is divided into areas created by odd angles, with the sense of depth contrived by the emphatic orthogonals that thrust the viewer's eye from the foreground to the distance. Here, however, in contrast to *City Park*, for example (Pl. 1), Chase deliberately moderates the eye's movement by placing figures along the edge of the pond as if to harmonize the formal elements with the relaxed atmosphere of the scene. Indeed, nothing here is raucous or hurried, except the small figure of the running boy at the distant end of the lake. The boats glide silently on the gentle waters; the boys attend to their own boats or quietly watch the others; everyone seems wrapped in his or her own private sphere—everyone, that is, except the little girl in the foreground, whose look of annoyance or wariness contradicts the otherwise peaceful mood. Her posture of watchfulness alerts us to the presence of another person who has interrupted her thoughts. The directness of her expression suggests a momentary exchange of gazes between her and the unseen observer. This pointed recognition of a viewer that exists outside the pictorial space (in fact, a viewer who inhabits our

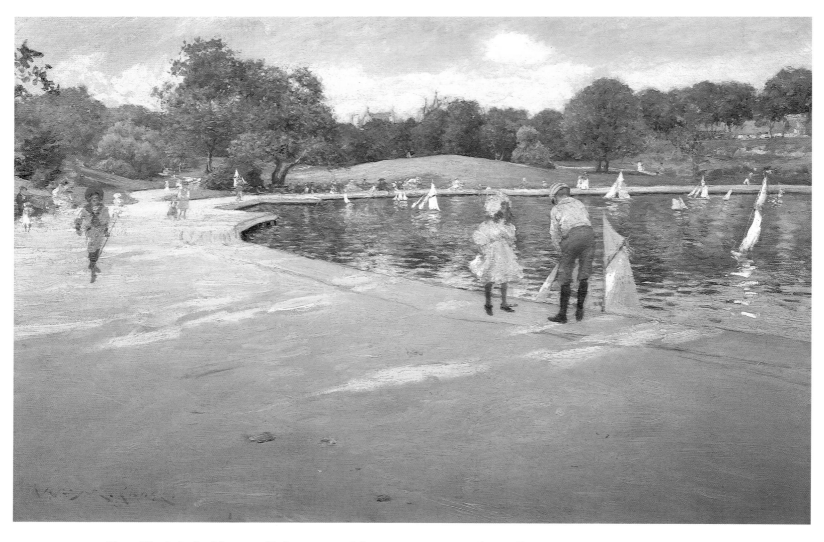

Pl. 39. The Lake for Miniature Yachts, *c. 1888. Oil on canvas, 16 × 24 inches. Collection of Mr. and Mrs. Peter G. Terian.*

space), breaks the serenity of the painting and functions as a theatrical aside in which an actor addresses the audience directly.[129] The implications attached to this conceit—that of observing the observer—are manifold and are embraced within Chase's conception of modern public space.

In his brief caption for the painting, Cook remarked on the variety of Chase's subject matter, noting that "of late he has opened a new vein in pictures combining landscape and figure where the scene is laid in the Central Park in New York and in Prospect Park."[130] Cook's statement is critical, not because he called attention to Chase's new city parks subjects, but because he acknowledged Chase's innovative ploy of integrating the figure in the landscape in a manner that inserted common contemporary experience into the realm of art. Chase's inventiveness in this area is today veritably concealed because such paintings as *Lilliputian Boat Lake, Central Park* and its "companion," a painting now known as *The Lake for Miniature Yachts* (Pl. 39), replicate our own experience to a large degree (see, for example, fig. 55) and because the iconography of (especially French) Impressionism itself is filled with similar imagery.

The original painting on which Cook based his comments (Pl. 40) has recently come to light and exhibits two substantial modifications, neither of which can be dated or securely attributed to Chase. One, the elimination of the figure and sailboat on the walkway on the right, is most likely the artist's reworking of the composition and aids in accentuating the radical linear pull of the eye from foreground to background. The second alteration, focusing on the little girl sitting at the edge of the pond, is more problematic, not only because of its slight awkwardness, but also because it ultimately reorients the mood of the painting. By making the child's expression less challenging, reconstructing her pose so that she holds a colorful floral bouquet, replacing her plain pinafore with a ruffled white dress, giving her a fetching straw hat, and changing her hair from dark to light, the painter (Chase or another) softened and prettified the image. As a result, the modern spirit of the work is diluted. Both changes, however, are directly related to how public space is interpreted and signify that the power of Chase's modern vision in the painting's first incarnation was judged too strong either by him or by another who later owned the work. Regardless of the difference between the original version of *Lilliputian Boat Lake, Central Park* and the painting as it is now, it must be noted that American artists working at home in the mid- to late 1880s

Fig. 54. Lilliputian Boat Lake, Central Park, c. 1888. Reproduced in Clarence C. Cook, Art and Artists of Our Time (New York: Selmar Hess, Publisher [1888]). Brooklyn Museum of Art Library Collection.

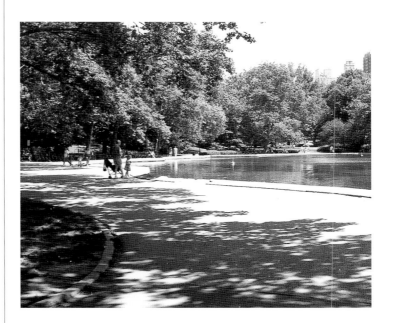

Fig. 55. Conservatory Water, Central Park, New York, 1999.

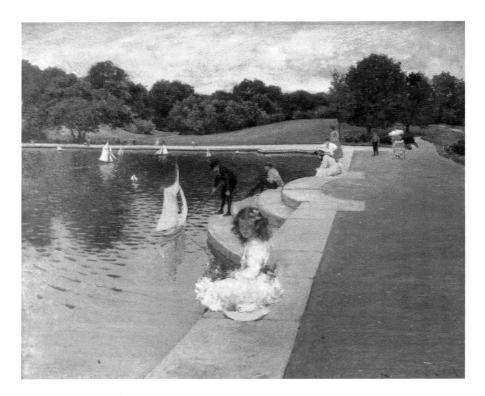

Pl. 40. Lilliputian Boat Lake, Central Park *(also known as* Lilliputian Boats in the Park *and* Lilliputian Boat Race*), c. 1888. Oil on panel, 19 × 22¼ inches. Private collection.*

had not yet thoroughly invested in this iconography. Only Winslow Homer can be looked to as a pioneer in this area, brought to it through his work as an illustrator, which then helped to construct his subsequent explorations in oil of contemporary recreation at beaches or on croquet lawns. By the late 1880s, however, Homer had largely abandoned this type of subject matter, leaving the field to others.

Chase's virtually unique position as an artist who integrated urban landscape with contemporary genre is demonstrated if the paintings shown in the American section of the World's Columbian Exposition of 1893 (where *Lilliputian Boat Lake, Central Park* was exhibited as *Lilliputian Boats in the Park*) are taken as a model cross section of artistic production in the United States. To be sure, Chase did not invent the genre of the figure in the landscape. Yet in surveying the works included in the Chicago display, it becomes clear that Chase's landscape-figure paintings were determinedly separate from the majority of the exposition works, where the dominant mode of landscape-figure subjects was derived from

French and Dutch peasant genres (for example, Daniel Ridgway Knight's [1839–1924] *Hailing the Ferry* [1888, Pennsylvania Academy of the Fine Arts]). Divested of a sense of specific time and place, such works were attractive, romanticized visions of foreign rural life. Even within the distinctly American context of New England, Eastman Johnson's masterful 1880 *Cranberry Harvest, Nantucket Island, Massachusetts* (Timken Museum of Art, San Diego), recalled Jules Breton's (1827–1906) panoramic views of European peasants working in the fields. Also prominent at the exposition were images of female nudes in wooded settings, some of which claimed a mythological theme, and all of which simply offered the excuse to portray an academic nude. Winslow Homer (who was represented by fifteen canvases at the exposition) was revealed as perhaps the greatest and most visible painter of the figure in the American landscape at the time, but his were timeless images of the wilderness and sea that invoked thoughts of mankind's relationship with nature. Among the artists of Chase's generation who deviated from these icono-

graphic norms was Thomas Wilmer Dewing. Dewing's dream-like *After Sunset* (1892, Freer Gallery of Art, Smithsonian Institution, Washington, D.C.) also differed radically from Chase's ostensibly matter-of-fact point of view. Only a few artists joined Chase at the exposition by contributing work that may be said to have broached the subject matter of *modern* American life. Of them, only Childe Hassam has ascended into the art-historical canon. Yet Hassam's decidedly Francocentric *Fifth Avenue in Winter* (fig. 56) operates within the broader spectrum of pure cityscape when it is compared with Chase's composition, which displays a more equable balance between figure and landscape. In the search for paintings at the exposition that approached Chase's in terms of subject and attitude, one must look to the submissions of two minor artists, Orin Sheldon Parsons (1866–1943) and Luther Emerson Van Gorder (1857–1931), who were represented by *Lawn Tennis* (1891, unlocated) and *The Terrace, Central Park, New York* (1891, unlocated), respectively. Significantly, both artists were Chase students and their paintings were executed a good six to seven years after Chase first investigated this type of subject matter.

As this brief discussion indicates, Chase virtually stood alone among his contemporaries as a purveyor of imagery that described American life in the urban public milieu. And, although he was not unique in his embrace of park subject matter, his blending of the public landscape with a genre mode placed this segment of his art outside the visual mainstream. This accounts for the security with which Charles De Kay stated: "He [Chase] has discovered Central Park."[131]

De Kay's article illustrated four of Chase's Central Park paintings: *The Lake for Miniature Yachts* (Pl. 39), *A Bit of the Terrace* (Pl. 41), *In the Park—A By-Path* (see Pl. 46), and *The Nursery* (see Pl. 47). Of these he noted that only *A Bit of the Terrace* represented a spot that was regularly frequented by the park's visitors. The other locations were, he said, "rarely troubled by any but special lovers of the Park, though 'The Lake for Miniature Yachts' . . . can be seen from Fifth Avenue. Indeed, the gay sight of little sails teetering, and little boys and girls rushing along the margin can be appreciated without passing the limits of the Park."[132] De Kay's comment is a cue toward recognizing that Chase applied a strategy in his Central Park paintings similar to that which he used in his Brooklyn park works. That is, he divided his attention between well-known, "iconic" sites and those that could be identified only by visitors who explored the inner reaches of the parks. Once

he had moved his family into Manhattan, Chase's opportunities for such explorations were greater, and, as Roof points out, it was only after he began living in New York that Central Park was assumed within his subject matter.[133]

A noticeable difference between the Central Park paintings and the Brooklyn works, however, is the painter's heightened regard for the figure. This feature may be the result of several factors, one of which was the increasing currency of figure painting as a whole within Chase's circle of colleagues. That, combined with what might be expected to be his growing ease with portraying or even considering the figure in the landscape, may have been the logical result of his earlier, more experimental park paintings. Such speculation invites consideration of the possibility that figural emphasis accompanied a formal maturation of sorts, which would have taken several seasons of thinking and looking on Chase's part to become fully formulated within his newly adopted format of the park landscape. Again, this process involved the composite image, which was the product of Chase's absorption of both formal and thematic ideals that he discovered in other examples of contemporary art.

It is in this light that a comparison of Chase's *A Bit of the*

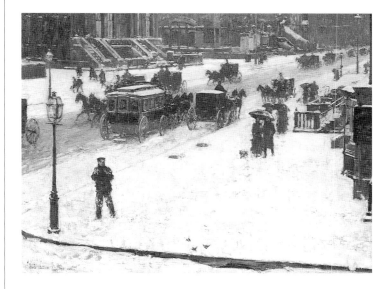

Fig. 56. *Childe Hassam*, Fifth Avenue in Winter (*also known as* Snowy Day on Fifth Avenue), *c. 1892. Oil on canvas, 22 × 28 inches. Carnegie Museum of Art, Pittsburgh; Museum purchase, 00.2.*

Pl. 41. A Bit of the Terrace, *c. 1890. Oil on canvas, 20¼ × 24½ inches. Private collection.*

Terrace (Pl. 41) and Giovanni Boldini's (1845–1931) *Noonday Promenade: Versailles* (fig. 57) is offered. Although Boldini's stylishly imaginative reconstruction of a late-eighteenth-century promenade in the royal gardens surrounding the French palace of Versailles has on the surface little to do with the quiet, almost domestic atmosphere with which Chase imbued the terrace overlooking the lake in Central Park, the two paintings are extraordinarily similar in composition. Chase appears to have renovated Boldini's scheme, taking an artfully conceived landscape with all of its formal features (horticultural as well as architectural) and translating it into an American image. The romantic frivolity and the elitist associations in Boldini's picture of aristocratic strollers are traded by Chase for a wholesome serenity emphasizing the park as an appropriate space for middle-class women and children. Highly significant is the foreground void, a modern compositional device that, in the hands of both artists, is punctuated by a small child at play. Coincidentally(?), each artist introduced a bright spot of red to the buff-colored foreground through those children—with the red ball in Chase's work (which fulfills the role of the dog in Boldini's motif) establishing a parallel color vehicle for the red sash worn by Boldini's toddler.

Chase's admiration for Boldini's art is not well documented, but in a letter written in the late summer of 1882 to Chase in Paris from Robert Blum in Madrid, Blum inquired if Chase had paid his intended visit to the Italian's Paris studio in 1882.[134] Moreover, Chase and Beckwith included one Boldini in the 1883 Pedestal Fund Loan Exhibition. Chase himself reported to A. E. Ives in an interview that he had shared "photographs of views of New York and the country in its immediate vicinity" with Boldini in Paris. Chase quoted Boldini's response as, "Ah! . . . if I lived in such a country as that, what pictures I would paint!"[135] Chase's reference to Boldini's reaction seems a bit self-serving, inasmuch as it validates his own choice of subject matter. Be that as it may, the anecdote, so deliberately reported by Chase, indicates his pride in the urban and suburban subject matter he had recently addressed, but which he had already quit by the time Ives's article was published in 1891. However, the most noteworthy point that establishes a possible connection between Chase and this particular painting by Boldini is the fact that *Noonday Promenade: Versailles* was probably in the collection of the architect Stanford White by the 1880s.[136] Chase's knowledge of White's collection as it developed throughout

Fig. 57. Giovanni Boldini, Noonday Promenade: Versailles, *1876. Oil on cradled panel, 19 × 34 inches. Photograph courtesy of Sotheby's, Inc.*

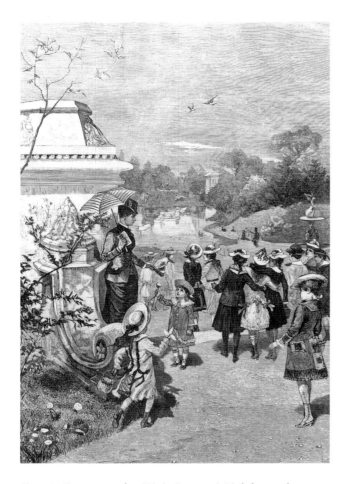

Fig. 58. Engraving after W. A. Rogers, A Holiday in the Central Park, *from* Harper's Bazaar *(June 28, 1879), 413. Brooklyn Museum of Art Library Collection.*

that decade cannot be doubted: the two were friends as well as professional colleagues and White owned a number of Chase's paintings and pastels (including at least one Brooklyn coastal scene).

Chase limited his selection of "iconic" views of Central Park to the terraced area below the mall, which had as its focal point the grand architectural environment created by Jacob Wrey Mould.[137] Consisting of the massive staircase, "marble arches," and terrace bordering the lake, which in turn was anchored by the famed Bethesda Fountain topped by Emma Stebbins's (1815–1882) *Angel of the Waters*, it was the most formal part of the park design as well as one of the first parts to be fully articulated within the converted landscape. Even here, however, the painter took an idiosyncratic approach in his several depictions of the site, for, rather than displaying the entire layout of the terrace and its relation to the surrounding geography, Chase presented it in piecemeal fashion (as he had done with Tompkins Park), showing only portions of it from varying angles—and then avoiding the typical view made familiar through roughly contemporaneous illustrations and photographs (figs. 58 and 59). Thus, in such works as *A Bit of the Terrace* (Pl. 41), *An Early Stroll in the Park* (see Pl. 51), *On the Lake, Central Park* (see Pl. 52), and *Terrace at the Mall, Central Park* (Pl. 42), the spectator is afforded a perspective that impedes rather than contributes to the full understanding of spatial relationships in the park's most famous and grandest location. As he did more pointedly in his Brooklyn park pictures (in which the Navy Yard interiors also form a part), Chase alludes to the larger space, relying on the "knowing" observer to identify it completely. By doing so, he could avoid being considered a scene painter (a damning category for one so bent on variation and originality) and open his subject matter to a wider audience by making it less localized and thereby more universal in appeal. A second by-product of Chase's approach is the apparent immediacy or casualness of the scene, which implies the momentary glance of someone who physically occupies that space—in contrast to the "view" provided by the detached recorder of a scene whose goal is to define the space, rather than to characterize the experience of operating within it. It is in this way that *The Lake for Miniature Yachts* (see Pl. 39), *The Nursery* (see Pl. 47), *In the Park—A By-Path* (see Pl. 46), and *Park Bench*, tentatively identified as *An Idle Hour in the Park—Central Park* (see Pl. 45) should also be considered.

An extreme example of this geographic subterfuge is rep-

resented in *A Gray Day in the Park* (Pl. 43), a notably abstract composition by virtue of its determinedly flat design, broad passages of color, and minimal detail. Unlike the imperatively rigid orthogonals of many of Chase's compositions, the serpentine curve of the walk encourages the eye to meander lazily into the pictorial space and buttresses the somber mood of the painting. A young woman walks alone on the broad pathway, her presence creating a suggestive element on which a narrative could be pinned to link the grayness of the day with an emotional state. To be sure, this work may be appreciated without the specific information as to where this intimate drama of urban life is performed. It is sufficient to know that it is a park, that the woman walks alone on a day that threatens rain, and that the energy of the city courses not far from this oasis of solitude. On another level, however, Chase insists that the spot be recognized by including the partially obscured rooftop of a park building—just enough information that would have enabled contemporaneous park familiars to

identify the spot with absolute surety. Ironically, the location of the site shown in the painting has been open to question in the late twentieth century mainly because the park building was confused with the Thatched Cottage of Prospect Park, a confusion heightened by the fact that neither building stands today.[138] In the end, Chase's subject is located by comparing his painting with Hassam's *Central Park* of about 1892 (fig. 60), which shows the same site from a more distant vantage point at the southeastern end of Conservatory Water. Hassam, however, was concerned with the larger, more typically scenic display provided by mothers and children who take pleasure in strolling around the small lake. But both artists took obvious care in recording the specifics of the trees and bushes in the area, with Hassam's painting documenting the growth that had occurred over the period between the making of the two paintings.

Although it is probably true that Hassam followed Chase's lead in assuming Central Park into his visual reper-

Fig. 59. J. S. Johnston, Bethesda Fountain Mall, Central Park, 1894. Photograph. Museum of the City of New York.

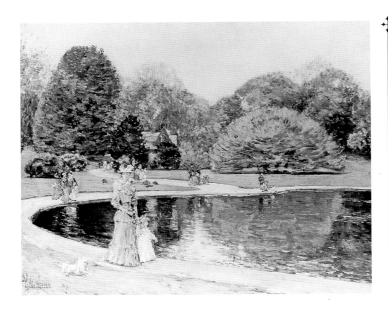

Fig. 60. Childe Hassam, Central Park, *c. 1892. Oil on canvas, 18 × 22½ inches. Photograph courtesy Christie's, Inc.*

toire, it is likely just as true that Chase found inspiration in Hassam's art for *A Gray Day in the Park.* As was noted in chapter 2, Hassam had preceded Chase in his investigations of American urban scenes, creating a number of "advanced" paintings in Boston prior to his departure for Paris in the fall of 1886.[139] Hassam's absence from the United States left the way clear for Chase to continue his parallel explorations independently. In 1888 a writer had mentioned Hassam's attraction to "modern life in the gay streets of Paris. The parks and the gardens give him many suggestions and material wherein his figures can move or loiter in shadow or light."[140] Before Hassam returned to the United States, a selection of his foreign canvases was shown at Boston's Noyes, Cobb & Co. in March 1889, and it is likely that at least one of his paintings of the Parisian Parc Monceau was included in the well-received exhibition. Characterized by smooth gravel pathways snaking through grassy lawns and inhabited by isolated figures of women or nursemaids with infants, Hassam's images of the French park (for instance, the 1889 *Parc Monceau* [private collection]) are strikingly similar to the approach taken by Chase in *A Gray Day in the Park*—enough so as to suggest that Chase had seen the Boston exhibition and revised Hassam's compositional ploys to suit this particular view of Central Park. Chase's and Hassam's visions, although cognate,

diverged in terms of mood and painterly style, with Chase fashioning an uncommonly melancholy image of the private experience of the park and Hassam re-creating a common, albeit pleasurable, sunlit scene of the French park's day-to-day use.

For the most part Chase forged his own way in introducing Central Park to the art audience of the 1880s. Occasionally he recalled the spare design he had earlier used in *Prospect Park* (see Pl. 17) and in *The Common, Central Park* (Pl. 44), both of which—despite their strong similarities in overall conception—accurately record the subtle topographies of each site. In the case of the latter work, Chase designates the broad expanse of meadow as a verdant relief from the real estate developments spurred, ironically, by the park's establishment. Although he seldom incorporated the city proper into his park views, on the few occasions that he did, it was entirely in keeping with his technique of defining the interiors of the parks in accordance with the fundamental aims of their designs: Prospect Park allowed no urban view, not only because of its design but also because the area had not been fully developed; Tompkins Park, modeled on the plan of a residential square, was by its nature overlooked by the relatively small multistory houses surrounding it. In this connection the lives of the well-dressed children and their nursemaids depicted in *The Lake for Miniature Yachts* (see Pl. 39) are linked with the social milieu that generated the growing number of stately residences along Millionaires' Row on Fifth Avenue, the rooflines of which had begun to intercede between trees and sky.[141]

Chase's inclusion of these architectural landmarks secured the viewer's recognition of the sites, and, while they do not dominate his compositions, they verify the reality of his outlook at least in geographic terms. From the evidence provided by the paintings' supplying of such recognizable guides, it can be assumed that the same truthfulness presides in all of Chase's landscape renderings. Chase's fusion of the "real" landscape and genre motifs, however, must be examined. While the choice of which part of the landscape to portray (however truthfully) is a subjective choice in itself, the addition of a deliberately arranged model or models to manufacture a "picture" further distances the resulting image from the zone of the real. Consideration of varying aspects of realism and its meaning to Chase and his audience provokes questions centering on whether his images reproduced the experience of the late-nineteenth-century park visitor or whether they represented a desired ideal that may or may not have conflicted with the philosophies of the parks' creators.

Pl. 42. Terrace at the Mall, Central Park, *c. 1888. Oil on panel, 11½ × 16½ inches. Private collection.*

Pl. 43. A Gray Day in the Park, *c. 1890. Oil on panel, 17½ × 17½ inches. Private collection.*

Pl. 44. The Common, Central Park, *c. 1889. Oil on panel, 10⅜ × 16 inches. Private collection.*

1. Kenyon Cox, "William Merritt Chase, Painter," *Harper's New Monthly Magazine* 78 (March 1889), 556.

2. "The Slaughter of Mr. Chase's Pictures," *Art Amateur* 24, no. 5 (April 1891), 115.

3. For a general overview of Brooklyn's history, see Margaret Latimer's entry in Kenneth T. Jackson, ed., *The Encyclopedia of New York City* (New Haven and London: Yale University Press; New York: The New-York Historical Society, 1995), 148–52.

4. For a well-written account of the economic and political factors leading to the Dutch acquisition of these lands, see Edwin G. Burrows and Mike Wallace, *Gotham: A History of New York City to 1898* (New York and Oxford: Oxford University Press, 1999), 14–74.

5. John A. Kouwenhoven, "Brooklyn before the Bridge," in *Brooklyn before the Bridge: American Paintings from the Long Island Historical Society*, exh. cat. (Brooklyn: The Brooklyn Museum, 1982), 12.

6. See Kenneth T. Jackson's introductory essay in John B. Manbeck, consulting ed., *The Neighborhoods of Brooklyn* (New Haven and London: Yale University Press, 1998), xxi. Estimates of the number of deaths on the British prison ships in Wallabout Bay range from 4,000 to 11,000. These figures are enormous when it is noted that by 1810, the population of Brooklyn was less than 5,000.

7. Kouwenhoven, "Brooklyn before the Bridge," 10.

8. Burrows and Wallace, *Gotham*, 1128.

9. For a short cultural history and demographic overview of Brooklyn, see Jackson's introduction to *The Neighborhoods of Brooklyn*, xvii–xxx.

10. David G. McCullough, *The Great Bridge* (New York: Simon and Schuster, 1972).

11. Henry R. Stiles, *The Political, Professional and Ecclesiastical History and Commercial and Industrial Record of the County of Kings and City of Brooklyn, N.Y., 1663–1884*, 2 vols. (New York: W. W. Munsell & Co., 1884).

12. See Burrows and Wallace, *Gotham*, 949–50, and bibliography relating to New York waterfront history cited therein, 1256.

13. For Brooklyn's economic and industrial growth, see David Ment, *The Shaping of a City: A Brief History of Brooklyn* (Brooklyn: Brooklyn Educational & Cultural Alliance, 1979).

14. *Lain's Brooklyn Directory 1883/84–1894/95* (Brooklyn: Brooklyn Directory Company).

15. See Howell's obituary, *New York Times*, September 20, 1896, 5, which further states that he died of pleurisy at age 52. At the time of his death his address was 49 Fifth Avenue, New York. No surviving family was listed. Other points included were that he liked yachting, owned a house on Long Island, and was a member of the Union Club. See also "The Thomas A. Howell Collection," sale cat., Fifth Avenue Art Galleries, New York, February 27, 1889. No more is currently known of Thomas Howell apart from the fact that he was the brother of F. H. Howell who also owned several works by Chase at the time of the artist's 1886 Boston exhibition: *Portrait of Master Howell*, *Portrait of Little Miss Howell*, and *Portrait of the Artist*.

16. Clark S. Marlor, *A History of the Brooklyn Art Association with an Index of Exhibitions* (New York: James F. Carr, 1970). Chase was on the faculty of the Brooklyn Art Association in 1886 (ibid., 54), but his connection with this Brooklyn institution went largely unnoticed. However, this professional alliance may have accounted for the more sympathetic reviews Chase received from the Brooklyn press after 1886. Chase was subsequently on the faculty of the Brooklyn Art School, an organization born of the 1891 consolidation of the Brooklyn Art School of the Brooklyn Art Association with the Art Department of Paintings of the Brooklyn Institute (later the Brooklyn Museum of Art). He taught there from 1891 to 1895, during which time the institute was advertised as a cooperative partner in the Shinnecock Summer School of Art. Chase served on the Executive Committee of the Brooklyn Institute's Department of Painting from 1891 to 1896.

17. There is no comprehensive history of the cultural institutions of Brooklyn. Marlor's history of the Brooklyn Art Association (as in n. 16) stands as the most thorough survey to date. More recently Linda Ferber has summarized the history of the Brooklyn Institute of Arts and Sciences ("History of the Collections," in *Masterpieces in the Brooklyn Museum* [New York: The Brooklyn Museum, in Association with Harry N. Abrams Publishers, Inc., 1988], 8–23) and the organizational links between the Brooklyn Art Association and the American Society of Painters in Watercolors in the late nineteenth century ("'A Taste Awakened': The American Watercolor Movement in Brooklyn," in Linda S. Ferber and Barbara Dayer Gallati, *Masters of Color and Light: Homer, Sargent, and the American Watercolor Movement*, exh. cat. (Washington and London: Smithsonian Institution Press, in Association with the Brooklyn Museum of Art, 1998), 1–39.

18. "The William Merritt Chase Exhibition," *Art Amateur* 16 (April 1887), 100. Although the text of the review indicates the writer saw a painting with more than one figure and also mentions suds, which are also lacking in this work, the inaccuracies are probably due to carelessness and the writer's desire to be witty. It is also possible that the critic conflated the pastel *Putting Out Linen* (Moore's cat. no. 10) with the oil on panel illustrated here. Also of interest in the critic's brief reference to *Washing Day* is the humorous but pointedly scornful reference to Brooklyn.

19. Keith L. Bryant, Jr., writes, "After Chase and his wife settled in Brooklyn, he became a habitué of Prospect Park." *William Merritt Chase: A Genteel Bohemian* (Columbia and London: University of Missouri Press, 1991), 116. This otherwise extensively footnoted biography offers no source for this information. The fine, although by virtue of the broader scope of the book, incomplete discussion of Chase's park paintings in H. Barbara Weinberg, Doreen Bolger, and David Park Curry, *American Impressionism and Realism: The Painting of Modern Life, 1885–1915*, exh. cat. (New York: The Metropolitan Museum of Art, 1994), does not explore the artist's relationship to the sites portrayed in his paintings. The major Chase scholar, Ronald G. Pisano, recently broached the subject by stating, "he stayed close to home [in 1886], painting in the parks and along the coast of Brooklyn, where his parents now lived." *Summer Afternoons: Landscape Paintings of William Merritt Chase* (Boston, Toronto, London: Bulfinch Press, 1993), 9.

20. Katherine Metcalf Roof, *The Life and Art of William Merritt Chase* (1917; repr., New York: Hacker Art Books, 1975), 151.

21. I am greatly indebted to Ms. Lee Roberts for providing the information concerning the Chase family's residence on Marcy Avenue. The lot (Block 1780, Lot 6) is listed in the current tax assessment records as vacant and owned by the City of New York.

22. Ala Story records David Hester Chase's age as 40 at the time of his marriage to Sarah Swaim. Since William was born in the first years of their marriage, David Chase must have been at least 78 by the time he moved to Brooklyn. See Ala Story, "A Personal Recollection," in *The First West Coast Retrospective Exhibition of Paintings by William Merritt Chase (1849–1916)*, exh. cat. (Santa Barbara: The Art Gallery, University of California, Santa Barbara in cooperation with La Jolla Museum of Art, 1964).

23. The pastel, *Study of a Silvered Glass Ball* (no. 113, Boston, 1886, and no. 1, Moore's, New York, 1887), was described as "reflecting . . . the flowers and foliage of a garden in which it is placed." "The William Merritt Chase Exhibition," *Art Amateur* 16 (April 1887), 100.

24. For Munkácsy, see F. Walther Ilges, *M. von Munkacsy* (Bielefeld and Leipzig: Velhagen & Klasing, 1899), and the catalogue entry for *Luncheon in the Garden* in Maureen O'Brien, *In Support of Liberty: European Paintings at the 1883 Pedestal Fund Art Loan Exhibition*, exh. cat. (Southampton, N.Y.: The Parrish Art Museum, 1986), 172–73.

25. For extended descriptions and interpretations of Chase's studio, see Nicolai Cikovsky, Jr., "William Merritt Chase's Tenth Street Studio," *Archives of American Art Journal* 16 (1976), 2–14, and Annette Blaugrund,

The Tenth Street Studio Building: Artist-Entrepreneurs from the Hudson River School to the American Impressionists, exh. cat. (Southampton, N.Y.: The Parrish Art Museum, 1997), 105–27.

26. As I have noted elsewhere (Gallati, *William Merritt Chase* [New York: Harry N. Abrams, Inc., in Association with the National Museum of American Art, 1995], 58), Hattie's pose in *The Open Air Breakfast* echoes that of Chase's c. 1887 portrait of her (private collection). Both images rely on James McNeill Whistler's *Harmony in Grey and Green: Miss Cicely Alexander* (1872–73, The Tate Gallery, London). The grouping of Alice Chase and Cosy is a reiteration of a motif in Chase's currently unlocated *Happy Hours*. The general treatment of the space recalls earlier compositions by Chase, for example, *Garden of the Orphanage*, c. 1883 (reproduced herein as fig. 9).

27. *The Toledo Museum of Art, American Paintings* (Toledo: The Toledo Museum of Art, 1979), 30. The catalogue entry for *The Open Air Breakfast* traces the provenance to the artist in 1916 and suggests a date of 1888.

28. Pisano, *Summer Afternoons*, 10.

29. Chase sale, American Art Galleries, New York, May 14–17, 1917, lot 375, as *The Back Yard: Breakfast Out-of-Doors*. From then it passed through several owners until it entered the Toledo Museum of Art's collection in 1953. *Afternoon Tea in the Garden* remains unlocated. If this painting were the *Afternoon Tea in the Garden* shown in Boston in 1886 and sold to Stanford White, and for some reason bought back by Chase, the baby could not have been Cosy, who was born the following year.

30. This is mainly in conformance with the date assigned to it in the object files of Toledo.

31. "Mrs. William M. Chase," *Daily Graphic*, February 17, 1887, 837.

32. Ibid.

33. I would like to thank Dr. Bruce Weber for sharing his knowledge of this article with me. Our nearly simultaneous and independent discoveries of these facts about Chase's life came by way of different routes of research: mine through questioning the history and iconography of *The Open Air Breakfast*, which led to a search of marriage records in 1887; and his through reading Jervis McEntee's diary, which contained the unidentified clipping cited here. Jervis McEntee Diaries, Archives of American Art, Smithsonian Institution, Washington, D.C., reel D180, frame 674.

34. John Davis discusses similar problems in connection with the reception of Eastman Johnson's *Brown Family* (1869, Fine Arts Museums of San Francisco), stating: "Our gaze is thus, by the standards of the day, an intrusive one. Custom would not have normally permitted us to peer into the parlor in this way, uninvited, without being formally received. There is a slightly unseemly element in this intimate association with a prominent New York family, which might explain the critics' uneasy response to the picture." Davis, "Children in the Parlor: Eastman Johnson's *Brown Family* and the Post–Civil War Luxury Interior," *American Art* 10, no. 2 (Summer 1996), 68. Sensitivity to the dangers of revealing otherwise private domestic space may have also accounted for Aaron Draper Shattuck's (1832–1928) apparent decision not to exhibit the painting known as *The Shattuck Family* (1865, Brooklyn Museum of Art), a group portrait of his wife, mother, and firstborn child in the parlor of their home. Gallati, "*The Shattuck Family*: Aaron Draper Shattuck's Experiment in Narrative Content," *American Art Journal* 20, no. 3 (1988), 36–47. I am grateful to Teresa A. Carbone for bringing John Davis's article to my attention in this context.

35. Chase himself did this. For the 1886 Boston exhibition, for example, only commissioned portraits of children bore their names or, in the case of female adults, only the portraits of Rosalie Gill and Dora Wheeler bore their names, probably because both were artists and were therefore considered public personalities. A more personal reason might be found in the coincidence of the marriage announcement and the birth of Cosy.

36. It could be argued that Chase violated the family's privacy in works like *I Am Going to See Grandma*, but the figures do not function as portraits because the action of the narrative (strengthened by the title) suppresses the reception of that aspect of the image. Similarly, the 1890s images of Alice and the children in the Shinnecock house could be interpreted as contradictions to my thesis about Chase's attentiveness to propriety. However, the Shinnecock house became an icon of the summer school and thereby assumed the same role held by the Tenth Street studio.

37. Quoted in Clay Lancaster, *Prospect Park Handbook* (New York: Long Island University Press, 1972), 22.

38. M. M. Graff, *Central Park and Prospect Park: A New Perspective* (New York: Greensward Foundation, 1985), 112.

39. Alexander Jackson Davis was at midcentury one of the most prominent architects in the nation. Grace Hill, commissioned by Edwin Litchfield in 1854, and Lyndhurst, in Tarrytown, New York (beg. 1838), are prime examples of the picturesque domestic style of architecture that he developed in harmony with the landscape design theories of Andrew Jackson Downing.

40. Graff states about Viele's Prospect Park plan: "It must have been evident that no citizen, affluent or otherwise, would be persuaded to keep his residence in Brooklyn on the merits of Viele's park whose chief panoramic view would have been traffic on the Flatbush Avenue causeway. Since one of the incentives for promoting a Brooklyn park was to outstrip the New York showpiece, it was natural for the commissioners to turn to the firm of Olmsted and Vaux which had directed its creation." Graff, *Central Park and Prospect Park*, 112.

41. The literature on Olmsted and Vaux is voluminous. For sources regarding the two, see Roy Rosenzweig and Elizabeth Blackmar, *The Park and the People: A History of Central Park* (New York: Henry Holt and Company, 1992).

42. Lancaster, *Prospect Park Handbook*, 52.

43. Olmsted described the topography of the Central Park lands in 1857: "The site is rugged, in parts excessively so, and there is scarcely an acre of level, or slope unbroken by ledges. With a barely tolerable design, tolerably executed, the park will have a picturesque character entirely its own, and New Englandish in its association much more than reflective of any European park. There is no wood but saplings on the ground." Quoted in Graff, *Central Park and Prospect Park*, 72.

44. "Fine Arts," *Brooklyn Daily Eagle*, October 5, 1882, 1.

45. "Brooklyn Art Club," *Brooklyn Daily Eagle*, November 21, 1884, 1.

46. *Brooklyn Life* 7, no. 169 (May 27, 1893), 4.

47. Henry W. B. Howard, ed., *The Eagle and Brooklyn: History of the City of Brooklyn* (Brooklyn: Brooklyn Daily Eagle, 1893), 338.

48. "The Academy of Design: A Well Chosen Exhibition," *New York Times*, April 2, 1887, 5. Unfortunately, the writer of the review confused Arthur Brown with Anna Wood Brown, attributing the Prospect Park painting to her.

49. For the provenance of *Mrs. Chase in Prospect Park*, see Doreen Bolger Burke, *American Paintings in the Metropolitan Museum of Art. Volume III. A Catalogue of Works by Artists Born between 1846 and 1864* (New York: The Metropolitan Museum of Art, 1980), 86.

50. Bastien-Lepage was much admired in the United States during the late nineteenth century, but his art has not been studied in this context. For the artist's impact on British painters, see Kenneth McConkey, "The Bouguereau of the Naturalists, Bastien-Lepage and British Art," *Art History* 1, no. 3 (1978), 371–82.

51. See Maureen O'Brien's entry for Beckwith's portrait of Walton in Annette Blaugrund et al., *Paris 1889: American Artists at the Universal Exposition*, exh. cat. (Philadelphia: Pennsylvania Academy of the Fine Arts, in Association with Harry N. Abrams, Inc., 1989), 112–13.

52. For an account of an American artist's experience of the Grez colony, see May Brawley Hill, *Grez Days: Robert Vonnoh in France*, exh. cat. (New York: Berry-Hill Galleries, 1987).

53. This work introduces the leitmotif of a woman reading in a public park in Chase's paintings. It appears again in *Park Bench* (Pl. 45) and in the unlocated *An Hour with Aldrich*, which depicted a figure seated with a book on a lawn near greenhouses. "The American Artists," *Chicago Tribune*, June 9, 1890, The Art Institute of Chicago Scrapbooks, Ryerson Library; "Notes on Current Art," *Chicago Tribune*, June 15, 1890, The Art Institute of Chicago Scrapbooks, Ryerson Library. The "Aldrich" of the painting's title probably refers to the then popular writer Thomas Bailey Aldrich. In addition to writing numerous plays, poems, short stories, and novels,

Aldrich was the editor of the *Atlantic Monthly* from 1881 to 1890.

54. Chase repeatedly exhorted his students to focus on "common" subject matter: "Aim to make an uninteresting subject so inviting and entertaining by means of fine technique that people will be charmed at the way you've done it." Frances Lauderbach, "Notes from Talks by William M. Chase, Summer Class, Carmel-by-the-Sea, California," *American Magazine of Art* 8 (1917), 433.

55. Late-nineteenth-century American criticism against French art seems to have been formulated mainly in terms of morality. This distinction was often made against the foil of the "moralizing wholesomeness" of English art. See, for instance, Margaret Bertha Wright, "American Pictures at Paris and London," *Art Amateur* 3, no. 1 (June 1880), 26–27. A review of the summer Royal Academy exhibition of 1885 expressed similar sentiment, stating that although the English exhibition was dismal, it nonetheless was a "positive relief after the disgust one experiences in confronting the pictorial horrors and indecencies which give the first impression on a visit to the Paris Salon." Montezuma, "My Notebook," *Art Amateur* 13, no. 3 (August 1885), 44. Lois Marie Fink traces this attitude to the strong American connections with Ruskinian thought, which emphasized spirituality through the accurate, detailed portrayal of nature. As Fink points out, such Ruskinian leanings conflicted with the French emphasis on technical facility. In turn this formal conflict between strict, "honest" facture and "superficial," summary brushwork influenced the reception of content, whereby emphasis on "manner" or technique signaled lack of sentiment or high meaning. Lois Marie Fink, *American Art at the Nineteenth-Century Paris Salons* (Washington, D.C., and Cambridge: National Museum of American Art, Smithsonian Institution, and Cambridge University Press, 1990), 90–93.

56. "My Notebook," *Art Amateur* 18, no. 2 (January 1888), 28.

57. See Gallati, *William Merritt Chase*, 71–74; and William H. Gerdts, *Impressionist New York* (New York, Paris, London: Abbeville Press, 1994), 184–87.

58. David Schuyler and Jane Turner Censer, eds., *The Years of Olmsted, Vaux and Company, 1865–1874*, vol. 6, *The Papers of Frederick Law Olmsted* (Baltimore and London: Johns Hopkins University Press, 1992), 398.

59. Ibid., 397–98.

60. This work was last traced to a sale at Gimbel's Department Store, New York, in 1948, advertised in the *New York Times*, September 5, 1948, for $84.50 and listed as measuring 13 x 18½ inches.

61. The Church of the Puritans was demolished in 1915.

62. Lancaster, *Prospect Park Handbook*, 30.

63. St. George's Episcopal Church has since relocated to 800 Marcy Avenue, a fact that complicated the identification of Chase's Tompkins Park paintings.

64. *26th Annual Report of the Brooklyn Park Commissioners for the Year 1886* (Brooklyn: Printed for the Commissioners, 1887), 16, 20.

65. William Merritt Chase, "Address of Mr. William M. Chase before the Buffalo Fine Arts Academy, January 28th, 1890," *Studio*, n.s., 5, no. 13 (March 1, 1890), 124.

66. *28th Annual Report of the Brooklyn Park Commissioners for the Year 1888* (Brooklyn: Printed for the Commissioners, 1889), 10.

67. Gerdts cites Chase's exhibition of *A Little City Park, Brooklyn* at the Fourth Prize Fund Exhibition at the American Art Galleries in 1888 (*Impressionist New York*, 185).

68. "The Pastel Exhibition," *Art Amateur* 21 (June 1889), 4.

69. L. P. Brockett, M.D., "The Commerce of Brooklyn," in Stiles, *The . . . History of the County of Kings*, vol. 2, 635.

70. General information on the history of the U.S. Navy Yard provided here is from Arnold Markoe's entry in Jackson, *The Encyclopedia of New York*, 159–60.

71. James D. McCabe, Jr., *Lights and Shadows of New York Life; or, the Sights and Sensations of the Great City* (Philadelphia, Cincinnati, Chicago, St. Louis: National Publishing Company, 1872), 778–79.

72. "Brooklyn Navy-Yard," *Harper's Weekly* 26, no. 1337 (August 5, 1882), 491.

73. Ibid.

74. *New York Naval Shipyard: A Journal of Progress through a Century and a*

Half of Service to the Fleet (Brooklyn: 150th Anniversary Committee, 1951).

75. "U.S. Naval Lyceum," *Naval Magazine* 1 (January 1836), 9.

76. "Miscellany," *Naval Magazine* 1 (May 1836), 282.

77. "U.S. Naval Lyceum," *Naval Magazine* 1 (January 1836), 9.

78. *A Short History of the New York Navy Yard* (February 23, 1941), 80.

79. Only small portions of the wall may be detected today, barely visible through undergrowth and obscured by modern constructions.

80. Brockett, "The Commerce of Brooklyn," in Stiles, *The . . . History of the County of Kings*, vol. 2, 644.

81. Ibid., 633.

82. For examples of New York harbor scenes by these artists, see John Wilmerding, *American Marine Painting* (New York: Harry N. Abrams, Inc., 1987).

83. "The Fine Arts: Fourth Annual Exhibition," *New-York Tribune*, April 3, 1881, 7, cited in Lisa Peters, "John Twachtman (1853–1902) and the American Scene in the Late Nineteenth Century: The Frontier within the Terrain of the Familiar," Ph.D. dissertation, City University of New York, 1995.

84. Ibid., 80.

85. "The Society of American Artists," *New York Sun*, March 23, 1879, 2.

86. Ibid.

87. Peters, "John Twachtman (1853–1902) and the American Scene," 84.

88. Charles H. Farnham, "A Day on the Docks," *Scribner's Magazine* 18 (May 1879), 34.

89. *New York Naval Shipyard: A Journal of Progress.*

90. Manbeck, *The Neighborhoods of Brooklyn*, 208. The landmarked Williamsburgh Bank at 175 Broadway was built in 1875. In the 1860s the area was a resort playground for wealthy magnates like Cornelius Vanderbilt, but more important, it was a vital industrial center. The new sugar refinery of Havemeyer and Elder, located on the waterfront of Williamsburgh, was completed in 1860. Also located on the Williamsburgh shore of the East River was the Pratt Astral Oil Works, founded by Charles Pratt in 1867. Both families, the Havemeyers and the Pratts, were also significant collecting and philanthropic forces in the arts. Ment, *The Shaping of a City*, 42–43, 57–58. With the opening of the Williamsburg Bridge in 1903, the demographics of the neighborhood changed; immigrant populations from the Lower East Side of Manhattan moved into Brooklyn, from which the commute to Manhattan jobs was convenient.

91. Owing to the acute curve in Wallabout Bay, it was possible to see the bank from the interior of the Navy Yard, as it is still possible today.

92. As Ronald G. Pisano has pointed out, at various times Chase's personal collection included works by Anton Mauve, Hendrik Willem Mesdag (1831–1915), Bernardus Johannes Blommers (1845–1914), Georg Hendrik Breitner (1857–1923), and Willem Maris, among other painters of the Hague School. Pisano, "William Merritt Chase: Innovator and Reformer," in O'Brien, *In Support of Liberty*, 68.

93. The distanced, "genteel" view that Chase adopted for these harbor and dock subjects bears comparison with several atypical works by William Morris Hunt, especially *Gloucester Harbor* (c. 1877, Museum of Fine Arts, Boston). Chase saw the Hunt memorial exhibition in Boston in 1879, but that exhibition did not include this type of Gloucester subject. However, it is possible that Chase was aware of this aspect of Hunt's art.

94. Stiles, *The History . . . of the County of Kings*, vol. 2, 640–42.

95. The isolated character of the Bath Beach resort is underscored by an anecdote provided by Roof: "Chase had returned on a late suburban train from a dinner given by Stanford White and conceived the brilliant idea of entering his room through the bedroom window instead of the door, in order not to awaken his wife. Mrs. Chase, who had been alarmed by the behavior of an employee about the place, had retired with a revolver under her pillow. Hearing some one fumble with the catch of the blind at her window she was naturally very much frightened. The next moment when a man's hand appeared on the edge of the shutter she assumed that the expected intruder had arrived, and raised her arm to shoot when by chance she caught sight of the man's ring and realized that the housebreaker was her husband." Roof, *The Life and Art of William Merritt Chase*, 152–53.

96. Interestingly, both Stevens and Chase may have been indebted to Ernest

Ange Duez (1843–1896) whose paintings of fashionable women at beach resorts were also popular at the time. A line drawing of Duez's *By the Sea* (a work displaying strong compositional parallels with Stevens's series mentioned in the text here and Chase's *Afternoon by the Sea*) was reproduced in "Glimpses of Parisian Art. I," *Scribner's Monthly* 21, no. 2 (December 1880), 170, thus demonstrating that Duez's work predates any of the works by Stevens and Chase cited here.

97. This and other incidents of barely disguised emulation on Chase's part have recently come to light and join previously cited examples (for instance, Nicolai Cikovsky's comparison of Stevens's *Salon of the Artist* and Chase's *Friendly Visit*). (Another example is outlined here in connection with a Boldini from Stanford White's collection, on 125–26). Chase's frequent reworkings of contemporary European motifs suggest that it might be worthwhile to make a comparative investigation of the contemporary European collections held by New Yorkers in the 1880s to see if Chase systematically attempted to appeal to those same collectors by fashioning determinedly American versions of compositions by more marketable European contemporaries.

98. McCabe, *Lights and Shadows*, 780.

99. "Coney Island," *Harper's Weekly* 26, no. 1336 (July 29, 1882), 475.

100. See Manbeck, *The Neighborhoods of Brooklyn*, 151, about Corbin's acquisition of 500 acres as a seaside haven for his sick child.

101. "Coney Island," *Harper's Weekly*, 475.

102. See Burrows and Wallace, *Gotham*, 1133, where they also point out that "'Seeing the Elephant' became New Yorkese for going to Coney."

103. Ibid., 1132.

104. *Chase Sale*, exh. cat. (New York: American Art Galleries, May 14–17, 1917), no. 100.

105. "A Brilliant Group of Painters' Drawings," *New York Herald*, December 22, 1889, 8. I would like to thank Mr. Stuart Feld of Hirschl & Adler Galleries, Inc., for bringing this article to my attention. The article also noted that Kathleen Cottage was the former summer residence of the popular actor Barney Williams and his wife. Williams had died in 1876 (see his obituary in the *New York Times*, April 26, 1876, 5), and the identity of the house's owner at the time the Chases stayed there in 1889 is currently unknown.

106. Manbeck, *The Neighborhoods of Brooklyn*, 6.

107. "The Slaughter of Mr. Chase's Pictures," *Art Amateur* 24 (April 1891), 115.

108. "Recent American Landscape," *Art Amateur* 19 (June 1883), 3.

109. Ian R. Stewart, "Politics and the Park: The Fight for Central Park," *New-York Historical Society Quarterly* 61 (1977), 126.

110. Appropriation of the Jones Wood site for a public park had already been passed by the legislature even though there still existed strong arguments for a "central" park that would incorporate a reservoir. The movement for Jones Wood was stalemated by a third proposal for enlarging Battery Park at the southern, more populated end of Manhattan. The politics governing the final choice of a centrally positioned park were complex and are summarized nicely in Rosenzweig and Blackmar, *The Park and the People*, 40–58.

111. William Cullen Bryant, *Letters of a Traveller; or, Notes of Things Seen in Europe and America* (New York: G. P. Putnam, 1850), 168–73.

112. Andrew Jackson Downing came to prominence as a landscape designer with the 1841 publication of his *Treatise on the Theory and Practice of Landscape Gardening*. He was a strong proponent for a centrally situated park in Manhattan and might have had a role in designing Central Park had he not drowned when the steamboat *Henry Clay* burned and foundered on the Hudson River in 1852.

113. A. J. D. [Andrew Jackson Downing], "Mr. Downing's Letters from England," *Horticulturalist and Journal of Rural Art and Rural Taste* 5, no. 4 (October 1850), 153.

114. Rosenzweig and Blackmar's *Park and the People* provides the finest modern history of Central Park and includes extensive references to contemporaneous newspaper and periodical sources concerning the politics and philosophies surrounding the park and its development to the late twentieth century.

115. The writings of the Englishmen Sir Uvedale Price (1747–1829) and William

Gilpin (1724–1804) were major factors in the formation of the idea of the picturesque landscape as it was understood by American landscape designers, writers, and artists. For their influence in America, see Edward J. Nygren with Bruce Robertson, *Views and Visions: American Landscape before 1830*, exh. cat. (Washington, D.C.: The Corcoran Gallery of Art, 1986).

116. Rosenzweig and Blackmar, *The Park and the People*, 211.

117. Richard J. Koke, comp., *American Landscape and Genre Paintings in The New-York Historical Society*, vol. 2 (New York: The New-York Historical Society; Boston: G. K. Hall, 1982), 298.

118. Clarence Cook, *A Description of the New York Central Park* (1869; repr., New York: Benjamin Blom, 1972); T. Addison Richards, *Guide to the Central Park* (New York: J. Miller, 1876).

119. Rosenzweig and Blackmar, *The Park and the People*, 283: "The park that had in the 1860s represented elite accomplishments would become in the 1880s and 1890s a more genuinely democratic public space."

120. "The Reception at the Academy," *New York Times*, April 6, 1885, 4. Chelminsky's Central Park paintings have not been located. However, a detail of his *In the Central Park, New York*, drawn by the artist, was featured on the cover of the February 1885 *Art Amateur* and thus provides an indication of the nature of his park paintings. According to A. Trumble, the author of the brief article on Chelminsky in the same *Art Amateur* issue, the Central Park painting on which the cover illustration was based, "was sold as soon as it left the easel, and, oddly enough, it is to be sent to Munich, whence the painter has lately arrived" (60).

121. George W. Sheldon, *Recent Ideals of American Art* ([1888–90]; repr., New York and London: Garland Publishing, 1977), 19. Depicted occasionally in contemporaneous paintings and photographs, the shanties surrounding Central Park also received considerable coverage in periodical literature. See, for example, "Shantytown," *Scribner's Monthly Magazine* 20 (October 1880), 855–69; and [William H. Rideing], "Squatter Life in New York," *Harper's New Monthly Magazine* 61 (September 1880), 562–69. Both articles positioned the quickly disappearing dwellings of the poor, which were being eradicated by Manhattan's rapid development, as symbols of the past. As Rideing observed, "The new Museum of Natural History, with its imposing façade looking over the hill and dale of the Park, glances from its rear upon a neighborhood which . . . is quite unique. It is not to be precisely described as city, nor as suburb, nor as the unsettled but broken territory that outlies most cities while waiting to be absorbed in their advance. . . . It is scarcely safe to let an artist loose among them. They abound with picturesque 'bits,' which he declares it next to impossible to exhaust" (563–64). Although Chase is not recorded to have painted the shanties of Manhattan, he addressed their Brooklyn equivalents at least once, in *A Squatter's Hut, Flatbush*, shown at the American Art Association in 1887 and again at the 1888 exhibition of the Society of Painters in Pastel (recorded then as owned by T. A. Howell).

122. "By Jones' Edict. Artists Excluded from Prospect Park," *Brooklyn Daily Eagle*, June 18, 1890, 6.

123. "Chase's Story. The Artist Replies to Messrs. Jones and Brower," *Brooklyn Daily Eagle*, June 19, 1890, 6.

124. Ibid.

125. "The New Autocrat at the Park," *Brooklyn Daily Eagle*, June 18, 1890, 4.

126. "My Notebook," *Art Amateur* 23, no. 3 (August 1890), 42.

127. "By Jones' Edict." For additional coverage of the episode, see also "Jones's Ridiculous Order," *New York Times*, June 19, 1890, 8; "'Anachronism' Jones," *Brooklyn Daily Eagle*, June 20, 1890, 4; "Gallery and Studio," *Brooklyn Daily Eagle*, June 22, 1890, 13; and "Big Politics in Brooklyn," *New York Times*, June 22, 1890, 20.

128. The painting was reproduced in Clarence Cook, *Art and Artists of Our Time* (New York: Selmar Hess, Publisher, [1888]), vol. 3, 281. Cook's text (284) noted that the painting was reproduced by permission of Mr. Knoedler (Knoedler & Co.). When the painting was exhibited at the World's Columbian Exposition (no. 725) the owner was Mr. R. L. Knoedler, who purchased it in November 1890 and sold it to Miss Anna C. Meyer of

New York in December 1908. See Carolyn Kinder Carr and George Gurney, with essays by Carr and Robert W. Rydell et al., *Revisiting the White City*, exh. cat. (Washington, D.C.: National Museum of American Art and National Portrait Gallery, Smithsonian Institution, 1993), 218.

129. I have noted this conceit in Chase's work in my discussion of *The Open Air Breakfast* in *William Merritt Chase*, 58.

130. Quoted in ibid.

131. Charles De Kay, "Mr. Chase and Central Park," *Harper's Weekly* 35, no. 1793 (May 2, 1891), 327.

132. Ibid.

133. Roof, *The Art and Life of William Merritt Chase*, 151.

134. Ibid., 107.

135. A. E. Ives, "Suburban Sketching Grounds," *Art Amateur* 25 (September 1891), 80.

136. See the entry for the painting in the sale catalogue, Sotheby's, New York, *Important 19th-Century European Paintings and Sculpture*, May 7, 1997, lot 68, in which White's ownership is included in its provenance.

137. The English architect Jacob Wrey Mould (1825–1886) was invited to design All Souls Church (4th Avenue and 20th Street) soon after arriving in the United States c. 1853. As Calvert Vaux's assistant in the construction of Central Park, Mould designed Bethesda Terrace and other early park structures (now demolished). He also designed the first buildings for the Metropolitan Museum of Art and the American Museum of Natural History.

138. See Pisano, *Summer Afternoons*, in which he states that *A Gray Day in the Park* "included a glimpse of what was known as the Thatched Cottage" (11). However, the period photograph showing Thatched Cottage repro-duced in Pisano (44) does not correspond with the structure in Chase's painting. Thatched Cottage was a Prospect Park refreshment/comfort facility, the rusticity of which corresponded with Olmsted and Vaux's design for the park. Also known as Swiss Thatched Cottage and Indian Shelter, the building was destroyed in a fire in 1937. See Lancaster, *Prospect Park Handbook,* 53–54.

139. Among the "advanced" urban paintings created by Hassam in 1885 are *Columbus Avenue, Rainy Day* (Worcester Art Museum), *Rainy Day, Boston* (The Toledo Museum of Art), and *Boston Common at Twilight* (Museum of Fine Arts, Boston). Hassam left the United States before Chase's exhibition opened in Boston. See Ulrich W. Hiesinger, *Childe Hassam: American Impressionist* (New York: Jordan-Volpe Gallery; Munich: Prestel-Verlag, 1994).

140. Frank T. Robinson, *Living New England Artists* (Boston, 1888), 103, as quoted in Franklin Kelly's discussion of Hassam's *Nurses in the Park* in *American Impressionism and Realism: The Margaret and Raymond Horowitz Collection*, exh. cat. (Washington, D.C.: National Gallery of Art, 1998), 82.

141. William H. Gerdts has identified these structures: "One of the towered buildings in the distance at the left belonged to the clothing manufacturer and real-estate investor Isaac Vail Brokaw. Constructed in 1887 by Rose and Stone at the northeast corner of Seventy-ninth Street, it was modeled on a French Renaissance Loire Valley chateau, complete with a moat. The building at the right is very likely the two-spired house of William Van Duzer Lawrence at Seventy-eighth Street, designed three years later in a similar Loire Valley style by one of the most renowned architects of the time, Richard Morris Hunt." *Impressionist New York*, 129–30.

Pl. 45. Park Bench (*probably* An Idle Hour in the Park—Central Park), *c. 1890. Oil on canvas, 12 × 16 inches. Courtesy Museum of Fine Arts, Boston, Gift of Arthur Weisenberger.*

Chapter Four

DISCOVERING MEANING IN CHASE'S REALISM

In his 1889 article praising Chase's painterly talents, the academic artist, teacher, and theorist Kenyon Cox (1856–1919) provided what has become the stereotypical assessment of the artist's oeuvre. Stating that Chase's art was "not so much the art of the brain that thinks or of the imagination that conceives as of the eye that sees and the hand that records," Cox continued, "He is, as it were, a wonderful human camera—a seeing machine—walking up and down in the world, and in the humblest things as in the finest discovering and fixing for us beauties we had else not thought of. . . . His art is objective and external, but all that he sees he can render, and he sees everything that has positive and independent existence."[1] Cox's often-quoted words fostered an approach to Chase's art that has lingered, one that ignores the possibility that the artist's paintings could be more than the products of the eye's random and objective exploration of the world.[2]

Chase, himself, was a culprit in this matter in that he promulgated (perhaps unintentionally) the view that he was an artist unconcerned with a content that delved beneath the merely visible. His methods, as they have been recorded in his own words and in the reminiscences of his many students, demanded technical proficiency. And, because Chase was most vocal about this aspect of art, it is that which has received the bulk of the attention by those who interpret his work. In one of his last public lectures he stated: "Touching, as a painter, upon the tech-

nical side, let me remind you that all good pictures are well made—thoroughly well made; and the aim of every great artist as far as technique goes, is, to as great an extent as possible, to do away with the intermission between his head and his hand—to express what he sees and feels in a way which may be lasting."[3] Yet even in this summary statement Chase alerted his audience to the fact that his conception of great art included technique, vision, and feeling. While the nature of that third element went undefined, it is likely that Chase meant it to relate to a content or subject that would arouse an associative or meaningful response in the viewer. Other, more emphatic quotations from Chase have created a more memorable, if not mistaken, impression of his attitude toward content: "We hear too much of subject, subject, subject";[4] "Aim to make an uninteresting subject so inviting and entertaining by means of fine technique that people will be charmed at the way you've done it"; or "Subject is not important. *Anything* can be made attractive."[5]

Much of the difficulty about Chase's presumed denial of content lies in a fairly simple problem of semantics in which "subject" is wrongly equated with "content." From a directed reading of a selection of Chase's lectures and art class aphorisms, it appears that Chase's use of the word *subject* related to his understanding of a conventional narrative modality that suffused the majority of academic art in his time, a manner that he considered old-fashioned. He spoke about this plainly, linking the older narrative

style with sentiment: "I am thinking we have behind us the story telling picture and the picture with a sentiment. Sentiment has covered up a multitude of sins in art. Yes, and probably will continue to do so. The story-telling picture, of course, is an absolute impossibility, the picture that depends for its interest alone in the story. Imagine how impossible!"[6] Through such statements Chase separated his art from that of many of his American contemporaries, for instance Thomas Hovenden (1840–1895), whose enormously popular genre paintings tugged at the hearts of viewers and found ready purchasers as well. Hovenden's work was equally pleasing to reviewers because it better accommodated the requirement of describing the works they saw. It was much easier to tell the story of Hovenden's *Breaking Home Ties* (fig. 61, a painting shown at the 1891 NAD spring exhibition and written about at considerable length) than it was to try to describe Chase's comparatively non-narrative and unemotional works.[7] The literary sensibility inherent in the art of Hovenden exemplifies the type of sentiment-laden subject Chase avoided. Chase's railings against "subject" should be interpreted in

terms of his antipathy to what he considered an antiquated visual form of expression that was better treated by writers, as confirmed by his comment, "The literary work I would always leave to the literary man."[8] Yet, to think that he was entirely dismissive of content per se is to discount his reverence for Velázquez, Rembrandt, and Millet, artists whose greatness depended on emotionally or intellectually stirring ideas as well as remarkable technique. Although we cannot be sure, Chase may have reacted negatively to Cox's comment about his being a "seeing machine," for in 1890 (the year after Cox's article appeared), he stated: "I cannot bring myself to feel it is well to make a machine of one's self. It ought to be a matter of feeling."[9]

In questioning why Chase has not been raised to the status of the "greats" within the canon of American art history, Sarah Burns has raised an interesting point regarding his profile as an art instructor. She attributes Chase's lesser position in the canonical hierarchy

to the fact that he was able to transmit art knowledge and technical lore so professionally [that it] set him on a slightly lower

Fig. 61. Thomas Hovenden, Breaking Home Ties, *1890. Oil on canvas, 52⅛ × 72¼ inches. Philadelphia Museum of Art: Given by Ellen Harrison McMichael in memory of C. Emory McMichael.*

plane than Homer and Inness, whose art was so personal—so autonomous—that it could never be passed on in any form (though each had a train of followers and imitators). . . . At a time when, numerically, the "typical" artists in the Chase mode were dominant and even flourishing, the "real American artist" mode of Homer and Inness gained an edge because it seemed so desirable and rare.[10]

Burns writes of Chase's position in the arts as it stood at a slightly later period than the point at which he is discussed here, but in terms of the manner in which his work has been interpreted over the last several decades, her observation sheds light on how his reputation as a teacher worked to his detriment in estimating his art. In his teaching role it was Chase's duty to make the basic principles of painting accessible. For the most part Chase's comments about art that have come down to us originated in the classroom and were aphorisms designed to communicate simple guidelines for the student approaching the blank canvas. The clarity of his dictations deprived the art-making process of its mystery and have been read to represent the whole of his aesthetic. In turn, this has led to the assumption that Chase's art is unpremeditated and therefore possesses no meaning beyond the immediacies of visual experience. While this is not to say that Chase's art rested on profound intellectual or spiritual notions, the possibility of discovering greater meaning than that normally credited to Chase's art should not be discounted.

Chase's fundamental identity as a realist (a designation he seems not to have claimed for himself) grew from the modern proposition asserted by Honoré Daumier (1808–1879), Courbet, and Manet that insisted that the artist must be of his own time. This tenet, of course, excluded from the repertoire of the modern artist mythological, historical, or overtly literary themes and raised what had been previously considered "common" observable subjects to the status of high art. In her classic study on the subject, Linda Nochlin described the nineteenth-century movement called Realism, as aiming "to give a truthful, objective and impartial representation of the real world, based on meticulous observation of contemporary life."[11] Yet, as Nochlin wrote, the issues of reality, Realism, and their attendant mitigating factors are manifold and ultimately subordinate to subjective choices bound in varying value systems. In the broadest sense of the word, Chase was a realist because he painted contemporary life, but the choices he made within that context cannot be considered

impartial or fully objective. The realist posture he adopted, especially as it concerns his park and harbor paintings, admitted him to the ranks of modernity because it intimated his participation in the flâneur tradition as it was manifested in American culture.[12]

CHASE AS BOURGEOIS PAINTER-FLÂNEUR

The idea of the flâneur came to prominence in mid-nineteenth-century Paris largely through the writings of Charles Baudelaire.[13] Referred to by Walter Benjamin as "one who botanizes on asphalt," the flâneur was the detached male observer of modern life as it was evidenced in the arena of urban spectacle.[14] Benjamin traced the origin of the type in France to the journalists writing for *feuilletons*, serialized feature sections in newspapers that surveyed the sights of the city and its residents from the standpoint of the all-seeing but nonjudgmental spectator. In turn, the source of such spectatorial reportage has been traced to the work of Joseph Addison and Richard Steele in eighteenth-century England in such publications as the *Tatler* and the *Spectator*.[15] Inherent in the definition of the flâneur is the element of dandyism, which attaches characteristics of elegant dress and aristocratic behavior to the person adopting the role and who therefore becomes part of the urban spectacle himself. As the art historian Robert L. Herbert has stated: "[The flâneur] was an ambulatory naturalist whose objectivity set the stage for Impressionism. Among the painters, only Manet, Degas, and Caillebotte could be counted among the flâneurs, but the other impressionists adopted the characteristic features of this modern Parisian: objectivity, and a devotion to contemporary life." Herbert continues:

Because parallels with writers are more evident for Manet and Degas than for Renoir or Monet, it is with their historians that we find the furthest advances towards a broader conception of Impressionism. Scholars have pointed out their devotion to contemporary urban settings and have brought out the paradoxical qualities of an art that was "natural," and yet thrived on artifice; . . . [T]he idea of the flâneur has been a welcome borrowing from literature, and it is the ideal beginning point for an inquiry into impressionist naturalism.[16]

In the United States the literary trope of the flâneur is cited as first emerging in such writings as Washington Irving's

Fig. 62. Walter T. Smedley, William Merritt Chase, *reproduced in Charles De Kay, "Mr. Chase and Central Park," Harper's Weekly 35 (May 2, 1891). Brooklyn Museum of Art Library Collection.*

Sketchbooks of Geoffrey Crayon and Nathaniel Parker Willis's *Pencillings by the Way*, the latter of which was commissioned as a series for the *New York Mirror*. While Irving's and Willis's essays were cast in travelogue form as told by Americans in Europe (and hence, from a point of view already distanced from the subject), the idea of the flâneur is believed to have achieved maturity in Edgar Allan Poe's short story "The Man of the Crowd."[17] Driven by a narrative that takes the protagonist-observer out of his seat in a café to pursue an unknown man whom he has spotted through the window, Poe guides the reader through the streets of London and simultaneously catalogues the types (pickpockets, gamblers, con men, and prostitutes) encountered along the way. As Dana Brand points out, these types are familiar and thus understandable, but when the narrator-observer finds his understanding thwarted

by a face "that does not permit itself to be read," anxiety is produced that becomes equated with the threatening atmosphere of urban life.[18] The prose and poetry of Walt Whitman are also frequently discussed in these terms, and while the same sense of the crush and multiplicity of urban humanity retains its collective incomprehensibility in Whitman's writing, he enjoined a celebratory attitude, reveling in the anonymity the spectacle of life permits.[19]

The flâneur (a type that investigated types) surveyed the entire range of society, offering a panoramic view of the city, which seemed to gather its own independent power of existence from the energies of the masses that swarmed within it. The genre fed and was fed by parallel forms of publications—such as McCabe's *New York by Gaslight* or even Stiles's history of Kings County, all of which were united in the goal of rendering a city legible. Although Chase was by no means the complete flâneur, the public persona he constructed for himself matched the traits of the urban observer in significant ways. He was, as the artist Harry Willson Watrous (1857–1940) recalled, "a gallant gentleman, the cynosure of all eyes, with mustache slightly tilted, sauntering down the Avenue wearing a flat brimmed French silk hat, a broad black ribbon hanging from his glasses, and accompanied by a beautiful white Russian wolfhound"[20] (fig. 62). The dandyism affected by this man, whose middle-class, midwestern origins had offered no encouragement for such self-definition, accorded his audience (which included the anonymous public viewer in addition to family, colleagues, and friends) the American equivalent of the flâneur in appearance and fulfilled the definition of the flâneur as the observer who adopts the demeanor of the detached aristocrat. At the same time Chase's promenades on New York's streets drew attention and the sight he produced was assimilated into the catalogue of the city's visual phenomena. Cox's description of Chase "walking up and down in the world" kindles the idea of the flâneur in this respect, but the idea was not carried to completion, perhaps because Cox realized that to take the comparison further would entail the admission that Chase's vision was, indeed, selective.

If Chase consciously engaged in touring the city with the purpose of gathering the kaleidoscopic view typically associated with *flâneurie*, it does not come through in his carefully edited glimpses of city and suburban sites. Yet he advised his students to practice something akin to the mode of looking given to the flâneur by reminding them that art is not simply learned

in the classroom and recommending that they paint and draw things "in their minds" as they went about their ordinary activities: "The street-car is a good place to study people and paint them in your mind—only I would advise you not to study them too much in detail, for fear you may disturb your sitter."[21] His own quest to elevate the arts in the United States prevented him from penetrating the dark corners of the city, for the ugliness of the realities to be found there ran counter to the hopes that he had for American culture as a whole. Beauty was still a necessary ingredient in his aesthetic formula, and, while he sought to prove that common things and experiences could be made beautiful by a sensitive painter, he never sanctioned the realist vision that emerged a short time later in the art of his contemporary and rival Robert Henri (1865–1929). It was undoubtedly Henri's circle of New York realists about whom Chase spoke when he said, "A certain group of painters in New York paint the gruesome. They go to the wretched part of the city and paint the worst people. They have the nickname of 'the Depressionists.'"[22] Despite the stylistic and thematic divisions between Chase's art and that of the Henri realists (most of whom had newspaper experience, which qualified them for charter membership in the fraternity of American flâneurs), it is likely that the impetus behind their inspections of the city stemmed from the same visual habits that originated in the desire to catalogue their modern world.

Regardless of how sanitized Chase's views of the parks and harbors seem to today's viewers, they nonetheless likely reverberated with associations for the contemporaneous viewer that would have merged Chase's art with the flâneur outlook. It is suggested here that Chase's imagery may have been distilled from his reception of similar imagery contained in novels of the decade that were popularized variants on the flâneur genre. A critical text in proving the worth of this theory is Joaquin Miller's *Destruction of Gotham*, a novel published in 1886.[23] Miller was an intimate of the Gerson circle and as such was present at the evenings at the Gerson home likewise attended by Chase.[24] Miller's novel is a fully worked example of the popularized flâneur genre as it had evolved in the United States. It tells the melodramatic tale of a recently orphaned country girl, Dottie Lane, who arrives in New York in search of her only living relative, her cousin Hattie. The intricate plot is anchored thematically in the disparities between the powerless underclasses and the amoral men whose Wall Street fortunes control the civilized glories of "Up

Town," as well as the vermin- and disease-ridden dens and dives of "Down Town." Seen through the eyes of a dispassionate narrator, the newspaperman Walton (who behaves in the style of the true flâneur), the city unfolds as a space made legible by discrete codes of behavior, social use, and outward appearance. At the outset Miller describes Walton as "a searcher after 'character,' a lover of 'types'—studies in nature he called them."[25] The novel also incorporates the mystery genre (an outgrowth of the flâneur theme), as Walton tries to discover the identity of the callous rich man who fathered Dottie's child.

Woven within the text is the requisite subtheme of watching and being watched. Walton watches the exhausted, penniless Dottie seek refuge in Madison Square Park when she first arrives in the city. He sees others watching her, reading the scene to devise ways to capitalize on her desperation and innocence. He is aware of her danger but does nothing to help her. Miller interjects at this point, stating cynically, "There is love waiting for her in the parks, the cool restful places; strong and handsome men, rich, romantic as herself, are ready to receive her."[26] Two years pass, and Walton, who had been instantly transfixed by the girl's dark beauty, comes across her again: "Walton, walking hastily through Central Park, saw the face of little 'Dottie' looking up at him from one of the benches by the path. At her feet in the grass played a child."[27] Dottie herself visits the park not only to give her little girl (Dollie) a healthful dose of fresh air but also to watch the daily parade of elegant carriages, searching the faces of passengers for the man who had taken advantage of her. In turn, Dottie senses that she is being watched, shadowed by someone for reasons unknown. It transpires that the person following her is in the hire of Matherson, the father of her child who, coincidentally, is courting her long-lost cousin Hattie. Matherson maintains his detachment from his child. Vicariously monitoring her growth, he is too much of a coward to assume his paternal role. Finally, overcome by paranoia, Dottie retreats from the safe domestic haven with a German couple that Walton had found for her (near Central Park) and travels a world away—downtown to hide among the faceless masses in one of the city's worst tenements. There she wastes away and dies, terrified for her child, who she is sure will become prey to the rats.

Miller's novel catalogues the social types inhabiting the various neighborhoods of the metropolis, often integrating the actual with the fictive. For instance, the nameless female vil-

Pl. 46. In the Park—A By-Path, *c. 1890. Oil on canvas, 14 × 19⅛ inches. Carmen Thyssen-Bornemisza Collection.*

lain, who is in league with Matherson's circle and who dies by her own hand in her bath, is a thinly veiled portrait of the infamous abortionist Madame Restell.[28] Justice of sorts is finally meted out to the moneymen (stereotyped, but based on Vanderbilt, Jay Cooke, Jay Gould, or any of their financial counterparts) whose stocks fail and whose properties are destroyed by the violent uprising of "the people," who bring Gotham to its knees in a hellish conflagration. In the end, Walton carries the dead Dottie's child to safety across the Brooklyn Bridge, leaving the flaming Gotham behind them.

Throughout Miller's novel, Central Park is positioned as a symbol for goodness, health, innocence, and cultural refinement. On the other hand, the downtown regions, rife with filth, corruption, and disease, represent the worst side of the urban sphere. Yet the two—good and evil—are linked by the essentially amoral quest for money.[29] Although Chase did not depict the bleak lives of the poor, his park imagery corresponds closely with passages in Miller's book that describe

events taking place in the park—not as if for the purpose of illustrating Miller's words, but because the two men shared similar beliefs about the park's purposes and uses. More important, because writer and painter were of the same time, place, and class, it can be assumed that their personal experiences of the park and its culture coincided.[30] Such shared cultural beliefs can account for the unity between the pictorial and verbal images established by the painter and the writer. Thus, with Miller's description of Dottie's trips to the park ("She took her child every day into the park. . . . For the first few days she kept quite hidden away in the deep woods and tortuous ways, and played, laughed, chatted with the child"), Chase's *In the Park—A By-Path* (Pl. 46) comes to mind.[31] Or, with the words, "and she sank into a bench at the side of the path, a better woman than she had been for a long, long time, at the sight of the little innocent at play in the cool peace and rest of the park," comes the thought of Chase's *Park Bench* (Pl. 45).[32]

Miller's narrative is aided and paced by his use of defi-

nite, confined territories, which he uses almost as sets for staging critical portions of dialogue. These passages present slices taken from the whole of the landscape that correspond to the segmented views of comparable spaces Chase depicts in his paintings—transient glimpses of life that the passerby might ignore or take in for the moment and then discard as inconsequential. The armature of narrative in the literary format supplies the reader's need for explication. However, Chase's purely visual rendering of almost identical motifs decontextualizes the subject, leaving the viewer with the blankness and opacity associated with the modern experience and the sometimes discomforting unintelligibility of contemporary life. Brand's observations about the impermeable expression, or the "face that does not allow itself to be read," as a signifier of the modern condition (in which the experiential cataloguing process breaks down) may be applied to this phase of Chase's art. Most conspicuous among these works is *The Nursery* (Pl. 47), in which the young woman seated in the left foreground stares out at us from the pictorial space. She is conscious of being observed and reciprocates by returning the gaze. Her situation is curious, yet, in the only extended contemporaneous discussion (or rather, description) of the painting, Charles De Kay saw fit to focus mainly on the location of the scene, taking care to orient the viewer precisely in "real" space:

"The Nursery" is a spot seen from the cars of the Hudson River Railroad, little frequented save by those who live near East 100th Street. Here flowers are raised for subsequent transplanting to other parts of the park; here one finds that peculiar mixture of straight lines with crooked, of orderly ranks of seedlings with frames abandoned to the wildest growth, which characterizes such places. The view is taken from the south. Just beyond the locust-trees is the winding piece of water called Harlem Lake, and on the other side of the heavy foliage in the left centre lies the old redoubt. The lady in front to the left has obtained a dispensation from the rule not to pick the flowers. These are brilliant, as are also the white of her dress and hat and the gold of the sunshine falling on hedges and trees, so that one gets from the illustration but little idea of the strong, joyous coloring of the original, which was painted at the height of the morning sunshine.[33]

It is odd that De Kay paid so little attention to the woman whom Chase placed prominently at the entrance to the pictorial space. Indeed, apart from stipulating the out-of-

the-way location of this site, De Kay's major concern appears to have been to reassure the viewer that no park ordinances had been broken. While this is ironic because of Chase's own famous skirmish with the Prospect Park authorities regarding permission to paint on park grounds, the more immediate issue to which De Kay referred was the well-known park rule stating: "All persons are forbidden: To cut, break, or in any way injure or deface the trees, shrubs, plants, turf, or any of the buildings, fences or other constructions upon the park." What is more, visitors were banned from bringing cuttings or flowers into the park.[34] De Kay's introduction of this slight narrative to explain the bouquet of flowers seems absurd in light of his omissions, the most pertinent of which centers on the question of why these women visit this out-of-the-way area of the park at an early morning hour. This issue introduces a set of rules or standards of behavior on which De Kay did not comment, either because he failed to see their relevance or, perhaps, because the strong but ambiguous psychological presence of the woman in the foreground literally prevented him from seeking further meaning in the painting— thus exemplifying the paralysis that occurred when traditional ways of narrative interpretation collided with modern, impersonal imaging. The same narrative impenetrability may be discerned in Tissot's *Richmond Bridge* (fig. 63) and in Manet's *Railway* (National Gallery of Art, Washington, D.C.), in which the accessibility of women (as implied by their placement in public settings and the outward direction of their gazes) is contravened by an indecipherable blankness of expression.

The inability of contemporaneous commentators to acknowledge or fully understand Chase's subject matter— women in the public arena—may stem from the fact that Chase's imagery surreptitiously violated, or at least challenged, a set of social codes that ordinarily facilitated the reading of meaning. Contemporary scholarship has investigated the idea of what is called public display from a number of angles, one of which resides in gender studies focusing on the transitional nature of private and public life in the decades surrounding the turn of the last century. As John F. Kasson has written, "Not only did the cityscape itself change radically; so, too, did notions of social relationships, appropriate behavior, and individual identity. Alterations in the physical character of streets, commercial districts, parks, theaters, concert halls, and residential neighborhoods . . . were directly linked to changes in the kinds of activities that transpired in these public settings, as well as to a larger redefinition of the character of public

Fig. 63. James-Jacques-Joseph Tissot, Richmond Bridge, *c. 1878. Oil on canvas, 14⅝ × 9¼ inches. Collection of William B. Ruger.*

and private life."[35] The changes of which Kasson writes characterized the 1880s, a period during which some of the most visible and unsettling social alterations were apprehended and interpreted through the "public" behavior of women. While Chase's picture of two women near the cold frames in the nursery of Central Park may not seem in any way transgressive to present-day viewers, the image possessed the potential to inspire a vague fluttering of unease in 1890. First of all, these women are unaccompanied, a fact that segregates them from the common practice of their day, when, with few exceptions, proper young women did not appear in public on their own. This social requirement is reiterated consistently in Edith Wharton's novels of manners as well as in the more sensational, popular novels of the 1880s, for example, Nellie Bly's 1889 *Mystery of Central Park*.[36] Bly's novel opens on a weekday morning with the orphaned heiress Penelope Howard sitting on a bench in Central Park with her suitor, Dick Treadwell. Treadwell has just proposed marriage and Penelope has turned him down because, although he has an income, he is an idler. As he implores her to reconsider, he cites his devotion to her: "When you took to a craze to walk in the Park at a hideous hour every morning before your friends, who didn't think it good form, were out to frown you down, did I not promise to be your escort?"[37] The two are so involved in their own private discussion that minutes pass before they realize that the young woman at the other end of the bench is dead. Thus begins the mystery that Penelope charges Richard to solve to prove his ability to apply himself to serious matters. As the discoverers of the unidentified body, Penelope and Richard must appear at the inquest. Although they are not suspects in the murder, their behavior is suspect for, as Bly writes, "Still the conscientious limb of the law determined to know more about two young people, who, while able to drive, were doing such unusual and extraordinary things as walking early in the Park and happening upon the dead body of a girl."[38]

The importance that these seemingly insignificant social codes held for urban dwellers at the end of the nineteenth century is inestimable. These rules helped to regulate behavior and as a result were seen as important tools in aiding to stabilize a society that threatened to fall into chaos as boundaries between classes and the sexes began to dissolve. Public behavior, comportment, and style of dress—always determining signals of status—were liable to stringent codes that not only were handed down within families but also were widely

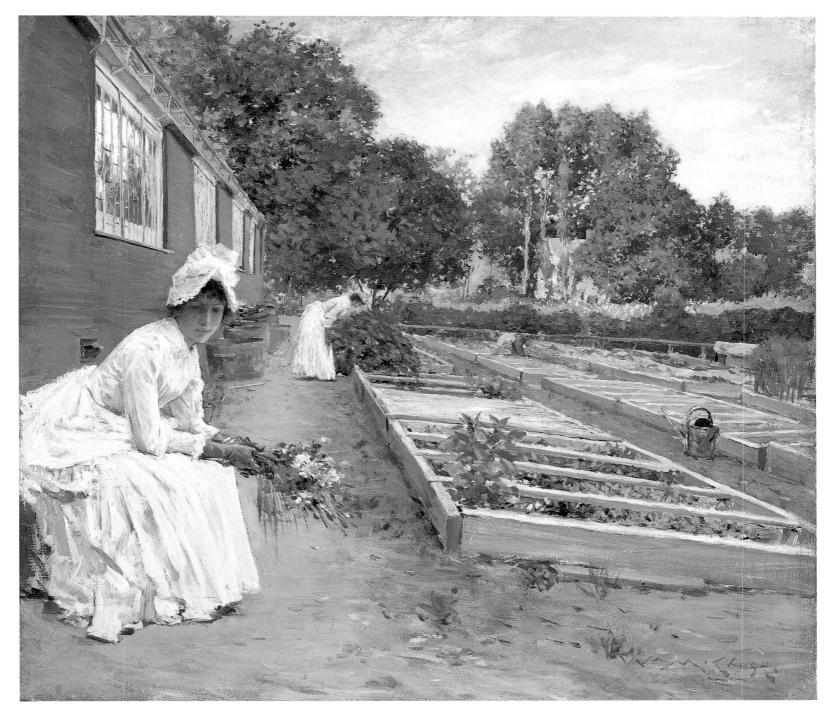

Pl. 47. The Nursery, 1890. Oil on panel, 14⅜ × 16 inches. Manoogian Collection.

disseminated in a plethora of etiquette manuals.[39] A selected reading of just a few of those manuals reveals that Chase's visitors to the nursery violated several of the basic codes that would have helped to ascertain which part of society they occupied. For those who ascribed to those rules of etiquette, the first impression these women gave would have also putatively provided insight into the essence of their characters. The white dresses they wear are entirely out of keeping with recommended daytime street attire. According to *Decorum: A Practical Treatise on Etiquette and Dress of the Best American Society*, "the morning dress for the street [when running errands] should be plain in color and make, and of serviceable material. . . . White skirts are out of place, the colored ones now found everywhere in the stores being much more appropriate."[40] In 1890 another writer stated, "Black is becoming to every woman, but as she does not dress to be seen when walking, it would be well to wear it, even if she thought it not becoming."[41] Yet another infraction of standard etiquette betrayed here is in the posture of the seated woman, who, by all accounts, should be sitting tall and erect, and certainly without her elbows on her knees.[42] Most inappropriate, however, is the directness of her glance. Women in public were considered vulnerable, and to stare, return a stranger's or even an acquaintance's gaze directly, was deemed an open invitation to social liberties.[43] However, because the 1880s were a period of remarkable social transition, the overt stare could also be interpreted as a positive sign of modernity by liberal viewers who favored the increasing independence and freedoms of women.

The question of whether or not Chase was concerned with such social proprieties demands discussion, and if he was, does such evidence inflect the meaning of his art? First, it is necessary to dispel the idea that his park paintings are purely objective or, as it has been suggested regarding *The Nursery*, that the painting is "a simple, straight-forward scene, most likely unpremeditated."[44] The fact that the nursery was so isolated and seldom visited should be enough to contradict the assumption that Chase simply happened on it and decided to paint it. The excursion to the northern end of the park took planning, not only in terms of the site but also in arranging for his model or models to accompany him. On further examination, the painting becomes more intriguing because, in concert with the park's formal terrace and boat basin, this spot testifies to the artificiality of the park itself. The forcing ground for the plants and shrubs that would be transplanted in the perennial task of landscaping the park, the nursery

underscored the basic character of the park as a work of art constructed to imitate nature. By painting this remote area and by including the gardener, Chase called attention to the constant behind-the-scenes labor that went into the making and maintenance of the city's pastoral oasis. With this the possibility arises that Chase saw in this motif a metaphor for his own art as an aesthetic construction that took from nature, but was ultimately a product of the painter's artifice. Furthermore, by extricating his model (an as yet unidentified woman who appears in a number of his works) from the common range of park activity and from the mode of dress and body language sanctioned by contemporary "polite" society, Chase separated his imagery from the purely objective function that Cox and others have attributed to his art. This is a composition that required calculation and is one that may have originated partly out of Chase's simple desire to exact "artistic" revenge on the Brooklyn parks superintendent Aneurin Jones, by creating an image that flouted the breaking of the park's rules.

Visual evidence of Chase's fluency in the language of social niceties may be found in the pairing of *The Nursery* with *Afternoon in the Park* (Pl. 48), a major pastel that depicts Alice Gerson Chase seated on the lawn of the Brooklyn Navy Yard.[45] In the latter work Chase carefully followed the requirements attached to the public appearance of a woman who conformed to rules of social etiquette. She is attractively but modestly dressed in a color recommended for dark-haired women.[46] Her dress and accessories (down to the fan that she holds) are carefully coordinated. And, except for wearing a bit too much jewelry, she is appropriately dressed for an afternoon outing—here most likely to listen to one of the concerts frequently given in the little bandstand on the lawn located in this area of the Navy Yard near the Lyceum. In this connection it is important to note that Chase has indicated the time of day—afternoon—in the title of this work, information that helps to establish that her mode of dress is correctly coordinated with the hour. The primary distinction separating *Afternoon in the Park* and *The Nursery* is that *Afternoon in the Park* is a portrait of the artist's wife. As such he has taken her out of the domestic sphere and placed her on public display both figuratively (within the pictorial space) and literally (by exhibiting the pastel in public).[47] His sensitivity to this level of accessibility is implicated by Alice's profile pose, which prevents eye contact with her and therefore wraps her even more firmly within the bounds of gentility

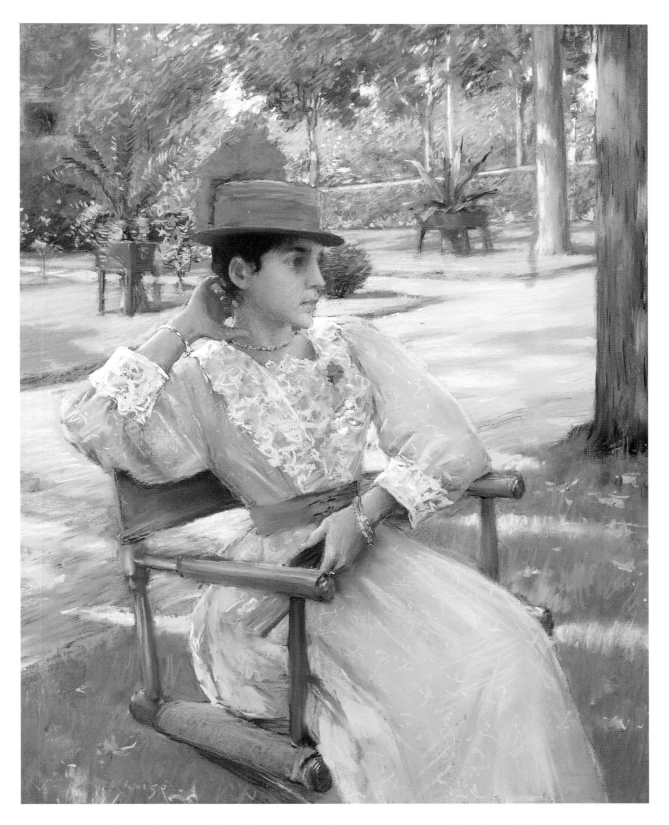

Pl. 48. Afternoon in the Park, c. 1887. Pastel on paper, 18¾ × 14¼ inches. Shein Collection.

Fig. 64. Rustic arbor in Prospect Park, 1904. Photograph. The Brooklyn Historical Society.

Fig. 65. Perils of the Park, *from National Police Gazette 33, no. 56 (October 19, 1878), 16. General Research Division. The New York Public Library. Astor, Lenox and Tilden Foundations.*

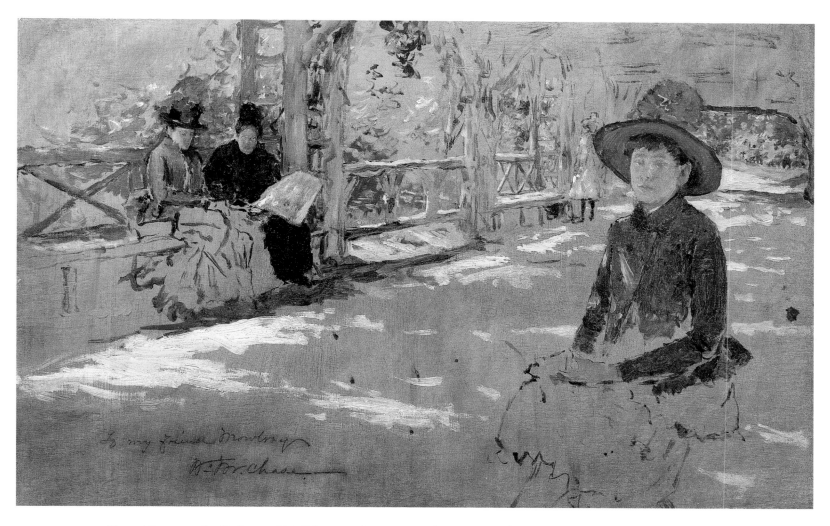

Pl. 49. Women under Trellis, *c. 1886. Oil on panel, 10¼ × 16 inches. Private collection. Courtesy Berry-Hill Galleries, Inc.*

that are already geographically buttressed by the cultural purposes associated with the landscape she occupies. Her abstracted, thoughtful expression further removes her from impropriety, for she appears unaware of being observed (or, as recommended by the etiquette manuals, feigns ignorance of being watched). Chase shields Alice in this way throughout his art, for in no image of her in the out-of-doors does he break these social constraints. This thinking ties in with the reasoning given in chapter three for Chase's apparent decision not to exhibit *The Open Air Breakfast* until 1915, well after social customs constraining the display of private life in the public sector had relaxed somewhat. Further, his reluctance to violate these rules of polite society may explain why he did not complete one of his more elaborately conceived Prospect Park paintings, *Women under Trellis* (Pl. 49), which shows a young woman (perhaps Alice, but possibly another member of the family) in the right foreground looking out of the picture space with three additional figures, two of whom appear to be Hattie (in the background) and the artist's mother (the elderly woman dressed in black). It has been implied that this painting is set in Central Park.[48] However, it is more likely, given the distinctive arched construction at its entrance, that the arbor is one of several that were once in Prospect Park (fig. 64). In contrast to these images, Chase's portrait of Alice in *At the Window* (Pl. 50) accommodates the more personalized portrait mode because of its private, interior setting.[49]

These nuances in Chase's portrayal of women in public spaces may be taken as tacit admission on his part of the existence of the perils to which women were subjected as they negotiated the new territories opening to them in urban society. However, only in the somewhat ambiguous figure of the man in a Tompkins Park painting (see Pl. 20) does Chase more overtly introduce the idea of the potential threat of the male urban observer and, by extension, the menacing side of city life. As other writers have remarked, Chase's park paintings are populated mainly by mothers or nursemaids accompanying children, a feature attributable to the weekday hours during which the artist painted, when most men were at their jobs. In the context of this painting the male presence lends a vaguely ominous tone to its mood. He stands alone near the drinking fountain, smoking a cigarette and apparently watching the retreating figures of the woman and child as they head for the exit at the corner. Judging from the large shadowed areas of the park and the long strips of sunlight that cut across it, the time is late afternoon, an interval in the day

when this little neighborhood park empties out and its visitors return to their homes on the surrounding streets. An abandoned ball adds visual interest to the expanse of grass in the left foreground and also augments the sense of temporal transition as this public space is literally transformed before our eyes from a welcoming sunlit haven to a deserted, perhaps threatening territory as evening nears. In considering the role of the man in this painting, it is useful to note that he does not qualify as a gentleman. He does not move with purpose, he smokes in public, and, worst of all, he subjects the woman to his scrutiny. At the very least he qualifies as the ill-bred type referred to as the "corner loafer" known to station himself in the doorways of hotels or on the streets, "gazing impertinently at the ladies as they pass."[50] Without explicitly creating a narrative, Chase calls up societal associations that played on the fears that accompanied the growing freedom of movement for women in the public sphere. These associations intersect with the leitmotif of the shadowy figure who follows Dottie in Miller's *Destruction of Gotham*, the prohibitions concerning watching and being watched in the etiquette manuals, and even extend to the lighthearted lyrics of "While Strolling in the Park One Day," a hit song written in 1884.[51] These parallels also point to the fictive nature of this painting, particularly with respect to its intimations of a purposeful experimentation with a narrative summoning popular conceptions of the dangers lurking in the parks (fig. 65). Yet it was Central Park that suffered the most from these problems, not Prospect Park and least of all Tompkins Park, where in 1888 and 1889 only two arrests were made, both for public intoxication.[52] However, the sensibility of surveillance is gently reiterated in a number of Chase's park paintings in which a figure turns an alert gaze toward someone or something outside the pictorial space (Pls. 1 and 47, for example). Chase does not seem to have been prepared to exploit the motif of urban spectatorship to the degree demonstrated in the works of his French realist contemporaries. His references to the menacing side of modern society remain furtive and incomplete. The women in his paintings are the "object of the gaze," and, when they do turn to examine their observer, we are never privileged to know whose gazes they return.[53] The anonymity of the observer neutralizes the aura of threat, for it allows us to place the artist or ourselves in that role. Yet even these tentative forays around the margins of modern life are extraordinarily progressive in comparison with the imagery of Chase's American colleagues.[54]

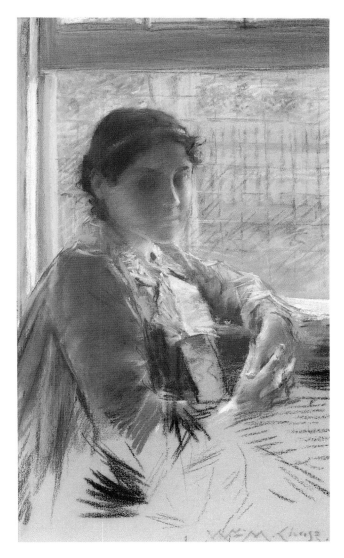

Pl. 50. At the Window, c. 1889. Pastel on gray paper mounted on canvas, 17½ × 10 inches. Brooklyn Museum of Art, 33.28, Gift of Mrs. Henry Wolf, Austin M. Wolf, and Hamilton A. Wolf.

The responsive attitudes of some of Chase's female park-goers are significant, because they denote an awareness of being observed by replying in kind, emulating a physical posture often found in photographs (fig. 66). Although there is no evidence that Chase used photography as a tool in constructing his compositions, the reflexivity implied by the motif of the woman whose body twists and leans in reaction to an observer mimics the natural reaction that accompanies the sudden realization of becoming the "subject." Such a realization attaches more to the photographic than the painted moment because of the temporal disparities between the two ways of imaging. Yet Chase imitated the photographic moment through the use of the reactive pose, thereby heightening the sensibility of the spontaneous, unpredictable nature of public life. The combination of the neutral, impassive gaze and the reactive pose, impressed within a spatial formula that possessed visual distortions and emphases reminiscent of those produced by the camera, insinuated Chase's modernity as well.

Although Chase assumed the guise of the flâneur, his paintings betray his strong personal attachment to his subject matter and his desire to portray the modernization of American society as beneficial. A common interpretation of New York City in the 1880s was that it stood for the "new Paris."[55] France, however, was notable for its "Latin" vulgarity, revealed in social flux and fluidity that were anathema to American social commentators. This fear was rooted in part to the anxiety attached to the growing inability to distinguish who was who in the anonymous urban crowd, a condition that possibly accounts for the myriad etiquette manuals in publication at the end of the century, which provided (and insisted on) codified behaviors that would promote social clarity.[56] As Karen Haltunnen has observed, it was within the nonelite urban middle class where the greatest difficulty lay in identifying the nature of the stranger. Chase's status as an artist placed him outside the conventional class structures, but his family background and his life at home aligned him most closely with middle-class virtues and experience. In large part it was the middle-class view of modernity on which he focused, featuring a normalized, contained use of public space that allowed for the idea of expanded public life; but he portrayed the spaces of that life mainly as arenas of genteel behavior. This was in keeping with the aims of public park design in New York, which spurred debates about the definition and use of "public" space.

CHASE AND THE GENTEEL URBAN SPACE

From the time of the earliest discussions about building a grand city park in Manhattan, the practicality, even the possibility, of an orderly democratic public space was consistently questioned. Although America could boast of a classless society, many people recognized that this was a nominal claim. In the face of a huge influx of immigrants and unrest among the laboring classes—populations whose behavior threatened to conflict with polite norms—it was difficult for some writers to conceive of a congenial mixing of such diverse peoples in a landscape of common enjoyment. Doubts along these lines were frequently published in newspapers, an example of which is quoted here at length because it encompasses the dominant reasoning as to why the ideal of Central Park was bound to fail:

It is by no means certain that the people of this city are not nursing for themselves a severe disappointment in relation to the Central Park. People figure it to themselves a magnificent garden, laid out with shady walks and groves, cool fountains, splendid exotics, winding carriage drives, statues, and summer houses of the most delicate taste; the most exquisite flowers adorning parterres laid out with skill and science, and trees of every shade and size flowering overhead; with lakes and silvery streams creeping through the sward, and swans and other rare birds, gold and other droll fish disporting themselves therein; finally, with stately rows of magnificent houses, with brown stone fronts, roomy balconies full of elegant women, and a gorgeous approach, encircling this delicious retreat from end to end. . . . We much fear that the Central Park, in the earth and stone, will be a very different affair. It appears already that the most persevering candidates for desirable sites around it are the lager bier [sic] dealers, and the keepers of corner groggeries.[57]

After describing English and European society, in which "the lower orders do not pretend to deny they are the 'lower orders' and therefore do not claim right to the same enjoyments of their 'superiors,'" the writer continued:

Here, we order things very differently. Here, we have no "lower orders;" nobody has any "superiors;" we know no "nobility and gentry;" nothing but a public which is all and everything, and in which Sam the Five Pointer is as good a man as William B. Astor. . . . Further, whatever is done by or for the public aforesaid, is done by or for Sam as much as any one else, and he will have his full share of it. Therefore, when we open a public park

Fig. 66. Swan Boat on Prospect Park Lake, c. 1890. Photograph. The Brooklyn Historical Society.

Sam will air himself in it. He will take his friends, whether from Church street or elsewhere. He will enjoy himself there, whether by having a muss, or a drink at the corner groggery. He will run races with his new horse in the carriage way. He will knock any better dressed man down who remonstrates with him. He will talk and sing, and fill his share of the bench, and flirt with the nursery girls in his own coarse way. Now, we ask what chance have William B. Astor and Edward Everett against this fellow-citizen of theirs? Can they and he enjoy the same place? Is it not obvious that he will turn them out, and that the great Central Park, which has cost so much money and is to cost so much more, will be nothing but a huge bear [sic, beer?] garden for the lowest denizens of the city—of which we shall yet pray litanies to be delivered![58]

In *Highbrow Lowbrow: The Emergence of Cultural Hierarchy in America* Lawrence Levine wrote of the inevitability of the changes immigrant populations would exert on the fabric of American culture and stressed that merely by their visibility on the streets they acted as daily reminders of the hazard they posed to the status quo. The support for public parks, museums, libraries, and symphony orchestras was therefore borne partly out of the basic duality of philanthropy in that it not only improved the lives of the "masses" but also promised to inculcate that population with elitist values.[59] Olmsted's philosophy for his park designs reflected this duality, since he sincerely believed that public parks would enhance the lives of the entire population and also because he believed that it was necessary to instruct people in the proper use of the parks through strict rules regulating behavior. His 1859 statement to the park commissioners contains a succinct rehearsal of these attitudes: "The Park is intended to furnish healthful recreation for the poor and the rich, the young and the old, the vicious and the virtuous, so far as each can partake therein without infringing upon the rights of others, and no further."[60] Anticipating thousands of daily visitors from all walks of life and desiring to shield them from the turmoil of the city, Olmsted and Vaux devised a plan that would effectively separate pedestrian and carriage traffic while accommodating both. Intended or not, the by-product of this eminently practical plan (defined mainly by the drives that hugged the perimeters of the park) was a separation of the classes. While the afternoon carriage rides of the wealthy figured significantly in the overall public experience of the space, only a small percentage of the city's population was wealthy enough to

participate in that ritualized social sport, leaving the inner landscape to the majority who viewed it on foot.[61] Although drivers were prohibited from racing, most of the park regulations were designed to manage the conduct of pedestrians. Olmsted drafted his "Regulations for the Use of the Central Park" in 1860. Ominously headed, "Central Park Visitors are Warned," the list of proscribed acts read: "Not to walk upon the grass; (except of the Commons), Not to pick any flowers, leaves, twigs, fruits or nuts; Not to deface, scratch or mark the seats or other constructions; Not to throw stones or other missiles; Not to annoy the birds; Not to publicly use provoking or indecent language; Not to offer any articles for sale." The final caveat promised that: "Disregard of the above warnings, or any acts of disorder, subject the offender to arrest and fine or imprisonment."[62]

Olmsted predicted that these restrictions would not be popular and he was proved right by the publication of numerous cartoons in periodicals and newspapers (fig. 67) as well as

Fig. 67. Keep Off the Grass, *cartoon from* Harper's Bazar, *September 23, 1882, 608. Brooklyn Museum of Art Library Collection.*

articles relating instances of park crime and punishment. In some cases the publicity devoted to the park's rules placed the restrictions in a positive light in terms of democratic enforcement. No one was too high or too low on the social scale to escape the force of law, a fact that was transferred to the larger matter of political corruption in which the park assumed a redemptive role. In *Harper's Weekly* "The Lounger" devoted a column to this topic, exclaiming,

Who is not proud that, in a day of swindling in politics, and of cast-iron in building, such grand works can be achieved in rugged honesty and solid stone? It silences forever the clatter of skeptics of the democratic principle as inimical to vast public works. In all the cities of Europe there were never better or more orderly laborers than the three thousand who work at the Central Park, with so little friction, such perfect and simple unconscious good feeling. This, also, being based on directness and the simplicity of absolute law.[63]

The impartial enforcement of the system of park regulations was then illustrated by "The Lounger," who recounted the story of a respected judge who had been apprehended for illegally walking on the park's turf: "Indignantly he pleaded his urgency, and gave his name as a guarantee of no lawless disposition. The stringent reply was, 'that the order is to arrest all persons crossing the grass, and judges of the highest courts are not excepted.'" The column concluded with a grand statement linking the park to the cultural health of the nation: "The throngs of visitors remember that the Park is the common property of all, and that no individual can justly appropriate a single flower, or the freshness of any lawn or margin of grass, to his private gratification. It is so universally in other countries. And the more parks we plant, the more galleries of art we open, the more we promote refinement of soul by the increasing influence of beauty, the more we shall find that faith in the people is justified and deepened."[64]

Established early on in the park's history, the policies maintaining the orderly use of its spaces remained in place and continued to be the focus of public discourse. Codes of law, their enforcement, and the actualities of public behavior were and are often quite separate, however. By the 1870s Olmsted and others perceived a marked decline in public decorum in the park, citing an upsurge in vandalism and general disorderly conduct.[65] Much of this had to do with the political workings of the park administration, which had fewer

funds allocated to pay park keepers and police, but also it reflected the changes in general public conduct that were occurring then. Had a park official been present on a warm summer night in the park in the early 1880s, Chase would likely have been arrested himself. Katherine Metcalf Roof records that Chase would often dine with the Gersons outdoors at the Casino restaurant in Central Park. On one such occasion, when his mother and sisters were visiting from St. Louis, Chase, Walter Shirlaw (1838–1909), Frederick S. Church, and the Gerson sisters took Mrs. Chase and her daughters to an evening supper there. After their meal they strolled through the park. Roof describes the ensuing events: "Chase, burlesquing a state of despair over some pretended neglect, ran to the edge of the lake as if to throw himself in, and it being a combination of dusk and nearly moonlight mistook a reflection for the solid earth, and promptly and unexpectedly disappeared beneath the surface of the lake, to the horror of all."[66]

This example of Chase's personal experience of the park helps to emphasize just how fictive his visions of the park are. In that connection it is useful to recall that Chase had first arrived in New York City in 1869 and lived there intermittently through 1870, studying at the NAD. This was a crucial period in the history of the Central Park (and for all New York parks) because it marked the passage of park administration from the hands of the state-appointed Board of Commissioners to the new Department of Public Parks, whose commissioners were appointed by the mayor. A residual effect of the Tammany Hall regime led by the famously corrupt Boss Tweed, the transfer of power led anti-Democrats to fear that the whole scheme forecast the ruin of the park.[67] Impassioned newspaper editorials bemoaned the imminent demise of the genteel, restful oasis that Olmsted had hoped would provide a refining balm for world-weary urbanites.

When Chase returned to New York in 1878, the same public debates were still receiving wide press coverage. And, although the Tweed Ring was long dismantled, the perception remained in some quarters that the park was doomed. This complex phase of the park's history was not formed simply out of political competition for the running of the park but was part of a larger set of problems stemming from the economic crash of the 1870s, the call for budget cuts, lower wages for city employees, and the growing opinion that the park was an "expensive luxury."[68] When reasonable funds were allocated for park maintenance, the lack of expertise in desig-

nating the uses to which those funds were put often ran counter to the initial philosophy of Olmsted and Vaux and worked to destroy the carefully planned vistas they had built into their design. One of the villains of this piece was Aneurin Jones, the same man whose unaccommodating nature later featured in Chase's Prospect Park permit brouhaha, and who was guilty in 1881 of cutting down park trees to provide a better view of the new Third Avenue elevated railroad.[69] Such changes, inimical to the ideals of the park's designers, were also on the increase because of the northward development of real estate on its east and west sides. In 1886 the trees at the park's borders near Fifth Avenue and 68th Street were cut down at the request of Mrs. Robert L. Stuart (the widow of the art collector and president of the American Museum of Natural History from 1872 to 1881) so that she would have a better view from her mansion.[70] New entrances were built as a convenience to the growing population of the wealthy lining the park, and, as the lobbying power of this group of taxpayers grew, more demands were placed on city officials for improved roadways across the park, later park curfews, artificial lighting, and the completion of the northern end of the park so as to make the adjacent real estate more marketable. Also entwined within this era of the park's development are the histories of two museums, the American Museum of Natural History and the Metropolitan Museum of Art, the fates of which were caught up in discussions about the legitimacy of sectioning off park lands for these cultural institutions, and the much debated correctness of Sunday hours.

Chase is not known to have been involved directly in any of these matters, which were reported in detail in the press. Yet this abbreviated account of the politics surrounding the park's administration helps to demonstrate the breadth and depth of public concern with respect to Central Park, the sum total of which revised the perception of "public" parks in general. Certainly Chase would have been interested in the tastes and demands of Mrs. Stuart; the plight of Olmsted and Vaux, whose artistic creation was being vandalized by numerous factions; and the outcome of the debates about open Sundays for museums (something he had had a taste of in connection with the Sunday openings for the 1883 Pedestal Fund Loan Exhibition). Finally, as a citizen involved in the cultural life of his community, Chase was likely to have followed the saga of the parks as it unfolded in the newspapers, journals, and on the streets themselves.

Most lucid in this connection are Chase's canvases that depict the area around Bethesda Fountain (Pls. 41, 42, 51, and 52). Rendered in the clear light of the morning sun, these scenes display women juxtaposed with or near the emblematic and controversial sculpture commissioned by the Park Commissioners in 1863 from Emma Stebbins for the considerable sum of sixty thousand dollars. The history of the commission is fascinating with regard to the debates concerning the appropriateness of public art in the park and the award of the commission to a relatively unheralded woman (who was, by the way, the sister of the president of the Central Park Board of Commissioners, Henry G. Stebbins, named chairman of the Committee on Statuary, Fountains, and Architectural Structures in 1860).[71] Olmsted and Vaux had originally aimed to keep the park free of sculpture to maintain the semblance of picturesque naturalness. Other tastes intervened, however, as demonstrated by the wealth of public monuments and statuary throughout the park today.[72] Vaux finally agreed to work with his assistant Jacob Wrey Mould in creating the elaborate architectural and sculptural program that would define the terrace marking the division between the upper and lower portions of the tract. Of the allegorical sculptures originally intended for the scheme, only those for the circular fountain basin in the center of the Lower Terrace were completed—the Angel of the Waters, which presides over that space today.[73] Based on the biblical Angel of Bethesda, whose airborne arrival would activate the healing capacity of the waters in Jerusalem's Bethesda pool (John 5:2–4), the fountain sculpture at the time of its installation was laden with contemporary meaning in that it alluded to the recent "gift" of fresh water to the citizens of New York from the reservoirs of Central Park. The four cherub figures flanking the bulrushes forming the support for the fountain represent Health, Purity, Peace, and Temperance, ideals also closely aligned with the motives behind the park.

The likelihood that Chase intended viewers of his terrace paintings to associate the restorative powers of nature (as represented by the park) with the content of Stebbins's fountain sculpture is strong.[74] In fact, the likelihood becomes even stronger in light of the efforts to purify the park's waters that took place in the late 1880s, slightly prior to the time that Chase painted these works. Uptown real estate developers and nearby residents became anxious in the mid-1880s about the threat of malaria stemming from the stagnant waters of the park's lakes, which suffered from inadequate drainage. As Roy Rosenzweig and Elizabeth Blackmar point out, "The

lawns and meadows were reverting to swamp, the half-filled lakes were covered with 'green scum,' and the transverse roads and bridle paths flooded after every rain. To make matters worse, sewers from the park's comfort houses dumped waste into the ponds."[75] The contemporary condition of the park and its own need for renewal fused with the historical meaning appended to the terrace and its angelic deliverer of healing. In the mid-1880s restorative measures were begun with the drainage of the lakes, repairs and replacement of water pipes, and, in 1888, the filling in of the western end of the pond near West 77th Street. Although these turned out to be mere stopgaps, when Chase painted the terrace and its surroundings, that area of the park had just been returned to a pristine state that coincided with the symbolic content originally attached to it.

Knowledge of the contemporary (1880s) campaign to cleanse the park's waters adds an otherwise absent layer of meaning to Chase's imagery. *An Early Stroll in the Park* (Pl. 51) conveys an amalgam of historic and contemporaneous references to real issues of community health, in which the *Angel of the Waters* can be interpreted to represent the historical past and the woman in white as the purified present. Within this visual text is an insistent theme linking women with the overarching ideal of improvement. The manner in which Chase achieved this meaning seems as eclectic in its own way as the more obvious eclecticism associated with his range of subject matter and varied ways of painting. Here he adopted a modern framework—a site that is contemporary, public, and schematized according to advanced artistic conventions of pictorial space. His selection of the site was done with an eye for content already established in the Stebbins fountain figure. To this he added his own annotation—the woman in a white dress, which, by virtue of its familiar reiterations in the art of contemporaneous figure painting, reads as a sign of feminine purity rather than a representation of a "real" figure, casually observed.[76] The additive aesthetic process perceived here, which took from the real and the ideal, was also constructed of conflicting ways of reading art. In place of a single art object to interpret, Chase presents us with several: the painting itself; the park (which was commonly characterized as a work of art); and the Stebbins fountain, all three of which originated out of separate aesthetic traditions (modern, romantic, and academic) relying on different interpretive methods and standards of evaluation, but which were united in meaning. Far from being obscure, such

a reading requires little beyond the act of looking and recognizing the significance of place, the latter of which was easily within the grasp of Chase's middle- and upper-class urban contemporaries—the audience to whom he catered.

On the Lake, Central Park (Pl. 52) encourages the same type of interpretation. In this instance we are presented with a broad vista that offers a view across the lake to the terrace where Bethesda Fountain is visible in the distance. This is truly the civilized urban landscape in which the industry of man has transformed the irregularities of nature into an artificial Edenic garden to demonstrate modernity in its most positive light. Employing the most modern of artistic means—a variant Impressionist mode—Chase created a sunlit vision that now seems strangely idyllic with its solitary woman rowing quietly among the swans. Yet her activity in itself would have signaled the currency of the image, for rowing was just coming into vogue as an acceptable recreational pursuit for women in polite society. In this work and in *An Early Stroll in the Park* discussed above, Chase relieves the woman of her parental role, removing her entirely from the domestic sphere and placing her in the public domain in which she exists independently. This is not to say, however, that the female loses all traditional symbolic meaning, for as the most familiar icon of refinement and beauty in the visual arts at the time, the female figure endows the landscape with gentility, feminizing it through a visual rhetoric that complies with the general view of the feminization of late-nineteenth-century American culture.[77] Chase's rower was not the dangerous New Woman, nor was she, as her chaste white dress proclaims, a denizen of "Down Town." To be sure, she is classless in that her costume is not that of the upper-class female, nor the modish dress recommended for rowing in the etiquette manuals.[78]

Through this discussion, which suggests the possible biographical, literary, social, and economic implications contained in Chase's paintings of real places, the conclusion that the artist himself acknowledged and consciously used varying types of "reality" for different ends becomes inevitable. With respect to the "woman in white," the figure takes on an emblematic presence in the terrace views of Prospect Park (see Pls. 5 and 6), on the docks and in the grounds of the Navy Yard (see Pls. 7 and 23), and in the areas surrounding Bethesda Fountain in Central Park (see Pls. 41 and 51), investing these spaces with a didactic content that coincides with the idealized cultural aims of the spaces themselves. As an anonymous sign of meaning rather than identity, this

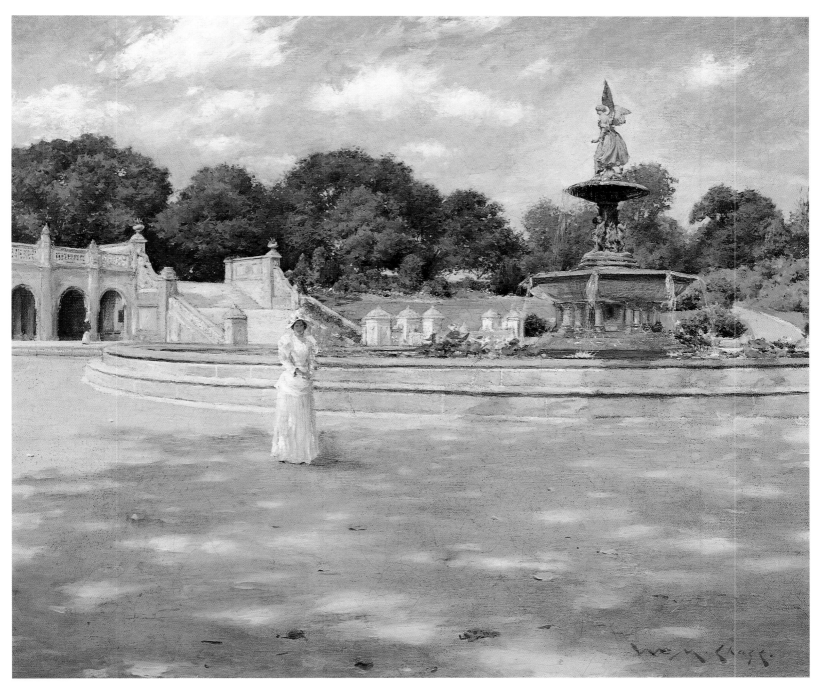

Pl. 51. An Early Stroll in the Park, *c. 1890. Oil on canvas, 19⅞ × 23¾ inches. Montgomery Museum of Fine Arts, Montgomery, Alabama, The Blount Collection, 1989.2.4.*

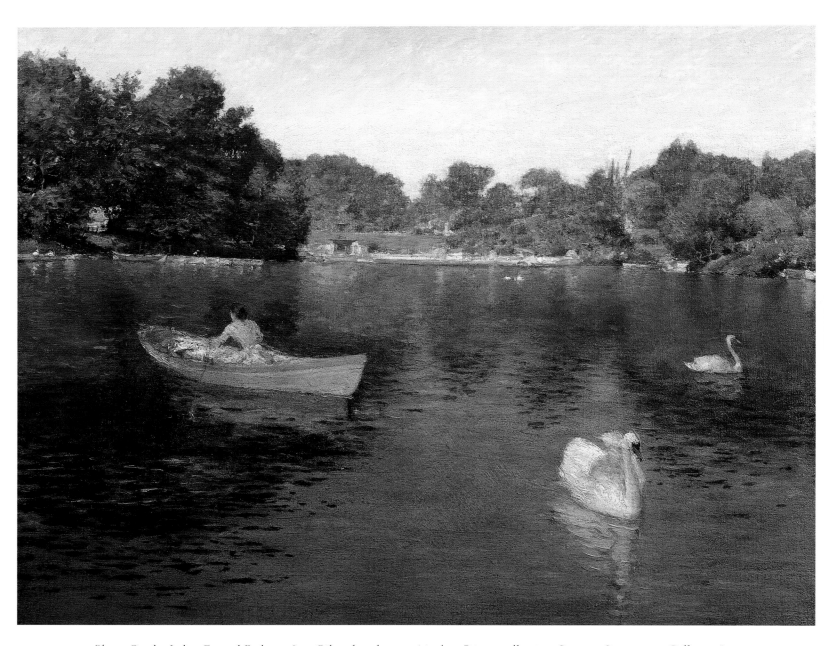

Pl. 52. On the Lake, Central Park, c. 1890. Oil on board, 14 × 16 inches. Private collection. Courtesy Spanierman Galleries, Inc.

aspect of the feminine in the landscape is deployed in much the same way that Chase used the female figure in his studio subjects—as a bearer and receiver of cultural refinement in the public sphere. Positioned in recognizable settings of studio and landscape, both of which were to be seen as modern in character and eminently "real," these white-gowned figures help to define further the places they occupy, marking them as harmonious regions conducive to solitary contemplation. Perhaps surprisingly, Chase's woman in *Park Bench* (see Pl. 45) bears a closer conceptual affinity to the numerous paintings of solitary women reclining in well-appointed interiors that prevailed at this time than it does to contemporaneous photographic, print, or painted images of woman in public parks. Despite the geographic truthfulness of Chase's images, they are utterly subjective evocations of "modern life" as it was desired and not necessarily as it was. In contrast to the works bearing this relatively symbolic construct, another subgroup emerges that evinces strong biographical associations. This group, rooted in the artist's private experience of particular spaces—mainly the Tompkins Park subjects and the views along Gravesend Bay—is less programmatic in nature. This is not to say that the paintings do not exhibit artistic devices and conventions or ultimately entail a wider meaning, but rather that their inspiration seems to originate from Chase's integration of the familiar, day-to-day realities of family routine into his art. In these, "place" assumes a personal (and therefore subjective) resonance because the sites he portrayed were not originally destinations specifically attached to art making but instead were first part of the geography of his private life.

The thematic polarities of the symbolic and the personal are encompassed within Chase's general efforts to represent his urban milieu. That these thematic strains can be detected along with other associative meanings derived from literary, topical, and artistic sources indicates that realism was not Chase's ultimate goal. Rather, the parks and harbors of Brooklyn and New York provided him with a basic spatial framework comparable to that of his studio, through which he could explore the tenets of modern art to revitalize his aesthetics and his reputation.

NOTES

1. Kenyon Cox, "William M. Chase, Painter," *Harper's New Monthly Magazine* 78 (March 1889), 549.
2. See H. Barbara Weinberg, Doreen Bolger, and David Park Curry, in *American Impressionism and Realism: The Painting of Modern Life, 1885–1915*, exh. cat. (New York: The Metropolitan Museum of Art, 1994), 144, where they state, "Ronald G. Pisano has discouraged investigation of the extrapictorial meanings of Chase's paintings, maintaining that the artist 'asserted that the importance of a work of art is in how it is painted, not in what is depicted.'"
3. William Merritt Chase, "Painting," *American Magazine of Art* 8 (December 1916), 50.
4. "Address of Mr. William M. Chase before the Buffalo Fine Arts Academy, January 28th, 1890," *Studio*, n.s., 5, no. 13 (March 1, 1890), 122.
5. Frances Lauderbach, "Notes from Talks by William M. Chase, Summer Class, Carmel-by-the-Sea, California, Memoranda from a Student's Notebook," *American Magazine of Art* 8 (1917), 433, 436.
6. Chase, "Painting," 52.
7. See "The Academy's Exhibition," *New York Times*, April 6, 1891, 4, in which Hovenden's painting received the following commentary: "'Breaking Home Ties,' by Hovenden, was shown lately at Philadelphia and bought by Mr. C. C. Harrison. So far as technical qualities go, the interior, with women, men and a dog, is painted with more skill than the artist has ever before exhibited. It has also a quality Mr. Hovenden has shown hitherto, that of hitting firmly a popular sentiment. In a bare country sitting room an overgrown boy, whose big feet and ungainly proportions indicate that he will soon become a man of large stature, stands sheepishly before his mother to say good-by. The artist has been very successful in the face as well as the figure. The boy is too much of a man to cry, but still young enough by show that parting from home gives a wrench to his feelings. The story is concentrated in his face and figure. Even the mother is unimportant except to explain the scene, while the girl and dog on the left (excellently painted) and the grandmother and sisters on the right are supernumeraries. The picture is a good one in many respects, and testifies to the progress of Thomas Hovenden in the power to compose and ability to paint well a large number of figures in one scene."
8. Chase, "Address of Mr. William M. Chase before the Buffalo Fine Arts Academy," 125.
9. Ibid.
10. Sarah Burns, *Inventing the American Artist: Art and Culture in Gilded Age America* (New Haven and London: Yale University Press, 1996), 45.
11. Linda Nochlin, *Realism: Style and Civilization* (New York and Baltimore: Penguin Books, 1971), 13.
12. Weinberg, Bolger, and Curry, in *American Impressionism and Realism*, 141, introduce Chase in this context but do not pursue the idea extensively.
13. Charles Baudelaire's essay "Le Peintre de la vie moderne" was first published in *Le Figaro* (Paris), November 26 and 29, and December 3, 1863.

Baudelaire's model for the painter of modern life is believed to have been Constantin Guys (the Monsieur G. referred to in his essay). In a text that draws attention to the pertinence of Edgar Allan Poe's "Man of the Crowd," Baudelaire defines the modern artist as "the lover of universal life" who "enters into the crowd as though it were an immense reservoir of electrical energy. Or we might liken him to a mirror as vast as the crowd itself; or to a kaleidoscope gifted with consciousness, responding to each one of its movements and reproducing the multiplicity of life and the flickering grace of all the elements of life." Quoted from Charles Harrison and Paul Wood with Jason Gaiger, eds., *Art in Theory, 1815–1900: An Anthology of Changing Ideas* (Oxford: Blackwell Publishers, 1998), 496–97.

14. Dana Brand, *The Spectator and the City in Nineteenth-Century American Literature* (Cambridge and New York: Cambridge University Press, 1991), 5.

15. See Brand's chapter "The Development of the Flâneur in England" in ibid., 14–40.

16. Robert L. Herbert, *Impressionism: Art, Leisure, and Parisian Society* (New Haven and London: Yale University Press, 1988), 33.

17. Edgar Allan Poe's "Man of the Crowd" was first published in *Gentleman's Magazine* (December 1840). For a modern interpretation of the story, see Robert H. Byer, "The Mysteries of the City: A Reading of Poe's 'The Man of the Crowd,'" in Sacvan Bercovitch and Myra Jehlen, eds., *Ideology and Classic American Literature* (Cambridge: Cambridge University Press, 1986), 221–46.

18. Brand, *The Spectator and the City*, 88.

19. See especially Brand's chapter on Whitman, "Immense Phantom Concourse: Whitman and the Urban Crowd," in *The Spectator and the City*, 156–85.

20. *Paintings by William Merritt Chase, N. A., LL.D.*, exh. cat. (St. Louis: Newhouse Galleries, 1927), n.p.

21. "Address of Mr. William M. Chase before the Buffalo Fine Arts Academy," 125.

22. Lauderbach, "Notes from Talks by William Merritt Chase: Summer Class, Carmel-by-the-Sea, California," 437.

23. Joaquin Miller, *The Destruction of Gotham* (New York and London: Funk & Wagnalls, 1886).

24. Juanita Miller, *My Father, C. H. Joaquin Miller—Poet* (Oakland, Calif.: Tooley-Towne, 1941).

25. Miller, *The Destruction of Gotham*, 43.

26. Ibid., 116.

27. Ibid., 46.

28. For Madame Restell, see Eric Homberger, *Scenes from the Life of a City: Corruption and Conscience in Old New York* (New Haven and London: Yale University Press, 1994), 86–140.

29. Miller pointedly describes the tax frauds on the part of wealthy tenement owners who continually raise rents on impoverished tenants. Yet in his eyes, money making was not morally abhorrent, for capitalism also produced the means for social improvement, as for instance, the Central Park.

30. By culture it is meant that the idea of the park attained a significance derived from its use, regulations governing its use, known history, current politics, newspaper accounts, and other sources of popular imagery, all of which combined to form a body of information that created social meaning concerning its spaces.

31. Miller, *The Destruction of Gotham*, 78.

32. Ibid., 97.

33. Charles De Kay, "Mr. Chase and Central Park," *Harper's Weekly* 35, no. 1793 (May 2, 1891), 328.

34. T. Addison Richards, *Guide to Central Park* (New York: J. Miller, 1876), 99–100. This was pointed out by Ronald G. Pisano in his entry for the painting in *American Paintings from the Manoogian Collection*, exh. cat. (Washington, D.C.: National Gallery of Art, 1989), 142–43.

35. John F. Kasson, *Rudeness and Civility: Manners in Nineteenth-Century Urban America* (New York: Hill and Wang, 1990), 4.

36. For Wharton, see Maureen E. Montgomery, *Displaying Women: Spectacles of Leisure in Edith Wharton's New York* (New York and London: Routledge, 1998). Nellie Bly, *The Mystery of Central Park* (originally published in the

New York Evening World) (New York: G. W. Dillingham, 1889). Nellie Bly was the literary pseudonym of Elizabeth Cochrane, a journalist and fiction writer who focused on exposing social ills. She occasionally went under cover to gather information for her exposés, investigating the darker side of New York.

37. Bly, *The Mystery of Central Park*, 13.

38. Ibid., 28–29.

39. For the range of books devoted to etiquette published in the United States to 1900, see Mary Reed Bobbitt, comp., "A Bibliography of Etiquette Books Published in America before 1900," *Bulletin of The New York Public Library* 51, no. 12 (December 1947), 687–720.

40. S. L. Louis, *Decorum: A Practical Treatise on Etiquette and Dress of the Best American Society* (New York, Boston, Cincinnati, and Atlanta: Union Publishing House, 1881), 271.

41. Kasson, *Rudeness and Civility: Manners in Nineteenth-Century Urban America*, 121.

42. See ibid., 177, for an illustration from *Hill's Manual of Social and Business Forms* (1882) showing "ungraceful positions." One of those positions mirrors that of Chase's seated woman in the Central Park nursery.

43. Even public exchanges between friends were carefully scripted. For instance: "Under all circumstances, upon the promenade, the street, or in other public places, her [a lady's] smiles are faint and her bows are reserved . . . no matter how cordially she may have received him at a recent ball or when he last paid his respects to her at home. . . . A faint smile and a formal bow are all that the most refined lady accords to the visitor of her family when she passes him in her walks or drives." *Social Etiquette of New York* (New York: D. Appleton and Company, 1883), 22.

44. *American Paintings from the Manoogian Collection*, 143.

45. The setting of this pastel may now be identified as the Brooklyn Navy Yard on the basis of the long sloped wall in the background and the close proximity of the building that appears at the left (possibly the building housing the Naval Lyceum).

46. Louis, *Decorum*, "Harmony of Color in Dress," 291–300.

47. The pastel was probably the work shown in the Fifth Prize Fund Exhibition in 1889 as no. 65, *Afternoon in the Park*.

48. See Ronald G. Pisano, *Summer Afternoons: Landscape Paintings of William Merritt Chase* (Boston, Toronto, London: Bulfinch Press, 1993), 78–79, in which the painting is reproduced opposite a photograph of the Wisteria Arbor in Central Park.

49. *At the Window* remained in the artist's possession until 1896, when it was sold at the auction marking the closure of his Tenth Street studio. See *The Collection of William Merritt Chase, N.A.*, exh. cat. (New York: American Art Galleries, January 7–11, 1896), where it is listed as no. 1127 (measurements reversed). It was purchased by the engraver Henry Wolf, whose family gave it to the Brooklyn Museum of Art in 1933.

50. Louis, *Decorum*, 125.

51. Originally titled "The Fountain in the Park," Ed Haley's 1884 song soon became known by its opening line, "While strolling in the park." Interestingly, the pattern of gendered looking is reversed in this song, which positions the male stroller as the object of a "pair of [female] roving eyes."

52. *28th and 29th Annual Reports of the Department of Parks of the City of Brooklyn*, 1888 and 1889, pages 35 and 48, respectively. The figures for Prospect Park for those years reveal that the population using it was remarkably law abiding. For 1888 the park report showed a total of 10,464,225 visitors. Out of this population there were recorded 40 lost children, 1 suicide, 17 arrests for intoxication, 1 for malicious mischief, 3 for illegal dumping, 13 for disorderly conduct, 3 for assault, 29 for violation of park ordinances, 1 for lounging, 11 for reckless driving, 3 for indecent exposure, 1 for suspicion of indecent exposure, 1 for vagrancy, and 5 for cruelty to animals. *28th Report of the Dept. of Parks of the City of Brooklyn*, 1888, 35.

53. The useful phrase "object of the gaze" grew out of theoretical investigations primarily of painting and film imagery in the 1970s and denotes a popular means of discussing the relationship of the spectator and the subject of vision (both within and outside the image). Based generally on the assump-

tion that seeing or looking implies the viewer's consumption of and power over that which is observed, examining the "gaze" has become a tool for determining social, political, economic, and sexual attitudes within particular iconographic texts. See, for example, the chapter "Modernity and the Spaces of Femininity," in Griselda Pollock, *Vision and Difference: Femininity, Feminism, and the Histories of Art* (London and New York: Routledge, 1988), 50–90.

54. Chase's middle-class, midwestern background may have had something to do with his aversion to vulgar subjects. It may be recalled that the reasons he decided against formal study in Paris were his fear of becoming swept up by the "Latin carnival" and his preference for the more work-oriented atmosphere of Munich. What is more, there was a generalized cultural bias in the United States that promoted the stereotype of French society as loose, vulgar, and uncontrolled.

55. New York's growing identification with Paris in the area of the fine arts stemmed from controversy over Sunday hours for museums and art exhibitions, which reached a high pitch in connection with the Pedestal Fund Art Loan Exhibition. See Lois Dinnerstein, "When Liberty Was Controversial," in Maureen C. O'Brien, *In Support of Liberty: European Paintings at the 1883 Pedestal Fund Art Loan Exhibition*, exh. cat. (Southampton, N.Y.: The Parrish Art Museum, 1986), 71–86.

56. See Karen Halttunen, *Confidence Men and Painted Women: A Study of Middle-Class Culture in America, 1830–1870* (New Haven and London: Yale University Press, 1982), 36–37, in which she writes: "The need to come to terms with the stranger clearly did not disappear along with the traditional methods used in the small towns of preindustrial American society. In all social groups people require information about those they meet, in order to avoid both psychological and physical damage. The city thus presented a serious problem: how could one identify strangers without access to biographical information about them, when only immediate visual information was available?"

57. "The Central Park and Other City Improvements," *New York Herald*, September 6, 1857, 4.

58. Ibid.

59. Lawrence Levine, *Highbrow Lowbrow: The Emergence of Cultural Hierarchy in America* (Cambridge, Mass., and London: Harvard University Press, 1988), 177.

60. Charles E. Beveridge and David Schuyler, eds., *The Papers of Frederick Law Olmsted*, vol. 3, *Creating Central Park, 1857–1861* (Baltimore and London: Johns Hopkins University Press, 1983), 213.

61. For the "carriage trade" and the costs of maintaining horses, footmen, and vehicles to participate in this elite social sport, see Roy Rosenzweig and Elizabeth Blackmar, *The Park and the People: A History of Central Park* (New York: Henry Holt and Company, 1992), 212–19.

62. Beveridge and Schuyler, *The Papers of Frederick Law Olmsted*, 279.

63. "The Lounger," *Harper's Weekly* 3 (October 1, 1859), 626.

64. Ibid.

65. Rosenzweig and Blackmar, *The Park and the People*, 320.

66. Katherine Metcalf Roof, *The Life and Art of William Merritt Chase* (1917; repr., New York: Hacker Art Books, 1975), 73.

67. Rosenzweig and Blackmar, *The Park and the People*, 263.

68. Ibid., 266.

69. Ibid., 288.

70. Ibid., 294.

71. For a fine account of this commission, see Elizabeth Milroy, "The Public Career of Emma Stebbins: Work in Bronze," *Archives of American Art Journal* 34, no. 1 (1994), 2–13.

72. For the more than 50 sculptures that are now integrated within the Central Park landscape, see Margot Gayle and Michele Cohen, *The Art Commissiion and the Municipal Art Society Guide to Manhattan's Outdoor Sculpture* (New York: Prentice Hall Press, 1988), 187–246.

73. As Milroy states, Vaux's designs called for a series of statues to be placed on the pillars of the stairway and the Upper Terrace. These included personifications of the Seasons; personifications of Sunlight, Moonlight, Twilight, and Starlight; and personifications of Mountain, Valley, River, and Lake. Allegories of Science and Art were to be installed at the Pond and representations of Nature (Flora, Pomona, Sylva, and Ceres) in the Arcade. Milroy, "The Public Career of Emma Stebbins," 7.

74. William H. Gerdts has raised this possibility in *Impressionist New York* (New York, London, Paris: Abbeville Press Publishers, 1994), 127.

75. Rosenzweig and Blackmar, *The Park and the People*, 294.

76. Western cultures have traditionally associated the symbolic meanings of purity, virginity, or innocence with the color (or rather the noncolor) white. This already strong association experienced extraordinary revitalization in European and American art in the wake of the critical reception of James McNeill Whistler's *Symphony in White No. 1: The White Girl* (1862, National Gallery of Art, Washington, D.C.), the iconography of which simultaneously drew on and questioned the standardized interpretation of women dressed in white as symbols of purity. Whistler's series of "white girls" (women garbed in flowing white, gauzy dresses) spawned a trend so pervasive that, by 1883, one critic could term an artist's *Lady in White* "a late eruption of the Whistler rash," and have his reference be completely understood. "The Society of American Artists," *New-York Daily Tribune*, March 25, 1883, 5. It is just as likely that Chase, painting in the mid- to late 1880s, would have expected his images of white-gowned women automatically to obtain like symbolic associations.

77. For the seminal interpretation of the culture of the United States in this context, see Ann Douglas, *The Feminization of American Culture* (New York: Knopf, 1977).

78. About the appropriate attire for rowing, Louis's *Decorum* (157–58) stated: "Of late years ladies have taken very much to rowing; this can be easily managed in a quiet river or private pond, but it is scarcely to be attempted in the more crowded and public parts of our rivers—at any rate, unless superintended by gentlemen. In moderation, it is a capital exercise for ladies; but when they attempt it they should bear in mind that they should assume a dress proper for the occasion. They should leave their crinoline at home, and wear a skirt barely touching the ground; they should also assume flannel Garibaldi shirts and little sailor hats—add to these a good pair of stout boots, and the equipment is complete. We should observe however, that it is impossible for any lady to row with comfort or grace if she laces tightly."

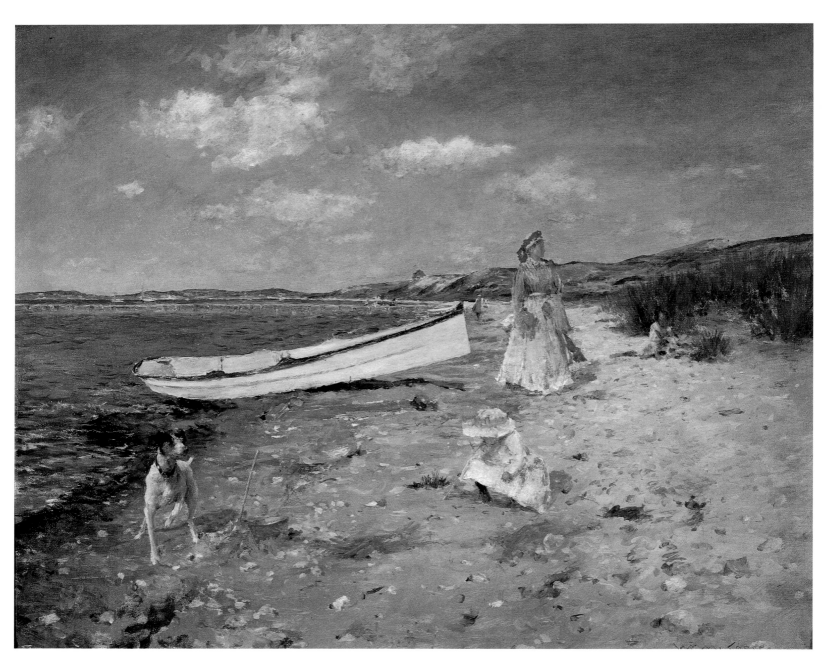

Pl. 53. A Sunny Day at Shinnecock Bay, *c. 1892. Oil on canvas, 18⅛ × 22⅞ inches. Private collection.*

Chapter Five

A Reputation Reclaimed

A basic premise of this study is that Chase saw his park and harbor subjects as a means to renovate his artistic reputation by essentially "Americanizing" it, not only to satisfy the critics, but also to establish himself as a modern painter in a unique way. To determine the effect these paintings had on Chase's career it is helpful to survey where and in what context he exhibited his Brooklyn and Manhattan paintings and the criticism they elicited. At the outset it must be said that, in general, this discrete group of works was viewed as just that—a connected body of paintings that Chase integrated within an oeuvre that was already perceived as remarkably eclectic. As an identifiable landscape genre unified by time and place, the subject matter formed a clear-cut and manageable category for critics to compare and contrast with his other efforts in portraiture, figure painting, and still life. A second source of insight into the reception of these works lies in the patronage they brought to the artist and how their ownership advertised his success.

Chase must have been heartened by the remarks his American landscapes drew at his 1886 one-man exhibition in Boston (shown in modified form at the Moore Art Gallery, in New York, for auction in early 1887). Although the small paintings did not receive extensive comment, they were noticed favorably and designated "exquisite" by one writer.[1] Such a reaction constituted a marked reversal in the critical responses his work had received in the time leading up to the 1886 exhibition, and it was probably enough to encourage him to display one urban park subject at the 1887 SAA annual, most likely *Prospect Park* (see Pl. 5). The tiny gemlike work, filled with vibrant color, faceted by active brushwork, and energized by dramatic pictorial space, undoubtedly stood apart from the other four paintings by him on view, one of which was a distinctly Whistlerian portrait of his sister (fig. 68).[2] Certainly Chase's Prospect Park painting provided a conspicuous contrast to the other landscapes in the exhibition, which included Homer Dodge Martin's (1836–1897) *Behind the Dunes, Lake Ontario* (described as a "beautiful, mysterious, unreal-looking landscape" lacking topographical detail) and what was probably a typical rural winter scene by Walter Palmer (1854–1932; described as rendered "with the exactness of a camera").[3] References to Chase's work in an *Art Amateur* review of the SAA exhibition struck a conciliatory chord. Alluding to the past controversies stemming from Chase's having appeared to dominate the prior society exhibitions by the sheer number of his works on the walls, the writer (possibly Theodore Child) justified the artist's display of five paintings saying, "Mr. Chase, the President of the Society, signs five canvases, which, as he exhibits his works on no other occasions, is not a large number, and none of these canvases are of the biggest. His smallest is a clever little decorative sketch made in Prospect Park, Brooklyn, and owned by Mr. Clarke."[4] These brief and

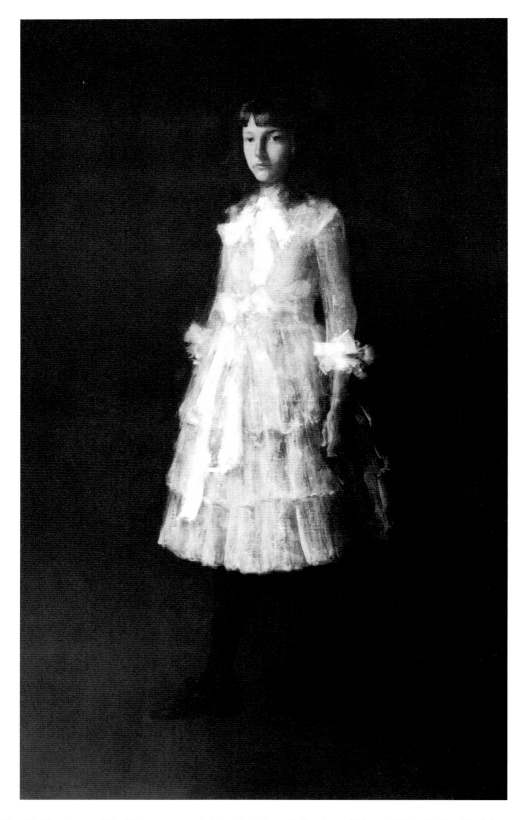

Fig. 68. Hattie, c. 1886. Oil on canvas, 64¾ × 38 inches. Collection of Mr. and Mrs. Richard J. Schwartz.

sympathetic remarks absolved Chase of whatever accusations might have arisen regarding a power play to outrank fellow members as a result of his showing a larger than average number of works. Furthermore, his work was small, decorative, and, therefore, unpretentious. Yet despite the modesty of his submissions, Chase could freely claim a measure of prestige because the "Mr. Clarke" who owned the little Prospect Park painting was Thomas B. Clarke, one of the most prominent collectors of contemporary American art at the time.[5] By the time Clarke divested himself of his American collection in 1899, he owned at least seven other works by Chase, including the early *Coquette* shown at the NAD in 1879 (in his collection by March of that year), *Girl in Japanese Costume* (fig. 69), and *A Stone Yard* (unlocated), the latter of which might be the unlocated *Stoneyard* displayed by Chase at the 1889 Paris Exposition Universelle.[6] Clarke's ownership of a Prospect Park subject publicly validated Chase's new style and subject matter in an artistic forum (the SAA) rather than in the commercial arena of Moore's auction house, where his new landscapes had debuted in New York.

The article's author was nearly accurate in stating that the SAA was Chase's only exhibition venue. After having exhibited at the annual exhibitions of the Pennsylvania Academy of the Fine Arts in 1879, 1880, and 1883, Chase ceased sending paintings there until 1892, when he began featuring his Shinnecock landscapes. A similar hiatus in his exhibiting pattern is revealed in the BAA records, which show his sporadic participation in the exhibitions from 1877 to 1884. He was then represented in 1892 in a loan exhibition when *In the Studio* (Pl. 4) (listed as *The Artist's Studio* and then owned by Carll H. de Silver) was shown, and then twenty years later with four portraits in 1912. Apart from an occasional showing at the Prize Fund exhibitions, the only other regular outlet for the display of his works was the annual exhibition of the American Watercolor Society.[7] His pattern there was also irregular, limited to a single work in the years he did participate.[8]

Evidence that Chase mounted a concerted effort to bring his art (especially his park subjects) before a wider audience surfaces in late 1887 and throughout 1888. The artist's campaign for greater visibility is initially witnessed by his appearance at the Fourth Prize Fund Exhibition in the fall of 1887, where he is reported to have shown four "landscape-impressions of New York suburbs."[9] This was followed by Chase's involvement with a new and unusual venue in New York City, the art gallery of the New York Society for the Promotion of Art located within

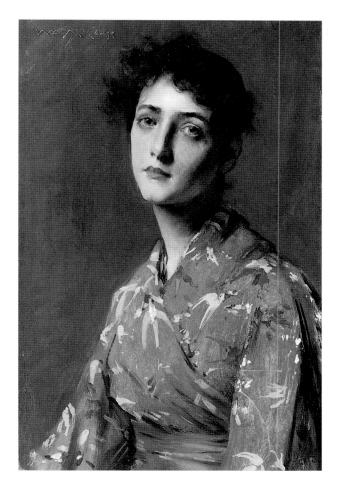

Fig. 69. Girl in Japanese Costume, *c. 1888. Oil on canvas, 24¾ × 15¾ inches. Brooklyn Museum of Art, 86.197.2, Gift of Isabella S. Kurtz in memory of Charles M. Kurtz.*

the Eden Musée. The Eden Musée, situated on Twenty-third Street between Fifth and Sixth Avenues, was a fascinating entertainment center possessing broad popular appeal, if it may be judged from the wildly disparate attractions it featured.[10] Billed as a "temple of art and amusement," the Eden Musée was a French corporate enterprise that opened in New York in 1884. Like its other North American branches (in Montreal, Chicago, and San Francisco), it was essentially a glorified waxworks museum, separate from its dime museum counterparts clustered in the Bowery in its declared intention of "affording to all an opportunity of instruction, amusement and recreation, without the risk of coming into contact with anybody that is vulgar or offensive."[11] In fact, it was advertised as "an ornament to the street—indeed, to the whole city."[12] The operation's catalogues and the newspaper coverage it received provide vivid descriptions of the Eden Musée's attractions. On passing through the front doors into the Central Hall visitors would encounter life-size wax tableaux featuring the world's notables, ranging from Washington crossing the Delaware to current world rulers, and including such contemporary luminaries of the sciences and arts as Louis Pasteur and Thomas Edison, Victor Hugo and Sarah Bernhardt. The San Francisco venue's catalogue, titled *Catalogue of the Eden Musée: a temple of art, and amusement, showing an interesting series of tableaux and figures in wax illustrating history, art, science, drama, fiction, etc.*, suggests that the waxworks at each site shared the same educative, theatrical functions. Each branch may have catered to its regional audiences as well, as indicated by the Chicago venue's attraction called the "Chicago Panopticon." New York's Eden Musée mounted live entertainment as well, as documented by various advertisements in the amusement section of the *New York Times*, which listed concerts by the Hungarian Munczi Lajos and Prince Paul Esterhazy's Orchestra and performances by the Viennese Lady Fencers. Open from 11:00 to 11:00 Monday through Saturday and from 1:00 to 11:00 on Sundays, the Eden Musée was symptomatic of the expansive nature of leisure-time diversion available in North American cities at the time. As reported in the newspaper entertainment sections, the Eden Musée appealed to a rather distinguished clientele. Opening night of the Hungarian orchestra drew the Mexican consul general, Juan N. Navarro; an actor and inventor of theatrical devices, Steele Mackaye; a pillar of New York society, Mrs. Paran Stevens; and, significantly, Joaquin Miller.[13] An exhibition of rare orchids, roses,

and ferns was attended by the socialites Mrs. S. Van Rensselaer Cruger, Mrs. Robert G. Remsen, Mrs. Jesse Seligman, Mrs. Ogden Goelet, Miss Heckscher, and Mrs. W. Seward Webb.[14]

There was another aspect to the Eden Musée, however, that was designed to titillate, horrify, and disgust—the Chamber of Horrors installed in the downstairs galleries. In contrast to the refined tableaux in the main halls, the Chamber of Horrors treated its visitors to wax re-creations of various styles of execution.[15] Leaving nothing to the imagination, these scenes of ghastly bloodletting apparently fascinated the same audience that examined the refined imagery presented "upstairs." This seemingly contradictory juxtaposition of the genteel and the grotesque is explained by Kathleen Kendrick as a resolution of the public's need to maintain and supervise social order:

Like illustrated crime newspapers and exposés of urban corruption, the Chamber of Horrors reflected and catered to a cultural obsession with the idea of carnal vice and crime lurking beneath the veneer of respectable, anonymous bourgeois life. Yet, if properly framed, this pornographic fascination with the netherworld of sex and violence could be rationalized as surveillance rather than voyeurism, as a means of identifying, monitoring, and controlling the chaotic and grotesque elements of the modern world. By exposing the transgressive bodies that society was struggling to suppress and regulate, therefore, the Chamber of Horrors might simultaneously threaten and fortify the emerging modern social order.[16]

In October 1887 an art gallery opened amid this civilized circus of culture, free to all with the price of admission to the Eden Musée. By December the second exhibition was on view, and, as noted in the *Art Amateur*, the new installation was a "decided improvement" on the first. The writer continued:

The new pictures are chiefly by Americans, the most notable being the four contributed by William M. Chase, who seems to be "going in" exclusively for landscapes just now, a departure one cannot regret, so long as he gives such charming, sparkling bits of out-door life as he has been painting in and about Brooklyn. The scene on a summer day in Tompkins Park, with the figures of a lady and child admirably introduced, is brilliantly executed and is full of atmosphere; and certainly no less can be said of the view of the Church of the Puritans by early morning light—a difficult effect very well managed.[17]

The two paintings described in the review were probably *The Park* (Pl. 18) and *Summer—Scene in the Park* (fig. 26), both of which, on the basis of the titles listed in the exhibition catalogue, may be retitled *In Tompkins Park* and *The Church of the Puritans*. The other two works were *Little White House in Brooklyn* and *View from Brooklyn Navy Yard*, neither of which can be conclusively identified at this juncture.[18] Without additional information regarding the circumstances surrounding the New York Society for the Promotion of Art and its association with the Eden Musée, Chase's venture in displaying his work at this untried and surely unconventional venue must be looked to as evidence of a certain amount of desperation on his part. And it is suggested here that his eagerness to test his newest experiments in urban subject matter before a cosmopolitan audience outweighed the risk of being labeled a seeker of professional advancement through purely commercial ploys. Then, too, the very modernity of the Eden Musée may have tipped the scales for Chase, who, as an American version of the flâneur, might have reckoned that projecting himself and his art as part of the urban spectacle in this milieu was an appropriate move so long as the "right" people were in attendance. If Bly's *Mystery of Central Park* is any indication, the entertainment spot was quickly assimilated into popular culture as a symbol for modernity. A passage of the novel captures the atmosphere of the place: "Richard took Dido to the Eden Musee, and after she had seen all the figures that interested her, Dick took her up to the cosy retreat above the orchestra, where the tall green palms cut off the glare of the electric light. He ordered some ice cream for Dido and some culmbacher for himself, and lighting a cigarette he gave himself up to the influence of the beautiful Hungarian music and dreams of Penelope."[19] In any event, Chase was not alone in the enterprise, for his paintings were among others by Twachtman, Hugh Bolton Jones (1848–1927), Dwight W. Tryon (1849–1925), H. Siddons Mowbray (1858–1928), and what was described as a "characteristic little Courbet, with a fleeing deer introduced."[20]

As demonstrated by the *Art Amateur* reviewer's comments, the undertaking was worth Chase's while. Indeed, the previously antagonist *Brooklyn Daily Eagle* reversed its opinion of Chase's art with the Eden Musée display: "William M. Chase has abandoned the palette knife and returned to his brushes, leaving his friend Twachtman to ramble over canvas with sticks and shoehorns. Mr. Chase's Brooklyn subjects have actual charm of light and color, and Paris has not afford-ed a better subject than the Church of the Puritans as he is able to see it from the park beside it."[21] A few weeks later Chase reinforced his new artistic profile as a painter of contemporary local life at the annual exhibition of the American Watercolor Society held at the NAD, also on 23rd Street, just a block east of the Eden Musée. There he showed what is probably the only documented result of an excursion into yet another Brooklyn park, Washington Park, by then renamed Fort Greene Park.[22] As one of many works in the exhibition, it did not receive substantial note, but it was appreciated as one of his Brooklyn studies having "lasting interest."[23]

Chase persisted in featuring his Brooklyn subjects at the SAA exhibition that spring, where he showed seven works, three of which were examples of his new urban genre, *View from Brooklyn Navy Yard*, *In Tompkins Square, Brooklyn*, and *The Croquet Lawn, Prospect Park* (possibly Pl. 17). The others, no less important in demonstrating the range of his skills, were *Portrait of Mr. Cheeks*, *Mother and Child*, *Hide and Seek* (fig. 14), and *A Winding Road*. Although the critical response was generally favorable with regard to each of these paintings, the landscapes (including *A Winding Road*, which was a view of the suburbs of Hoboken) fared the best among the reviewers. The writer for the *Art Amateur*, after describing *Hide and Seek* as "a picture of a dark wood floor," continued, "But if Mr. Chase's figure subjects sometimes smell of affectations his little landscapes do not, but are admirably honest and true to nature."[24] A month later a columnist in the same periodical declared Chase "one of the best landscape painters of them all, who goes a very different way from . . . these painters [J. Francis Murphy, Charles Melville Dewey, and Bruce Crane] or that of Mr. Twachtman."[25] These comments demonstrate that Chase was, indeed, defining a unique place for himself within American painting, particularly in landscape genre. The individuality he attained was achieved through ironically simple means, that of portraying the familiar, which, when elevated to art, attained a purity and truthfulness perceived lacking in other works of the time. This sensibility was spelled out clearly in an assessment of *A Winding Road*:

Any bit of out-doors will serve him for a subject, though he is very fond of broad stretches of greensward or water surface; one of his best studies was that of A Winding Road, in the suburbs of Hoboken or anywhere, stretching over a waste common, with an insignificant little house in the extreme distance and an empty tomato-can in the foreground to give the requisite spot of color.

At first sight it would be declared to be merely a very careful study, but somehow the impression grows on the spectator as he looks that the realism is illuminated with something more subtle; not poetry nor anything very fine, for a shabby green common on the edge of a city, neither town nor country, is always forlorn and rather vulgar. The painter makes us feel that it is cheap ground, and that just over the rise yonder, the dreary little suburb will begin; it is all quite natural, and yet we are not only interested but pleased.[26]

The truthfulness of Chase's landscapes worked in vivid contrast to the majority of works in the SAA exhibition that year. In galleries dominated by such allegorical or determinedly aesthetic works as Abbott Thayer's *Angel* (National Museum of American Art, Washington, D.C.), Thomas and Maria Dewing's *Allegorical Figure (Hymen)* (Cincinnati Museum of Art), and George Willoughby Maynard's (1843–1923) *Genius of Civilization* (possibly the work known as *Civilization*, National Academy Museum), Chase's works must have seemed a veritable breath of fresh air. What is more, the apparent naturalness of his subjects and the fact that they portrayed American scenery went far in erasing the specter of European, and particularly Munich, influence from his art. This is revealed in several pointed commentaries summarizing his SAA showing:

Mr. Chase's landscapes are among the best things he has done of late. With true artistic instinct he has found his subjects near at home, and from the Dan of the Navy Yard to the Beersheba of Tompkins Square, in Brooklyn, where an ordinary man would have found all barren, Mr. Chase has discovered motives for a score of pretty pictures. With our galleries full of bits of Holland, France and Munich and America either snubbed outright or dressed up in some or other of Europe's cast off suits, it is pleasant to meet with someone who sees the pictorial value there is in home scenes painted in their true colors.[27]

The sentiments expressed in the passage quoted above became the standard for critical reaction to the artist's Brooklyn landscapes, which were praised for "their brightness, their color and their happy composition." Almost as important to the majority of critics was that Chase was becoming his own man stylistically, and, as the same writer observed, "Mr. Chase is a disciple of the Munich school, but he no longer paints in that aggressively bold fashion that has made for the representatives of the Munich school here so

many enemies."[28] That Chase relied on a distinctly French (and therefore equally foreign) style was either overlooked or referred to in a positive light because he translated that influence into an American vernacular. After launching a lengthy discussion about the ubiquity of peasant imagery in French art and its impact on American painters who had adopted similar subjects, a commentator continued:

But while it is to some extent natural for French artists to paint this class of subjects, since they believe France to hold all things that are great and beautiful and good, it is less excusable in Americans to follow their trite example. There are plenty of things in this country that are worth intrinsically as much for pictures as those pervasive peasants in sabots and blue clothing, and are in reality worth more since they have not been reduced to conventions. Phases of Paris life are more common in the Salon than they used to be, for the French painters are acquiring that high gift of discovery that unfolds rare beauty in the commonest of our surroundings and makes even Brooklyn charming to the eye of so earnest a seeker as William M. Chase.[29]

Thus, in the context of the writer's interpretation as set out here, Chase was on a parallel course with the French painters of his generation, linked to them by their simultaneous explorations of urban and suburban life and the discovery of its artistic potential. Concurrently, growing familiarity with French Impressionist cityscapes was encouraging some American writers to "see" New York with new eyes. Charlotte Adams, for instance, introduced her 1887 article, "Color in New-York Streets," with a telling reference to the "receptive condition of mind characteristic of the artistic flâneur." She continued with a catalogue of analogies she perceived between New York sights and contemporary French art:

There are Monets all along Sixth Avenue. The waterfronts present a succession of Boudins. The truncated compositions of Degas, especially applied to figures, strike one unexpectedly at the turn of a street. The popular types recall Manet in character and in their treatment—that is, their relation with the physical vision and mental receptivity of the spectator. Thus it really seems as if that genuine New York school of art which shall be evolved from its streets and public life, as is the case with all true municipal schools of art, will be based on the principles taught by the French Impressionists. The same intensity, even crudity of color; the same prevalence of primary hues; the same

lack of tone; the sharp, crisp atmospheric quality and the general feeling of uncompromising solidity and body which form the attributes of those ultra-modern compositions, are to be found in the artistic scheme of New York streets.[30]

Thus, a tendency was simultaneously emerging to interpret the city in terms of a foreign and modern artistic movement at the same time that Chase was claiming the American urban scene as the subject matter of his art.

Other events made 1888 a banner year for Chase, for it marked his return as an exhibitor to the NAD, another opportunity to participate in an exhibition mounted by the Society of Painters in Pastel, and his participation in the fall exhibition at the American Art Galleries.[31] In each case Chase continued to feature his Brooklyn subjects. As noted elsewhere in this volume, Chase's art politics had kept him away from the academy. The last time a work of his had been displayed in one of its annuals was in 1879, when *The Coquette* (then owned by Thomas B. Clarke) was the only example of his art on view in the academy's galleries. Since 1888 was a year of rapprochement between the SAA and the NAD, Chase's reappearance at the academy that year was especially significant because of his position as president of the SAA. As a demonstration of its liberality within this era of reconciliation, the academy's acceptance committee included five works by Chase in its spring exhibition: two portraits (*Miss B.* and *Mrs. G.*) and three Brooklyn subjects (*Rotten Row, Brooklyn Navy Yard* [Pl. 7], *Summer-time* [possibly fig. 26], and *Peace-Scene, Fort Hamilton* [Pl. 2]). Each of the landscapes had already been seen by New York audiences, who, by this time (especially if they had read the season's art columns) might be expected to recognize these works as representative of Chase's innovative attempts to reconfigure his art. As would be the case in large exhibitions, however, Chase's small landscapes did not receive star billing. But, in an exhibition where the place of honor was given to a painting by the NAD's president Daniel Huntington (*A Burgomaster of New Amsterdam*) and contained such varied works as Winslow Homer's *Eight Bells*, Frederick Bridgman's (1847–1928) orientalizing *Souvenir of Flemcen*, and large landscapes by George Inness (*September Afternoon*) and Thomas Moran (1837–1926; *Sand Dunes of Fort George Island, Florida*), it is remarkable that Chase's work was noticed at all. Yet, in the columns of lists naming artists and titles, Chase received his due, as exemplified by the *Art Amateur*'s comment, "Wm. M. Chase, as if to make amends for his long absence

from these halls, sends five canvases, three of his excellent little summer studies made in the vicinity of New York and Brooklyn, and two portraits of ladies."[32] The peaceful relations between the two art organizations were further cemented by Chase's election to NAD associate status in 1888.

The difficulty reviewers seem to have had in defining or categorizing Chase's Brooklyn and New York landscapes needs some mention at this juncture. As a rule, the art writers of the 1880s organized their discussions of large exhibitions according to three main categories—genre, portraiture, and landscape—with an occasional nod to sculpture appended at the end of the review. For some reason (one of which is probably attributable to the uniqueness of Chase's subject matter), writers did not include their comments on his park and harbor scenes within the texts devoted to landscape. Instead, these works remained confined within the nomenclature of "study," not only because they were comparatively small but also because the majority of American critics had had little experience with this type of urban-suburban imagery and, therefore, lacked the wherewithal to treat it adequately in their reviews. This difficulty was admitted by a writer for the *Nation* in 1889, who, after covering Chase's portraits and genre paintings, stated, "Mr. Chase has a number of those little studies of parks and docks which are so well known and which it is hard to classify, which are sure to be among the greatest attractions of any exhibition where they are found."[33] Also, while it was consistently remarked that Chase's new, brightly colored palette and his "sketchy" brushwork contradicted the Munich norm, there seems to have been no effort by the reviewers in 1888 to connect his facture directly with French Impressionism. The question of whether these obvious connections were purposely ignored or simply not recognized must also be relegated to the realm of the unanswerable. Yet because the issue of national influence was so sensitive and because Chase was virtually alone among resident American artists in his use of these techniques, it is likely that writers chose to overlook the French aspects of his art and determined, instead, to concentrate on his "Americanness."

At the same time the NAD annual was on view, the second exhibition of the Painters in Pastel opened May 7 at the gallery of Messrs. H. Wunderlich & Co. at 868 Broadway, where it continued until May 26. Although his six pastels were far outnumbered by his friend Robert Blum's thirty-one entries, Chase drew the highest critical acclaim for *Pure*, a masterful depiction of the back of a seated nude model.

Hailed as the "most striking pastel in the exhibition," it surprised Chase's audience with yet another departure from his usual subject matter that was so stunningly marvelous it inspired unusually extensive commentary.[34] The power of *Pure* notwithstanding, the artist's *Shelter House, Prospect Park* and *Sunlight and Shadow* also garnered substantial note that once more credited Chase with the capacity to find art in the everyday. As one writer observed, it was

two of those views in Prospect Park, Brooklyn, that show how easily a born artist can find subjects at home. Subjects for the artist lie all about him in every great city as in every country town and village, but not one in 20 of our men seem to take advantage of his opportunity. Mr. Chase lives in Brooklyn, a city whose alleged barrenness and want of interest are the butt in New York of quips and jibes without number, yet for a year past Mr. Chase has been finding these subjects for a series of pictures: View [sic] in Prospect Park, studies in the old navy-yard, studies in the outskirts of the town, that have given a new turn to his already many-sided reputation.[35]

By the close of 1888 Chase had effectively revitalized and renovated his reputation, an endeavor accomplished mainly through the exhibition of his Brooklyn paintings. The success he achieved with these paintings over the short span of two years likely encouraged him to feature them at the 1889 Paris Exposition Universelle (see pp. 13–19), where he won a silver medal. In turn, it is probable that this series of critical and artistic victories led to his being accorded exclusive use of an entire gallery for the display of seventy-four of his works (fifty-nine oils and fifteen pastels) at the Inter-State Industrial Exposition in Chicago, which opened in September 1889. Of those works twenty-two were Brooklyn and New York park and harbor subjects, the popularity of which among Chicago patrons was attested to by the ownership designations in the catalogue. Seven works in the display were on loan from private collectors. Two were studio interiors owned by James H. Dole, Esq., of Chicago, and S. M. Dodd of New York, and another was a pastel, *Fisher-Folk*, from the collection of George L. Dunlap of Chicago. The remaining four were park subjects from Chicago and New York collections: *Summer* (presumably a park subject) owned by Charles L. Hutchinson; *Sunlight and Shadow, Prospect Park* owned by the author Charles Norman Fay; *Boat House* (Prospect Park) owned by Potter Palmer; and *In the Park*, owned by Mrs. C. H. Wilmerding.[36]

Chase's Chicago showing was met by one of the most thoughtful reviews to have been dedicated to his work to that time, a long article in the *Chicago Tribune*.[37] Claiming that Chase had "few rivals either in the old world or the new," the writer described at length the quality of Chase's vision, noting the painter's satisfaction in appealing, not to the heart or spirit, but to the eye. The review is intriguing in that its author connected Chase's aesthetic influences with Japan rather than with Europe, a stylistic analysis common today but unusual in nineteenth-century Chase criticism. In discussing his art in general, the issue of Chase's previous Munich style surfaced in the observation that it was "strange that an artist who studied six years in Munich during his early manhood should have to revolutionize his methods and become a Parisian of the Parisians." The article closed with an extended passage praising the park and harbor paintings:

Mr. Chase is always eager to explore new fields of beauty. Of late he has omitted his usual summer trips to Europe and sought inspiration in the neighborhood of his own home. The result is a series of richly colored studies of Brooklyn parks and docks, pictures gay, and joyous, and brilliant as a June festival, giving us the splendor of flowers, the brightness of sunshine on grass and walks, the vivacity of crowds in gala colors—scenes of richly colored life and pleasure. Nothing in all the artist's work is better than these flashing jewels, which give the lie to the familiar moan of many American artists, who persist in painting much bepainted Holland because there is nothing worth painting in America. By such reasoning they accuse their eyes of blindness and condemn their fame to that early extinction which surely awaits all imitators. Our artists cannot paint foreign themes with the sincerity which is within the reach of men who have felt them all their lives. . . . Mr. Chase shows us how many a happy refuge art may find along the busy wharves of a great city, or in the flowered and terraced avenues of a park. He studies a boathouse embowered in green, its pink roof reflected in the limpid water, and canopied pleasure-boats moored near by, and straightway we have a joyous little masterpiece. Or he stands at the terrace in Central park [sic], and soon we have a canvas crowded with life and color, with green foliage and flowering bushes softening the lines of the stone balustrade. Everywhere beauty appears to him.[38]

Although Chase's park and harbor pictures were generally admired, he refrained from including them in subsequent

NAD exhibitions, perhaps because he recognized that it would be more to his benefit if he showed portraits at the still relatively conservative academy. His NAD exhibition history from 1889 onward consists mainly of portraits, which in 1891 were joined by examples of his Shinnecock landscapes. Because portions of the SAA annuals sometimes traveled to other cities after the New York annual closed, it is likely that Chase (who remained president of that organization until 1895) placed his primary loyalties with that group and gained as well from the added exposure through the touring exhibitions. One such tour proved to be especially to Chase's advantage in 1890 following his triumphant showing at the 1889 Chicago Inter-State Industrial Exposition, for his display of seven paintings in the Third Chicago Prize Fund Exhibition (comprising mainly works selected from the 1890 New York SAA exhibition) included five of his garden and beach landscapes.[39]

Reviews of that exhibition elucidate the thematic configuration of art production within the society's ranks at the time and signal subtle changes that were occurring. The majority of paintings were devoted to figure subjects, a genre that garnered the bulk of the critical commentary. Indeed, the Ellsworth and Art Institute Prizes were awarded to Dennis Miller Bunker (1861–1890) for *The Mirror* and to John Singer Sargent for *Carmencita*.[40] Chase's landscapes took high honors among the reviewers, however, with *Kathleen Cottage, Bath Beach* (fig. 41, exhibited as *At Kathleen Villa* and by then owned by Frank G. Hecker, the Detroit business partner of Charles Lang Freer) drawing most of the comment directed to his work.[41] Also popular with the critics was *An Hour with Aldrich*, a still unlocated painting described as "a delightful little black-robed figure seated with a book on a sunny lawn dappled with shadows of trees—a little canvas filled with the warmth of summer, the soft repose of sunny days."[42] This, too, was probably a park subject, for a later press notice referring to it indicates that the background for the figure included a garden with greenhouses.[43] Although Chase's coastal scenes were appreciated, and he was singled out for his "exquisite little glimpses of city parks, a field of vision which he [had] made peculiarly his own,"[44] it may be a significant reflection of the general preference for figure painting that the two works by Chase that earned the most attention were figural. Other evidence of artistic trends manifested in the Chicago reviews is the emerging currency of urban imagery in the form of street scenes, a taste promoted by the return of Hassam from Paris, which was felt not only in the SAA exhi-

bition but also in the 1890 Pastel Society exhibition. As one Chicago critic noted, Hassam's Parisian street scene in the Art Institute's galleries was possibly even better than the artist's highly touted *Fifth Avenue in the Snow*, "though the subject [lacked] the charm of familiarity."[45] Although Chase had popularized the urban subject in his park paintings, Hassam's imagery was thought to evoke a stronger sense of city life, as demonstrated in his ability to "render the character and style of 'mondains' and 'mondaines' in which the American painter generally fails."[46] With the growing frequency of comments such as this in praise of Hassam's cosmopolitan street scenes and considering Chase's own reluctance to investigate these less genteel aspects of the city, it is possible that Hassam's return to New York was a factor in Chase's election to quit painting the park subjects that had nonetheless revitalized his career.[47] The summer of 1890, just five years after he had first painted in Prospect Park, marked the last season that he would explore the city's gardens for the purposes of his art. Moving on to other territories that again melded the concepts of culture (the Shinnecock Art School) and geographic transition, Chase relinquished his claim to the urban landscape as if to cede his position to Hassam before his priority in this field could be overshadowed.

Throughout this period of growing recognition and critical approbation, Chase was in constant financial difficulty. Despite the reversal of his critical fortunes, the income from his paintings was never sufficient to cover his professional expenses, his almost uncontrollable collecting activity, and the ever increasing domestic needs of a rapidly growing family. (After Cosy's birth in 1887, more children arrived in quick succession: Koto Robertine in January 1889, William Merritt Chase, Jr., in June 1890 [died July 1891], and Dorothy in August 1891. By 1904 the Chases had eight children and various households and studios to manage.) To augment his finances Chase continued to teach at the Art Students League and parlayed his reputation as a stimulating instructor into what was virtually a second full-time career.[48] Chase also periodically consigned large segments of his art for sale at auction. The timing of these exhibition-sales (the first of which was the 1887 Moore's auction in New York) seems tied to the recent or impending birth of a child, as shown by the April 1890 exhibition and sale at the American Art Association and the March 1891 sale at Ortgies & Co. (New York), where Chase's works were sold without reserve prices established.[49] These displays offered the critics additional opportunity to

assess large groups of Chase's art, and their reviews reveal how vital Chase's park and harbor subjects had become to their perceptions of his work. Many of the paintings in these sales were the Brooklyn scenes Chase had first shown in 1886 (for instance *Wash Day, Brooklyn Docks, Cob Dock, Brooklyn Navy Yard*), which, although they were appreciated by the art press, had not been popular on the market. The 1891 Ortgies exhibition and the favorable press it received (despite its disappointing financial outcome for Chase) provided a nicely timed prelude to the four Central Park subjects that would be introduced at the SAA exhibition later that spring. A brief but cogent commentary in the *Critic* concentrated on the Brooklyn pieces:

After discarding his Munich teaching and coquetting a little with impressionism, Mr. Chase has developed a new manner and betaken himself to subjects of local and contemporaneous interest. In this he has set a very good example to his brother artists, who leave the picturesque at home while they rush around the globe in search of it. Yet we cannot commend without reserve all of the paintings on exhibition. . . . The park scene and some of the figure subjects seem to us to have only a superficial interest. But the views along the Brooklyn docks, the Coney Island piers and stretches of summer sea, and many other local "bits," have been observed with the eye of a true artist and transferred to canvas with perfect skill. Among the most delightful of his studies are the "Stone Yard," littered with chips and strewn with oblong blocks of granite; the sketch of "Rotten Row" in the Brooklyn Navy Yard; the two scenes "Back of Brooklyn," in which the characteristic landscape created by real estate speculators and finished by nature is portrayed with all its peculiar features of roads wandering among hap-hazard groups of houses and shanties and cuttings and terraces transformed by the rains and vegetation of many seasons into the semblance of natural shapes.[50]

A writer for the *Sun* also had laudatory comments for the pre-auction display. With the exception of the portraits, in which he believed Chase sometimes sacrificed likeness for the sake of the picture as a whole, the *Sun* columnist declared that "not one [of the works on view] lacks pictorial interest."[51] The highest praise was saved for the park scenes, followed by the harbor subjects. According to the typical organizational format used by reviewers for assessing the work of a single artist, the discussion of the paintings deemed the best was saved for the conclusion of the article so as to construct a

suitably dramatic ending for the piece. Chase could not have expected better press had he commissioned a review himself:

Finally one notes a long list of those park subjects which during the past two or three years have brought Mr. Chase into a popularity greater than he had ever earned before. In the parks of Brooklyn and New York he has found subjects which, although so close at hand, none of our other painters had appreciated; and he has treated them so charmingly and so characteristically that we fear it will be long before anyone else can attempt them without being accused of the wish to "do a Chase." Nor in treating them has Mr. Chase closely followed the French painters who had painted park scenes before him. He has been true to his own brush and true to the facts before him, not scorning the more prosaic details which sometimes in this country obtrude themselves, and not fearing our bolder effects of light and color. Some of the examples which might be seen in his studio last autumn were, we think, more remarkable than any now exhibited; but the fact should not be complained of, for it may be supposed to prove that they then won the instant appreciation they deserved. The groups of children sailing boats and the views of the great lake terrace in the Central Park which one admired then are not equalled by anything on these walls. Yet there are many very delightful examples here. Perhaps the best, as a rule, are those like Nos. 24, 31, and 39, where pictorial dignity is given by long straight lines of path running away from the eye. But for the effect of sunlight none is better than No. 65; in color and in composition No. 56, "Commons, Central Park," with its broad stretch of green grass almost filling the canvas, is very remarkable; and best of all in color is "Flower Beds," no. 49, a veritable little marvel of bright yet exquisitely harmonious tints, and of fresh and skilful handling.[52]

Such glowing pre-auction reviews notwithstanding, the Ortgies sale yielded dismal results for Chase, bringing only $5,565 from bids placed mainly by dealers. The highest price of $325 was offered for a still life; several park subjects fared relatively well, with one fetching $225 and *Flower Beds, Central Park* going for $220.[53] Despite the sluggish sales, the favorable commentary directed to Chase's Brooklyn and New York scenes served to prime the audience for the 1891 SAA exhibition in which he would feature this area of his subject matter for the last time. Again, Chase was well represented with six paintings, three of which were already sold: *On the Lake, Central Park* (owned by Potter Palmer; Pl. 52), *A Visit to*

the Garden (The Nursery) (owned by George S. Baxter; Pl. 47), and *An Early Stroll in the Park* (owned by Rose & Co.; Pl. 51). Also on view were *A Gray Day in the Park* (Pl. 43) and *Long Island Landscape*, which, according to the writer for the *New York Times*, also looked like a park, "owing to the graded slopes and plants in pots."[54] Although the critical reaction to these landscapes was favorable, the novelty of the subject appeared to be waning. Chase's sixth contribution was *Alice* (The Art Institute of Chicago), in which the *Times*'s critic took obvious pleasure: "The six sendings by the President of the Society are headed by a full-length portrait of a young girl in short white dress pleated in many folds. She throws her head up and back, smiling the while with most engaging frankness and fun, while she holds the ends of a pink ribbon that she has thrown about her neck. This is an excellent piece of work."[55] For Chase to have prospered so well in the judgment of the critic is impressive since his chief competition in this genre was John Singer Sargent, whose portrait of the young Beatrice Goelet (private collection) occupied the place of honor in the exhibition and in the united critical opinions.

While the SAA exhibition was in progress a major article devoted to Chase written by Charles De Kay was published in *Harper's Weekly*. Titled "Mr. Chase and Central Park," the piece was contrived as a defense of Chase's art in the light of the recent auction debacle at Ortgies. After summarizing Chase's accomplishments, De Kay concluded that one of the reasons why the artist had so little commercial success was that he failed to cater to prevailing tastes and, instead, painted what interested him. De Kay continued:

In William M. Chase we have a painter who has slowly won away from entangling alliances with his masters in Paris and Munich until he has struck out a line for himself. Observe that of late years he has hit upon a discovery which is yet to be made by a very great proportion of the inhabitants of New York. He has discovered Central Park. Not that most New York people do not know there is such a place, and are not more or less proud of it, but comparatively few of them ever go into it, and when they go, they rarely see anything. . . . The distinction of being the artistic interpreter of Central Park and of Prospect Park, Brooklyn, has come to Mr. Chase very naturally and without special forethought on his part.[56]

In addition to presenting an apologia for Chase, De Kay carefully inserted comments throughout the article that rein-

forced the ideals behind the park's creation. Chase's *In the Park—A By-Path* (Pl. 46) was enlisted to illustrate the potential of the park's positive influence: "here, again, the ever-present nurse and child recall the purposes for which Central Park and many another park of New York have been established. Their proper maintenance is a matter which concerns the health of the future generation; that is the practical side; but it is also one that concerns the education of the masses; that is the side which interests us just now."[57] De Kay went on to describe the beauties of the park in late spring and the skillfully engineered design of the landscape. Uniting his pleas in favor of both the park and Chase's art within a nationalistic theme, he reasoned, "Indeed, why should not these exquisite scenes of Central Park find their way from the artist's easel to the walls of citizens as easily as pictures of Niagara, or views taken in Lutetia Parisiorum? Few cities can boast so beautiful a park as New York." De Kay concluded his argument optimistically:

There is hope, then, that Mr. Chase may hereafter combine a reasonable financial success with the pursuit of landscape and figure work in the way he prefers; for his pictures of Central Park, while they ought to be popular by reason of circumstances, have all the possibilities he may demand for the painting of fresh natural subjects under the changes of light and shadow out-of-doors, and for the treatment of the human figure in a bright, unhackneyed fashion.[58]

Whether he intended it or not, De Kay's article stands as a postmortem for Chase's involvement with the park subject. Chase would spend that summer teaching in Shinnecock, while Alice and the children stayed in Hoboken for the greater part of the season. By the fall of 1891 he was already announcing the newest phase of his subject matter with the display of *Evening at the Shinnecock Hills, Long Island* and a pastel titled *Grain Field, Shinnecock Hills* at the tenth autumn exhibition of the NAD.[59] That September Chase had been quoted extensively in A. E. Ives's article, "Suburban Sketching Grounds," in which Ives confirmed that "it is generally conceded that he [Chase] was the first metropolitan artist to appreciate the hitherto almost untouched field of landscape in and about the city."[60] Ives's use of the past tense "was" is the operative factor; Chase had closed that chapter of his career, leaving others, like Hassam, to portray the city environs. Certainly without the critical acclaim derived from

his Brooklyn and Manhattan paintings that established him as a leading plein-air landscapist, Chase would never have received the invitation to head the Shinnecock Summer School of Art.

In 1890, the advent of his Shinnecock years, Chase was secure in the knowledge that his reputation was fixed at a high point. He must have been conscious that much of that security was owed to his own "discovery" of parts of Brooklyn and Manhattan as viable artistic material. By carving out this new subject matter he thoroughly satisfied the critics' demands for American subject matter. At the same time, his adoption of a variant Impressionist style rid his art of Munich associations. However, the brighter palette, broken brushwork, and plein-air methods Chase employed did not constitute a full embrace of French Impressionism. In his hands light remained a means of defining form rather than a means of dissolving it; and color was put in service of describing objects as they were, rather than approximating the shimmering spectrum of colored shadows and reflections that altered visual perception. Where he was once castigated for relying on European masters, critics were now positioning him as an artist worthy of emulation: "The best of our artists are staying at home. . . . Chase is growing in greatness as he is crystalizing into selfhood. His old associates, Currier, Duveneck, . . . where are they?"[61]

Throughout this process of transformation Chase never forfeited the formal values that signified modernity, the most important of which, for him, was the construction of pictorial space. Critics, whose attention was caught by the charm of Chase's elevation of common local scenes into art, rarely looked deeper than the superficialities attached to the novelty of his vision or the proficiency of his brushwork. To be sure, writers were aware of Chase's avant-garde tendencies and were quick to cite his artistic kinship with such painters as de Nittis, Manet, and Whistler. Keyed mainly to the geographic spaces Chase portrayed, most commentators ignored the existence of a basic compositional template used by the artist that overrode issues of subject and place and united all of his work within the 1880s rubric of modernity as conceived in the organization of space on the flat surface of the canvas. The concept of "l'accidents de la perspective" promoted by the teachings of Horace Lecoq de Boisbaudran (1802–1897) and assimilated by a generation of the international avant-garde painters of Chase's time had infiltrated the manner of building pictorial space.[62] Directed primarily to the psychological

tensions evinced by the pictorial relationship of the human figure and the architectural interiors it occupies, Lecoq's theories are credited with prompting the expressive use of space that was manifested in the dismantling of the symmetrical, right-angled, regular spaces of academic compositional practice. Edgar Degas's *Interior* (fig. 70) now stands as a classic example of this type of pictorial space, in which the emotional atmosphere of a mysterious narrative is intensified, indeed, created by the distribution of figures and objects in a destabilized interior space that is built from shifting spatial planes. Susan Sidlauskas has codified the elements of this compositional tendency, which through such codification assumes the character of artistic convention. In her discussion of realist interior subjects as driven by her reading of Lecoq de Boisbaudran, she has observed:

Despite their apparent idiosyncracies [sic], they actually conform to a predictable compositional style: a mix of assymmetry [sic], imbalance, unexpected arrangements, and distortions of proportion and scale. In other words, they negate the representation of order. In fact, the compositions of these paintings derive from an explicit and systematic repudiation of the rules of history painting—asymmetry, balance, the even distribution of figures and tones, and clearly-defined planes—still considered to be the pictorial equivalents of propriety, decorum and clarity.[63]

In the hands of recognizedly bolder artists like Degas, Manet, and Caillebotte these new rules of space threatened the traditional aesthetic order and simultaneously raised questions about the social propriety, decorum, and clarity cited by Sidlauskas. Chase also participated in this formal construction of meaning, adapting it most overtly in his studio pictures in which the studio space is appropriated thematically to convey the idea of modern artistic life. Returning to *Hide and Seek* (fig. 14) and *In the Studio* (Pl. 4), it may be observed that the very composition of these paintings embodies and abstracts the idea of the artistic process that takes place within this real, measurable domain. Defined by irregularity, imbalance, and dislocation, these normally stable architectural confines defy the logic of the "real" in which floors are customarily flat, walls and floors meet at right angles, and bodies occupy parallel planes in correct proportional relationships. Chase took this conventionalized, destabilizing template indicative of modern interior space and applied it to his landscapes, superimposing images of exterior spaces symbolic of

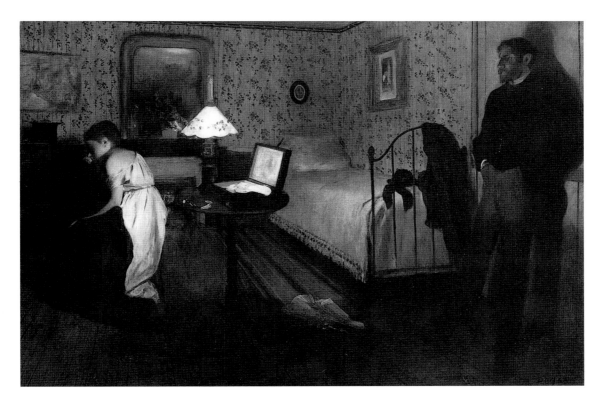

Fig. 70. Edgar Degas, Interior, *1868–69. Oil on canvas, 32 × 45 inches. Philadelphia Museum of Art: The Henry P. McIlhenny Collection in memory of Frances P. McIlhenny, 1986–26–10.*

modern life onto artistic schemata already possessing similar meaning. In her discussion of *Hide and Seek* Sidlauskas noted "the constant play between surface attention and deep space" and concluded that "the sensation of distance is so over-whelming as to constitute the *subject* of the painting."[64] A similar effect is achieved in Chase's outdoor subjects. One end of the extreme is found in *The Common, Central Park* (Pl. 44) and in *Prospect Park* (Pl. 17), both of which exploit the same conflicting and simultaneous impulses to experience distance and surface. Another particularly cogent example of this characteristic lies in *The Lake for Miniature Yachts* (Pl. 39), the composition of which thwarts the traditional (Western) way in which the viewer is meant to decipher pictorial space. Chase seems willfully to have chosen a vantage point that would afford the least stable impression of "real" space. Overlaid by the rigid rectangle of the canvas itself, the equally rigid rectangular shape of the park is skewed, contradicted by the dominant diagonal created by the edge of the pool, which to the mind's eye should parallel the line of Fifth Avenue

marked by the buildings at the center of the line of trees that function as a horizon line intersecting the hidden but acknowledged line of the avenue. On this conceptual fusion of two opposing but regular rectangular shapes Chase super-imposed his own pictorial space, the irregularity of which conflicts with the logical geometry of mapping and relies on the vagaries and illusions of vision. Here, the space becomes fluid, the ground shifts upward to meet the picture plane, lines that in life are parallel converge or diverge. In artistic terms, Chase joined in destroying the mechanics of the geo-metric grid that had organized pictorial space in Western art since the Renaissance. For the viewer the experience pro-vokes a psychological tension introduced by the need to accommodate the contradictions posed by the knowledge of the actual space against what is pictured. Similar tensions arise throughout Chase's Brooklyn and Manhattan paintings (see especially *Park Bench* [Pl. 45] and *In the Park—A By-Path* [Pl. 46]), and, although these compositional strategies received passing note from the critics, Chase's paintings were

Pl. 54. Wind Swept Sands, Shinnecock, Long Island, *c. 1894. Oil on canvas, 34¼ × 39¾ inches. The Art Institute of Chicago; restricted gift of Mrs. Eric Oldberg in honor of Milo M. Naeve; Friends of American Art and R. H. Love Galleries Funds; Walter Aiken Endowment; through prior acquisitions of the Charles H. and Mary F. S. Worcester Collection (1991.249). ©1999 The Art Institute of Chicago. All Rights Reserved.*

not recognized for being the avant-garde works that they are. The reason for this is lodged in the normalizing effect of the subjects he depicted, the overarching charm of which softened the impact of the formal devices he used. The same may be said of his later Shinnecock landscapes, for just as viewers were captivated by the wholesome simplicity of sunlit scenes of Long Island shores or painterly depictions of common sand dunes, they were inured to the effects of Chase's thoroughly modern treatment of pictorial space. Yet, if comparisons are made between *A Bit of the Terrace* (Pl. 41) and *A Sunny Day at Shinnecock Bay* (Pl. 53) or *The Common, Central Park* (Pl. 44) and *Wind Swept Sands, Shinnecock, Long Island* (Pl. 54), virtually the same compositional templates are applied to these otherwise incongruent spaces. With such comparisons the consistency of Chase's pictorial vision becomes apparent. Chase's knowledge of progressive European artistic trends in depicting pictorial space dovetailed with what appears to have been a personal predisposition for such compositional patterns. His appreciation for contemporary French art in particular matured at the same time that critics were agitating for American

subject matter, a coincidence that prompted him to apply modern formal techniques and compositional structures to the types of urban and suburban landscapes featured in French painting. Cognizant of his home audience's resistance to foreign influence, Chase blunted the often sharp social content contained in the work of his French counterparts and, instead, created a genteel, civilized vision of American urban life. Although he abandoned painting in Brooklyn and Manhattan by 1890, the five-year period he spent in addressing the metropolitan landscape in modern terms endowed him with the technical means to achieve an even greater sophistication in his art, as witnessed by his Shinnecock landscapes. What is more, he emerged from that period as a painter who was not only favored by the critics but one who could also claim success by virtue of the collections his park paintings had entered. That Chase's park and harbor scenes represent a transitional phase in his career is undisputed. However, in considering these civilized urban landscapes as an identifiable and separate aesthetic endeavor, it is revealed how completely apart they stood from the mainstream of American art.

NOTES

1. "The William Merritt Chase Exhibition," *Art Amateur* 16 (April 1887), 100.

2. The other works by Chase on view in the 1887 SAA annual were *Portrait of Mrs. H.* (probably a portrait of Mrs. F. H. Howell) and two works simply designated *Landscape* and *Portrait*.

3. "The Society of American Artists," *Art Amateur* 17 (June 1887), 5.

4. Ibid.

5. For Clarke, see H. Barbara Weinberg, "Thomas B. Clarke: Foremost Patron of American Art from 1872 to 1899," *American Art Journal* (May 1976), 52–83.

6. Ibid., 72. Weinberg lists *A Coquette, Girl in Costume, The Model* (pastel), *Prospect Park, A Stone Yard, A Visitor, Weary,* and *Who Rang?* as Clarke's Chase holdings.

7. The Prize Fund exhibitions were established in 1884 to stimulate interest in and provide support for American art. The first exhibition was held in New York in 1885. A committee of donors composed mainly of collectors and art dealers, working in association with the American Art Association, invited any and all American artists to submit works to a jury, which would select from them an exhibition from which four prize pictures would be chosen. The monies contributed by the subscribers to the Prize Fund were awarded to the four winning artists, "it being understood that each artist . . . should,

upon receipt thereof, relinquish all claim upon the picture upon which the award was made, and further, that the pictures known as 'the Prize Pictures' should become the property of the public Art galleries situated in the cities from which the bulk of the contributions to the fund had come,—being distributed thereunto by lot." "Introductory," *Illustrated Catalogue of the Prize Fund Exhibition Held under the Auspices of the American Art Association of New York*, exh. cat. (New York: American Art Galleries, April 20, 1885), n.p.

8. Chase's exhibition record at the American Watercolor Society for the decade of the 1880s was slight: 1880, no. 213, *Study;* 1881, no. 243, *Portrait Study* (Horowitz collection); 1882–83, no. 192, *Lady in Black;* 1883, no. 331, *Here She Comes;* 1885, nothing; 1886, no. 177, *A Madrid Dancing Girl,* and no. 314, *A Summer Afternoon in Holland;* 1887, nothing; 1888, no. 303, *In Washington Park, Brooklyn, N.Y.;* 1889, no. 190, *Au revoir* (Chase was on the Committee on Decorations); 1890, nothing; 1891, no. 632, *Portrait of Mrs. C.*

9. "The Fine Arts," *Critic* 12 (May 12, 1888), 234.

10. For the Eden Musée, see Kathleen Kendrick, "'The Thing Down Stairs': Containing Horror in the Nineteenth-Century Wax Museum," *Nineteenth Century Studies* 12 (1998), 1–35, and Andrea Stulman Dennett, *Weird and Wonderful: The Dime Museum in America* (New York and London: New

York University Press, 1997). The New York Public Library catalogue lists four scrapbooks of clippings about the Eden Musée, but at the time of this writing none of them could be located. Neither Kendrick nor Dennett discusses the role of the fine art exhibitions mounted at the Eden Musée.

11. *Eden Musée Monthly Catalogue* (New York: Eden Musée, 1884), quoted in Kendrick, "The Thing Down Stairs," 1.

12. Ibid.

13. "New Band at the Eden Musee," *New York Times*, December 4, 1886, 2:6.

14. "Rare Orchids, Roses, and Ferns," *New York Times*, October 30, 1887, 9:2.

15. In this respect the Eden Musée seems to have been a North American equivalent to the Musée Grévin, Paris, a wax museum established in 1882 by the journalist Arthur Meyer and the caricaturist Alfred Grévin. Dedicated to depicting current events (both horrific and uplifting), the "museum" was termed a "living newspaper." See Vanessa R. Schwartz, "Cinematic Spectatorship before the Apparatus: The Public Taste for Reality in Fin-de-Siècle Paris," in Linda Williams, ed., *Viewing Positions: Ways of Seeing Film* (New Brunswick, N.J.: Rutgers University Press, 1995), 87–113. Schwartz observes the same fascination with the grisly there, citing a cartoon she found in the museum's archives, the punch line of which is, "This is almost as much fun as the real Morgue" (94).

16. Kendrick, "The Thing Down Stairs," 4. For a contemporaneous account of the contrasts, see "The Eden Musée: A Queer Medley of the Horrible and Historic," *New York Herald*, March 29, 1884, 6.

17. "My Notebook," *Art Amateur* 18, no. 2 (January 1888), 28.

18. *Catalogue. New York Society for the Promotion of Art. Inaugural Exhibition, December 1887–1888*, exh. cat. (New York: Lockwood Press, 1887).

19. Nellie Bly, *The Mystery of Central Park* (New York: G. W. Dillingham, 1889), 151.

20. "My Note Book," *Art Amateur* 18 (January 1888), 28.

21. C. M. S., "Gallery and Studio. A New Enterprise at the Eden Musee," *Brooklyn Daily Eagle*, December 11, 1887, 2.

22. Fort Greene Park is situated on a 30-acre tract between Canton and Cumberland Streets and Myrtle and De Kalb Avenues in Brooklyn. Dedicated to the memory of the American Revolutionaries who died in the Wallabout prison ships and the heroes of the War of 1812, the park contains a vaulted monument in which the remains of the prison ship martyrs are interred.

23. C. M. S., "Gallery and Studio," *Brooklyn Daily Eagle*, February 19, 1888, 11:6.

24. "The American Artists' Exhibition," *Art Amateur* 18 (May 1888), 130.

25. "Recent American Landscape," *Art Amateur* 19 (June 1888), 2–3.

26. Ibid.

27. C. M. S., "Gallery and Studio," *Brooklyn Daily Eagle*, May 20, 1888, 10:3. This review is quoted from an as yet unlocated review in the *Studio*.

28. C. M. S., "Gallery and Studio," *Brooklyn Daily Eagle*, June 22, 1888, 4:3.

29. C. M. S., "Gallery and Studio," *Brooklyn Daily Eagle*, May 27, 1888, 15:5.

30. Charlotte Adams, "Color in New-York Streets," *Art Review* (September–November 1887), 19.

31. His exhibits at the American Art Galleries in the fall of 1888 were mentioned in "Fall Exhibition at the American Art Galleries," *Art Amateur* 18 (January 1888), 34, which stated, "The big canvases, however, do not carry off all the honors; Wm. M. Chase sends five little landscape studies in oil and pastel, which are all exceedingly clever."

32. "The National Academy of Design," *Art Amateur* 18 (May 1888), 132.

33. "Fine Arts. The Society of American Artists," *Nation*, no. 1247 (May 23, 1889), 433.

34. See, for example, Clarence Cook, "The Painters in Pastel," *Springfield Republican*, June 27, 1888, 9: "The most striking pastel in the exhibition was William M. Chase's 'Pure' the rather challenging title of a study of the nude model loaned for the occasion by its owner, Thomas H. Clarke, who is gradually getting together what will be in time a remarkable collection of American pictures. In securing this pastel by Mr. Chase, Mr. Clarke has obtained a masterpiece of technical execution. I speak of it in this way because, as it professed to be merely a study of the model, no particular sentiment or feeling had to be interpreted. The model was sitting on the floor with one leg bent under her, showing the sole of one foot. She was

leaning upon a green cushion with her back turned toward us. She was in full light, and so true were the tones that the effect had all the dazzling quality that belongs to the human body seen under such conditions, with a softness and firmness united that were almost magical. The flesh seemed to emit light. No piece of flesh painting has been seen in these parts that could approach this performance of Mr. Chase. Mr. Chase has been made the subject of some amicable criticisms among his brother artists, to the effect that he could do this, that or the other thing, but, painting the nude figures was not in his line. The quiet answer to this has been a half-dozen studies of the nude, of which Mr. Clarke's is only the most complete and I speak of those I have seen, but taken singly or together they throw everything else that has been done here, into the shade."

35. Ibid. The critical community was unified in its opinion of Chase's pastels. See, for example, "The Pastel Exhibition," *Art Amateur* 19 (June 1888), 3; Mrs. Schuyler Van Rensselaer, "Fine Arts. An Exhibition of Pastels," *Independent*, May 24, 1888, 647; and "Art Notes. The Pastel Exhibition," *Art Interchange* 20, no. 11 (May 19, 1888), 161.

36. *Catalogue of the Paintings Exhibited by the Inter-State Industrial Exposition of Chicago*, Seventeenth Annual Exhibition, September 4–October 19, 1889. Interestingly, patronage for Chase's civilized urban landscapes came from a sector of society whose personal and business concerns included cultural and civic improvement. Charles Lawrence Hutchinson (1854–1924) was a founder of the Chicago Academy of Fine Arts (later the Art Institute of Chicago) for which he served as president from 1882 to 1924. Among his many contributions to the cultural life of Chicago, he was chairman of the Fine Arts Committee for the Chicago World's Columbian Exposition and was a member of Chicago's Board of South Park Commissioners from 1907 to 1922. The author Charles Norman Fay (b. 1848) wrote extensively on labor relations. Businessman and real estate developer Potter Palmer was a key figure in transforming the Chicago lakefront from wasteland to elegant residential and civic spaces and was active in the administration of the South Side park system in its early years. Both Palmer and his wife, Bertha, were influential in the organization of the World's Columbian Exposition and, with the advice of the art critic Sarah Tyson Hallowell, formed a remarkable collection of contemporary French and American paintings, which reflected their taste for Impressionism. The New York socialite Mrs. C. H. Wilmerding was also active in civic affairs, most notably with respect to this study, as a delegate to the (New York) Parks Conservation Association in the early 1920s (when her complaints regarding the politics surrounding city park administration drew headlines).

37. "Mr. Chase's Pictures," *Chicago Tribune*, September 15, 1889, 24.

38. Ibid.

39. For the 1890 New York SAA exhibition, Chase showed *At Kathleen Villa* (no. 37), *A Stormy Day at Bath Beach, Long Island* (no. 38), *The Beach* (no. 39), *Long Island Landscape* (no. 40), *An Hour with Aldrich* (no. 41), and *Well, I Should not Murmer, for God Judges Best* (no. 42). To this group a seventh work was added for the Chicago exhibition, referred to as a "portrait of Legendre" in "American Artists," *Chicago Tribune*, June 9, 1890, contained in The Art Institute of Chicago Scrapbooks, Ryerson Library. The portrait of William Charles Le Gendre recently came up for auction (*Christie's Important American Paintings, Drawings, and Sculpture*, New York, May 26, 1999, lot 89).

40. "Ellsworth and Art Institute Prizes," *Chicago Tribune*, June 14, 1890, clipping contained in The Art Institute of Chicago Scrapbooks, Ryerson Library.

41. Hecker's ownership of this painting is somewhat anomalous in that the bulk of his collection echoed the taste of his partner, Freer, who preferred works by Dewing, Tryon, and Thayer. Several possibilities arise in attempting to explain the presence of *At Kathleen Villa* in Hecker's collection. Dewing, a close friend and colleague of Chase's, sometimes advised Freer and Hecker in their art purchasing activities and it may have been through him that Hecker was introduced to Chase's painting. More likely, however, is that there was a familial connection between Caroline Hecker (who was an active exhibitor in the Society of Painters in Pastel) and Frank Hecker that

accounts for this sole instance of his acquiring a work depicting contemporary life.

42. "The American Artists," *Chicago Tribune*, June 9, 1890, The Art Institute of Chicago Scrapbooks, Ryerson Library.

43. "Pastels and Paintings by Chase," *New York Times*, March 1, 1891, 12.

44. "Wafted from the Sea. Like a Fresh Breeze from the Ocean Are the Paintings at the Art Institute" [1890]. Clipping. The Art Institute of Chicago Scrapbooks, Ryerson Library.

45. "Notes on Current Art," *Chicago Tribune*, June 15, 1890, The Art Institute of Chicago Scrapbooks, Ryerson Library.

46. "The Pastel Exhibition," *Art Amateur* 23 (June 1890), 4.

47. Taken in and of themselves, Chase's paintings demonstrate his disinterest in conveying the idea of modernity through the chaos of the urban sphere. His depictions of the parks and harbors of New York and Brooklyn retained a genteel veneer that enabled him to express modern life without having to focus on what he called the "skyscraping monsters [which] have smothered quite out of existence as objects of beauty many of the sightly old land marks [sic] of this city." William Merritt Chase Papers (undated notes for lectures), Archives of American Art, Smithsonian Institution, Washington, D.C., reel N69-137, frames 48–49.

48. Chase taught at the Art Students League from 1878 to 1896 and from 1907 to 1911; at the Brooklyn Art Association in 1887 and from 1891 to 1896; at the Shinnecock School of Art from 1891 to 1902; at the Chase School of Art (later the New York School of Art) from 1896 to 1907; and at the Pennsylvania Academy of the Fine Arts from 1896 to 1909. In addition, he was a guest instructor at the Art Institute of Chicago in 1897 and conducted numerous summer classes in Europe following the close of the Shinnecock School of Art.

49. The 1890 American Art Association sale included 47 paintings and pastels by Chase which were offered with paintings by J. W. Champney (1843–1903), Charles Melville Dewey, C. H. Eaton (1850–1901), Frank Rehn (1848–1914), F. D. Millet (1846–1912), Robert Minor (1839–1904), H. R. Poore (1859–1940), Frederic Remington (1861–1909), and Carleton Wiggins (1848–1932). Several works in the display were on loan from noted collectors, included, no doubt, to heighten interest in available works. They were Clarke's *In Prospect Park*, *Afternoon in the Park* owned by F. H. Howell, and *Over the Hills*, owned by John Dallet. See *Catalogue of the American Art Association—American Art Galleries* (6 East 23rd Street), April 7, 1890. The Ortgies sale consisted of paintings and pastels by the artist.

50. "Paintings and Pastels by William M. Chase," *Critic*, no. 375 (March 7, 1891), 128. There were several park subjects on view; it is impossible to say which of them seemed so weak to the critic.

51. "Some Questions of Art. Pictures by Mr. William M. Chase," *Sun*, March 1, 1891, 14.

52. Ibid.

53. "Sale of Mr. Chase's Pictures. The Bidding Was Light and Low Prices Were Brought," *New York Times*, March 7, 1891, 5.

54. "Society of American Artists," *New York Times*, April 26, 1891, 5.

55. Ibid.

56. Charles De Kay, "Mr. Chase and Central Park," *Harper's Weekly* 35, no. 1793 (May 2, 1891), 327.

57. Ibid., 328. In the case of *In the Park—A By-Path*, Chase may have called on specific cultural associations that amplified the civilized nature of the park site he portrayed. As William H. Gerdts has pointed out, the stone wall supporting the young child as she makes her way down the sloped pathway was a remnant of the foundation of what was originally Mount Saint Vincent's Convent. Gerdts traced the history of the spot: "The Sisters of Charity of Saint Vincent de Paul, primarily Irish, had to move from their convent in 1859 when the park came into existence, though they returned temporarily to run a military hospital there during the Civil War. The hospital was replaced by a restaurant, while the chapel became an art gallery housing the sculptures of Thomas Crawford . . . [and] both structures burned to the ground in 1881." *Impressionist New York* (New York, London, Paris: Abbeville Press Publishers, 1994), 131. Although, as Gerdts added, the restaurant was rebuilt in 1883, Chase did not stress that fashionable feature of the park's landscape and focused, instead, on the more secluded adjacent area that had in recent memory been identified sequentially with faith, healing, and art.

58. Ibid.

59. A brief description of *Evening at the Shinnecock Hills, Long Island* appeared in "The Autumn Academy," *New York Times*, December 20, 1891, 13, which stated that the painting showed "a slope with woman's figure, the head turned to watch the bright sky at the high horizon." Although it cannot be said with certainty, it is possible that the painting in question is that which was listed as *Shinnecock*, lot 99, *American 19th- and 20th-Century Paintings, Drawings, Watercolors & Sculpture*, Sotheby Parke Bernet, New York, April 21, 1977. I am grateful to Mr. Stuart Feld for bringing this auction record to my attention. The evening hour Chase chose for this painting contrasts substantially to the normally bright, sunny daylight Shinnecock scenes for which he is known. A likely explanation for the relatively somber, even melancholy, mood of the work may perhaps be connected with the untimely death of the Chases' first son, who died in July 1891.

60. A. E. Ives, "Suburban Sketching Grounds," *Art Amateur* 25 (September 1891), 80.

61. C. M. S., "Gallery and Studio," *Brooklyn Daily Eagle*, September 11, 1892, 19.

62. For an excellent analysis of Lecoq de Boisbaudran's influence on the realist artistic vision, see Susan J. Sidlauskas, "A 'Perspective of Feeling': The Expressive Interior in Nineteenth-Century Realist Painting," Ph.D. dissertation, University of Pennsylvania, 1989.

63. Ibid., 18.

64. Ibid., 183.

SELECTED BIBLIOGRAPHY

A. J. D. [Andrew Jackson Downing]. "Mr. Downing's Letters from England." *Horticulturalist and Journal of Rural Art and Rural Taste* 5, no. 4 (October 1850), 153–60.

Adams, Charlotte. "Color in New-York Streets." *Art Review* (September–November 1887), 17–19.

Atkinson, D. Scott, and Nicolai Cikovsky, Jr. *William Merritt Chase: Summers at Shinnecock, 1891–1902.* Exh. cat. Washington, D.C.: National Gallery of Art, 1987.

Bercovitch, Sacvan, and Myra Jehlen, eds. *Ideology and Classic American Literature.* Cambridge: Cambridge University Press, 1986.

Bienenstock, Jennifer Martin. "The Formation and Early Years of The Society of American Artists, 1877–1884." Ph.D. dissertation, City University of New York, 1983.

Blaugrund, Annette. *The Tenth Street Studio Building: Artist-Entrepreneurs from the Hudson River School to the American Impressionists.* Exh. cat. Southampton, N.Y.: The Parrish Art Museum, 1997.

Blaugrund, Annette, et al. *Paris 1889: American Artists at the Universal Exposition.* Exh. cat. Philadelphia: Pennsylvania Academy of the Fine Arts, in Association with Harry N. Abrams, Inc., 1989.

Bly, Nellie [Elizabeth Cochrane]. *The Mystery of Central Park.* New York: G. W. Dillingham, 1889.

Bobbitt, Mary Reed, comp. "A Bibliography of Etiquette Books Published in America before 1900." *Bulletin of The New York Public Library* 51, no. 12 (December 1947), 687–720.

Brand, Dana. *The Spectator and the City in Nineteenth-Century American Literature.* Cambridge and New York: Cambridge University Press, 1991.

"A Brilliant Group of Painters' Drawings." *New York Herald*, December 22, 1889, 8.

Brooklyn before the Bridge: American Paintings from the Long Island Historical Society. Exh. cat. Brooklyn: The Brooklyn Museum, 1982.

"Brooklyn Navy-Yard." *Harper's Weekly* 26, no. 1337 (August 5, 1882), 488–91.

Bryant, Keith L., Jr. *William Merritt Chase: A Genteel Bohemian.* Columbia and London: University of Missouri Press, 1991.

Burns, Sarah. *Inventing the Modern Artist: Art and Culture in Gilded Age America.* New Haven and London: Yale University Press, 1996.

Burrows, Edwin G., and Mike Wallace. *Gotham: A History of New York City to 1898.* New York and Oxford: Oxford University Press, 1999.

Carr, Carolyn Kinder, et al. *Revisiting the White City: American Art at the 1893 World's Fair.* Exh. cat. Washington, D.C.: National Museum of American Art and National Portrait Gallery, Smithsonian Institution, 1993.

"The Central Park and Other City Improvements." *New York Herald*, September 6, 1857, 4.

Chase, William Merritt. "Address of Mr. William M. Chase before the Buffalo Fine Arts Academy, January 28, 1890." *Studio*, n.s., 5, no. 13 (March 1, 1890), 124.

——. "Painting." *American Magazine of Art* 8 (December 1916), 50–53.

——. "The Two Whistlers: Recollections of a Summer with the Great Etcher." *Century Magazine* 80 (June 1910), 219–26.

C. M. S. "Gallery and Studio." *Brooklyn Daily Eagle*, August 1, 1886, 11.

——. "Gallery and Studio. The Pictures of Chase and Whittredge Contrasted." *Brooklyn Daily Eagle*, March 6, 1887, 2.

"Chase's Story. The Artist Replies to Messrs. Jones and Brower." *Brooklyn Daily Eagle*, June 19, 1890, 6.

Cikovsky, Nicolai, Jr. "William Merritt Chase's Tenth Street Studio." *Archives of American Art Journal* 16 (1976), 2–14.

Coffin, William A. "The Fine Arts at the Paris Exposition." *Nation*, no. 1268 (October 17, 1889), 311.

"Coney Island." *Harper's Weekly* 26, no. 1336 (July 29, 1882), 475.

Cook, Clarence. *A Description of the New York Central Park.* 1869. Repr., New York: Benjamin Blom, 1972.

——. "The Painters in Pastel." *Springfield Republican*, June 27, 1888, 9.

Cox, Kenyon. "William Merritt Chase, Painter." *Harper's New Monthly Magazine* 78 (March 1889), 549–57.

De Kay, Charles. "Mr. Chase and Central Park." *Harper's Weekly* 35, no. 1793 (May 2, 1891), 324–28.

Dennett, Andrea Stulman. *Weird and Wonderful: The Dime Museum in America.* New York and London: New York University Press, 1997.

"The Eden Musée: A Queer Medley of the Horrible and Historic." *New York Herald*, March 29, 1884, 6.

Exhibition of Pictures, Studies and Sketches by Mr. William M. Chase, of New York City under the auspices of the American Art Association at the Gallery of the Boston Art Club. Boston, November 13–December 4, 1886.

Farnham, Charles H. "A Day on the Docks." *Scribner's Magazine* 18 (May 1879), 32–47.

Fink, Lois Marie. *American Art at the Nineteenth-Century Paris Salons.* Washington, D.C., and Cambridge: National Museum of American Art, Smithsonian Institution, and Cambridge University Press, 1990.

The First West Coast Retrospective Exhibition of Paintings by William Merritt Chase (1849–1916). Exh. cat. Santa Barbara: The Art Gallery, University of California, Santa Barbara, in cooperation with the La Jolla Museum of Art, 1964.

Gallati, Barbara Dayer. *William Merritt Chase.* New York: Harry N. Abrams, Inc., in Association with the National Museum of American Art, Smithsonian Institution, 1995.

Gerdts, William H. *American Impressionism.* Exh. cat. Seattle: Henry Art Gallery, University of Washington, 1980.

———. *Impressionist New York.* New York, London, Paris: Abbeville Press Publishers, 1994.

Graff, M. M. *Central Park and Prospect Park: A New Perspective.* New York: Greensward Foundation, 1985.

Haltunnen, Karen. *Confidence Men and Painted Women: A Study of Middle-Class Culture in America, 1830–1870.* New Haven and London: Yale University Press, 1982.

Herbert, Robert L. *Impressionism: Art, Leisure and Parisian Society.* New Haven and London: Yale University Press, 1988.

Hiesinger, Ulrich W. *Childe Hassam, American Impressionist.* New York: Jordan Volpe Gallery; Munich: Prestel-Verlag, 1994.

Homberger, Eric. *Scenes from the Life of a City: Corruption and Conscience in Old New York.* New Haven and London: Yale University Press, 1994.

Howard, Henry W. B., ed. *The Eagle and Brooklyn: History of the City of Brooklyn.* Brooklyn: Brooklyn Daily Eagle, 1893.

Ives, A. E. "Suburban Sketching Grounds." *Art Amateur* 25 (September 1891), 80–82.

J. M. T. "The American Artists' Exhibition." *Art Amateur* 11, no. 2 (July 1884), 30.

Jackson, Kenneth T., ed. *The Encyclopedia of New York City.* New Haven and London: Yale University Press; New York: The New-York Historical Society, 1995.

Kasson, John F. *Rudeness and Civility: Manners in Nineteenth-Century Urban America.* New York: Hill and Wang, 1990.

Kendrick, Kathleen. "'The Thing Down Stairs': Containing Horror in the Nineteenth-Century Wax Museum." *Nineteenth Century Studies* 12 (1998), 1–35.

Lancaster, Clay. *Prospect Park Handbook.* New York: Long Island University Press, 1972.

Lauderbach, Frances. "Notes from Talks by William M. Chase, Summer Class, Carmel-by-the-Sea, California." *American Magazine of Art* 8 (1917), 432–38.

Levine, Lawrence. *Highbrow Lowbrow: The Emergence of Cultural Hierarchy in America.* Cambridge, Mass., and London: Harvard University Press, 1988.

Louis, S. L. *Decorum: A Practical Treatise on Etiquette and Dress of the Best American Society.* New York, Boston, Cincinnati, Atlanta: Union Publishing House, 1881.

McCabe, James D., Jr. *Lights and Shadows of New York Life: or, the Sights and Sensations of the Great City.* Philadelphia, Cincinnati, Chicago, Saint Louis: National Publishing Company, 1872.

Manbeck, John B., ed. *The Neighborhoods of Brooklyn.* New Haven and London: Yale University Press, 1998.

Marlor, Clark S. *A History of the Brooklyn Art Association with an Index of Exhibitions.* New York: James F. Carr, 1970.

Ment, David. *The Shaping of a City: A Brief History of Brooklyn.* Brooklyn: Brooklyn Educational & Cultural Alliance, 1979.

Milgrome, Abraham David. "The Art of William Merritt Chase." Ph.D. dissertation, University of Pittsburgh, 1969.

Miller, Joaquin. *The Destruction of Gotham.* New York and London: Funk & Wagnalls, 1886.

Miller, Juanita J. *My Father C. H. Joaquin Miller—Poet.* Oakland, Calif.: Tooley-Town, 1941.

Milroy, Elizabeth. "The Public Career of Emma Stebbins: Work in Bronze." *Archives of American Art Journal* 34, no. 1 (1994), 2–13.

Montgomery, Maureen E. *Displaying Women: Spectacles of Leisure in Edith Wharton's New York.* New York and London: Routledge, 1998.

Morgan, H. Wayne. *New Muses: Art in American Culture, 1865–1920.* Norman: University of Oklahoma Press, 1978.

"Mr. William Merritt Chase's Art." *Art Interchange* 12, no. 13 (June 19, 1884), 148.

"Mrs. William Merritt Chase." *Daily Graphic*, February 17, 1887, 837.

Nochlin, Linda. *Realism: Style and Civilization.* New York and Baltimore: Penguin Books, 1971.

O'Brien, Maureen C. *In Support of Liberty: European Paintings at the 1883 Pedestal Fund Art Loan Exhibition.* Exh. cat. Southampton, N.Y.: The Parrish Art Museum, 1986.

"Paintings and Pastels by William M. Chase." *Critic*, no. 375 (March 7, 1891), 128.

Paintings by William Merritt Chase, N.A., LL.D. Exh. cat. Saint Louis: Newhouse Galleries, 1927.

"Pedestal Art Loan." *New York Times*, December 16, 1883, 5.

"Pedestal Fund Art Loan Exhibition." *Art Amateur* 10 (January 1884), 43.

Peters, Lisa. "John Twachtman (1853–1902) and the American Scene in the Late Nineteenth Century: The Frontier within the Terrain of the Familiar." Ph.D. dissertation, City University of New York, 1995.

"Pictures. The Society of American Artists. Its Supplementary Exhibition." *Brooklyn Daily Eagle*, May 14, 1882, 1.

Pilgrim, Dianne H. "The Revival of Pastels in Nineteenth-Century America: The Society of Painters in Pastel." *American Art Journal* 10 (November 1978), 43–62.

Pisano, Ronald G. *Summer Afternoons: Landscape Paintings of William Merritt Chase.* Boston, Toronto, London: Bulfinch Press, 1993.

———. *William Merritt Chase, 1849–1916: A Leading Spirit in American Art.* Exh. cat. Seattle: Henry Art Gallery, University of Washington, 1983.

Pisano, Ronald G., and Alicia Grant Longwell. *Photographs from the William Merritt Chase Archives at the Parrish Art Museum.* Exh. cat. Southampton, N.Y.: The Parrish Art Museum, 1992.

Pyne, Kathleen. *Art and the Higher Life: Painting and Evolutionary Thought in Late Nineteenth-Century America.* Austin: University of Texas Press, 1996.

Quick, Michael, and Eberhard Ruhmer. *Munich and American Realism in the 19th Century.* Exh. cat. Sacramento, Calif.: E. B. Crocker Art Gallery, 1978.

Roof, Katherine Metcalf. *The Life and Art of William Merritt Chase.* 1917. Repr., New York: Hacker Art Books, 1975.

Rosenzweig, Roy, and Elizabeth Blackmar. *The Park and the People: A History of Central Park.* New York: Henry Holt and Company, 1992.

Schuyler, David, and Jane Truner Censer, eds. *The Years of Olmsted, Vaux & Company, 1865–1874.* Vol. 6, *The Papers of Frederick Law Olmsted.* Baltimore and London: Johns Hopkins University Press, 1992.

Sidlauskas, Susan J. "A 'Perspective of Feeling': The Expressive Interior in Nineteenth-Century Realist Painting." Ph.D. dissertation, University of Pennsylvania, 1989.

"The Slaughter of Mr. Chase's Pictures." *Art Amateur* 24, no. 5 (April 1891), 115–16.

Social Etiquette of New York. New York: D. Appleton and Company, 1883.

"The Society of American Artists." *Art Amateur* 17 (June 1887), 5.

"Society of American Artists (Last Notice)." *New-York Daily Tribune,* June 2, 1884, 2.

"Society Artists." *New York Times,* May 25, 1884, 9.

"Some Questions of Art. Pictures by Mr. William M. Chase." *Sun,* March 1, 1891, 14.

Stewart, Ian R. "Politics and the Park: The Fight for Central Park." *New-York Historical Society Quarterly* 61 (1977), 124–55.

T. "A Boston Estimate of a New York Painter." *Art Interchange* 27, no. 12 (December 4, 1886), 4.

"U.S. Naval Lyceum." *Naval Magazine* 1 (January 1836), 8–9.

Van Rensselaer, M. G. "American Painters in Pastel." *Century Magazine* 29 (December 1884), 207–8.

——. "The Recent New York Loan Exhibition." *American Architect and Building News* 15, no. 421 (January 19, 1884), 29.

——. "William Merritt Chase. First Article." *American Art Review* (January 1881), 91–98.

Weber, Bruce. "Robert Frederick Blum (1857–1903) and His Milieu." Ph.D. dissertation, City University of New York, 1985.

Weinberg, H. Barbara. *The Lure of Paris: Nineteenth-Century American Painters and Their French Teachers.* New York, London, Paris: Abbeville Press Publishers, 1991.

——. "Thomas B. Clarke: Foremost Patron of American Art from 1872 to 1899." *American Art Journal* (May 1976), 52–83.

Weinberg, H. Barbara, Doreen Bolger, and David Park Curry. *American Impressionism and Realism: The Painting of Modern Life, 1885–1915.* Exh. cat. New York: The Metropolitan Museum of Art, 1994.

"The William Merritt Chase Exhibition." *Art Amateur* 16 (April 1887), 100.

Williams, Linda, ed. *Viewing Positions: Ways of Seeing Film.* New Brunswick, N.J.: Rutgers University Press, 1995.

EXHIBITION HISTORY

This exhibition history of Chase's American urban and suburban landscapes spans a period from late 1886, when the artist first showed these subjects, through the World's Columbian Exposition in 1893. The latter event establishes a logical terminus date in that it was the last international exhibition in which Chase displayed a park subject as a representative example of his current work. Titles and ownership are listed as they appeared in exhibition records. For tentative matches between original titles and known works, see the text and captions of this volume. It is hoped that future research will fill lacunae in this list (such as the particulars of an exhibition at Reichard Gallery, New York, mentioned in a review of the 1890 Union League Club exhibition; *Sun*, November 16, 1890, 6).

A number of works cited here remain unidentified, unlocated, and/or unpublished (for example, *Afternoon in the Garden* and *A Summer Afternoon in My Garden*, from the 1886 Boston exhibition). In addition, twentieth-century auction catalogues sometimes provide tantalizing descriptions of works by Chase, suggesting the existence of even more paintings (see, for instance, *In Prospect Park*, in *Illustrated Catalogue of the Private Collection of Valuable Modern Paintings belonging to Mr. George N. Tyner*, American Art Galleries, New York, February 1, 1901, lot 13). The fact that no exhibition record has been discovered for *The Lake for Miniature Yachts* (Pl. 39) for the period under examination suggests that some works may have been purchased directly from the artist without having been displayed publicly prior to sale. This problem is compounded by modern titles, which were probably attached to paintings long after they left the artist's studio, as is probably the case for *The East River* (Pl. 25), for which no 1886–90 reference is known but which might be *On the River*, listed as no. 87 at Moore's auction house in 1887. Finally, because Chase seems to have occasionally shown works under titles that varied slightly from exhibition to exhibition and, in other cases, used similar titles for different works (for instance, *Hills Back of Brooklyn* and *Back of Brooklyn*, both of which are unlocated and were shown at the Chicago Inter-State Industrial Exhibition), some of these puzzles may never be completely solved. As it stands, however, this history indicates the patterns of Chase's exhibition of this portion of his oeuvre and documents the order and intensity of his treatment of distinct geographies of Brooklyn and New York City in his art.

1886: Boston Art Club, November 13–December 4 (*Exhibition of Pictures, Studies and Sketches by Mr. William Merritt Chase, of New York City under the Auspices of the American Art Association at the Gallery of the Boston Art Club*)

Afternoon in the Garden, no. 17
On the Lake, Prospect Park, no. 35
Brooklyn Docks, no. 36
Over the Hills and Far Away, no. 39
The Hills—Back of Brooklyn, no. 40
A Bit of Green, no. 41
Sandunes, Coney Island, no. 42
At West Brighton, Coney Island, no. 43
In the Park, no. 45
In Prospect Park, no. 46
A Summer Afternoon in My Garden, no. 47
A Bit off Fort Hamilton, no. 60
By the Side of the Lake, no. 63
Pulling for Shore, no. 64
Washing Day—A Backyard Reminiscence of Brooklyn, no. 65
A Long Stretch of Country, no. 66
A Country Road, no. 72
Gray Day on the Bay, no. 75
Prospect Park, no. 79 (owned by T. B. Clarke)
The Pet Canary, no. 95
Near Brighton, Coney Island, no. 97
A Bit on Long Island, no. 98
The Old Pier, Brooklyn, no. 99
Poplar Lake, no. 100
Old Boats, Long Island, no. 101
Afternoon Tea in the Garden, no. 102D
Study of a Young Girl against Grass, no. 110 (pastel)
In the Garden, no. 114 (pastel)

1887: Moore's Auction Galleries, New York, March 2 and 3 (*Paintings by William Merritt Chase*)

Sunlight and Shadow, no. 7 (pastel)
In the Garden, no. 16 (pastel)
The Pet Canary, no. 22
Near Brighton—Coney Island, no. 23

Old Boats—Long Island, no. 24
A Gray Day on the Bay, no. 26
A Bit Off Fort Hamilton, no. 31
Over the Hills and Far Away, no. 37
A Bit of Green, no. 48
In Prospect Park, no. 49
A Summer Afternoon in My Garden, no. 50
Pulling for Shore, no. 57
By the Side of the Lake, no. 58
Afternoon Tea in the Garden, no. 64
A Long Stretch of Country, no. 68
Washing Day—A Backyard Reminiscence of Brooklyn, no. 69
In the Park, no. 70
Sand Dunes—Coney Island, no. 71
Brooklyn Docks, no. 75
On the River, no. 82
Poplar Lake, no. 84
A Bit on Long Island, no. 90

1887: Society of American Artists, New York (Annual Spring Exhibition)
Landscape, no. 29
Prospect Park, Brooklyn, no. 32 (owned by T. B. Clarke)

1887: American Art Association, New York (*American Paintings and Sculpture*, Fall Exhibition)
In Navy Yard Park, no. 62
The Old Road, Flatbush, no. 63
Stone Yard, Brooklyn Navy Yard, no. 64
A Squatter's Hut, Flatbush, no. 65 (pastel)
Sunlight and Shadow, Prospect Park, no. 66 (pastel)

1887: Eden Musée, New York, December (Society for the Promotion of Art, Inaugural Exhibition)
In Tompkins Park (for sale)
The Church of the Puritans (for sale)
Little White House in Brooklyn
View from Brooklyn Navy Yard

1888: Society of American Artists, New York (Annual Exhibition)
View from Brooklyn Navy Yard, no. 18
In Tompkins Square, Brooklyn, no. 19
The Croquet Lawn, Prospect Park, no. 20
A Winding Road, no. 21

1888: American Watercolor Society, New York (Annual Exhibition)
In Washington Park, Brooklyn, N.Y., no. 303

1888: National Academy of Design, New York (Annual Exhibition)
Rotten Row, Brooklyn Navy Yard, no. 112 ($200)
Summer-time, no. 298 ($300)
Peace-Scene, Fort Hamilton, no. 350 ($300)

1888: New York, May 7–26 (*Second Exhibition of the Painters in Pastel*)
Shelter House, Prospect Park, no. 37
Sunlight and Shadow, no. 39
A Squatter's Hut, Flatbush, no. 40 (loaned by T. A. Howell)

1888: American Art Galleries, New York (*Fourth Prize Fund Exhibition*)
A Little City Park

1888: The Art Institute of Chicago, May 30–June 30 (*Annual Exhibition of American Oil Paintings*)
Summer Time, no. 243

1889: American Art Galleries, New York (*Fifth Prize Fund Exhibition*)
Afternoon in the Park, no. 65

1889: Society of American Artists, New York (Annual Exhibition)
A Misty Day—Gowanus Bay, no. 32
Brooklyn Docks, no. 33
Early Morning in the Park, no. 35

1889: Society of Painters in Pastel, New York
Gravesend Bay
Afternoon by the Sea
Sunlight and Shadow

1889: Exposition Universelle, Paris
A City Park, no. 49
Peace (Peace-Fort Hamilton), no. 50
Gowanus Bay, no. 53

1889: Chicago Inter-State Industrial Exhibition, September 4–October 19
On the Lake, Prospect Park, no. 68
A Gray Day, no. 70
Summer, no. 74 (owned by Charles L. Hutchinson)
The Terrace, Central Park, New York, no. 76
Early Morning in the Park, no. 77
Back of Brooklyn, no. 82
The Common, Central Park, New York, no. 83
Sunlight and Shadow, Prospect Park, no. 87 (owned by Charles Norman Fay)
Brighton Beach, Long Island, no. 88
Scene in Brooklyn Navy Yard, no. 101
Repair Docks, Gowanus Bay, no. 102
Long Island Landscape, no. 103
Good Friends (pastel), no. 104
Brooklyn Docks, no. 106
Cob Dock, Brooklyn Navy Yard, no. 107
Docks, no. 108
"Rotten Row," Brooklyn Navy Yard, no. 118
By the Sea, no. 119
Boat House, no. 121 (owned by Potter Palmer)
A City Park, no. 125
Misty Day, Gowanus Bay, no. 130
Wash Day, no. 131
In the Park, no. 133 (owned by Mrs. C. H. Wilmerding)
Hills Back of Brooklyn, no. 135
In Prospect Park (pastel), no. 137

1890: American Art Galleries, American Art Association, New York, April 7 (*Exhibition and Sale of Paintings by J. W. Champney, W. M. Chase, C. M. Dewey, C. H. Eaton, F. K. M. Rehn, F. D. Millet, Robert Minor, H. R. Poore, Frederic Remington, Carleton Wiggins*)
Good Friends, no. 187
Early Morning in the Park, no. 189
Garden-Landscape, no. 193
A Bit of Long Island, no. 203
On the Beach, Coney Island, no. 205

Docks, no. 206

Brooklyn Docks, no. 208

Scene in Brooklyn Navy Yard, no. 210

A City Park, no. 213

Back of Brooklyn, no. 216

City Park, no. 217

Sailboat at Anchor, no. 219

Rotten Row, Brooklyn Navy Yard, no. 223

By the Seashore, no. 224

Long Island Landscape, no. 225

In Prospect Park, no. 227 (Thomas B. Clarke)

Over the Hills, no. 229 (John Dallet)

Afternoon in the Park, no. 231 (F. H. Howell)

1890: New York, May 1–24 (*Fourth Exhibition of the Painters in Pastel*)

Gravesend Bay, no. 4

Afternoon by the Sea, no. 6

Sunlight and Shadow, no. 7

1890: Society of American Artists, New York (Annual Exhibition)

At Kathleen Villa, no. 37

A Stormy Day at Bath Beach, Long Island, no. 38

The Beach, no. 39

Long Island Landscape, no. 40

An Hour with Aldrich, no. 41

1890: The Art Institute of Chicago, June 9–July 30 (*Annual Exhibition of American Oil Paintings*)

At Kathleen Villa, no. 31

Sail Boat at Anchor, no. 32

On the Beach, no. 33

Long Island Landscape, no. 34

An Hour with Aldrich, no. 37

1890: Union League Club, New York, November 13–15 (*Collection of Old Master, Modern Paintings and Antique Silver*)

An Idle Hour in the Park—Central Park, no. 49

Lilliputian Boat Lake—Central Park, no. 50

Happy Hours for the Little Ones, no. 51

Threatening Weather in the Park, no. 52

By the Lake—Central Park, no. 53

Long Island Lake, no. 54

Springtime in the Park (Reichard & Co.), no. 55

1891: Ortgies & Co., New York, March 6 (*Paintings by William Merritt Chase*)

The Lower Bay (pastel), no. 1

Docks, no. 2

Cobb Dock, Brooklyn Navy Yard, no. 3

Repair Docks, Gowanus Bay, no. 4

Gowanus Bay, no. 5

Brooklyn Docks, no. 7

Wash Day, no. 11

Hills, Back of Brooklyn, no. 13

On the Beach, Coney Island, no. 16

A Bit of Long Island, no. 18

Garden-Landscape, no. 23

Landscape, no. 24

By the Seashore, no. 26

Scene in Brooklyn Navy Yard, no. 27

Stone Yard, no. 29

A City Park, no. 31

An Hour with Aldrich, no. 34

Sailboats at Anchor, no. 36

Back of Brooklyn, no. 38

City Park, no. 39

Rotten Row, Brooklyn Navy Yard, no. 43

Long Island Landscape, no. 45

In Brooklyn Navy Yard, no. 46

Flower Beds, Central Park, no. 49

Gray Day in the Park, no. 52

Landscape, Long Island, no. 55

Commons, Central Park, no. 56

Misty Day, Gowanus Bay, no. 59

Landscape, no. 63

In the Park, no. 65

1891: Society of American Artists, New York (Annual Exhibition)

On the Lake—Central Park, no. 38 (Potter Palmer)

A Visit to the Garden, no. 39 (George S. Baxter)

An Early Stroll in the Park, no. 40 (Rose & Co.)

A Gray Day in the Park, no. 41

Long Island Landscape, no. 42

1892: Society of American Artists, December 5–25 (Retrospective Exhibition)

Lilliputian Boat Lake, Central Park, no. 49

1893: World's Columbian Exposition, Chicago

Lilliputian Boats in the Park, no. 725

INDEX

Page numbers in italics refer to illustrations. Parentheses following page numbers denote references to endnotes.

Adams, Charlotte, 168
Addison, Joseph, 139
After Sunset (Dewing), 123
alla prima (technique), 23, 42
allegorical landscape, 115
American Art Association, 134
 (n 121), 177 (n 7), 185
 exhibition-sale (1890), 109, 171,
 179 (n 49)
American Art Galleries (New York),
 39–42, 48 (n 25), 59, 169, 178
 (n 31), 185–86
American Museum of Natural History
 (Manhattan), 134 (n 121), 155
American Watercolor Society, 23, 165,
 167, 177 (n 8), 185
Angel of the Waters (Stebbins), 126,
 155–56
*Art and Nature at the West End of
 Coney Island* (Barnard), 104; *104*
art criticism, 15, 27–29, 31, 51, 169
 and call for national art, 18, 21, 49
 (n 38), 108, 168
 on morality issues, 46, 133 (n 55),
 151, 161 (n 54)
 on Munich style, 24–27, 32, 33,
 170
 on painting size, 14, 15, 39
 See also specific critics' names; works
art-for-art's-sake aesthetic style, 26
Art Institute of Chicago, 59, 178 (n 36),
 179 (n 48), 185, 186
Art Students League (New York), 22,
 37, 171, 179 (n 48)
At the Foot of Hicks Street (Falconer),
 91, 92; *92*

avant-garde practice, 13, 18, 39, 43,
 44, 71, 75, 82, 109
 use of perspective, in, 91, 174–75
Avery, Samuel P., 22, 23, 34 (n 4)

Barbizon style, 29, 35 (n 33)
Barnard, F., 104; *104*
Bartholdi, Frédéric Auguste, 29
Bastien-Lepage, Jules, 66, 132 (n 51)
Bath Beach (Long Island), 94, 105,
 133 (n 95); *105*
Baudelaire, Charles, 139, 159–60 (n 13)
Beckwith, J. Carroll, 29, 33, 45, 66, 125
Bellows, Albert Fitch, 116
Benjamin, Samuel (S. G. W. Benjamin),
 24, 26
Benjamin, Walter, 139
Berlin Academy, 30
Bethesda Fountain (Central Park),
 126, 155; *124, 129, 157, 158*
Bethesda Terrace (Central Park), 135
 (n 137), 155
Bienenstock, Jennifer, 25–26, 35 (n 48)
Birch, Thomas, 86
Blackmar, Elizabeth, 112, 117, 155–56
Blum, Robert, 31, 45, 48 (n 4), 125, 169
Bly, Nellie, 144, 160 (n 36), 167
Boggs, Frank Myers, 14
Boldini, Giovanni, 125
Boston Art Club exhibition (1886),
 38, 46, 48 (n 5), 71, 109, 163, 184
Boudin, Louis-Eugène, 41, 42
Bouguereau, Adolphe-William, 30, 35
 (n 40)
bourgeois gentility, portrayal of, 59
 See also gentility, in paintings
Brand, Dana, 140, 143
Brandt, Josef, 27
Breaking Home Ties (Hovenden), 138,
 159 (n 7); *138*

Breton, Jules, 122
Bridgman, Frederick, 169
Brighton Beach, 44, 96, 101
Brooklyn Art Association (BAA), 53,
 179 (n 48)
 as exhibition venue, 53, 131 (n 16),
 165
Brooklyn Art Club, 63, 64
Brooklyn Navy Yard, 52, 78–83, 133
 (n 78); *83*
 and Naval Lyceum, 81–82, 146,
 160 (n 45); *82*
Brooklyn Navy Yard, The (Walker), 86;
 86
Brooklyn Navy Yard paintings, 78–93,
 126
 art criticism of, 51
 misidentification of, 78
 as portraying gentility, 17, 82–83
 and subject choice, 17, 87–89
 See also specific paintings
Brooklyn (New York), 51–53, 55, 61,
 83–86, 111; *55*
 as subject choice, 7, 44, 51, 55–56
Brooklyn park paintings, 13, 19 (n 13),
 123, 126
 See also specific parks; works
Brown, Anna Wood, 132 (n 48)
Brown, Arthur, 64–66, 132 (n 48)
Brown, George Loring, 114, 115; *114*
Brush, George De Forest, 61
Bryant, William Cullen, 111
Bulfinch, Charles, 82
Bunker, Dennis Miller, 171
Burns, Sarah, 138–39

Cabanel, Alexandre, 30, 35 (n 40)
Caillebotte, Gustave, 18, 41, 75, 139,
 174
Carr, Samuel S., 63–64, 64

1876 Centennial Exposition
 (Philadelphia), 23, 81, 104
Central Park (Brown), 114–16; *114*
Central Park (Harvey), 116; *116*
Central Park (Hassam), 127–28; *128*
Central Park Lake, 112–15
Central Park (Manhattan), 111–36, 154
 administration transfer (1870), 117,
 154
 carriage rides, in, 115, 153, 161 (n 61)
 crime, in, 148, 150, 152, 153–54;
 148 and debate over art, in, 155
 democratization of park use, 117,
 134 (n 119), 152–55
 design of, 63, 112, 115, 116, 134
 (n 112), 146, 151, 153
 in *Destruction of Gotham*, 141–42
 early paintings of, 112–18
 and elitism, 117–18, 134 (n 121),
 153, 161 (n 61); *118*
 establishment of, 111–12
 health concerns in, 154–56
 improvements to (mid-1880s), 155–56
 map of, 111; *111*
 park regulations, 153–54; *153*
 photographs of, 118, 121; *118, 121,
 127*
 public funds limited for, 154–55
 and real estate development,
 117–18, 134 (n 121), 155; *118*
 topography of, 63, 132 (n 43)
Central Park paintings, 118–36, 173
 versus other park paintings, 123,
 126
 and subject choice, 17, 123, 126–27
 and views, in, 126, 128
Chambers, Thomas, 86
Chase, Alice Dieudonnée (Cosy)
 (daughter), 56, 60, 78
 birth of, 37, 48 (n 3), 60, 83

Chase, David Hester (father), 55, 81, 131 (n 22)

Chase, Hattie (sister), 55
　as model, 39, 56, 59, 66, 94, 150, 163

Chase, Sarah Swaim (mother), 55, 150, 154

Chase, William Merritt
　aligned with middle-class virtues, 151
　appearance, 140; 140
　birth of, 21
　children of, 44, 171, 179 (n 59). See also Chase, Alice Dieudonnée (Cosy)
　as collector, 29, 133 (n 92), 171
　European travels of, 15, 29, 37, 55–56
　exhibition history of, 184–86
　financial difficulties of, 38, 171
　"as human camera" (Cox), 137–39
　on feeling, in painting, 137–38
　on Impressionism, 48 (n 27)
　influence of artists, on, 21–22, 30, 46, 170. See also specific artists
　marriage of, 37–38, 48 (n 2), 60, 78, 133 (n 95)
　Munich School influence, on, 19 (n 6), 19 (n 13), 23, 25, 27, 30, 34 (n 22), 168
　parents of, 44, 53, 55–56. See also Chase, David Hester; Chase, Sarah Swaim
　professional affiliations of, 23. See also NAD
　and professional anxieties (1886), 38, 109
　residences of, 21, 55, 56, 60, 94, 131 (n 21), 133 (n 95)
　and self-promotion, 23–25, 27, 29–30, 38, 61, 89, 165
　at Tenth Street Studio Building (Manhattan), 22, 27, 39, 48 (n 2)
　training, of, 21–22
　in U. S. Navy's apprentice program, 81
　works by:
　Afternoon by the Sea, 94–96, 104, 185, 186; 95
　Afternoon in the Garden, 39, 48 (n 10), 184
　Afternoon in the Park, 78, 146–50, 160 (n 45), 160 (n 47), 179 (n 49), 185, 186; 147
　Afternoon Tea in the Garden, 39, 48 (n 10), 132 (n 29), 184, 185
　　See also Open Air Breakfast, The

Alice, 173
Artist's Studio, The. See In the Studio
At Kathleen Villa. See Kathleen Cottage, Bath Beach
At the Window, 150, 151, 160 (n 49); 151
At West Brighton, Coney Island, 39, 48 (n 10), 184
Back of Brooklyn, 109, 184, 185, 186
Bath Beach: A Sketch, 104, 106, 108; 106
Bit off Fort Hamilton, A, 39, 48 (n 10), 184, 185
Bit of Green, A, 109, 184, 185
Bit of Long Island, A, 13, 19 (n 4), 185, 186
Bit of Sunlight, A, 78, 79, 82; 79
Bit of the Terrace, A, 123–26, 125, 156, 177; 124
Bit on Long Island, A, 39, 48 (n 10), 109, 184, 185
Boat House, Prospect Park, 69, 71, 170, 185; 69
Boat House (Prospect Park), 170, 185
Boy Smoking—The Apprentice, 23, 24; 24
Brooklyn Docks, 39, 48 (n 10), 172, 184, 185, 186
Brooklyn Landscape, 109, 110; 110
Brooklyn Navy Yard, 78, 80, 82, 172, 185; 80
By the Side of the Lake, 39, 48 (n 10), 184, 185
Child on a Garden Walk, 83, 85; 85
　detail of, 4; 4
City Park, A, 12, 78, 119, 150; 12
　exhibition history of, 13, 185, 186
　views in, 72, 75
Coastal View, 103, 104; 103
Cob Dock, 172
Common, Central Park, The, 128, 130, 175, 177, 185; 130
Coquette, The, 165, 169
Courtyard of a Dutch Orphan Asylum, 32, 61, 132 (n 26); 32
Croquet Lawn, Prospect Park, The. See Prospect Park (Pl. 17)
Dowager, The, 22–23
Early Stroll in the Park, An, 126, 156, 157, 173, 186; 157
East River, The, 87, 88; 88
Evening at the Shinnecock Hills, Long Island, 173, 179 (n 59)
Fisher-Folk, 170
Flower Beds, Central Park, 172, 186

Friendly Visit, 134 (n 97)
Garden of the Orphanage. See Courtyard of a Dutch Orphan Asylum
Girl in Japanese Costume, 165; 165
Good Friends, 66–71, 185; 67
Gowanus Bay, 16, 19 (n 13), 91; 16
　exhibition history of, 13, 185, 186
Grain Field, Shinnecock Hills, 173
Gray Day, A. See Seashore
Gray Day in the Park, A, 127–29, 135 (n 138), 173, 186; 129
Gray Day on the Bay, A, 39, 48 (n 10), 184, 185
Hackensack River, The, 27–28, 32, 185, 186; 28
Harbor Scene, Brooklyn Docks, 89, 90; 90
Hasty Sketch of a Young Girl, 39, 48 (n 10)
Hattie, 163, 164; 164
Hide and Seek, 53–55, 167, 174–75; 53
Hills—Back of Brooklyn, The, 39, 48 (n 10), 109, 184, 185
Hour with Aldrich, An, 132 (n 53), 171, 186
I Am Going to See Grandma, 56, 57, 132 (n 36); 57
Idle Hour in the Park—Central Park, An. See Park Bench
In Brooklyn Navy Yard, 78, 84, 156, 186; 84
In Navy Yard Park. See In Brooklyn Navy Yard
In Prospect Park, 39, 48 (n 10), 179 (n 49), 184, 185, 186
Interior of a Studio, 25
In the Garden, 39, 48 (n 10), 184
In the Park, 39, 48 (n 10), 170, 184, 185, 186
In the Park—A By-Path, 123, 126, 142, 173, 175, 179 (n 57); 142
In the Studio, 20, 27, 53, 174; 20
　art criticism on, 27, 28
In Tompkins Park. See Park, The
In Tompkins Square, Brooklyn, 72, 167, 185
In Venice, 25; 25
Kathleen Cottage, Bath Beach, 104–8, 134 (n 105), 171, 178 (n 41), 186; 108
"Keying Up"—The Court Jester, 23, 27
Lady in Black, 13, 15, 19 (n 13); 15
Lake for Miniature Yachts, The, 120,

121, 123, 126, 128, 135 (n 141), 175, 184; 120
Landscape, near Coney Island, 101–4; 102
Landscape. See Hackensack River, The
Lilliputian Boat Lake, Central Park, 119–22, 134–35 (n 128), 186; 121, 122
Little City Park, Brooklyn, A, 78
Little White House in Brooklyn, 167, 185
Long Island Landscape, 173, 185, 186
Meditation, 38, 60
Misty Day, Gowanus Bay, 186
　See also Gowanus Bay
Moorish Warrior, The, 22, 23, 34 (n 5); 23
Mother and Child, 167
Mrs. B., 169
Mrs. Chase in Prospect Park, 65, 66; 65; See also On the Lake, Prospect Park
Mrs. G., 169
My Studio. See In the Studio
Near Bay Ridge, 107, 108; 107
Near Brighton, Coney Island, 39, 48 (n 10), 184
Nursery, The, 123, 126, 143–46, 150, 172–73, 186; 145
Old Boats—Long Island, 39, 48 (n 10), 184, 185
Old Garden, An, 53
Old Pier, Brooklyn, The, 39, 48 (n 10), 184
On the Lake, Central Park, 126, 156, 158, 172, 186; 158
On the Lake, Prospect Park, 39, 48 (n 10), 185; See also Mrs. Chase in Prospect Park
Open Air Breakfast, The, 56–61, 132 (n 26), 132 (n 29), 150; 58
Outskirts of Madrid, 42
Over the Hills and Far Away, 109, 184, 185
Park, A, 78
Park, The, 72–75, 166–67, 185; 73
Park Bench, 126, 132 (n 53), 136, 142, 159, 175, 186; 136
Park in Brooklyn, 74–75, 77, 150; 77
Peace, Fort Hamilton, 13, 14, 108, 169, 185; 14
Pet Canary, The, 39, 48 (n 10), 56, 61, 184; 56
Portrait of Dora Wheeler, 32
Portrait of Mr. Cheeks, 167

Prospect Park, Brooklyn, 70, 71; *70*

Prospect Park in Brooklyn. See Park in Brooklyn; Tompkins Park, Brooklyn

Prospect Park (Pl. 5), 36, 39, 43, 48 (n 10), 55, 156, 163–65, 184; *36*

Prospect Park (Pl. 6), 39, 40, 48 (n 10), 156; *40*

Prospect Park (Pl. 17), 70, 71, 128, 167, 175, 185; *70*

Pulling for Shore, 39, 48 (n 10), 184, 185

Pure, 169–70, 178 (n 34)

Putting Out Linen, 131 (n 18)

Ready for the Ride, 22, 23, 27

Repair Docks, Gowanus Pier, 91, 93; *93*

Riverside Landscape, 26–27

Rotten Row, Brooklyn. See Woman on a Dock

Sailboat at Anchor, 96, 98, 186; *98*

Sandunes—Coney Island, 39, 48 (n 10), 184, 185

Seascape, 96, 100; *100*

Seashore, 96, 97, 185; *97*

Shelter House, Prospect Park, 170, 185

Spanish Bric-a-Brac Shop, 32

Squatter's Hut, Flatbush, A, 134 (n 121), 185

Still-Life, 33

Stoneyard, The, 13, 19 (n 4), 165

Stormy Day, Bath Beach, A, 96, 99; *99*

Studio, In the, 20; *20*

Study of a Child, 32

Study of a Glass Ball, 56, 131 (n 23)

Summer, 170, 185

Summer Afternoon in My Garden, A, 39, 48 (n 10), 184, 185

Summer—Scene in the Park, 74, 133 (n 60), 133 (n 61), 167–69, 185; *74*

Sunlight and Shadow, 61, 170, 184, 185, 186

Sunlight and Shadow, Prospect Park, 170, 185

Sunny Day at Shinnecock Bay, A, 162, 177; *162*

Terrace, Prospect Park, 50, 53; *50*

Terrace at the Mall, Central Park, 126, 129; *129*

Tompkins Park, Brooklyn, 74, 76; *76*

View from Brooklyn Navy Yard, 167, 185

View of Brooklyn Navy Yard, 89, 91; *91*

Visit to the Garden, A. See Nursery, The

Wash Day—A Backyard Reminiscence of Brooklyn, 39, 53–56, 131 (n 18); *54*

 exhibition history of, 48 (n 10), 172, 184, 185

Winding Road, A, 167–68, 185

Wind Swept Sands, Shinnecock, Long Island, 176, 177; *176*

Woman on a Dock, 46, 47, 81, 156, 169, 185, 186; *47*

Women under Trellis, 149, 150; *149*

Young Orphan, The, 32

Chase School of Art. *See* New York School of Art

Chelminsky, Jan, 118, 134 (n 120)

1889 Chicago Inter-State Industrial Exposition, 170–71, 184, 185

Child, Theodore, 41, 163

Church, Frederick S., 37, 48 (n 4), 154

Church of the Puritans (Brooklyn), photograph of, 74, 133 (n 61); *74*

cityscapes, 44, 89–91, 115, 123

 See also urban landscape paintings

civilized urban landscape, 13, 17, 42, 156, 178 (n 36)

Clarke, Thomas B., 39, 163–65, 169, 177 (n 6), 177 (n 34)

clothing

 etiquette, on, 144–46, 156

 and rowing attire, 156, 161 (n 78)

 symbolism of white, for, 156, 161 (n 76)

Cob Dock (Navy Yard), 89

Cochrane, Elizabeth. *See* Bly, Nellie

Coffin, William A., 15, 48 (n 25)

collectors, 21, 22, 59, 96, 101, 155, 170, 173, 178 (n 36)

 and Clarke, 39, 163–65, 169, 177 (n 6), 177 (n 34)

 and Davis, 29, 35 (n 36)

 and Hecker, 104, 171, 178 (n 41)

 and Howell, 52–53, 151 (n 15)

 and 1883 Pedestal Fund Loan Exhibition, 29, 30

color, use of, 43, 125, 156, 161 (n 76), 174

"composite" image, 21, 33, 66, 96, 115, 119–21, 123

 defined, 21, 34 (n 1)

 and perspective, 71, 75, 125, 174

Concert Grove (Prospect Park), 43, 68, 71; *68*

Coney Island (Brooklyn), 64, 96–101, 104; *104*

 See also specific works

Conservatory Water (Central Park), 121, 127; *121*

content, in painting, 61, 89, 137–38

 and biographical layering, 56, 59

 and historicized present, 18, 30–31, 44, 89

Cook, Clarence, 116, 119–21; *121*

Cooper, James Fenimore, 81

Corbin, Austin, 96, 101

Corot, Jean-Baptiste-Camille, 29

Cottier, Daniel, 29, 35 (n 33), 35 (n 41)

Cotton, Maria Benedict, 13

Courbet, Gustave, 41, 59, 167

 as realist, 29, 34 (n 22), 41, 139

Couture, Thomas, 43

Cox, Kenyon, 137

Creeft, José de, 119

crime, 150

 in Central Park, 148, 150, 152, 153–154; *148*

 in Prospect Park, 160 (n 52)

Cropsey, Jasper Francis, 115

Culverhouse, Johann Mongles 115–16; *115*

Currier, Frank, 26, 174

dandyism, 139, 140

Daumier, Honoré, 139

Davis, Alexander Jackson, 62, 132 (n 39)

Davis, Erwin, 29, 35 (n 36)

Degas, Edgar, 18, 42, 45, 53, 66, 75, 139, 174

 works by, 29, 42, 174, 175; *175*

De Kay, Charles, 123, 143, 173

de Nittis, Giuseppe, 19 (n 13), 30, 31, 45, 75

"Depressionists," 141

Destruction of Gotham, 141–43, 150, 160 (n 29), 160 (n 30)

Dewing, Maria, 168

Dewing, Thomas Wilmer, 123, 168, 178 (n 41)

dock scenes, 7, 25, 51, 52, 86–87, 89–91, 96, 139, 170

 art criticism on, 15, 46, 51, 169, 170

 localized views in, 71, 89, 126–27

 as subject choice, 87–89, 96

 transformed into high art, 17–18

 See also specific themes; works

Donoho, Roger, 33

Downing, Andrew Jackson, 111–12, 132 (n 39), 134 (n 112)

Dredging in New York Harbor (Twachtman), 87, 89; *89*

Drive in the Central Park, The (Homer), 112, 113; *113*

Duez, Ange, 133–34 (n 96)

Durand, Asher B., 82, 115

Durand-Ruel, Paul, 35 (n 36), 39, 42, 48 (n 14)

 See also American Art Galleries

Duret, Théodore, 41, 48 (n 16)

Eakins, Thomas, 26

eclecticism, in work, 14, 156

Eden Musée (New York), 72, 165–67, 178 (n 15), 185

elitism, and Central Park, 117–18; 134 (n 121), 153, 161 (n 61); *118*

etiquette, 150, 151, 160 (n 43)

 and attire, 144–46, 156, 161 (n 78)

exhibition-sales (Chase), 171–72

 See also Moore's Art Galleries

exhibitions (Chase), 165

 chronology of, 184–86

 See also specific venues

expression, models and, 143, 150, 151

 See also gaze

Falconer, John Mackie, 91, 92; *92*

feuilletons, 139

Fifth Avenue in Winter (Hassam), 123; *123*

figure, use of, 41, 61, 121, 122

figure painting, 13–14, 17, 39

flâneur genre, 139–41, 151, 167, 168

Flower, Seller, The (Weir), 49 (n 35)

 See also In the Park (Weir)

Fort Hamilton (Bay Ridge), 94, 104, 108

Fort Lafayette Looking East towards Shore Road, Bay Ridge, Brooklyn (Sykes), 108, 109; *109*

Fort Lewis (Bay Ridge), 108

Freer, Charles Lang, 60, 171, 178 (n 41)

gaze, 59, 143, 146, 150

 artist-viewer's presence acknowledged by, 59, 119–21

 modernity expressed by, 143, 146, 151

 and women, as "object of the gaze," 150–51, 160–61 (n 53)

 See also expression, models and genre, 59, 116, 169

 of figure, in landscape, 94, 122, 128–29

gentility, in paintings, 59, 61, 82–83, 146, 150, 151, 156, 179 (n 47)

Gerdts, William H., 18, 48 (n 26), 135 (n 141), 179 (n 57)

Gérôme, Jean-Léon, 30

Gerson, Alice (wife), 37, 38, 48 (n 2), 55, 133 (n 95), 146–50
 as model, 37, 38, 56, 59, 66, 146, 150

Gerson, Julius (father-in-law), 37, 48 (n 2), 48 (n 4), 141

Gerson, Mary Virginia Marks (mother-in-law), 48 (n 2), 60

Gerson, Minnie (sister-in-law), 37, 48 (n 2), 56, 154

Gerson, Virginia (sister-in-law), 37, 56, 59, 60, 154

Gill, Rosalie, 15, 132 (n 35)

"glare aesthetic," 42–43, 48 (n 26)

Gowanus Bay, 83, 87–89

Gravesend Bay (Long Island), 94, 159

Gray, Asa, 112

Greeley, Horace, 112

Greenough, Horatio, 82

Greensward Plan (Central Park), 63, 112, 116, 153

Grosvenor Gallery (London), 26–27

Hague School, 29, 34 (n 28), 35 (n 33), 89–91, 133 (n 92)

Hahn, William, 116–17; 117

Halsey, John C., 82

Haltunnen, Karen, 151

Hamilton, Alexander, 108

harbor scenes. See dock scenes

Harvey, George, 63, 116; 63, 116

Hassam, Childe, 123, 128, 135 (n 139), 171
 works by, 14, 17, 45, 123, 127–28, 135 (n 39), 171; 17, 123, 128

Havemeyer, H. O., 96

Hecker, Frank G., 104, 171, 178 (n 41)

Henri, Robert, 141

Herbert, Robert L., 139

high art, subjects transformed into, 7, 17–18, 139, 141

historicized present, use of, 18, 30–31, 44, 46, 89, 115

Holiday in the Central Park (Rogers), 126; 126

Homer, Winslow, 112, 113, 116, 122, 139, 169; 113

hortus conclusus, 59–61

Hovenden, Thomas, 138, 159 (n 7); 138

Howell, Thomas A., 52–53, 131 (n 15)

Hudson River School, 112, 115

Hunt, William Morris, 38, 43, 133 (n 93), 135 (n 141)

Huntington, Daniel, 46, 169

iconography
 figure painting, as, 13–14
 of gentility, 42, 156
 of men, 150
 of obfuscation, 71
 of place, 39
 of social fluidity, 17
 Victorian, 56, 61
 of white, 156, 161 (n 76)
 of women, 42, 56, 61, 156
 See also leitmotifs; motifs

immigrants, effect of, 152, 153

Impressionism, 29, 31, 41–43, 121, 139
 defined (19th century), 35 (n 43), 121
 1886 French Impressionist exhibition, New York, 39–43. See also Durand-Ruel, Paul; American Art Galleries

impressionist naturalism, 139

Impressionist style (Chase), 9, 13, 18, 19 (n 6), 19 (n 13), 31, 39, 89, 121
 artists' influence on, 39–43, 51, 168
 linked with modern American life, 18, 91, 108, 168

Impression of a Rainy Night, New York (Lungren), 44–45; 45

Inman, John O'Brien, 115–16; 115

Inness, George, 115, 139, 169

Interior (Degas), 174, 175; 175

interior settings, use of, 126, 150

In the Garden. See Luncheon in the Garden (Munkácsy)

In the Park (Weir), 44, 45, 49 (n 35); 45

Inventors' Gate (Central Park), 119

Iron Pier (Coney Island), 96–101; 101

Irving, Washington, 112, 139–40

Ives, A. E., 125, 173

Jackson, Andrew, 82

James, Henry, 23

Johnson, Eastman, 23, 122, 132 (n 34)

Johnston, J. S., 126, 127; 127

Jones, Aneurin, 118–19, 146, 155

Jones, Hugh Bolton, 167

Jones Wood (Manhattan), 111, 134 (n 110)

Juengling, Frederick, 24

Kasson, John F., 143–44

Keene Valley. See Landscape (Wyant)

Keep Off the Grass (cartoon), 153; 153

Kendrick, Kathleen, 166

Knaus, Ludwig, 30

Knight, Daniel Ridgway, 122

Kouwenhoven, John, 52

"l'accidents de la perspective," 174–75

La Farge, John, 24

Lancaster, Clay, 74

landscape
 as art criticism category, 169
 meaning of feminine, in, 156–59
 See also civilized urban landscape

landscape paintings (Chase), 14, 15, 41, 61, 128–29
 art criticism on, 15, 26, 168
 See also specific themes; works

Landscape (Wyant), 14, 17; 17

Laurens, Jules-Joseph-Augustin, 39

Lawn Tennis in Prospect Park (Thulstrup), 68; 68

Lecoq de Boisbaudran, Horace, 174

Leibl, Wilhelm, 41

Leibl-Kreis (Munich), 34 (n 22), 41

leitmotifs, use of, 132 (n 53), 150

Lerolle, Henry, 39

Levine, Lawrence, 153

light, use of, 43, 55, 56, 174
 and "glare aesthetic," 42–43, 48 (n 26)

Long Meadow (Prospect Park), 63, 71

Loveridge, Clinton, 63

Luncheon in the Garden (Munkácsy), 30, 59; 59

Lungren, Fernand, 44–45

Lyceum Building (Navy Yard), 82, 146; 82
 See also Naval Lyceum

Macy, William S., 26

Manet, Edouard, 29, 35 (n 36), 41, 42, 48 (n 17), 66, 71, 139, 143, 174

Manhattan Beach (Coney Island), 96, 101

Manhattan (New York), 7, 151

Manhattan (New York) paintings, 7, 13, 15, 53, 177
 See also specific themes; works

"Man of the Crowd, The" (Poe), 140, 159–60 (n 13), 160 (n 17)

Maris, Jacob Hendricus, 28, 30, 34 (n 28), 91

Martin, Homer Dodge, 163

Mauve, Anton, 28, 29, 34 (n 28), 64, 133 (n 92)

Maynard, George Willoughby, 168

McCabe, James D., Jr., 81, 87, 96, 140

Kendrick, Kathleen, 166

McEntee, Jervis, 112, 114, 115; 114

men, iconography of, 150, 151, 161 (n 56)

Messrs. H. Wunderlich & Co. See Wunderlich & Co.

Metropolitan Museum of Art, 34 (n 1), 155

middle class, urban, 61, 125, 150, 151, 156, 161 (n 54), 161 (n 56)

military theme, in paintings, 108

Miller, Joaquin, 48 (n 4), 166
 and Destruction of Gotham, 141–43, 150, 160 (n 29), 160 (n 30)

Millet, Jean-François, 29, 64, 138

models, 44, 60, 61, 132 (n 5), 146, 150, 151
 See also gaze

modernity, shift toward, in American art, 46

modernity (Chase), 7, 13, 18, 39, 75, 108, 121, 123, 151, 168, 174
 and compositional format, 42, 55, 125
 and expression, as signifier of, 143, 146, 151
 and historicized present, 18, 30–31, 44, 46, 89, 115
 portrayed through gentility, 156, 179 (n 47)

Monet, Claude, 41–42, 42, 43, 48 (n 27), 66, 139

Montenard, Frédéric, 39

Moonlight Skating, Central Park, The Lake and Terrace (Inman), 115–16; 115

Moore, W. P., 31

Moore's Art Galleries, 38, 39, 46, 59, 109, 163, 165, 184–85

morality, in paintings, 31, 33, 133 (n 55), 161 (n 54)

Moran, Thomas, 169

Morisot, Berthe, 42, 48 (n 25)

Morris, William, 35 (n 33)

Mother with Her Children on a Terrace (Stevens), 94; 94

motifs, use of, 128–29, 146, 150, 151
 See also iconography; leitmotifs, use of

Mould, Jacob Wrey, 126, 135 (n 137), 155

Mowbray, H. Siddons, 167

Munich (Germany)
 Leibl-Kreis, in, 34 (n 22), 41
 painting techniques associated with, 18, 21–29, 31, 59
 negative associations attached to Munich school by critics, 33, 39, 46, 168

Munich Royal Academy, 21, 22
Munkácsy, Mihály, 30–31, 39, 59
Museum of Natural History. *See* American Museum of Natural History

NAD (National Academy of Design), 29, 51, 60, 108, 154, 167, 169, 185
 as exhibition venue, 22–23, 108, 118, 138, 165, 170–71, 173, 185
 separatist policy with SAA, 24, 35 (n 48), 51, 169
narrative, in painting, 56, 59, 82, 87, 137–38, 150, 174
 artists' influence on, 30–31, 44, 46
nationalism, 108, 155, 173
 and call for authentic American art, 18, 21, 49 (n 38), 108, 168
naturalism, 32, 33, 35 (n 43), 133 (n 55), 139, 146, 155
Naval Lyceum (Navy Yard), 81–82, 146, 160 (n 45); 82
Near Central Park (Nicholls), 118; *118*
Newmarche, Strafford B., 63
New York School of Art, 179 (n 48)
New York Society for the Promotion of Art, 72, 165–67, 185
Nicholls, Burr H., 118; *118*
Nochlin, Linda, 139
Nocturne in Black and Gold: The Falling Rocket (Whistler), 27, 48 (n 34)
Noonday Promenade: Versailles (Boldini), 125; *125*
Northrop, Benjamin, 46

"object of the gaze," 150–51, 160–61 (n 53)
Ogden, H. A., 101; *101*
Olmsted, Frederick Law, 63, 74, 153
 and Central Park design, 112, 117, 132 (n 43), 153, 155
 See also Olmsted and Vaux
Olmsted and Vaux, 63, 72, 74; *72*
 and Central Park design, 63, 112, 116, 153
 See also Olmsted, Frederick Law; Vaux, Calvert
On the Iron Pier, Coney Island—The Rush for the Last Boat (Ogden), 101; *101*
On the Terrace. See Two Sisters (Renoir)
Ornamental Water (Central Park), 119
Ortgies & Co., 109, 171–73, 179 (n 49), 186

outdoor scenes, 32, 61, 71, 94, 109, 128, 150
 See also specific themes; works

Palmer, Potter, 170, 172, 178 (n 36)
Palmer, Walter, 163
Paris Exposition Universelle (1878), 44, 81
Paris Exposition Universelle (1889), 13–15, 18, 19 (n 7), 19 (n 13), 170, 185
Paris Salon, 66, 133 (n 55), 151, 161 (n 54), 168
park ordinances, 118–119, 143, 146, 153
park paintings, 7, 13, 21, 46, 66, 123, 150
 and anonymous views, 71, 143
 art criticism, on, 15, 169, 170
 cessation of, 171, 173
 paralleled with *Destruction of Gotham*, 142
 realism, in, 139, 142
 and subject choice, 13, 17, 71, 123
 See also specific themes; works
parks. *See* specific parks
Parsons, Orin Sheldon, 123
patronage. *See* collectors
1883 Pedestal Fund Loan Exhibition, 27–30, 35 (n 40), 41, 59, 89–91, 155, 161 (n 55)
Peña, Narcisse-Virgile Diaz de la, 29
Pennsylvania Academy of the Fine Arts, 45, 165, 179 (n 48)
Perils of the Park (illustration), 148, 150; *148*
perspective, use of, 66, 71, 75, 91, 96, 125, 126
 and anonymous views, 71, 82, 104, 126, 143
 and "l'accidents de la perspective," 174–75, 177
Peters, Lisa, 87
photography, painting and, 137–39, 151
Pic-Nic Prospect Park, Brooklyn (Carr), 64; *64*
picturesque landscape, 134 (n 115)
Piloty, Karl Theodor von, 22, 27, 34 (n 22), 39
Pisano, Ronald G., 18, 29, 131 (n 19), 159 (n 2)
Place de la Concorde (de Nittis), 30; *30*
plein-air technique, 41, 42, 51, 66, 174
Poe, Edgar Allan, 140, 159–60 (n 13), 160 (n 17)

political corruption, Central Park and, 154
Pony Path in Central Park (Hahn), 116–17; *117*
portraiture, 23, 38, 39, 61, 132 (n 35), 169
 See also studio picture genre
private space, 59–61, 132 (n 34), 150
 and anonymous views, 71, 82, 104, 126, 143
 and interior settings, 61, 126, 132 (n 34), 150
Prize Fund exhibitions, 165, 171, 177 (n 7), 185
Prospect Park (Brooklyn), 52, 61–63, 127, 135 (n 138), 150, 160 (n 52); *62*
 design of, 63, 74, 132 (n 40)
 photographs of, 66, 68, 148, 150, 151, 152; *66, 68, 148, 152*
 as subject choice, 17, 44
Prospect Park (Brooklyn) paintings, 7, 13, 61–71, 78, 128
 art criticism, on, 51, 121
 and permit dispute, 118–19, 143
 See also specific works
Prospect Park (Harvey), 63; *63*
public behavior, 154
 See also crime; etiquette
public health, 155–56
public space, 7, 71, 123, 150, 151, 156–59
 and studio setting, 61, 132 (n 34)

reactive pose, 151
real estate development, 52, 83, 115
 and Central Park, 117–18, 134 (n 121), 155; *118*
realism (Chase), 18, 89, 139, 141, 142, 150, 156–59, 161 (n 54), 174
 and identity with, 31, 56, 96, 139
Realism, 41, 59, 139
Reed, Luman, 82
Renoir, Pierre-Auguste, 41–43, 139
resorts (Brooklyn), 94–110
 See also specific resorts
resorts (Brooklyn) paintings, 17
 See also specific resorts; works
Restell, Madame, 142
Richards, T. Addison, 116
Richmond Bridge (Tissot), 30, 143, 144; *144*
Rockaway (resort), 96
Rogers, W. A., 126; *126*
Roof, Katherine Metcalf, 55, 60, 94, 123, 133 (n 95), 154
Rosenzweig, Roy, 112, 117, 155–56

Rue Lafayette: Winter Evening (Hassam), 14, 17; *17*
Ruskin, John, 27, 35 (n 33), 133 (n 55)

SAA (Society of American Artists), 23–28, 33, 45, 104, 165, 185, 186
 Chase, as president of, 13, 24, 37, 169
 1881 annual exhibition, 25, 44–45, 44–46, 86
 1884 annual exhibition, 31–32, 33, 35 (n 48)
 1886 annual exhibition, 38, 45
 1887 annual exhibition, 163, 185
 1888 annual exhibition, 72, 167–68, 185
 1890 annual exhibition, 171, 178 (n 39), 186
 1891 annual exhibition, 172–73, 186
 self-promotion accusations in, 24–25, 165
 separatist policy with NAD, 24, 35 (n 48), 51, 169
Saint-Gaudens, Augustus, 32
Sargent, John Singer, 19 (n 8), 19 (n 13), 38, 49 (n 34), 171, 173
Schreierstoren, Amsterdam, The (Maris), 30, 35 (n 41), 91, 92; *92*
seaside scenes, 42, 96, 134 (n 97)
 See also specific themes; works
self-portrait (conceptual), 59
Seurat, Georges, 41
Shaw, Erwin, 41
Shinnecock landscapes, 46, 115, 165, 171, 177, 179 (n 59)
Shinnecock School of Art, 15, 171, 173, 174, 179 (n 48)
Shirlaw, Walter, 22, 34 (n 5), 154
Sidlauskas, Susan, 174
signature devices, 119–21
 See also techniques
Sisters, The (Thayer), 33; *33*
size of painting, art valuation and, 15
Skating on the Ladies' Skating-Pond in the Central Park, New York (Homer), 112, 113; *113*
Skating Scene, Central Park (Culverhouse), 115–16; *115*
Smedley, Walter T., 140; *140*
Snowy Day on Fifth Avenue. See Fifth Avenue in Winter (Hassam)
social classes, 17, 151–56, 161 (n 54)
 elitism in, 117–18, 134 (n 121), 153, 161 (n 61); *118*
 and middle class, 61, 125, 150, 151, 156, 161 (n 54), 161 (n 56)

and social order, 143, 153, 166
and subject choice, 141, 161 (n 54)
Society of Painters in Pastel, 23, 178
(n 41)
as exhibition venue, 31, 78, 134
(n 121), 169–71, 178 (n 34), 185, 186
space, use of, 82, 119–21, 174
See also private space; public space
St. George's Episcopal Church
(Brooklyn), 74, 133 (n 63)
Statue of Liberty, 29
Stebbins, Emma, 126, 155
Steele, Richard, 139
Stevens, Alfred, 43–44, 94–96, 134
(n 97); 94
Stewart, Alexander Turney, 96
Stiles, Henry R., 52, 78, 140
still-life paintings, 17, 26, 33, 39
Strahan, Edward, 44–45
Stuart, Gilbert, 82
studio picture genre, 17, 25, 59, 61,
132 (n 34), 156–59, 174
subject matter, 13, 43, 56, 61, 71, 137, 151
and anonymous views, 71, 104, 126,
143
and aversion to vulgarity, 141, 161
(n 54)
for collector appeal, 96, 134 (n 97)
eclecticism in, 14, 156
transformed into high art, 7, 17–18,
139, 167
used to appease critics, 39, 108
suburban landscape paintings, 15, 17,
42, 43, 51, 108, 115
See also specific themes; works
Sykes, Frederick J., 108, 109; 109

Tammany regime, 117, 154
teacher, Chase as, 34 (n 1), 131 (n 16),
137–39, 179 (n 48)
at Art Students League, 22, 37,
171, 179 (n 48)

chronology of, 179 (n 48)
at Shinnecock Art School, 15, 171,
173, 174, 179 (n 48)
and students, 13, 15, 35 (n 48), 37,
123, 132 (n 35)
and teaching tenets, 71, 133 (n 54),
137, 140–41
techniques, artistic, 23, 41, 42, 61,
126, 137
and influence of Impressionism,
42–43, 168
plein-air, 41, 42, 51, 66, 174
and signature devices, 89, 119–21
Tenth Street Studio Building
(Manhattan), 22, 27, 39, 48 (n 2)
Thatched Cottage (Prospect Park),
127, 135 (n 138)
Thayer, Abbott Handerson, 26, 33,
61, 168
Thompson, Thomas, 86
Thulstrup, T. de, 68; 68
Tiffany, Louis Comfort, 44
Tile Club, 23, 42
time of day, symbolism of, 150
Tissot, James-Jacques-Joseph, 30–31,
143, 144; 144
titles, choice of, 61, 101, 132 (n 35), 146
Tompkins Park (Brooklyn), 72, 74, 75,
150; 72, 75
Tompkins Park (Brooklyn) paintings,
71–78, 126, 128
and subject choice, 17, 78, 159
See also specific works
Tompkins Square, 72
Tryon, Dwight W., 167
Twachtman, John H., 45–46, 48 (n 4),
86–89, 167
Tweed, Boss, 117, 154
Two Sisters (Renoir), 43; 43

Ulrich, Charles, 28
Union League Club (New York), 23, 186

Union Square (Weir), 49 (n 35)
See also In the Park (Weir)
urban landscape paintings, 9, 15–17,
30–31, 44, 46, 48 (n 34), 49 (n 38),
71, 122, 123, 139, 171, 179 (n 47)
misidentification of, 17, 19 (n 1)
subject choices for, 14, 17, 42, 44,
51, 112
used to underscore civility, 13, 17,
42, 156, 178 (n 36)
See also specific themes; works
urban spectatorship motif, 150

Van Gorder, Luther Emerson, 123, 185
Van Rensselaer, Mariana, 23, 26, 31
Vaux, Calvert, 62–63, 112, 135 (n 137),
155, 161 (n 73)
Velázquez, Diego, 39, 41, 56, 138
Viele, Egbert L., 62–63, 132 (n 40)
View in Central Park (McEntee), 114,
115; 114
views, 59, 115, 119–21, 126, 143
anonymous, 71, 82, 104, 126, 143
reductive, 71, 91, 96
used to portray gentility, 82, 83,
156
vision, in painting, 137
Vollon, Antoine, 29, 39, 45

Walker, A. M., 86; 86
Wallabout Bay, 52, 78, 83, 89
Wallabout Bay paintings, 51, 87–89
See also specific works
Ward, John Quincy Adams, 117
Washington Park (Brooklyn), 17, 178
(n 22)
Washington Park (Brooklyn) paintings,
167
See also specific works
Watrous, Harry Willson, 140
Webb, James Watson, 24
Weir, Julian Alden, 14, 35 (n 36), 44

West Brighton (Coney Island), 96,
104
Wharton, Edith, 144
"While Strolling in the Park One Day,"
150, 160 (n 51)
Whistler, James McNeill, 26, 27, 31,
37, 161 (n 76)
art criticism, on, 26–27, 33, 49 (n 38)
influence on Chase, 37, 39, 51, 71,
87, 96
White, Stanford, 59, 125–26
white, symbolism of, 156, 161 (n 76)
Whitman, Walt, 140
Whittredge, Thomas Worthington,
46
Williamsburgh Savings Bank
(Brooklyn), 89, 133 (n 90), 133
(n 91)
Willis, Nathaniel Parker, 140
women, 156
and clothing, 144–46, 156, 161
(n 76), 161 (n 78)
and expression, 143, 150, 151
and freedom of movement, 150
iconography of, 42, 56, 61, 156
in landscape, compared with studio
subjects, 156–59
as "object of the gaze," 150–51,
160–61 (n 53)
in The Open Air Breakfast, 60–61
and public display theme, 143–46
and "reactive pose," 151
and social etiquette, 143–46, 150,
160 (n 43)
as subject choice, 42, 143
See also models
World's Columbian Exposition of
1893, 122–23, 134–35 (n 128), 178
(n 36), 184, 186
Wunderlich and Co., 169–70
Wyant, Alexander Helwig, 14, 17;
17